D0016740

DATE DUE

MULTICULTURALISM
AND
PUBLIC ARTS POLICY

DAVID B. PANKRATZ

BERGIN & GARVEY
Westport, Connecticut • London

Library of Congress Cataloging-in-Publication Data

Pankratz, David B.
 Multiculturalism and public arts policy / David B. Pankratz.
 p. cm.
 Includes bibliographical references and index.
 ISBN 0-89789-361-1
 1. Ethnic arts—United States. 2. United States—Cultural policy.
 I. Title.
 NX730.P36 1993
 700'.89—dc20 93-25008

British Library Cataloguing in Publication Data is available.

Library of Congress Catalog Card Number: 93-25008
ISBN: 0-89789-361-1

First published in 1993

Bergin & Garvey, 88 Post Road West, Westport, CT 06881
An imprint of Greenwood Publishing Group, Inc.

Printed in the United States of America

The paper used in this book complies with the
Permanent Paper Standard issued by the National
Information Standards Organization (Z39.48-1984).

10 9 8 7 6 5 4 3 2 1

To the Memory

of My Parents

Contents

Tables

Acknowledgments

I express my sincere appreciation to James Hutchens, of the Ohio State University (OSU), for his guidance and sage advice throughout this research project and to Louis Lankford and Patricia Stuhr, of OSU, for their incisive criticisms and suggestions. My thanks go to Ralph Smith and Ralph Page, of the University of Illinois at Urbana Champaign, for encouragement of my work and to the Getty Center for Education in the Arts for providing needed financial support. The technical assistance of Susan Anderson and Roz Singer is gratefully appreciated. To my brother, John, my respect for blazing this same trail before me. Finally, I extend my heartfelt gratitude to my wife Susan and son Nathaniel, without whose patience, understanding, and inspiration this book could not have been completed.

MULTICULTURALISM
AND
PUBLIC ARTS POLICY

Introduction:
Policy Contexts in the Arts

The evidence that American society is characterized by racial, ethnic, and cultural diversity, and increasingly so, is inescapable. During the 1980s, all population groups showed a numerical increase. But the percentage of whites in the total population of 248,709,873 declined from 83.1 to 80.3%, whereas the percentages of other populations have increased: black (11.7 to 12.1%), American Indian (0.6 to 0.8%), Asian (1.5 to 2.9%), and Hispanic (6.4 to 9.0%). These trends were fueled by several factors: heavy immigration by Hispanic and Asian groups; higher birthrates among peoples of color than whites; and lower death rates among the relatively younger Hispanic, Asian, and American Indian populations than whites.[1]

There is every reason to believe that these population trends will continue. It is estimated that by the year 2000 one out of every four Americans will be of black, American Indian, Asian, or Hispanic descent; by 2030, it is predicted that the figure will grow to nearly one in three.[2]

But to demonstrate, even unarguably, that American society is racially, ethnically, and culturally diverse is not a sufficient basis to conclude that the same society is multicultural. *Multiculturalism* is a normative term. It embodies a vision of an ideal state of affairs in a society; in particular, it comprises concepts and value commitments concerning how the cultural, political, economic, and social relations of racial and ethnic groups ought to be in American society. Multiculturalism also entails value positions in many spheres of human experience, both individual and social.

CURRENT POLICY ISSUES IN THE ARTS

Whenever questions of value arise in a societal context, especially those with implications for the public at large, those questions are likely to become a matter of debate over public policy. Public policies involve action and allocation of resources to achieve individual, group, and societal purposes, purposes rooted in human values and ideals. Policy issues arise when there is some conflict of values. Choice among values is necessitated,

most often, by scarcity of resources such as time, materials, finances, and personnel. In contemporary American society, the process of making choices among policy options is extremely complex and inevitably involves advocacy activities by groups with interests in securing public resources to support their value positions and goals for society.

Over the past decade, and with accelerated momentum during the past five years, multiculturalism as a societal ideal has taken a prominent place in the complex policy contexts of the arts. This increased attention has been generated by strong and visible advocates for increased public support for the production and distribution of the arts of diverse cultures.[3] Multicultural concerns are on the agenda of numerous arts service organizations as well[4] and, most significantly, have become a focus for discussion, planning, and action by public arts agencies at national, state, and local levels.[5] In turn, these activities have yielded numerous questions of public policy: What artists and organizations should have access to public funds? On what criteria should funding decisions be based? Who should be involved in the making of such decisions? What balance should be sought between equal opportunity and equal results in the distribution of funds? This trend also raises questions about the goals and purposes of public support of the arts.

There are many ways to seek an understanding of the rise of multicultural concerns in arts policy contexts. A traditional means often utilized by policy analysts would be first to view policymakers, interest groups, and even academics primarily as advocates for a point of view or, in more technical jargon, as "interest–maximizers." Utilizing such a method, one would go on to analyze the politics of policy formulation—who has influence in a policy context; the nature of that influence; the means by which influence is exercised; the accommodation of diverse interest groups through bargaining, negotiation, and trade–offs; and the salesmanship and public relations techniques involved in selling a final policy proposal to ultimate decision makers and, in some cases, those potentially affected by a policy proposal. In this mode of analysis, the researcher focuses almost exclusively on policy processes. He or she also stands above the policy fray, in a particularly crucial sense, by avoiding or remaining value neutral on the policy issues involved. No attempt is made to clarify, analyze, question, or affirm the values and theoretical concepts that inform choices made by participants in a policy process.

This book, on the other hand, will illustrate an alternative approach to analyzing policies, in this case, those regarding multiculturalism and the arts. It is squarely within an emerging tradition of policy analysis that confronts the explicit and implicit values of policy positions, the concepts that embody those values, and theoretical presuppositions underlying choices of policy goals and means.[6] In so doing, this mode of policy analysis takes

as a given that persons, including those in policy contexts, are not merely collections of behaviors acting to maximize individual or group interests but interpreters and makers of meaning and choices.

This book also represents an effort toward methodological innovation. It combines features of the newer modes of policy analysis, outlined in brief above, with a traditional method of philosophy—conceptual analysis. In conceptual analysis, the researcher probes the meanings of concepts as used in the formulation of arguments to support statements of belief. It can yield insights into how usage of terms such as *art*, *culture*, *aesthetic value*, and *justice* in arguments surrounding multiculturalism, public arts policy, can fall prey to the pitfalls of language—ambiguity, equivocation, and vagueness. Policy analysis, in turn, can examine whether proposed policies' goals are worthwhile and whether selected means are likely to effect achievement of these goals in an equitable and efficient manner.

This type of analysis is needed at this time, I believe, because public arts agencies, despite overall growth in number and budgets that has been dramatic over the past three decades, are facing the greatest crisis of purpose in their shared histories. This crisis was spawned in 1989 by National Endowment for the Arts (NEA) funding, in some cases directly and in others indirectly, of controversial works by artists Robert Mapplethorpe, Andres Serrano, David Wojnarowicz, Karen Finley, and Holly Hughes. The content of these works, critics claimed, was deeply offensive to many Americans' moral values and religious beliefs. In the eyes of assorted columnists, commentators, religious organizations, and interest groups, the NEA was the captive of avant–garde artists and purveyors of pornography and infected with an anti–Christian bias.[7] Arts advocates, initially at least, often dismissed these claims with ad hominem attacks arguing, for example, that NEA critics were merely "homophobic" and that their attacks on government funding of certain works were motivated out of a disguised fear and hatred of life–styles they find strange and threatening. Others viewed these attacks as attempts to further the conservative social agenda that the Reagan administration never implemented, as merely a fund–raising ploy for conservative political candidates, as a way of keeping busy in the absence of a cold war, or as an effort to censor the free expression of divergent viewpoints and ideas under the guise of a populist taxpayer revolt. Congress, for its part, instituted content restrictions on the kinds of art that could receive NEA funding during the 1989 appropriations process.

The 1990 reauthorization process for the Endowment yielded one House proposal to eliminate the NEA entirely on grounds that decisions about support for the arts should be made solely by private individuals and organizations. Another proposal called for a long list of content restrictions. However, bolstered by the conclusions and recommendations of a congressionally appointed, bipartisan Independent Commission,[8] the final

reauthorization legislation avoided these extremes. While it stipulated that the NEA chairman must consider "general standards of decency"[9] in making final grant decisions, the final legislation did reject specific content restrictions on the kinds of art the NEA could fund, arguing that the courts are the most appropriate forum to resolve obscenity issues.

Despite the passage of this legislation, there is no reason to believe that the potential for controversy surrounding the NEA and the idea of public support for the arts itself has been eliminated. Conservative interest groups and politicians have promised continued vigilance over NEA funding policies, decision–making processes, and granting decisions.[10] The impact of this period of controversy on the public's perception of the NEA and public arts policy is less clear. Not surprisingly, there has been no shortage of commentators willing to appoint themselves as spokespersons for the "American people." But it is reasonable to assume, I think, that public arts agencies, as a result of this controversy, are in need of a renewal of public purpose.

One consistent definition of purpose for public arts agencies was offered by many arts advocates during this period. It consisted of a reaffirmation of constitutional protections afforded freedom of speech and artistic expression, called "among our most important and cherished rights."[11] The significance of this right, it is argued, is rooted in the significance of the individual artist—"all art and the work of arts organizations flow from the creativity of the individual artist—in solitude, in collaboration, in community."[12] As applied to arts policy, the argument went as follows: The Congress may decide or not to establish grant programs to fund artists and arts organizations with public funds. But once it decides to do so, it may not direct a public agency to administer programs in a way that would abridge the constitutional rights of grant applicants or recipients, including freedom of speech. Thus, content restrictions on publicly funded art are inappropriate and unconstitutional.

This argument is supported by a considerable body of legal opinion.[13] Conservative critics of the NEA remain unpersuaded. But whatever one's conclusions on this constitutional issue, it cannot be concluded with any logical force that the protection of artistic freedom therefore constitutes an ultimate purpose of, or goal, for public arts agencies. This is so, I believe, because "protection of artistic freedom" is most accurately thought of as the *means* of a policy rather than as a purpose or goal. It is a principle that applies to how decisions should be made—perhaps, arguably, one without which the work of public arts agencies would be severely compromised—rather than to a purpose that decisions should serve.

It is in this context of public arts agencies' search for a defensible sense of purpose, born of controversy, that this volume on the subject of multiculturalism and arts policy takes on added significance.

Multiculturalism is being proposed, in many circles, as an important, even necessary goal for public arts policy.[14] Indeed, recent NEA chairman John Frohnmayer articulated five new policy priorities for the NEA designed to "rebuild" the bridge between the arts and public, a bridge damaged during the yearlong controversy.[15] Among them is the promotion of access to the arts in multicultural communities. But until multiculturalism and its implications for arts policy are subjected to critical analysis and evaluation, it is not at all clear that this goal will reinvigorate public arts agencies' sense of purpose in a defensible way.

Chapter 1 focuses on defining key terms used throughout the study, most notably, *multiculturalism*. The chapter begins with a historical review of definitions of the concept of culture. I argue, as with the concept of art, it may be possible to list some nonneccessary and nonsufficient conditions that can guide use of the term culture. Explication of these conditions are yielded through analysis of the terms *cultural diversity* and *ethnicity*. These analyses conclude with a descriptive definition of multiculturalism, leading, in turn, to consideration of how multiculturalism as a social ideal is conditioned by the American social structure and, significantly, possible actions that government can undertake relative to multiculturalism. It is the role of the state, I argue, that has contributed to the current rise of interest in multiculturalism, as well as other factors. These explanations apply to multicultural interests in arts policy as well. But several other explanations, unique to the arts policy sphere, are examined.

Chapter 2, "Foundations of Policy Research Methodologies," explores the epistemological and logical foundations of different methodological approaches to policy research. This extended inquiry is necessitated, in part, I argue, by the lack of tradition of policy research in the arts, at least as compared with the amount of policy research in other fields. The paradigm of positivism has dominated the practice of policy research for several decades. This chapter explores several possible alternatives to positivistic policy research. One approach is rooted in analysis of the logic of the term *policy*. But I argue that this logical analysis only goes so far as a corrective to positivism. It leaves unanswered and even unaddressed key questions, most notably, Is it possible, and if so, how, to decide whether some policy purposes and goals are more worthwhile than others? Possible means of resolving value questions underlying policy prescriptions include interpretive social science, critical theory, and political philosophy. Each has made contributions to the methodology of policy research. But none, by itself, yields criteria for deciding among alternative policy prescriptions. It is here that Chapter 2 explores the potential of conceptual analysis as a resource in policy research. It can give special attention to the role of definitions in premises and arguments, especially the sorts of definitions used in practical, including policy, contexts. In this way, I argue, conceptual

analysis and policy analysis are complementary tools in an integrated methodology of policy research. Chapter 2 concludes with an exposition of how this integrated research methodology will be applied to multiculturalism and arts policy.

Chapter 3 represents an effort to understand the policies of public arts agencies regarding multiculturalism. This interpretation has as its subject, for a variety of reasons, the policy mechanisms of state arts agencies. Policy mechanisms are the means by which public arts funds are made available to potential grantees. A full–fledged evaluation of the impact of state arts agencies' policy mechanisms on multicultural constituencies would require the presence of comprehensive, reliable trend data that do not exist. Instead, it is the purposes and likely effectiveness of these policy mechanisms that will be analyzed. Policy mechanisms consist of many elements, in various configurations. Based on information gleaned from a significant sample of state arts agencies' grant guidelines, annual reports, special research studies, and long–range planning documents, many elements of these policy mechanisms are analyzed: agency goals; eligibility requirements; evaluative criteria; the composition of agency staffs, boards, and review panels; application guidelines; and terms of grants. In addition, special agency initiatives and affirmative action plans, as they address multicultural concerns, are also analyzed. Out of this examination, several issues that are fundamental to multiculturalism and arts policy emerge: the ideal of cultural pluralism, the relation of art and culture, affirmative action, and determining the nature of artistic value.

Chapter 4 begins with an analysis of historical conceptions of "cultural pluralism," views of how the political, social, and economic relations of cultural and ethnic groups ought to be in society. This analysis is necessary because many public arts agencies justify their programs as means to promote cultural pluralism. Some critiques of cultural pluralism raise questions about the relation between art and culture, in particular, whether production and consumption of the arts of diverse cultural and ethnic groups can and do foster cultural pluralism in the society at large. The subsequent argument revolves around the claim that art "reflects" a culture. This claim is analyzed in logical and sociological terms, starting with the production of art in diverse cultural traditions and extending to questions of artistic perception, patterns of consumption of the arts, the role of the marketplace in the production and consumption of the arts, and the arts' social functions and cultural meanings. The picture that emerges is equivocal. I argue that if it is not clear that the production and consumption of the arts of diverse cultural traditions foster the development of cultural diversity in society, then a stronger justification for arts policymakers to address multicultural concerns must be found. The concepts of justice, in general, and affirmative action, specifically, are thus analyzed as possible justifications for the

formulation of public policies in the arts. Many policy mechanisms utilized by public arts agencies are justified in terms of affirmative action, which is the specific application of concepts of justice to public policy settings. I focus on general arguments that have been formulated to justify affirmative action policies. Based on conceptions of compensatory justice, distributive justice, human rights, utilitarian justice, and equal opportunity, these arguments are analyzed on conceptual grounds and in terms of their implications for arts policy. A final conceptual issue with ramifications for arts policy is artistic value. Artistic value is invoked by public arts agencies as a key criterion in making decisions among potential grantees. But, as will be shown, the concept of artistic value has been challenged on many grounds, including the claim that artistic value is relative to specific cultural traditions. There is no shortage of claims about artistic value. The more extreme claims are critiqued on logical grounds. But a major philosophical question remains: Is value in art best thought of as one thing or as many? Various claims for the instrumental value of art are reviewed, including the aesthetic, cognitive, moral, and religious values of art. My conclusions on this issue are traced for their relevance to the formulation of public arts policy.

The concluding chapter, Chapter 5, begins with a discussion of the limitations of this book as a research study as a prelude to an assessment of the prospects for policy research in the arts. Research gaps in our understanding of the policy environment of the arts are also reviewed. The chapter concludes with a discussion of reasonable expectations of, and defensible criteria of effectiveness for, the utilization of policy research in the arts.

NOTES

1. These figures are cited in Barbara Vobejda, "Asian, Hispanic Numbers in U.S. Soared in 1980s, Census Reveals," *Washington Post*, 11 March 1991, pp. A1, A5.

2. These figures are cited in National Endowment for the Arts, *The Arts in America: A Report to the President and Congress* (Washington, DC: National Endowment for the Arts, Public Information Office, 1988).

3. See, for example, Donovan Gray, ed., *Open Dialogue II: Summary Report* (Washington, DC: Association of American Cultures and National Assembly of Local Arts Agencies, 1987); and Association of American Cultures (TAAC), *Open Dialogue III* (Washington, DC: Association of American Cultures, 1988).

4. See, for example, William Keens and Naomi Rhodes, eds., *An American Dialogue* (Washington, DC: Association of Performing Arts

Presenters, 1989); and William Keens, ed., *The Road Ahead: Arts Issues in the 1990s* (New York: American Council for the Arts, 1989).

5. See National Endowment for the Arts, *Arts in America 1990: The Bridge Between Creativity and Community* (Washington, DC: National Endowment for the Arts, 1990); National Assembly of State Arts Agencies, *Report of the NASAA Task Force on Cultural Pluralism* (Washington, DC: National Assembly of State Arts Agencies, 1989); and National Assembly of Local Arts Agencies, *Policy on Cultural Diversity and Cultural Equity* (Washington, DC: National Assembly of Local Arts Agencies, 1991).

6. See, for example, Frank Fischer, *Politics, Values, and Public Policy: The Problem of Methodology* (Boulder, CO: Westview Press, 1980); Daniel Callahan and Bruce Jennings, eds., *Ethics, the Social Sciences, and Policy Analysis* (New York: Plenum Press, 1983); Frank Fischer and John Forester, eds., *Confronting Values in Policy Analysis: The Politics of Criteria* (Newbury Park, CA: Sage Publications, 1987); and M. E. Hawkesworth, *Theoretical Issues in Policy Analysis* (Albany: State University of New York Press, 1988).

7. For a summary of these charges, see Robert H. Knight, *The National Endowment for the Arts: Misusing Taxpayers' Money* (Washington, DC: Heritage Foundation, 1991).

8. Independent Commission, *A Report to Congress on the National Endowment for the Arts* (Washington, DC: Independent Commission, 1990).

9. For this legislation in its complete form, see *Reauthorizaton of Foundation on the Arts and the Humanities Act of 1990*, U.S., Congress, 101st Cong. (Washington, DC: Government Printing Office, 1990).

10. See Robert H. Knight, *The National Endowment for the Arts.*

11. American Arts Alliance, *Artistic Freedom: Our American Heritage* (Washington, DC: American Arts Alliance, 1990), p. 2.

12. Ibid., p. 1.

13. Much of this legal opinion can be found in Independent Commission, *A Report to Congress on the National Endowment for the Arts.* See also Kathleen M. Sullivan, "Artistic Freedom, Public Funding and the Constitution," in Stephen Benedict, ed., *Public Money and the Muse: Essays on Government Funding for the Arts* (New York: W. W. Norton, 1991).

14. See, in particular, Robert Garfias, "Cultural Diversity and the Arts in America," and Gerald D. Yoshitomi, "Cultural Democracy," in Stephen Benedict, ed., *Public Money and the Muse.*

15. John Frohnmayer, "Talking Points" (Briefing paper prepared for Newsmakers Breakfast, National Press Club, Washington, DC, 17 September 1990).

1

Multiculturalism and Arts Policy Research

British cultural critic Raymond Williams, throughout his extensive writings,[1] has explored the concept of culture in great depth. In doing so, he has examined the sociocultural contexts that have shaped the formulation and usage of both normative and descriptive definitions of culture. Rather than dismissing these definitions as merely historically conditioned expressions of bias, he has attempted to understand each as yielding potential insights into the fashioning of a modern concept of culture. I propose to work in a similar manner in seeking a descriptive definition of the term *multiculturalism*. This approach is based on the belief that no single discipline or school of thought has a monopoly on insights into the concept of multiculturalism. Many stipulative and programmatic definitions of *multiculturalism*, *culture*, and *ethnicity* can be found, but the intent here, at least at this point, is not to seek some kind of rapprochement between different uses of these terms. Instead, my intent is to construct a descriptive definition of multiculturalism, one that will serve to orient subsequent discussions in this chapter and throughout the book.

DEFINITIONS OF CULTURE, ETHNICITY, AND MULTICULTURALISM

A necessary first step in formulating a descriptive definition of multiculturalism is to examine the root term of *culture*. Definitions of culture, historically, have been proposed in two primary forms of discourse—in the course of formulating explanatory, interpretive, or predictive theories of culture; and in critiques of the quality and character of culture and accounts of conditions that diminish a culture's quality. Obviously, given the diverse purposes of theorists from different disciplines, schools of thought, and historical periods, and the different assumptions and premises utilized in their arguments, the content and form of these definitions vary considerably. But each was formulated, directly or indirectly, in response to one or more basic questions: In what does a culture consist? Is it a property of individuals, a group of persons, a society, and/or a nation? If

culture is a property of an entity larger than the individual, what is the actual or ideal relation of the individual to the culture? Is culture separable from the socioeconomic structure of a society? What factors contribute to the continuation of culture, or cultural change? What are the factors that condition relations between cultures within a society and between cultures in different societies? Is it possible to make qualitative judgments about the contents of different cultures? If so, are standards of evaluation universal in nature or, in some sense, best conceptualized as evolutionary or as stages in a developmental process?

Reflecting various responses to some or all of these questions, three categories of definitions of *culture* can be identified: (1) the use of *culture* as a synonym for a body of artistic and intellectual work;[2] (2) a process of individual cultivation leading to an ideal state of human perfection;[3] and (3) the use of *culture* to refer to the whole way of life of a society, with varying emphases on meanings and values or the material organization of social life. While reference to culture as a body of artistic and intellectual work, according to Williams, "is still probably the most common popular meaning of the word 'culture,'"[4] and while conceptions of culture as the development of an individual's best self through immersion in the best that has been thought and said continue to exert influence in contemporary thinking about culture and education, the focus here will be on definitions of culture that refer to the whole way of life of a society, in large part because such definitions are assumed most often in current discussions of multiculturalism and arts policy.

The final category of definitions of the term *culture* represents a dramatic shift in usage from the other two categories. It is a departure from reference to a singular culture, whether defined as a body of intellectual and artistic work or as a process of developing an individual's best self, to talk of a plurality of cultures. The term *culture* was extended (persons with differing views might say appropriated) by late nineteenth century social scientists to refer to the whole way of life of given societies. Several factors contributed to this shift. The first was European intellectuals' growing awareness of, and interest in, folk life, those particular and distinctive customs and arts of different people within nations. Their accumulating knowledge of non–European societies such as India and China, among others, societies with different and complex social organizations and sophisticated artistic and intellectual traditions, also contributed to this conceptual shift. "Although many Europeans saw these societies as merely backward in comparison to their own, with its highly developed technology and politics, others saw them as distinctive shapings of the human mind that could not easily be assimilated to a simple, unilinear idea of civilization"[5] or culture. Further, these observers were discovering significant connections between economic and social life and the styles and content of intellectual

and artistic work.[6] As Williams states, "The concept of a specific 'culture'
was an obvious way of expressing these relations."[7] Finally, it can be
argued that the concept of culture was important to the development of
anthropology, providing this fledgling discipline, in the late nineteenth
century, with a needed and unique focus of analysis.

Anthropologist E. B. Tylor is credited with the first use of *culture*
as a social scientific term. He defined culture, a definition of considerable
influence even today, as "that complex whole which includes knowledge,
belief, art, morals, law, customs, and any other capabilities and habits
acquired by man as a member of society."[8] But, historically, there has been
considerable controversy in the social sciences over this concept of culture.
These disputes have centered on the relations between the many clcmcnts
in the "whole way of life" of a society. Notably, under the influence of
Marxist and neo–Marxist theories, many social scientists have posited "a
definite relation between that 'complex whole' of meanings and values
'acquired by man as a member of society' and particular types of social and
economic institutions. In general, types of organization of material life were
held to determine systems of meaning and values.... According to this view,
'culture' inevitably includes the material organization of life and cannot be
confined to the area of meanings and values."[9]

Williams, in his cultural criticism, is a major contemporary
proponent of this view. He sees questions of culture not as matters of
meanings and values but as matters of social relations and political economy
in a society. In particular, culture, he argues, is conditioned by inequitable
social and economic relations. Those with economic and social power are
able to achieve cultural hegemony in a society, with dominance over the
production, dissemination, and consumption of culture. In turn, such
cultural dominance, through a continual process of renewal within powerful
classes, reinforces such classes' claims of legitimacy as well as actual power.
Other social groups, as a result, Williams argues, exist in a condition of
"lived dominance." Such groups have some degree of cultural autonomy,
allowing them to create resistant or oppositional cultural forms. Yet
Williams concludes that by incorporating alternative cultural forms under
systems of cultural dominance, groups with economic and social power are
able to maintain cultural dominance, even in the face of opposition.[10]

Many social thinkers have rejected the primacy of socioeconomic
structures in Marxist and neo–Marxist theories of culture. These thinkers
are more impressed with the extraordinary cultural differences between
societies, especially those between societies with comparable social and
economic structures. The work of anthropologist Clifford Geertz exemplifies
this point of view. It stresses the particularity of culture and the variety of
lived experiences in different societies. Geertz calls for ethnographic study
of individual cultures in their "thick particularity," study that examines those

meanings that inform the actions of members of a particular culture. Such inquiry, for Geertz, is rooted in a view of culture as creative, inhering in the way people create and use symbols to construct new interpretations of social experience, both public and private. He formally defines culture as "an historically transmitted pattern of meanings embodied in symbols, a system of inherited conceptions expressed in symbolic form by means of which men communicate, perpetuate and develop their knowledge about and attitudes towards life."[11] But neo–Marxist critics remain unpersuaded by arguments for a symbols–and–meanings conception of culture such as the one proposed by Geertz. These critics argue that Geertz "aestheticizes" the concept of culture through his neglect of the factors of socioeconomic power and repression in conceiving culture.[12]

Dispute over the concept of culture as a whole way of life is not limited to arguments between neo–Marxists and proponents of the symbols–and–meanings perspective; there are numerous disputes within the latter perspective as well. There are many specific unresolved issues within the symbols–and–meanings conception of culture, a perspective comprising a plurality of views of reality, mind, meaning, and symbols. This plurality of approaches to understanding the elements of cultures can be placed in three categories: universalism, developmentalism, and relativism.

A universalist approach is rooted in what Richard Shweder terms "enlightenment" assumptions: "that the mind of man is intendedly rational and scientific, that the dictates of reason are equally binding regardless of time, place, culture, race, personal desire, or individual endowment, and that in reason can be found a universally applicable standard for judging validity and worth."[13] From these assumptions flows an effort to uncover universals across cultures, "to induce the nature of man, and the dictates of reason, from practices *common* to humanity."[14] Further, as Shweder argues, "to do this successfully, one must search for deeper and underlying agreements hidden behind surface differences."[15] It is admittedly difficult to uncover similarities across cultures. This process entails the assumption that diversity among cultures and its members is more apparent than real. But critics argue that the results of enlightenment research undercut this assumption. Too often, they argue, such inquiry yields accounts of similarities that are overly general and, in so doing, overlook significant differences between cases.[16]

Developmentalists share the assumption of the enlightenment approach that the dictates of reason and evidence are the same for all persons regardless of culture, time, or place. But developmentalists, in contrast, argue that these same dictates of reason and evidence are not equally developed in all persons and cultures. Developmentalists stipulate normative standards or end points for thought or action in a particular sphere of human activity. In applying such standards, developmentalists take

the diversity of human behavior as a given. They then interpret this diverse behavior on a continuum, as it approaches the stipulated end point or not. Thus, developmentalists see thought and action in different cultures as a matter of progress in steps and stages, involving adaptation and problem solving as individuals or whole cultures make progressively better adaptations to the demands of their environments. The developmental perspective has been utilized in the study of the cognitive,[17] moral,[18] and aesthetic[19] domains of individual experience and has been extended to the history of ideas, seen as "a history of more and more adequate representations of reality."[20] These widespread applications of developmentalism have, in turn, generated criticisms from numerous points of view. But a more general criticism of developmentalism is of greater interest here, a criticism that focuses on developmentalism's normative claims. The dispute centers on developmentalist theorists' efforts to establish end points toward which development progresses in domains of human experience. Critics are not persuaded that, whatever the merits of their theories, it is possible for developmentalists to justify claims that one form of cognition, morality, or artistry is better or worse than another, let alone provide normative grounds for stipulating end points for development. By disputing these premises, critics thus call into question any attempts to rank thought and action on a continuum and, hence, the validity of stage theories of progress.

These criticisms of developmentalism are primarily the domain of theorists working within the perspective of relativism. A central tenet of this view "holds that ideas and practices have their foundation in neither logic nor empirical science, that ideas and practices fall beyond the scope of deductive and inductive reason, that ideas and practices are neither rational nor irrational but rather *non*rational."[21] Under the paradigm of relativism, cultures are seen as self–contained frameworks for understanding experience, each with its own rules and modes of interpretation. A relativistic perspective does not lend itself to comparative evaluation of cultures and their practices on normative grounds. Indeed, for a relativist, any choice between frameworks and practices, in the absence of normative grounds, must, of necessity, be an act of faith.

A recent and major development within the relativist paradigm is the addition of a significant premise to the symbols–and–meanings perspective on culture, namely, the conception of culture as an arbitrary code.[22] Many influential, contemporary theorists argue for a 'symbolic' anthropology, an anthropology primarily concerned with nonrational ideas (presuppositions, cultural definitions, declarations, arbitrary classifications) and their verbal and nonverbal means of expression. Indeed, the main idea of a symbolic anthropology is that much of our action "says something about what we stand for and stands for our nonrational constructions of reality."[23]

But these new developments in anthropological theory do not alter the primary thrust of relativism—to defend the coequality of fundamentally different frames of thought and action characteristic of diverse cultures. Predictably, the notion of cultural relativism is problematic for many. It generally is conceded that relativism, from its origins in the early twentieth century, was a worthwhile reaction to the prejudice of ethnocentrism. As Williams argues, "It was evidently wrong to interpret all cultural phenomena in terms of categories applicable to European societies, and it was arbitrary and dangerous to attempt to evaluate very diverse cultures by references to a fixed value system that was likewise derived from European tradition;"[24] and relatively few would argue with the idea that "a particular complex whole should be studied as far as possible in its own terms, rather than assimilated to the observer's terms."[25] Still, at the very least, the idea of cultural relativism seems to be tinged with irony. While the notion of cultural relativism may be extended to the study of other cultures, those cultures themselves, far from agreeing with premises of cultural relativism, many times are absolutist in defense of their own systems of thought, belief, and action. The idea of cultural relativism has also been critiqued on grounds of logical consistency. The defense of the coequality of cultures, to some, seems to be an absolutist approach to understanding other cultures, thereby exempting such a defense from the idea of cultural relativism, resulting in a logical contradiction. Not surprisingly, universalists are simply not willing to accept the idea that all forms of thought and action are equal in rational or normative terms; developmentalists are unwilling to forgo the idea of progress in the thought and actions of individuals and cultures. Still other critics focus on the consequences of a belief in cultural relativism, arguing that the emphasis on self–contained worldviews yields no common standards for rational criticism of diverse cultural practices. Without such standards, it is argued that when disputes arise between cultures, the only available recourse for reconciliation is force, domination, or nonrational conversion.

At this point, it seems obvious that any attempt to legislate a definition of culture is futile. Culture is quite similar to the concept of art, in that no set of necessary and sufficient conditions can be identified for its uniform use, only a complicated network of similarities overlapping and crisscrossing, or family resemblances.[26] Yet, as with art, it may be possible to list some nonnecessary and nonsufficient conditions that could at least guide our decisions about whether something can be called a culture. The work of the philosopher Richard Pratte points to a solution to this dilemma. He explores the logical conditions of the term *cultural diversity*. As will be seen, an understanding of cultural diversity can help make it possible to describe conditions for use of the term *culture*, a necessary step in constructing a descriptive definition of multiculturalism.

Pratte begins with the premise that human groups do not exist in nature but are things that human beings decide to identify and distinguish. Every society is characterized by diversity of some sort. But when we say that a society is homogenous, we have decided simply that the ways that different groups in a society differ are unimportant or irrelevant in a particular context. On the other hand, when we say that a society is diverse, we have decided that there is an important and relevant reason to identify and distinguish groups as different. This is not sufficient to establish the diversity of cultures, however, in that groups can be distinguished along noncultural lines such as occupation, neighborhood, club membership, and the like. Pratte argues that more is required. He suggests that the "differences between groups must be viewed as fundamental enough to be capable of producing values and dispositions that contribute to significantly different outlooks on the world."[27] Further, and this question has been begged so far, it is not enough to say that someone from an omniscient or powerful point of view merely decides that there is cultural diversity in a society. It must also be the case that a group considers itself different or unique in its outlook on the world. But even this goes only so far. Just because a group says it is different does not make it so—for a group to say it is different only means that we have a group that says it is different. Pratte thus posits that differences among groups must be more than merely self–proclaimed. In particular, this diversity "must be made incarnate within the behaviors of the people...and expressed in a concrete situation which bears on political, economic, and social policy."[28] Pratte posits a final condition, a historical condition, that goes beyond identity within a present–day social system, that cultural diversity is a matter of cultural transmission across generations. He contends that without the transmission of values, dispositions, and outlooks on the world, it would be difficult to describe a society as culturally diverse. In summary, then, *cultural diversity* as a descriptive term "refers to the coexistence of unlike or variegated groups within a common social system."[29]

These conditions for the descriptive use of the term *cultural diversity* offer a way to talk about cultures that does not involve the heavily value––laden premises that inform concepts of culture such as "a process of individual cultivation" or a "whole way of life of a society." By the process of conceptual analysis, then, it can be said that a culture consists of a group that is seen and sees itself as having relatively unique shared and transmitted values, dispositions, and outlooks on the world made manifest in the group's behaviors within a common social system and with significant bearing on political, economic, and social policy.

The premises in this definition of culture that touch on social structure and political, economic, and social policy bear closer scrutiny. This will be done by examining the concept of *ethnicity*, in particular,

contemporary definitions of ethnicity as a new social form conditioned by political and economic structures. Consideration of the concept of ethnicity is also a necessary step, as will be seen, in constructing a descriptive definition of multiculturalism.

There seems to be general agreement on the premises, as Talcott Parsons argues, "that what we call ethnicity is a primary focus of group identity, that is, the organization of plural persons into distinctive groups and, second, of solidarity and the loyalties of individual members to such groups."[30] But beyond these premises numerous reference points have been invoked in diverse definitions of ethnicity. These reference points have included: (1) national identity, in which identification with a common culture and shared territory of residence is maintained across generations; (2) language, with identity rooted in an oral tradition and documents of written language; (3) religion, in which sets of beliefs and rituals form the basis of group identity; (4) cultural behaviors, such as norms and customs; (5) historical experience, in which identity is born of experiences as a group historically, notably, colonization, enslavement, or exploitation; and (6) self—image, ideas about who a group is as a people, for example, hard—working, brave, or "chosen people," among others.

These points of reference for ethnicity are not mutually exclusive, and they appear in various configurations in diverse definitions of the term. They are frequently invoked in definitions that tend to be backward looking, reflecting the belief that ethnicity is a basic, primordial feature of human nature that is inherited and will endure over time, even in the face of suppression. But these points of reference are also invoked in more dynamic theories of ethnicity, theories that see ethnic groups as "dynamic flexible mechanisms that grow and change and have integrity [and are] not necessarily threatened by the change."[31] Such theories focus on interactions between ethnic groups within a common social structure. Through the influence of interaction and acculturation, it is argued that while the commonalities between these groups increase, certain ethnic characteristics become more distinctive and are voluntarily emphasized and developed in the face of threats of homogenization.[32]

These conceptions of ethnicity, as a basic, primordial reality and as a conscious reassertion of ethnic characteristics in a multiethnic society, stand in contrast to contemporary conceptions of ethnicity as a new social form. In part, this new conception consists in a shift from stress on identification with acquired or learned aspects of ethnic heritage, such as language, national identity, religion, norms, customs, historical experience, or self—image, to biological differences, such as race. Notably, in the American context, racial minorities of African, Hispanic, Asian, and Native American descent have asserted that their values, dispositions, behavior, and outlooks on the world are sufficiently distinct for them to be considered

ethnic group cultures. By the logical conditions of culture stipulated by Pratte, as discussed above, this shift in meaning can be absorbed. But the new conception of ethnicity entails additional criteria for usage of the term, in particular, economic and political criteria. It is argued that modern ethnic groups tend to feel a shared sense of economic fate, that the economic future of ethnic group members is intimately tied together, and that they respond to political issues collectively and attempt to promote public policies and programs that will serve the interests of the group. Pratte argues that ethnicity in modern America "is a strategy for asserting claims against the institutions of society, for any oppressed group has the best chance of changing the system if it raises the communal consciousness of its members."[33] Thus, this view of ethnic culture rests on the quest for power to harness sources of discontent, rooted in deprivation, racial discrimination, and powerlessness, within a political system. And as Daniel Bell has argued, the modern efficacy of ethnicity rests on the combination of economic and political interests with the "affective ties" of cultural identity as a basis for social and political action, a force far more potent than class.[34]

It is time to bring these strands together in a descriptive definition of multiculturalism. But first, a couple of final points. The discussion to this point has, to some degree, foreshadowed my conclusion that a descriptive definition of multiculturalism must include premises underlying concepts of both culture and ethnicity. This conclusion is warranted, I believe, because contemporary conceptions of ethnicity, with their stress on political and economic structures, flesh out the premise in the definition of culture referring to political, economic, and social policy. Further, new conceptions of ethnicity seem to stress, as mentioned above, biological characteristics such as race. Thus, a definition of multiculturalism that stresses characteristics and conditions of racial minorities within a social system could be said to be descriptive, in that it would reflect and summarize previous usage. But it must be admitted that some would object to the focus on racial minorities in a definition of multiculturalism, in that such a focus would neglect other points of reference for the term, including the ethnicity of white Americans as well as group memberships based on age, sex, sexual preference, and physical capability, among others. Thus, those who would extend the term *multiculturalism* to cover these points of reference would likely argue that a definition of multiculturalism that stresses racial minorities, at the very least, is a stipulative definition, an attempt to lay down conditions for usage of the term within a certain context. But whether one considers it a descriptive or stipulative definition, this focus is warranted, I think, because in the policy contexts of the arts, talk of multiculturalism tends to stress groups of African, Hispanic, Asian, and Native American descent. That said, subsequent discussions of multiculturalism will assume the following definition: Multiculturalism is the

coexistence of groups of racial minorities within a common socio–political system, groups that, while continually undergoing change, are seen and see themselves as having relatively unique shared and transmitted values, dispositions, behaviors, and outlooks on the world as well as a shared economic future and that draw on the loyalty of group members to harness discontent in the face of racial discrimination and powerlessness as a basis for social and political action.

As stressed above, a descriptive or even stipulative definition of multiculturalism does not foreclose subsequent examination of programmatic definitions of multiculturalism. Indeed, this will be done in later chapters. But, for now, I will examine the rise of interest in multiculturalism in American society and in the policy contexts of the arts.

THE RISE OF INTEREST IN MULTICULTURALISM

To speak about the rise of interest in multiculturalism at this point in time would doubtless be surprising to many, especially those who, over the past several decades, predicted that such interest would inevitably wane. These predictions have taken numerous forms and are rooted in diverse theoretical perspectives. Milton Gordon, in his *Assimilation in American Life*,[35] predicted that differences between ethnic groups, especially behavioral differences, would virtually wither away in the face of structural assimilation—the integration of ethnic groups members into the institutions of the dominant group in a society—and in the face of cultural assimilation—the acquisition, usually forced, of the cultural characteristics of one ethnic group by another group. Liberal social theorists, such as Nathan Glazer and Daniel Patrick Moynihan,[36] predicted that ethnic identification would continue as voluntary activity in private community organizations and families but would melt away in the public institutions of an open, democratic society emphasizing equality of opportunity, objective standards of performance, and rewards based on merit. Marxists such as Stephen Steinberg[37] predicted that ethnicity, despite its power to combine interests with affective ties, would be increasingly viewed as reactionary and an ineffectual force that delays social and economic transformation in inequitable societies.

But many contemporary theorists have been impressed with the continued and growing salience of multiculturalism in American life and, in turn, have offered explanations for this phenomenon. Sociologist Daniel Bell, for one, outlines broad social and political trends that, in his view, laid the groundwork for the reemergence of multiculturalism as a force in American society. He identifies four trends.

1. *A shift from marketplace to political decisions.* A market economy is one where the demands of consumers are made by individuals acting independently and where supply decisions are made by an aggregate of competitive producers and distributors of goods and services. Thus, markets, at least in "pure" market economic theory, comprise countless uncoordinated decisions by individuals and corporate entities. But Bell contends that, increasingly, decisions previously left to the marketplace are coming under the purview of politics, government bodies at the local, state, and federal levels. A wide array of decisions are now negotiated in the political arena resulting in "the organization of persons into communal and interest groups, defensively to protect their places and privileges, or advantageously to gain place and privilege. As the multiplication of groups increases community conflict, in self–protection, more and more persons are impelled to join one or another of the groups in order not to be excluded from the decisions."[38] Ethnic groups are among these groups seeking to achieve their purposes through political negotiation.

2. *The redefinition of social values.* This redefinition has occurred, Bell argues, around the concept of equality, in particular, in a shift from talk of "equality of opportunity" to enhance fair competition in society to "equality of result," entailing a redistribution of public resources. Concomitantly, the concept of "rights" has taken on new meanings beyond the eighteenth–century claim to liberty and full protection of the law. In the late nineteenth and early twentieth centuries, the meaning was extended to include *political* rights, especially voting rights; the major shift in recent years has been toward *social* rights, including rights in such diverse areas as privacy, self–determination, employment, adequate standards of living, and significantly, cultural identity, often demanded as entitlements.

3. *The decline of authority.* Bell contends that in many spheres of American life and its institutions, traditional authority structures and bases of authority are being challenged and eroding. He notes a growing defensiveness about unearned privilege and the appearance of elites; the jettisoning of one–person authority in organizational life in favor of communities, task forces, and consultative groups; increased skepticism about professionalism as a legitimate source of authority and resistance to distance between "experts" and those affected by "expert" decisions; and in cultural life, the denial of standards of judgment rooted in expertise, age, or experience.

4. *A shift in ideology.* Bell argues that antiimperialism is the chief ideological passion in contemporary thought and politics. If, as he argues, imperialism today has subsided as an economic fact, "it is clearly a political and symbolic reality and represents the perceived power hegemony, and feared cultural paramountcy, of the United States."[39] Antiimperialistic sentiment is also increasingly expressed in reference to American society, as

a means of characterizing actions by the dominant culture, in particular, those by which ethnic groups are acculturated in Anglo–Saxon values.

In this increasingly politicized environment, according to Bell, the bases for group cohesion are decisive. Bell identifies two such bases for social and political action: "symbolic and expressive movements whose ties are primarily affective; and instrumental groups whose actions are bound by a set of common, usually material, interests."[40] As he says, the problem with exclusively symbolic–expressive groups is that while they can be quickly mobilized during a time of crisis or stress, such groups can disappear without sustaining interest in tangible rewards and achievement of those rewards. For instrumental groups, once stated goals have been realized, it is difficult to readapt toward new purposes. In a highly politicized and competitive environment, those social units that can combine symbolic and instrumental purposes tend to be most successful in political terms. Ethnic groups, by providing a sense of coherence, meaning, and identity and a leverage for material rewards from governmental bodies, have the potential of such success.

While Bell, in his analysis, concentrates on broad social, political, and economic conditions that have facilitated the rise of interest in multiculturalism, James Banks offers explanatory hypotheses for the increase of interest in multiculturalism. Banks seeks explanation in the perceived gap between the promise of equality of opportunity, the cornerstone of liberal ideology, and the reality of institutionalized discrimination and racism in America. He contends that ethnic minority groups had internalized the egalitarian and democratic ideals of liberal ideology. Yet while they were expected to assimilate culturally, this concession to dominant forces in society was not met with increased opportunities for political participation or tangible rewards of economic and social mobility. The passage of government legislation in the past few decades, legislation designed to address blatant forms of racial discrimination as well as social and economic conditions, helped to create rising expectations among racial minorities. But, as Banks concludes, "rising expectations outpaced the improvement within the social, economic and political systems; [and] widespread discrimination, racism, and structural exclusion experienced by ethnic groups served as a vehicle for political mobilization."[41]

These explanations offered for the increasing salience of ethnicity in society at large apply to the arts world as well. Notably, with the growth and institutionalization of public arts agencies at the national, state, and local levels over the last 25 years, numerous nonprofit arts organizations have been formed and, in turn, have sought to procure public resources in the form of grants and fellowships.[42] In an environment where applicants outstrip available funds, ethnicity has served as a mobilizing force in the competition for such funds. There is some evidence that for culturally

diverse arts organizations, in the face of limited access to private funds, receipt of public funds is viewed as essential to organizational growth and development.[43] Multiculturalism in the arts world is also rooted in the general cultural trend toward undermining claims of authority in defining aesthetic values. A growing consciousness has emerged of how concepts of aesthetic values are socially based, in particular, how economic and social interests have been able to reify a Eurocentric concept of the arts through the creation and expansion of high–culture institutions.[44]

There are also more specific explanations unique to the arts world that can be identified to account for the increasing salience of ethnicity. One is the rise of interest group politics in the arts. Groups of arts organizations, often organized by discipline (e.g., the American Association of Museums and the American Symphony Orchestra League), have learned the lessons of interest group politics that they now practice with considerable skill in representing their interests to legislatures, bureaucracies, and public arts agencies.[45] During the 1980s, an arts service organization, the Association of American Cultures (TAAC), has been an active voice in lobbying for the arts of ethnic cultures. By building coalitions among artists and arts organizations rooted in African, Asian, Hispanic, and Native American traditions, it has effectively placed a number of issues on the policy agendas of public arts agencies: the need for communities of color to establish "institutions to counterbalance the efforts of white institutions to define [entities] based on their concepts of reality;"[46] the lack of enforcement of civil rights/affirmative action legislation and statutes by public arts agencies; the need for greater ethnic representation on arts agencies' staffs and grant review panels; and the need to raise funds from private sector funders while at the same time competing more effectively for a "redistribution of wealth" from public arts agencies. In an era of expansion of public dollars for the arts, these issues could be resolved and interests accommodated. But the heyday of public arts funding, the 1970s, is past. This constricting of resources has increased the competition for funds, and hence the activities of arts interest groups, including TAAC.

Despite this competitive environment, public arts agencies, at least via rhetoric, have been receptive to the policy issues raised on behalf of ethnic cultures. For example, the National Assembly of Local Arts Agencies (NALAA) is advocating the promotion of culturally diverse arts as part of NALAA professional standards for local arts agencies (LAAs) and has advocated the development of incentives to LAAs for increased support to culturally diverse constituencies.[47] These activities are backed up by statements advocating cultural pluralism, for example, that "the major European arts are no longer the major culture in America. Ethnic arts are just as important as symphonies, because they are the basis of our culture and...the strength of the United States lies in the mix of cultures."[48] The

National Endowment for the Arts has also been affected by increased attention to cultural diversity in the arts. Recent congressional documents reauthorizing the NEA have stipulated that the NEA must increase the availability of the Endowment's programs to emerging, rural, and culturally diverse artists, arts organizations, and communities.[49] Despite these expressions of interest, the degree to which public arts agencies have instituted policies to promote cultural diversity in the arts is an open question, to be explored later in this book.

It is interesting to speculate, at this point, as to why, increasingly, there is expressed interest in multiculturalism among public arts agencies. In exploring this question, it must be said that many theorists, notably, neo–Marxist theorists, would not have predicted such a phenomenon. By such thinking, representatives of the dominant culture are able to control the governance and decision making of public arts agencies, ensuring that the vast majority of available funds are granted to artists and arts organizations whose work reflects their Eurocentric tastes. Indeed, this argument has been made.[50] But how, then, can we account for this rhetorical support of multiculturalism by public arts agencies?

One explanation was offered earlier, namely, that the NEA, in particular, has adopted multiculturalism as a goal for the agency amidst a crisis of purpose following recent political battles over NEA funding of controversial art. This discovery of a new purpose, it can be argued, is quite consistent with a larger strategy that the NEA has utilized historically to bolster its precarious political position as a young and not uniformly popular agency. This strategy, *pluralism*, entails the use of multiple sets of evaluative criteria in resolving questions of funding allocations to grants competitors. This strategy aims at a very broad distribution of funds to many kinds of art, artists, genres, and cultural traditions and thus aims to increase the number of constituencies and potential arts advocates with interests in the growth of government arts support. The strategy of pluralism, clearly, is consistent with the promotion of multiculturalism in the arts.

Political considerations, however, only go so far in helping to explain the rise of interest in multiculturalism among public arts agencies. Legal matters have contributed to this trend as well, for example, employment laws and policies. Public arts agencies are just that—public—and are subject to federal, state, and local laws regarding affirmative action in the workplace. As a result, public arts agencies have been hiring more and more persons of color to fill staff positions and have been appointing persons of color to advisory and governing bodies. Consequently, these persons have, to a growing extent, contributed to growing awareness of the arts of ethnic cultures within their agencies.

Just as important in explaining the rise of interest in multiculturalism are changes in arts organizations themselves. Arts organizations, after

all, are primary constituents of public arts agencies. The most significant recent changes in the arts world, at least for the issue at hand, are those in audiences for the arts and arts administrators. Judith Balfe, for example, notes that despite their higher levels of education and more socialization experiences in the arts as compared with older cohorts (variables that are traditionally associated with high levels of participation in the arts), baby—boomers, on many measures, participate in the arts less frequently than their elders did at the same age. Balfe attributes this trend to two primary factors: (1) the broadening of easily available arts offerings in American society to include the commercial arts, the arts of non—Western cultures, and traditional art forms, and (2) the filtering of arts presentations through the mass media entailing, in her view, reduction of expectations for and effort toward the arts.[51] Richard Peterson also points to growing eclecticism in the presentation of the arts as a source of change in audiences for the arts. For example, the wide—scale reproduction of visual art works, Peterson argues, "has altered the view of painting by bringing the works of all ages and all countries together at one place and on the same scale,"[52] making it possible for persons to juxtapose works of art made in vastly different traditions because they happen to "look good" together. This phenomenon, Peterson contends, amounts to a break from a traditional supply—side aesthetic with focus on the artist and his or her tradition to a demand—side aesthetic, where art, irrespective of its origins, can be looked at and even evaluated on the basis of its uses and effects.

This growing eclecticism in the behavior of audiences for the arts also has implications for the management of the arts. Contemporary arts administrators tend to mirror the aesthetic tastes of their audiences; thus, the tastes of newer and younger arts administrators tend to be eclectic in nature. This relationship between "professional" arts administrators stands in contrast to the charismatic arts leaders of the nineteenth century who were, to a great extent, able and willing to *lead* audience tastes. But even when current arts administrators are able to do this, their training in marketing and grantsmanship leads them to be in a responsive mode to their audiences and patrons, including public arts agencies who make attention to the arts of ethnic cultures a condition of receiving grants.[53]

EMERGING ISSUES AND ARTS POLICY RESEARCH

This section exploring possible explanations for the rise of interest in, and rhetoric about, multiculturalism among, specifically, public arts agencies was admittedly speculative, yielding hypotheses for further study. Hopefully these hypotheses will be the subject of further research. They, along with the broader topic of multiculturalism and arts policy, have

received little attention to date. Arts policy literature, as developed mostly by American researchers in the disciplines of political science, sociology, and economics, and in professional fields of arts administration and arts education, has tended to focus on three basic questions: Can public support of the arts be justified?[54] What are defensible goals for public support of the arts?[55] and What are the effects of public subsidy, as currently administered in the U.S., on the arts? Yet despite the dramatic rise of interest in multiculturalism within the arts world, the implications of multiculturalism for these questions have yet to be explored.

This paucity of research, while a condition that does little to assist arts policymakers in assessing policy options, does present a wide–open field for researchers approaching the topic. Indeed, one could follow the lead of the arts policy research conducted to date and address questions such as: Can a persuasive rationale for public support for the arts be constructed that focuses on the arts in a multicultural society? or Have current policies by public arts agencies been effective regarding the arts of those working in African, Asian, Hispanic, and Native American traditions? But to focus on these questions, I believe, would be to beg numerous conceptual, theoretical, and normative questions that are, by virtue of their significance, logically prior.

It should be clear by now that multiculturalism, as applied to arts policy, yields numerous value questions. To this point and for a variety of reasons, I have focused on descriptive tasks—describing various conceptions of culture, ethnicity, and multiculturalism in an effort to construct a descriptive definition of multiculturalism. But it is now time to turn to value questions and the programmatic definitions through which diverse value positions are expressed. Attention to such questions is unavoidable as a basis for rational assessment of policy options regarding multiculturalism and the arts. How such assessment can best be done, the primary methodological challenge of this volume, is the subject of the next chapter.

NOTES

1. See, in particular, Raymond Williams, *Culture and Society, 1780–1950*, second edition (New York: Columbia University Press, 1983); and idem, *The Long Revolution*, revised edition (New York: Harper & Row, 1966).
2. For a contemporary expression of this conception, see Samuel Lipman, *Arguing for Music, Arguing for Culture* (Boston: David R. Godine, 1990).
3. For explorations of this conception of culture, see Matthew Arnold, 1869, J. Dover Wilson, ed., *Culture and Anarchy* (Cambridge:

Cambridge University Press, 1971); Lesley Johnson, *The Cultural Critics: From Matthew Arnold to Raymond Williams* (Boston: Routledge and Kegan Paul, 1979); T. S. Eliot, *Notes towards the Definition of Culture* (New York: Harcourt, Brace, 1949); and F. R. Leavis, *Education and the University* (London: Chatto and Windus, 1961); and F. R. Leavis and Denys Thompson, *Culture and the Environment* (London: Chatto and Windus, 1960).

4. Raymond Williams, "Culture and Civilization," in *The Encyclopedia of Philosophy* (New York: Macmillan and Free Press, 1967), p. 274.

5. Ibid., p. 273.

6. For discussions of early writings on the relations of economic and social life and the arts, see Milton C. Albrecht, James H. Barnett, and Mason Griff, eds., *The Sociology of Art and Literature: A Reader* (New York: Praeger, 1970).

7. Raymond Williams, "Culture and Civilization," p. 273.

8. E. B. Tylor, *Primitive Culture*, Volume 7 (London: Murray, 1871), p. 7.

9. Raymond Williams, "Culture and Civilization," p. 274.

10. For an example of Williams's recent thought, and more extensive discussions of these ideas, see Raymond Williams, *The Sociology of Culture* (New York: Schocken Books, 1981).

11. Clifford Geertz, *The Interpretation of Cultures* (New York: Basic Books, 1973), p. 89.

12. For a summary of critiques of the work of Clifford Geertz, see Diane J. Austin–Broos, *Creating Culture: Profiles in the Study of Culture* (Boston, MA: Allen and Unwin, 1987).

13. Richard A. Shweder, "Anthropology's Romantic Rebellion against the Enlightenment," in Richard A. Shweder and Robert A. Levine, eds., *Culture Theory: Essays on Mind, Self, and Emotion* (Cambridge, MA: Cambridge University Press, 1984), p. 27.

14. Ibid., p. 32.

15. Ibid.

16. For a review of critiques of enlightenment research on culture, see Richard A. Shweder, "Anthropology's Romantic Rebellion against the Enlightenment."

17. See, for example, Jean Piaget, *The Construction of Realty in the Child* (New York: Basic Books, 1954).

18. See, for example, Lawrence Kohlberg, *The Philosophy of Moral Development* (New York: Harper & Row, 1981).

19. See, for example, Howard Gardner, *The Arts and Human Development: A Psychological Study of the Artistic Process* (New York: John Wiley and Sons, 1973).

20. Richard A. Shweder, "Anthropology's Romantic Rebellion against the Enlightenment," p. 32.

21. Ibid., p. 28.

22. See, for example, Clifford Geertz, *The Interpretation of Cultures*; and M. Sahlins, *Culture and Practical Reason* (Chicago: University of Chicago Press, 1976).

23. Richard A. Shweder, "Anthropology's Romantic Rebellion against the Enlightenment," p. 45.

24. Raymond Williams, "Culture and Civilization," p. 275.

25. Ibid.

26. For a discussion of this feature of the concept "art," see Morris Weitz, *The Opening Mind* (Chicago: University of Chicago Press, 1977).

27. Richard Pratte, *Pluralism in Education: Conflict, Clarity, and Commitment* (Springfield, IL: Charles C. Thomas, 1979), p. 149.

28. Ibid.

29. Ibid., p. 150.

30. Talcott Parsons, "Some Theoretical Considerations on the Nature and Trends of Change of Ethnicity," in Nathan Glazer and Daniel P. Moynihan, eds., *Ethnicity: Theory and Experience* (Cambridge: Harvard University Press, 1975), p. 53.

31. Nicholas Appleton, *Cultural Pluralism in Education: Theoretical Foundations* (New York: Longman, 1983), p. 34.

32. For a discussion of this theory, see Andrew Greeley, *Ethnicity in the United States* (New York: John Wiley and Sons, 1974).

33. Richard Pratte, *Pluralism in Education*, p. 158.

34. See Daniel Bell, "Ethnicity and Social Change," in Nathan Glazer and Daniel P. Moynihan, eds., *Ethnicity: Theory and Experience*.

35. Milton Gordon, *Assimilation in American Life: The Role of Race, Religion, and National Origins* (New York: Oxford University Press, 1964).

36. Nathan Glazer and Daniel P. Moynihan, *Beyond the Melting Pot* (Cambridge: Harvard University Press and MIT Press, 1963).

37. Stephen Steinberg, *The Ethnic Myth: Race, Ethnicity, and Class in America* (New York: Atheneum, 1981).

38. Daniel Bell, "Ethnicity and Social Change," p. 145.

39. Ibid., p. 150.

40. Ibid., p. 165.

41. James A. Banks, "Multicultural Education: Development, Paradigms and Goals," in James A. Banks and James Lynch, eds., *Multicultural Education in Western Societies* (New York: Praeger, 1986), p. 5.

42. For a discussion of the relationship between the availability of public funds and the creation and behavior of nonprofit art organizations, see Paul J. DiMaggio, "Nonprofit Organizations in the Production and

Distribution of Culture," in Walter W. Powell, ed., *The Nonprofit Sector: A Research Handbook* (New Haven, CT: Yale University Press, 1987).

43. See Chris Linn, *Culturally Diverse Organizations in the United States: An Organizational Survey* (Washington, DC: Association of American Cultures, 1988).

44. See, for example, Paul J. DiMaggio and Michael Useem, "Cultural Property and Public Policy: Emerging Tensions in Government Support for the Arts," *Social Research* 45 (1978): 356–389.

45. For a discussion of interest group politics and the arts, see Margaret J. Wyszomirski, "Arts Policymaking and Interest Group Politics," *Journal of Aesthetic Education* 14 (October 1980): 28–34.

46. Donovan Gray, ed., *Open Dialogue II: A Summary Report* (Washington, DC: Association of American Cultures and National Assembly of Local Arts Agencies, 1987), p. 20.

47. National Assembly of Local Arts Agencies, *Policy on Cultural Diversity and Cultural Equity* (Washington, DC: National Assembly of Local Arts Agencies, 1991).

48. National Assembly of Local Arts Agencies, *Minority Art Issues Focus Group* (Washington, DC: National Assembly of Local Arts Agencies, 1986), p. 2.

49. See, for example, *Reauthorization of Foundation on the Arts and the Humanities Act of 1990*, U.S. Congress, 101st Cong. (Washington, DC: Government Printing Office, 1990).

50. See, for example, Edward Arian, *The Unfulfilled Promise: Public Subsidy of the Arts in the United States* (Philadelphia, PA: Temple University Press, 1989).

51. Judith Huggins Balfe, "The Baby–boom Generation: Lost Patrons, Lost Audience? in Margaret J. Wyszomirski and Pat Clubb, eds., *The Cost of Culture: Patterns and Prospects of Private Arts Patronage* (New York: American Council for the Arts, 1989).

52. Richard A. Peterson, "Audience and Industry Origins of the Crisis in Classical Music Programming: Toward World Music," in David B. Pankratz and Valerie B. Morris, eds., *The Future of the Arts: Public Policy and Arts Research* (New York: Praeger, 1990), p. 211.

53. See Richard A. Peterson, "From Impresario to Arts Administrator: Formal Accountability in Cultural Organizations," in Paul J. DiMaggio, ed., *Nonprofit Enterprise in the Arts: Studies in Mission and Constraint* (New York: Oxford University Press, 1986).

54. See, for example, Kevin V. Mulcahy, "The Rationale for Public Culture," in Kevin V. Mulcahy and C. Richard Swaim, eds., *Public Policy and the Arts* (Boulder, CO: Westview Press, 1982); and Dick Netzer, *The Subsidized Muse: Public Support for the Arts in the United States* (New York: Cambridge University Press, 1978).

55. See Margaret J. Wyszomirski, "Controversies in Arts Policy-making," in Kevin V. Mulcahy and C. Richard Swaim, eds., *Public Policy and the Arts*; Monroe C. Beardsley, "Aesthetic Welfare, Aesthetic Justice, and Educational Policy," *Journal of Aesthetic Education* 7 (Winter 1973): 49–61; Herbert J. Gans, *Popular Culture and High Culture: An Analysis and Evaluation of Taste* (New York: Basic Books, 1974); and Don Adams and Arlene Goldbard, *Crossroads: Reflections on the Politics of Culture* (Talmage, CA: DNA Press, 1990).

2

Foundations of Policy
Research Methodologies

Chapter 1 contained a brief description of the research methodology of this book, a methodology that integrates features of policy analysis and conceptual analysis. In this chapter, my aim is to provide a rationale for the choice of this methodology and to spell it out in greater detail. Formulating such a rationale, it will be seen, involves consideration of a number of epistemological and logical questions and must at least consider the methods of social science disciplines. The difficulty in doing this is borne of methodological turmoil in these disciplines, turmoil characterized by challenges to the practice and theoretical underpinnings of positivism. Discussion of this controversy forms the first section of Chapter 2.

EPISTEMOLOGICAL FOUNDATIONS: CHALLENGES
TO POSITIVISM

The methodology of policy analysis as conceived of and practiced by the large majority of contemporary researchers in diverse fields such as health care, urban planning, crime, education, communications, and transportation aspires to be "scientific." All share a basic commitment to *policy science* and its philosophical roots in positivism.

Positivism can be described in reference to three premises, premises that reveal its epistemological assumptions and stance on the role of the researcher vis–à–vis objects of knowledge. First, positivism is a deeply skeptical philosophy embodying the impulse to set aside all claims to truth and value based on the authority of posited belief systems or historical practice. It contends that if human knowledge could only free itself from accumulated belief in dogmas of all kinds, "it could dig down deep to some bedrock of certainty and then logically and methodically rebuild a body of knowledge, [and thus] know the truth."[1] Second, scientific discovery, achievement of knowledge of the truth, places severe demands on the activities of the researcher. "Not only must scientists avoid sources of error coming from outside, they must also control or suppress sources of bias

within themselves."[2] Hence, the first obligation of the social science researcher, according to positivism, is to maintain objectivity, value neutrality, and an emotional distance from objects of study. Accordingly, "the cardinal sin is to allow judgments of value or preference to influence one's analysis of facts."[3] Third, positivism externalizes the relationship between the researcher, that is, the knowing subject, and the objects of knowledge. Positivism assumes that there are facts, including social facts, with an objective reality apart from the beliefs and opinions of individuals. The scientific researcher, in the pursuit of knowledge, must systematically observe that reality but cannot, in any significant way, participate in it.

Policy science is the application of the tenets of positivism to inquiry into public policies. It strives to serve as a bridge between verifiable laws of human behavior and the practical world of policy formulation and implementation. In this role, the policy analyst's credibility and hence usefulness are derived primarily from the scientific validity of the knowledge he or she presents to the policymaker. Thus, the work of the policy researcher, in this paradigm, is basically reactive to the data needs of policymakers and limited to questions of empirical fact. Policies are evaluated in terms of their effectiveness to achieve preset ends and in their efficiency in doing so. Not surprisingly, as a scientist, the policy scientist makes no claims to authoritative knowledge about the ends or purposes of policies. Indeed, the work of the policy scientist involves little or no reference to values, either in himself or in the social actors under study.

Two issues contained or implied in this description of policy analysis as science merit closer attention. One is the theory of values adhered to by positivism, a theory that underlies its value neutrality and the dichotomy of facts and values in the process of policy inquiry. This theory is known as "value noncognitivism," according to which value judgments are basically emotional responses to specific circumstances and general conditions of human existence.[4] As subjective commitments, therefore, value judgments contain no truth content that can be verified by scientific inquiry. Thus, since values lie beyond the capacity of scientists to investigate them, adherence to the fact–value dichotomy must remain as the governing principle of policy analysis that aspires to the mantle of "science."

Another issue surrounding the practice of policy analysis as science is its place within democratic politics. Many theorists have portrayed the role of the policy sciences in a democracy in almost visionary terms. Policy science, it is believed, "enters politics on the basis of its authority—to discover 'facts,' to generate useful hypotheses, to develop theoretical and data based statements, and to solve the problems presented to it."[5] This belief is often coupled with a conception of the policy scientist as a "social therapist" who shows "lively concern for the problem of overcoming the divisive tendencies of modern life and of bringing into existence a more

thorough integration of the goals and methods of public and private action."[6] Taken together, these ideas express a vision of policy science as a force for social betterment, in which enlightened decisions and hence more effective control over the social environment lead to increased rationality and efficiency in the delivery of public goods and services. Finally, policy science is also seen as an antidote to political power struggles, seen by some as a force that can retard social progress.[7] By producing objective data and explanatory and predictive theories, it is hoped that policy science can counteract the special pleading of political interest groups, the self–seeking behavior of politicians, and unwieldy, inert bureaucracies.

Given the breadth and almost utopian character of its claims and its dominant placc in thc practice of policy researchers, it is not surprising that policy science has been the object of numerous criticisms and fundamental critiques. Some critiques are rooted in fundamental reexaminations of the philosophy of social science, whereas others stem from some policy analysts' dissatisfaction with the practice of policy research. These criticisms from diverse sources focus on the epistemological assumptions of positivism, the place of values in policy research, and the role of policy research in a democratic society.

One of the building blocks of positivism is the tenet that social science, if practiced with scientific rigor, can yield accurate descriptive accounts of phenomena, including social phenomena. This, again, is based on the view that reality is separate from human cognition. Objective reality is apprehended only through systematic observation of manifest behavior, which is amenable to corroboration by intense objective testing. But this conception of an objective social reality has been challenged on the grounds that social reality is a far more complex phenomenon, that it is socially constructed through individual and collective definitions of the meanings of human situations. Thus, it is argued, that attempts to portray this complex social reality in empirical generalizations about relationships between discrete variables are selective, limited, and partial. As Bruce Jennings argues, the "facts" that positivistic examples of social science report "are inevitably artifacts of particular conceptual schemes and theoretical suppositions that are built into survey instruments, public records, and other sources of social information."[8]

A final aspect of the epistemological critique of positivism, and related to debates over the nature of social reality, concerns conceptions of human nature. Positivism views human beings as configurations of behaviors, behaviors caused by external agents, forces, or events of which individuals are largely unaware. This conception of human nature is consistent with the deterministic outlook of science. In contrast to this conception, many social scientists have begun to reinterpret the behavior of human beings as actions. Human beings, in this view, are agents who

perform actions for reasons and to achieve purposes. As summarized by
David Paris and James Reynolds:

> Central to the agentistic perspective is the notion that the human
> individual is an agent, a doer, some of whose behaviors are voluntary
> actions, many of which are related to purposes and goals he has
> adopted and choices he has made. The individual is more than a cog
> in a causal process beyond his control. His voluntary actions are
> things that he does and not merely events of which he is a part or
> movements that happen to or through him.[9]

In sum, then, in light of these theoretical shifts, many social scientists are
now coming to view their work not as a positivistic search for immutable
laws of human behavior but as a process of cultural interpretation.[10]

Another key element in the critique of positivism centers on the
question of the role of values in social science. Positivism is based on a
strict fact–value dichotomy. While policy scientists consider systematic
control of values in the research process as an essential means of achieving
bias–free research results, critics of positivism see this stance as one of
neglect. Neglected are the values of the investigator and those of the
subjects under study. Critics of positivism are simply not convinced that
values can be excised from any stage of a research process. Values of the
researcher and, often, the research sponsor exert influence in the setting of
research problems, the interpretation of research results, choice of vehicles
for the dissemination of research studies, and most certainly, the utilization
of research findings.[11] Further, by neglecting the values of subjects under
study, critics contend, positivism fails to consider the most significant
questions of human existence—questions of right and wrong, good and bad,
and what ought or what ought not to be done. This neglect of values, it is
argued, is especially egregious when the object of study is public policy, an
enterprise suffused with competing value positions on questions of public
purpose.

Finally, critics of positivism trace implications of the fact–value
dichotomy for policy scientists' conception of their role in a democracy.
Policy science, by its professed mission of producing reliable, technical
knowledge about the means of achieving policy goals, leaves questions of
value and policy goals for resolution by decision makers and politicians. The
political underpinnings of policy science has been a focus of recent
debate.[12] Policy science, it is argued, implicitly accepts three premises:
(1) interests in a democracy form spontaneously and naturally; (2) there is
a natural balance of interests represented before government decision
makers; and (3) government acts as a neutral, mechanical referee of active
interests in society.[13] This view is branded as, at best, naive by policy

science's critics. It fails, they say, to consider the reality of political influence and power, whereby policymakers, politicians, and entire government agencies are coopted by those groups and individuals best able to articulate and promote their interests. These powerful interests are in effect incorporated into the decision–making processes of government agencies and legislative bodies and are thus essentially delegated public authority. Robert Bellah argues that this political naïveté of the policy scientist has serious antidemocratic consequences. He contends that the value–free and purportedly "useful" technologies, practices, and concepts produced by policy scientists "turn out to be manipulative interests in the hands of political and economic power. It is precisely a science that imagines itself uninvolved in society, that sees itself as operating under no ethical norm other than the pursuit of knowledge, that will produce instruments of manipulation for anyone who can afford to put them into practice."[14]

To this point, I have catalogued essential elements of the growing critique of policy science and its underlying philosophy of positivism. These criticisms, made on epistemological, normative, and political grounds, are, I believe, a serious challenge to claims of dominance by policy scientists within the larger domain of policy research. But this critique, however persuasive it is, does not by itself yield a defensible conception of policy research methodology, in particular, one that is appropriate to policy research in the arts. The foundations of such a conception will be explored in the next several sections starting with a logical analysis of the term *policy*. As will be seen, the concept of policy that emerges from this analysis is consistent with one element of the critique of positivism, namely, its failure to consider persons as purposeful agents of action.

LOGICAL FOUNDATIONS: DEFINITIONS AND CRITERIA FOR EVALUATION

To ask the question What is a policy? is a far different matter than asking what a particular policy is or ought to be. The question is metaphilosophical in nature and calls for an examination of conditions of usage of the term *policy*. Philosopher Donna H. Kerr, to my knowledge, has done the most thorough work on explicating the logical conditions of policy analysis and evaluation. The following discussion draws extensively on her thinking.[15]

She begins with the premise that policies are not just instinctive, reactive, and determined behavior, things about which humans and animals could not do otherwise. To talk of a policy as a "pattern of response," "structure of behavior," or "process output," as is common in the literature of policy science, is to assume a deterministic model of explanation. In

Kerr's terms, use of the term *policy* reflects action language, in that policies are a matter of doing, that is, taking action in situations where we can always choose to do otherwise. Such choices are usually based on intentions, purposes, and plans. Admittedly, though, this distinction does not take us very far because many categories of actions can be described as planned and undertaken with purposes in mind. What, then, is distinctive about a policy?

While, as discussed above, policies entail choice and all persons can exercise choice to a greater or lesser degree, it does not follow that all persons can make policies. Anyone can make policy *proposals*, whether in private or in the public domain such as in a book or journal article. But a policy agent, whether a person, agency, or institution, must have some kind of authority to act on policy proposals and to make, enforce, and revise policies. Kerr argues that a policymaker must usually have some kind of formal authority either by law or by administrative decision. Policymakers with such authority are called, in Kerr's terms, *authorizing* agents and are authorized to decide under what conditions an *implementing* agent, including but not limited to one's self, must take particular actions. (The idea of authority as a logical condition of the term *policy*, it must be stressed, does not necessarily mean that all policies developed by those in authority to do so are therefore justifiable.)

Not all "conditions for action," however, are consistent with the term *policy*, at least by Kerr's reasoning. Guidelines, for example, can be selectively applied, ignored, or judged irrelevant to particular cases. But policies are not arbitrary. By declaring a policy, a policymaker undertakes an *obligation* to act in accordance with a *conditional imperative*. That is, he or she must do a specified something *whenever* specified conditions occur. Take, for example, university policies for the granting of degrees. When a university adopts a policy regarding the granting of degrees, it directs (based on its authority) certain university officials to do something specific, that is, grant a degree, whenever specific conditions occur, that is, a student completes all degree requirements. For these university officials to do otherwise would be to violate the policy. For them to claim that they are under no obligation to grant a degree when a student meets graduation requirements is to deny the fact that they have a policy.

But why do policymakers assume conditional imperatives to act in a certain way? The answer to this question reveals another condition of the term *policy*, namely, that policies (and their obligations) are undertaken in order to achieve purposes. Kerr identifies four categories of policy purposes. Unachievable purposes refer to utopian states of affairs. A policy with an unachievable purpose can be judged successful "if it is affecting states of affairs that progressively resemble more closely the ideal state of affairs to which the purpose refers."[16] In contrast to once–achievable purposes, repeatedly achievable purposes are achieved only if an

implementing agent's actions repeatedly bring about the specified state of affairs. Any of the above purposes can be embedded purposes, which, if recognized, can work at cross–purposes to stated purposes of policies. Kerr offers specific examples illustrating these categories of purposes. But for my purposes here, identification of policies' relation to purposes provides an additional condition for defining the term *policy*. Based on this discussion so far, a policy can be defined as an obligation undertaken by an authorizing agent to direct an implementing agent to act in accord with a specified conditional imperative for the purpose of effecting a specified state of affairs.

A return to the topic of justifying policies is warranted here. Kerr acknowledges that since most policies are formulated in political environments, it is often contended that the attempt to justify policies on rational grounds is a futile enterprise of the politically naive. Under this view, the justification of a policy choice consists of sales pitches designed to persuade the potential "buyers" of a policy that the policy will bring them something they want. It is assumed that the pitch that "works"—that is, survives the marketplace of policy ideas—determines the best policy choice. But Kerr argues that the practical difficulties involved in formulating rationally justifiable policies do not mean that the attempt to do so is unwarranted. She identifies four broad evaluative tests that any policy must pass if we are to say it is justifiable on rational grounds.

The *desirability test* of policies has a weak form and a strong form. The weak form holds that the purposes of, for example, an education policy must be desirable and defensible on educational grounds. The strong form holds that a policy's purpose must promote the development of skills, values, or understandings that are in some sense constitutive of the good life.

The *effectiveness test* implies that a defensible policy must also specify the means that are likely to effect the policy's purposes. As stated above, the purposes of some policies are unachievable. In such cases, a policy's means must be more likely to effect a state of affairs that resembles the unachievable goal more closely than other means.

The *justness test* holds that the means of a policy must be just. Kerr stresses that it is not enough for a policy's agent to abide by the conditional imperative and attendant rules with which it claims to abide. For example, an arts council may have a funding distribution policy according to which it discriminates between claimants for funds on irrelevant or unsupportable grounds. That is, while the agency's distributional policy may not violate the rules by which it claims to abide, those rules may themselves be unjust. Thus, for a policy to pass the justness test, the rules with which the means accord must themselves be just.

Finally, the *tolerability test* holds that the costs of a policy must satisfy three criteria: (1) The costs of carrying on a policy must not be out

of proportion to the policy's purpose; (2) the costs of implementing a policy must be the least costly of the means that are available; and (3) any side effects of a policy's implementation must be tolerable when weighed against the value of the policy's purpose.

Kerr considers two final logical conditions for the formulation of rationally justifiable policy choices: (1) theoretical and empirical knowledge and (2) participation in decision making. First, policy choices made under certainty, in which all possible outcomes of a policy are known in advance, are extremely rare. Most choices are made with uncertainty (in Kerr's terms, under conditions of partial ignorance), where the exact possibilities of a policy's outcomes are unknown. But policymakers have an obligation to generate and consider empirical evidence on, and theoretical explanations of, the policy's likely impact if the policy they choose is to be considered rationally justifiable. Second, Kerr argues that policymakers are under no obligation to choose the *best* policy because not all *logically* possible choices are possible in practical contexts and because such policy choices might never be able to realize their purposes within certain contexts. But it does seem reasonable to expect that policymakers must at least choose the best of the alternative and practically achievable policy options. But for such a choice to be rational, Kerr argues, it must be considered so by participants in the policy–making process—policymakers themselves and those with input in the process. This condition is termed *distributive rationality*. Kerr notes that it is obviously unrealistic to expect that each policy choice be considered rational by *all* involved in the process. Thus, a final requirement for rational policy choices is the broadest possible representation of diverse perspectives in the decision–making process and the presence of procedures to reduce conflicts of interest and undue influence.

Based on Kerr's explication of the logic of the term *policy*, it becomes clear that the subject matter of policy research can be quite broad. Policy research can focus on several elements of policies—goals, means, enforcement, and impacts—either separately, as they work in conjunction, or at cross–purposes. *Policy goals* can be viewed in terms of their clarity, comprehensiveness, and worthwhileness, while the processes utilized to formulate goals can be interpreted in terms of concepts of justice and political participation. The *means* to achieve policy goals can be analyzed in terms of *effectiveness*, their adequacy to meet policy goals, and *justness*, their fairness with respect to groups and individuals affected by a particular policy. The *enforcement* of policies can be *imposed* (stringent enforcement backed by sanctions or penalties), *endorsed* (compliance motivated by anticipated benefits), or *implied* (completely voluntary compliance). The *impacts* of policies can be direct or indirect, immediate or long–term, anticipated or unanticipated, primary or secondary (usually termed *externalities*), or measurable or nonmeasurable.

This brief description of the subject matter of policy research is clearly an elaboration on Kerr's logical conditions of the term *policy*; but it is also consistent with her thinking. Indeed, Kerr's logical analysis provides important elements of a corrective to policy science rooted in positivism. For example, it poses basic questions that can be asked of policies—whether something that is claimed to be a policy is indeed a policy; the authority of persons or institutions to make, enforce, or revise policies; the purposes that policies are purported to serve; the worthwhileness of policy goals; the effectiveness and justness of policies' means of implementation; the costs and side effects of policies; the use of empirical evidence and theoretical frameworks in making policy choices; the policy alternatives considered; and the breadth of participation in, and fairness of, policy—making processes. Her schema also represents a significant broadening of criteria for policy evaluation beyond those utilized in policy science—effectiveness and efficiency. Finally, employment of Kerr's scheme can mean that the work of the policy researcher need not be reactive, instrumental to predetermined ends, or limited to questions of fact and practical means.

But, for all of its merits, Kerr's logical analysis of the term *policy* takes us only so far toward the goal of constructing a defensible policy research methodology. On the one hand, her analysis does not address assumptions that critics of positivism have challenged. Notably, her account of the empirical knowledge necessary for rational policy development does not contain any discussion of the fact–value dichotomy or how values suffuse all phases of research (even empirical research) processes. In addition, Kerr does not address the political evaluation of policies, that is, how a policy proposal is likely to be received by participants in a political process.[17] But the most significant gap in Kerr's schema is found in her treatment of policy goals and the purposes that inform policy goals. She argues that for a policy to be rationally justifiable it must promote states of affairs that are in some sense constitutive of the good life. This test of policies, however, is no substitute for the articulation of a means to determine whether some policy goals are more worthwhile, or simply better, than others. If policy research is to play a role in the formulation of policies that extends beyond the recommendation of policy means to achieve predetermined ends, a method of choosing among alternative policy goals, therefore, must be found. That is the subject of the next section.

ISSUES IN JUSTIFYING POLICY GOALS AND MEANS

The entire enterprise of trying to forge a role for policy research in mediating between value positions underlying policy goals, it must be admitted from the outset, will be objected to on at least two grounds. Policy

scientists, it will be recalled, contend that policy researchers' work *should not* include value considerations for two reasons: (1) because policy researchers have no special skill in analyzing value claims and (2) because the presence of values in a research design primarily serves to undercut the empirical validity of research results. Values, at best, should only be a subject of empirical inquiry, according to policy scientists, to see the extent of support for value positions among policy actors in particular policy contexts.[18] Other theorists contend that consideration of values in policy research, rather than a practice to be avoided as a matter of methodological principle, is, instead, a misdirected or even futile enterprise.[19] What follows, however, is an exploration of several perspectives on policy research, each of which holds that examination of the merit of value–laden policy goals is not misdirected or futile. Indeed, each seeks to define a method to explicate or evaluate value–laden policy goals and means. These methods include (1) critical theory, (2) political philosophy and (3) interpretive policy analysis.

Critical Theory

Critical theory, as developed primarily by Jurgen Habermas,[20] has as one of its central tenets the belief that it can provide an objective basis for normative claims. This belief is rooted in the contention that traditional distinctions between theory and action are misguided and serve only to provide ideological support for fostering inequitable power relations in society. Critical theory, in contrast, seeks to unify theoretical understanding of contradictions inherent in a society with action in order to achieve a transformation of that society. "By painstaking criticism of both traditions of thinking about society and the institutions of society, critical theory hopes to provide a basis for transforming society. The appeal of critical theory lies in its claim to unite empirical and normative concerns—to be objective and relevant—in a way which will lead to social reform. Social science and policy inquiry are thus fused."[21]

Central to Habermas's critical theory is the idea of cognitive interests, those viewpoints, in his terms, from which we apprehend reality. These include the *technical*, through which persons seek to maintain and further their material existence, and the *practical*, those shared meanings in a society that permit day–to–day communications among a society's members. These interests, Habermas argues, have spawned the empirical sciences and historical inquiry, respectively. A third cognitive interest, the *emancipatory*, is the basis of critical theory. Empirical sciences and historical inquiry, it is argued, depend upon free, open communication if they are to serve societal interests in achieving technical control of the means of

material existence and mutual understanding of social and cultural interactions. The point of critical theory, rooted in the emancipatory interest, "is to probe, through philosophical reflection, the conditions of such free communication *and* to reflect upon the conditions which distort it. Philosophical inquiry and social criticism...are [thus also] fused."[22]

This theory of cognitive interests, and especially the emancipatory interest, is the basis of a critique of positivism and its consequences. According to Habermas, positivism, by its reduction of all possible knowledge of the model of scientific knowledge, disavows philosophical reflection. Positivism, thus, it is argued, fails to recognize the importance of other cognitive interests and thus negates the possibility of choice and rational action in political life. Critical theory also critiques positivism's conception of values, and its consequent view that rational action is limited to "the selection of efficient means to realize ends and not the selection of ends themselves."[23] A view of politics follows from this conception—political problems are not matters of disputes over value positions but technical problems to be solved by policy scientists. These criticisms have been made by other critics cited above. But critical theory offers one additional criticism, namely, that this limited conception of politics as technical control ultimately debases political life and reinforces inequitable power relations in society.

As an antidote to positivism and avowed catalyst for social change, critical theory aims to restore critical self-reflection in "the search for the ground of all claims to knowledge...[and] involves the critical examination of all cognitive claims and obstacles to rational consensus about them."[24] The knowledge gained from this process, it is expected, will be emancipating and yield practical guidance and greater individual autonomy.

But a key question for critical theory is the requirements necessary to formulate a rational consensus on policy issues. The central idea in Habermas's answer to this question is that of communicative competence, an "ideal speech" situation "in which there is no domination or distorted communication and in which consensus is...achieved simply due to the force of the better argument."[25] This idea has important implications for the place of values in policy inquiry in that Habermas argues that the discourse of ideal communication is a normative standard inherent in the structure of social action and language. This standard, in turn, can be used in critiques of distorted communication. "The ideal speech situation is thus the vehicle for bridging artificial gaps between theory and practice, 'is' and 'ought,' and providing an objective basis for normative claims promoting human emancipation."[26]

Despite its attention to the place of values and norms in policy inquiry, it is not clear that critical theory and its idea of an emancipatory interest attained through an ideal speech situation settle the issue of

resolving value disputes in policy contexts. Critical theory validates the place of philosophical reflection in policy inquiry; but it also seems to assume that such reflection will necessarily yield a critique of society consistent with a Marxist or neo–Marxist perspective. The diversity of philosophical traditions would seem to undermine this assumption, unless one was also to assume that any non–Marxist philosophical perspective is an example of "distorted communication." Few would be willing to do so. Thus, despite the claims of critical theory, it does not seem reasonable to assume that the mere act of philosophical reflection will yield any generally applicable normative criteria to settle value disputes in policy contexts or will yield any specific program for social change.

On the other hand, it could be argued that critical theory still could provide a general framework for dealing with value–laden policy issues. But, if this were claimed, then one could not also claim, as Habermas does, that critical theory is a specific and practical means of social reform. Further, the claim that critical theory collapses traditional divisions between theory and practice and between philosophy and ideology is thereby undermined. In sum, then, critical theory appears to lack the specificity needed to resolve policy debates; and, as Paris and Reynolds argue, "far from lacking ideological content or removing ideological distortion, critical theory is actually an attempt to advance a certain ideological perspective by claiming that it has an objective philosophical basis, supportable in an ideal speech situation."[27]

Political Philosophy

Unlike proponents of critical theory, policy analysts who draw on *political philosophy* in analyzing policy issues do not claim that their work results in an objective basis for resolving value questions in policy debates. Instead, political philosophers try to construct arguments to defend, on rational grounds, why certain values should be chosen over others in a society. Such argumentation, in most instances, entails a deductive method. First, political philosophers construct models of an ideal way of life, identifying ultimate values, such as freedom or equality, that should underlie decisions in a polity. Often these social and political values are related to conceptions of human nature and the ideal person. Then, arguments are marshaled to try to demonstrate what would happen in an ideal society if a particular value or set of values were adopted. The case for value positions is often made in comparative fashion using interpretive tools such as imagination and speculation.

Through the imaginative creation of alternative sociopolitical systems, the political philosopher attempts to highlight the effects resulting from a surplus of one value (or value system) or the implications of the decline of another.... Available empirical evidence about the instrumental or contributive value of particular values can be marshalled to support one conception over another.... As the ideal model is necessarily speculative, empirical evidence is generally available only through insightful extrapolation and analogy based on existing systems.[28]

The contemporary philosophers whose work has influenced many policy analysts are John Rawls and Ronald Dworkin. Their work illustrates how the deductive methods of political philosophy have relevance to the establishment of value frameworks for policy decisions. Rawls has aimed to determine which type of society a rational person would choose to live in and the reasons such a person would offer for obeying the society's rules. He posits a methodological device, called the "original position," whereby the rational person, free of the distractions of everyday life, would be able to make rational choices about basic values. Rawls argues that persons in the original position would reject, on logical grounds, the principle of utility as an inadequate basis for reconciling value disputes in a just manner. Instead, he contends that the person would choose to enter into a social contract that guarantees the basic rights of all of a society's citizens. In this conception of a good society, the utilitarian principle is subordinated to principles of justice.[29] In a fashion similar to Rawls, Dworkin argues that the principle of utility—the greatest good to the greatest number—is insufficient as an organizing value for a good society because it does not protect key political rights. He contends that many decisions about public purpose cannot be defended solely on the basis of anticipated social consequences. Some especially difficult decisions require arguments based on statements of principle.[30]

An evaluation of the specific arguments of Rawls and Dworkin will not be attempted here. Their work was cited at this point as examples of the potential impact of political philosophy on policy inquiry. Clearly, political philosophy can serve as a corrective to the narrow focus of positivistic policy science and broaden the questions that policy inquiry can address. Notably, political philosophy affirms that all aspects of rationality, including deductive reasoning, insight, imagination, and intuition, can be used as a resource in policy inquiry. Policy researchers need not be restricted to the empiricism and instrumental reasoning of positivism. Further, by its invocation of the concept of a good society, political philosophy moves policy inquiry beyond questions of means to consideration of the value of policy goals themselves; and by its invocation of key

principles and rights, political philosophy offers criteria for the evaluation of policies beyond those utilitarian criteria found in policy science, that is, effectiveness and efficiency.

Despite the value of these contributions to the conduct of policy inquiry, a significant question about political philosophy remains: Can it help to resolve value disputes in specific policy contexts? A goal of political philosophy is to construct a set of principles, rooted in fundamental values, that can be applied consistently across particular cases. Achievement of this goal primarily entails a process of deriving specific policy proposals from these principles. But, as Charles W. Anderson argues, "this effort frequently leads to disappointing results. Most principles do not yield unambiguous prescriptions."[31] For example, it is not clear how a general principle of justice would facilitate a resolution of issues in public arts policy, such as: What artists and organizations should have access to public funds? On what criteria should funding decisions be based? Who should be involved in the making of such decisions? On the other hand, advocates of quite specific policy proposals can invoke the same general principle in making a case for their favored proposal. For example, a utilitarian concept of justice—the greatest good to the greatest number—could be invoked in arts policy debates to justify anything from subsidy of large traditional arts organizations to redistribution of public dollars in support of individual folk artists. The generality of principles can lead not only to diverse uses in policy contexts but to misuse as well, by masking the political agendas of policy actors.

Finally, the aim of political philosophy to yield principles that can be applied across cases can be challenged. In a differentiated pluralistic society, where policy issues take many forms in many areas of experience, it seems unreasonable to expect that all policy decisions can be reducible to a single set of principles. A more reasonable expectation is that the assessment of existing policies and the formulation of policies will turn on a variety of principles, such as individual rights, distributive justice, utility, and even, in some cases, efficiency. Thus, while the general principles of political philosophy have potential utility in specific policy contexts, the hope that a general principle or set of principles can resolve value disputes in all policy contexts appears unfounded.

Interpretive Policy Analysis

Interpretive policy analysis is rooted in interpretive social science, a primary source of the critique of positivism on epistemological and normative grounds. Interpretive social science is based on three key premises. First, "it construes human behaviors, social relationships, and

cultural artifacts as texts...and then seeks to uncover the meaning that those texts have to the agents who constitute them and to others located spatially or temporally outside them."[32] Stated in terms used previously, interpretive social science takes an agentistic perspective on human nature.

Second, following the first premise, interpretive social science aims to elucidate or make sense of individuals' actions in terms of agents' reasons for given actions. Rather than seeking to explain or predict human behavior in reference to causal laws, interpretive social science attempts to reconstruct processes of practical reasoning utilized by social actors. These actors' intentions are an important focus of analysis; they "are explicated in terms of the cultural context of conventions, rules, and norms within which they are formed.... Intentions are not construed as internal mental events or private wants but rather as the purposes that an agent constructs or might in principle have constructed using the publicly available concepts and meanings of his or her culture."[33]

A final feature of interpretive social science is its attention to the complexity of the cultural contexts in which actions take place and its effort to demonstrate the interconnections between social actors' values, intentions, and roles in these contexts. "In the connections it looks for, positivistic social science moves from the specific to the general, the aim being to subsume particular events under general laws. In interpretive social science the analysis does not move up and down a ladder; it spins a web...[and] seeks to place a particular event in an ever–widening network of relationships."[34]

Drawing on these premises, interpretive policy analysts aim to explicate and interpret the practical reasoning and intentions of policy actors in making policy choices and seek to place those choices in the complex cultural contexts in which they are argued for, enacted, and implemented. Special attention is given to the points of view of policymakers and those potentially affected by particular policy decisions. Interpretive policy analysis theorists acknowledge that the interpretations produced reflect, to a significant degree, the value positions of individual researchers. In contrast to positivism and policy science, interpretive policy analysis holds that the values of the researcher are, and indeed ought to be, prominent throughout any research process. As a result, and at times by design, the analyses that this methodology yields are contestable. The relative power of these diverse interpretations, not surprisingly, given the previous point, depends on the insight and rhetorical skills of the researcher.

A common criticism of interpretive policy analysis, given its attention to explicating the value positions and intentions of policy actors, is that it too often becomes trapped in the "native's point of view" and, further, that this immersion merely serves to reinforce existing worldviews and conceptions. Most significantly, at least for the current discussion, critics

charge that the practice of interpretive policy analysis does not yield evaluative criteria that can mediate between conflicting policy proposals and, thus, "inevitably involves a circle of potentially conflicting accounts."[35]

These criticisms, while serious, can be addressed by supplementing the description of interpretive policy analysis offered to this point. First, immersion in the intentions and actions of policy actors does not mean that interpretive policy analysts necessarily will be unable to move beyond these actors' perspectives. Interpretive policy analysis is not merely a descriptive research method. It can, and at times must seek to, go beyond the necessarily limited understanding policy actors have of their own situations. This is done by "filling out and correcting that comprehension with a broader, more critical perspective,"[36] a process involving two primary tasks: (1) an attempt to accurately describe the sociopolitical circumstances surrounding a policy's formulation and implementation and (2) a focus on understanding the diverse norms and values that are operative in a policy context and how they can and do shape policy options.

But can interpretive policy analysis generate criteria needed to decide among value–laden policy options? The possibility of serving this function rests on particular conceptions of values and concepts. Proponents of interpretive policy analysis contend that a conception of values as arbitrary sentiments or irrational ventings of emotion, as found in positivism and policy science, is defective. They argue that values, "as assertions concerning what is right, what is good, or what ought to be done, represent far more than individual preferences...[and] as reasoned judgments concerning appropriate forms of behavior and desirable states of affairs, individual value commitments are far from arbitrary choices."[37] Value judgments, it is argued, are made through processes of critical reflection (in individuals) and deliberation (in groups), processes that yield reasons for value positions and calculations of the consequences likely to follow from the adoption of particular values.

This process of rationally assessing alternative value positions does not rely upon mysterious cognitive processes such as intuition, as is common in political philosophy. Instead, the concepts employed in this process are, as Jennings states, "'publicly available' concepts...drawn from a common, intersubjectively meaningful set of cultural norms, traditional values, and...commonsense understandings of what human beings need and how they react in various circumstances."[38] Jennings acknowledges that these concepts are essentially contestable and that no single use of them can be reasonably prescribed or enforced. That concession, however, does not in any way preclude rational assessment of the different use of concepts.

While the discussion to this point has established key premises in justifying the practice of rationally assessing alternative value positions, advocates of interpretive policy analysis are less clear in stipulating how such

assessment ought to proceed. It is one thing to say that value–laden concepts can be assessed on rational grounds; it is another thing to elucidate a method of how this can be done. It is in this regard that conceptual analysis as a method of explicating concepts can supplement policy analysis. The complementary value of these research methods is the subject of the next section.

THE POTENTIAL OF CONCEPTUAL ANALYSIS IN POLICY RESEARCH

The practice of philosophy in the twentieth century, in a dramatic departure from practice in all previous times, does not aim to construct general worldviews. Instead, it tends to seek perspective on the world by analyzing the roots of knowledge—the basic concepts, assumptions, and arguments characteristic of different domains of knowledge. In particular, it deals with how language is used in discourse in the formulation of arguments to support statements of belief.

Conceptual analysis seeks to probe the meanings of concepts that inform our everyday thinking and speech as well as more formal arguments. It does so by pointing out how discourse falls prey to the pitfalls of language—ambiguity, equivocation, and vagueness. *Ambiguity* entails the use of a word in two distinct senses within a particular discourse; *equivocation* involves an unmarked shift of the meaning of a word in a specific context; and *vagueness* applies to words where understanding of their meaning leaves too much to interpretation.[39]

Definitions constitute an effort to control the meaning of terms within discourse. The philosopher Israel Scheffler identifies three sorts of definitions used in practical, including policy, contexts. *Stipulative definitions* are attempts to lay down conventions for the interpretation of terms within a certain context. While stipulative definitions may or may not be coherent and pragmatically well chosen, they do not reflect conventional usage and can thus be considered arbitrary. *Descriptive definitions*, in order to resolve questions of meaning, give an account of a term's prior usage as it is ordinarily and most usually applied. Thus, descriptive definitions are not arbitrary. *Programmatic definitions* are like stipulative definitions in that they are not bound by prior usage of a term and like descriptive definitions in that they attempt to go beyond matters of economy. Programmatic definitions are unique in that they imply a program of social practice. (The use of *implication* is not in the logically necessary sense. As Scheffler points out, definitions do not directly imply a particular practical program. They must be supplemented by principles of action. But definitions can be said to imply programs in the sense of being highly suggestive of them.)

Scheffler emphasizes that the difference between these types of definitions is not formal in nature in that a definition with the same formal construction may be stipulative, descriptive, or programmatic. Identifying a definition by type can only be done by reference to the context of its use, that is, within a series of arguments and/or in practical contexts and by determining the interest underlying each use. As Scheffler states, "The interest of stipulative definitions is communicatory, that is to say, they are offered in the hope of facilitating discourse; the interest of descriptive definitions is explanatory, that is, they purport to clarify the normal application of terms; the interest of programmatic definitions is purposeful and practical, that is, they are intended to embody programs of action."[40]

This feature of definitions has important implications for the conduct of conceptual analysis and evaluation. There is no point in pitting these sorts of definitions against each other. For example, there is nothing gained by critically evaluating a stipulative definition by revealing its divergences from prior usage. But use of each of these types of definitions, as Scheffler argues, is subject to double evaluation. Individual terms can be analyzed in terms of vagueness, whereas the use of terms within discourse can be examples of ambiguity or equivocation. These pitfalls of language can befall the use of terms, whatever the context. But this sort of analysis takes us only so far. The need for double evaluation is best illustrated by reference to programmatic definitions. A programmatic definition seeks to lay down conventions of usage in the interest of furthering a program of action. Such a definition may indeed be internally consistent in a formal sense. But it does not follow that the program of action it recommends is worthwhile. Thus, the need for an additional step. A programmatic definition is to be evaluated in terms of the moral and practical consequences that could be reasonably expected as a result of adoption of such a definition, an evaluation "in light of our commitments, of the practical alternatives open to us as well as alternative ways of putting desired actions into effect."[41] The importance of this step is illustrated by the point that it does not follow that if a definition is vague, its recommended program is not worthwhile. These two steps, however, are not unrelated. Notably, vague terms or ambiguous discourse can, within specific contexts, undercut the force of an argument for a recommended program, thus threatening its prospects for adoption and implementation.

Scheffler's notion of double analysis and evaluation has important implications for the practice of policy analysis. Policy language, as discussed previously, is action language as distinct from behavior language. It contains many definitions that are programmatic in nature that embody value positions and imply programs of action. But if the language used to define policy goals and means to achieve these goals is unclear and imprecise, implementation of the policy can be a source of confusion, arbitrariness, and

controversy. Policy evaluation also requires an additional step, namely, analysis of whether a policy's goals are worthwhile and whether its means are likely to effect achievement of the goals in a fair, cost–effective manner with minimal negative side effects. These steps are well captured in Scheffler's concept of the double evaluation of programmatic definitions. But most significantly for the argument in this chapter, the idea of analyzing programmatic definitions of key value–laden concepts as utilized in policy contexts fills a significant gap in the theory of interpretive policy analysis: It provides a means of rationally assessing the value positions underlying policy options.

CONCLUSION: A METHODOLOGY FOR ANALYZING MULTICULTURALISM AND THE ARTS

The thread throughout this chapter has been the attempt to define a methodology integrating features of logical analysis of the term *policy*, interpretive policy analysis, and conceptual analysis. It is based on several key premises. First, it construes a policy as a matter of choice in which a policy agent obligates herself or himself or others to act in accordance with a conditional imperative—an obligation to do a specified something *whenever* specified conditions occur—in order to achieve purposes rooted in human values. This conception, in turn, is based on a conception of human nature in which human beings are not merely configurations of externally caused behaviors but are agents who perform actions for reasons and to achieve purposes.

Second, this integrated methodology, drawing on interpretive policy analysis, takes as its focus the explication and interpretation of the reasoning, intentions, and value positions of policy actors in making policy choices within a cultural context. At the same time, it seeks to round out and go beyond policy actors' understanding of their own choices.

The final feature of this methodology is its use of the tools of conceptual analysis to rationally assess alternative value positions that inform policy options. This step is premised on the view that values are not mere personal preferences or ventings of emotion but assertions of what is good, right, or ought to be done and judgments based on rational processes of critical reflection and deliberation. Conceptual analysis probes how the use of value concepts in discourse can fall prey to the pitfalls of ambiguity, equivocation, and vagueness. It also can analyze definitions of terms, especially definitions that embody value positions and imply purposeful programs of action (programmatic definitions), in terms of the normative and practical consequences that can reasonably be expected from the adoption of such definitions. Thus, policy goals can be subjected to a double

evaluation—one that seeks to clarify the language used to express value positions and policy goals and the other that calculates the potential effects of programs implied in the definitions of key terms. Policies' means, in turn, can be analyzed in terms of whether they are likely to effect achievement of policy goals in a fair, cost–effective manner, with minimal negative side effects.

This integrated methodology is, I believe, an appropriate and potentially powerful means of analyzing policy issues surrounding multiculturalism and public support of the arts. Policy debates in arts policy too often do not explicitly acknowledge, let alone explicate, the value positions behind policy proposals. This tendency, as will be seen, is most evident in the policy documents of those public agencies whose policies can and do have significant effects on the practice of the arts. Thus, considerable attention will be given to explicating, in the manner of interpretive policy analysis, the value positions of public arts agencies as expressed in their usage of terms such as *art, culture, justice,* and *artistic value* in premises and arguments in support of policy goals. But beyond merely understanding the point of view of these policy actors, the attempt will be made to rationally assess their use of these value–laden terms as well as the theoretical assumptions that inform premises in their arguments for policy goals. This rational assessment will be achieved through the double evaluation of key concepts both on formal, logical grounds and in terms of potential practical consequences of the programs implied in value–laden definitions of these terms.

NOTES

1. Bruce Jennings, "Policy Analysis: Science, Advocacy, or Counsel?" in Stuart S. Nagel, ed., *Research in Public Policy Analysis and Management*, 4 (Greenwich, CT: JAI Press, 1987), p. 124.

2. Bruce Jennings, "Interpretation and the Practice of Policy Analysis," in Frank Fischer and John Forester, eds., *Confronting Values in Policy Analysis: The Politics of Criteria* (Newbury Park, CA: Sage Publications, 1987), pp. 136–137.

3. Ibid., p. 137.

4. For further discussion of "value noncognitivism," see Frank Fischer, *Politics, Values, and Public Policy: The Problem of Methodology* (Boulder, CO: Westview Press, 1980).

5. M. E. Hawkesworth, *Theoretical Issues in Policy Analysis* (Albany: State University of New York Press, 1988), p. 14.

6. Ibid.

7. For further discussion of this point, see Carol H. Weiss, "Ideology, Interests, and Information: The Basis of Policy Positions," in Daniel Callahan and Bruce Jennings, eds., *Ethics, the Social Sciences, and Policy Analysis* (New York: Plenum Press, 1983).

8. Bruce Jennings, "Interpretation and the Practice of Policy Analysis," pp. 141–142.

9. David C. Paris and James F. Reynolds, *The Logic of Policy Inquiry* (New York: Longman, 1983), p. 30.

10. For a discussion of this trend, see Clifford Geertz, "Blurred Genres: The Refiguration of Social Thought," *American Scholar* 49 (Spring 1980): 165–179.

11. For discussions of these issues, see Carol H. Weiss, "Ideology, Interests, and Information: The Basis of Policy Positions"; and Frank Fischer, *Politics, Values, and Public Policy: The Problem of Methodology*.

12. See, for example, M. E. Hawkesworth, *Theoretical Issues in Policy Analysis*.

13. For a full exposition of this view, see Theodore J. Lowi, *The End of Liberalism* (New York: W. W. Norton, 1969).

14. Robert N. Bellah, "Social Science as Practical Reason," in Daniel Callahan and Bruce Jennings, eds., *Ethics, the Social Sciences, and Policy Analysis* (New York: Plenum Press, 1983), pp. 40–41.

15. Donna Kerr, *Educational Policy: Analysis, Structure, and Justification* (New York: David McKay, 1976), pp. 1–2.

16. Ibid., p. 29.

17. For an extensive discussion of the political evaluation of policies, see Frank Fischer, *Politics, Values, and Public Policy: The Problem of Methodology*.

18. For further discussion of such research, see Stuart S. Nagel, "Political Science and Public Policy," in George J. McCall and George H. Weber, eds., *Social Science and Public Policy: The Role of Academic Disciplines in Policy Analysis* (Port Washington, NY: Associated Faculty Press, 1984).

19. See, for example, Aaron Wildavsky, *Speaking Truth to Power: The Art and Craft of Policy Analysis* (Boston: Little, Brown, 1979); Charles Lindblom and David Cohen, *Usable Knowledge: Social Science and Social Problem Solving* (New Haven, CT: Yale University Press, 1979); Charles W. Anderson, "Political Philosophy, Practical Reason, and Policy Analysis," in Frank Fischer and John Forester, eds., *Confronting Values in Policy Analysis: The Politics of Criteria* (Newbury Park, CA: Sage Publications, 1987); and John L. Foster, "An Advocate Role Model for Policy Analysis," *Policy Studies Journal* 8 (Summer 1980): 958–964.

20. See the works of Jurgen Habermas: *Theory and Practice* (Boston: Beacon Press, 1973); *Knowledge and Human Interests* (Boston: Beacon

Press, 1971); *Communication and the Evolution of Society* (Boston: Beacon Press, 1979); and *Legitimation Crisis* (Boston: Beacon Press, 1973).

21. David C. Paris and James F. Reynolds, *The Logic of Policy Inquiry*, p. 192.

22. Ibid.

23. Ibid., p. 193.

24. Ibid.

25. Ibid.

26. Ibid., p. 194.

27. Ibid., p. 195.

28. Frank Fischer, *Politics, Values, and Public Policy*, p. 169.

29. See John Rawls, *A Theory of Justice* (Cambridge, MA: Belknap Press, 1971).

30. See Ronald Dworkin, *Taking Rights Seriously* (Cambridge, MA: Harvard University Press, 1977).

31. Charles W. Anderson, "Political Philosophy, Practical Reason, and Policy Analysis," p. 31.

32. Bruce Jennings, "Policy Analysis: Science, Advocacy, or Counsel?" p. 129.

33. Bruce Jennings, "Interpretation and the Practice of Policy Analysis," pp. 143–144.

34. Ibid., p. 145.

35. David C. Paris and James F. Reynolds, *The Logic of Policy Inquiry*, p. 191.

36. Bruce Jennings, "Interpretation and the Practice of Policy Analysis," p. 144.

37. M. E. Hawkesworth, *Theoretical Issues in Policy Analysis*, p. 62.

38. Bruce Jennings, "Interpretation and the Practice of Policy Analysis," p. 146.

39. For an extended discussion of conceptual analysis, see Monroe C. Beardsley, *Thinking Straight: Principles of Reasoning for Readers and Writers*, fourth edition (Englewood Cliffs, NJ: Prentice–Hall, 1975).

40. Israel Scheffler, *The Language of Education* (Springfield, IL: Charles C. Thomas, Inc., 1960), p. 22.

41. Ibid., p. 33.

3

An Interpretation of Arts Policy Mechanisms

This chapter constitutes an effort to interpret the policies of public arts agencies regarding multiculturalism. It rests on the methodological assumptions of interpretive policy analysis and thus aims to explicate the actions of policy agents and how they understand such actions. This stress on action is intentional. It is consistent with the concept of a policy as a choice to *act* in accord with a stated imperative whenever specified conditions pertain. Further, such an emphasis counters the view that interpretive policy analysis can lose track of what policy agents actually do in trying to understand their intentions. Thus, this chapter will concentrate on what public arts agencies are doing and plan to do rather than what they say they do or plan to do. Of course, the language used in the documents of arts policy agents is not unimportant. Indeed, the language of arts policy agents is a primary focus of the current and subsequent chapters. But the focus here is on action language, the normative concepts of art, culture, justice, and artistic value by which arts policy agents make sense of or rationalize what they actually do. It is in the next chapter that we will go beyond this necessary first step of explicating arts policy agents' understandings of what they do by clarifying assumptions in contestable value positions as revealed in their usage of normative concepts in policy contexts.

RATIONALE FOR FOCUS ON STATE ARTS AGENCIES

The decision in this book to attend to the actions of public arts agencies regarding multiculturalism begs a question that has not been addressed to this point—namely, What is the significance of decisions by public agencies relative to those made in the private sector as they affect arts organizations of ethnic cultural traditions? The previous chapter cited the shift from marketplace to political decisions as a force in the reemergence of the salience of multiculturalism in American society. But the relationship between public and private decisions in the arts warrants closer scrutiny.

In contrast to Europe, the United States, rooted in its political history, has tended to leave to private and local institutions the determination of decisions that most overtly affect the conduct of cultural institutions—by some accounts, a policy decision in itself.[1] Indeed, the establishment of the National Endowment for the Arts was resisted in the early 1960s on the grounds that government would inevitably supplant private funding sources, leading to the consequences of bureaucratic control and government censorship of the arts.[2] But the focus of critical discussion of government support of the arts has shifted since then. Edward Banfield, for example, argues that aesthetic experience, even at its best, is purely a private experience and, therefore, that government promotion of aesthetic experience is not in the public interest. Nor is support of the arts a legitimate function of a government whose sole purposes, in Banfield's view, are the protection of individuals' rights and security and the establishment of preconditions for a competent citizenry.[3]

In more practical terms, critics contend that government subsidy to the arts is not necessary to artistic achievement, arguing, from a historical point of view, that America's most notable cultural achievements, and the expansion of its arts institutions, occurred prior to the 1960s, without the aid of government subsidy.[4] Both the theoretical argument cited above and this more practical, historical argument are parts of a conceptual model of the ideal relationship between private and public sector funding of the arts, termed the private–sector–as–leader model.[5]

In response, critics of this model and proponents of a government-as–leader model of public–private sector relationships tend to cite figures that purport to show how the cultural landscape in America has changed since 1965, the year the National Endowment for the Arts was created. In 1965, there were 22 professional theaters, 27 opera companies, 58 orchestras, and 37 dance companies; by 1990, the figures were 420 theaters, 120 opera companies, 230 orchestras, and 250 dance companies. Nonprofit arts organizations also now extend far beyond large East and West Coast cities to smaller cities, towns, and rural areas throughout the country. The size of audiences attending arts performances also increased during this period, from 1 million to 15 million for theater, from 3 million to 18 million for opera, from 9 million to 24 million for orchestras, and from 1 million to 16 million for dance, and the number of persons calling themselves professional artists has nearly tripled, to 1.5 million, during the same period. Finally, prior to 1965, financial support for the arts from the private sector and state governments was limited. At the time, only seven states had public arts agencies. Also, in the ten years prior to the creation of the Endowment, private funding of the arts had held relatively steady at approximately $250 million per year, of which $40 million came from corporate sources. Today,

every state and territory has a public arts agency, and private giving to the arts stands at about $6 billion annually.[6]

The significance of public arts funding was placed in dramatic relief for advocates of the government–as–leader model during recent events surrounding NEA funding of controversial contemporary art. The accompanying assaults on the decision–making processes of the NEA and on the idea of public support of the arts spawned numerous predictions that if the NEA were subject to content restrictions on the kinds of art it could fund or if its administrative structure were altered, the result would be a chilling effect on private sector funding of the arts.[7]

This contention was rooted in several premises. The government–as–leader model stresses that public arts agencies' decisions do, and should, guide philanthropic decisions in the private sector. It is argued that such guidance is, and should be, based on the expertise of public arts agencies' grants evaluation panels in identifying those arts organizations and activities that merit support, in that corporations and foundations who seek to fund the arts do not have the background and expertise to make the aesthetic judgments necessary for sound grants decisions. This guidance gains significance from the fact that many programs of public arts agencies are designed to leverage private funding for arts organizations and activities. At a minimum, public arts agencies also follow the principle of not funding the total or even majority of the cost of any project, requiring a substantial private funding match to complement the arts agency grant. As a consequence of this relationship, it has become virtually axiomatic in the arts funding world that a grant from a public arts agency, especially the NEA, serves as an imprimatur that improves dramatically an organization's chances of securing private support. Defenders of the government–as–leader model view this as an effective and fair relationship between public and private sectors, a relationship consistent with the American tradition of private initiative and action.

But this model of public–private relations has been seen as problematic on diverse grounds. From a historical point of view, it is difficult to establish with certainty that a causal relationship exists between the growth of public arts funding and the increased numbers of arts organizations, artists, and audience members cited above. Other factors cited that seem to have contributed to what is often called the "arts boom" are increased levels of education; the use of the nonprofit mechanism to establish arts organizations; tax laws that have encouraged private donations to nonprofit organizations; mass communications; and the building of arts centers by cities and universities, frequently termed the "edifice complex," which have increased the "supply" of the arts.[8] Thus, while few would argue that the impact of public arts funding has been negligible, it remains difficult to separate its effects from these other factors in spurring the arts boom.

Conservative cultural critics, however, are less interested in the relative influence of public or private factors than in the nature of the arts boom itself. Rather than viewing it as a renaissance of artistic achievement and cultural participation, it was seen as a period, as Samuel Lipman contends, where "the cry of pleasure was everywhere in the air, and forces of seriousness and reflection were in full flight, the consequence of [which] was a gathering tendency to see the arts as entertainment and artists as entertainers, lavishly paid to sing for their suppers."[9] He further argues that "institutions were measured by their turnstile count; museum exhibitions were evaluated in terms of drawing power.... Everywhere the goal was to expand and enhance the arts' image as a bringer of pleasure. Everywhere the enemy was the dull image of the status quo."[10] Thus, according to Lipman, the emergence of public arts funding spurred not a renaissance in the arts but contributed in many ways to the "debased idea of the market-ability of art as entertainment."[11]

Another potential criticism of the government–as–leader model does not rely upon critiques of the state of the arts in American society; instead, it has a more empirical focus that calls into question the capacity of government funds to the arts to leverage private funds. One feature of this relationship that advocates of the government–as–leader model seem to neglect is that private funding of the arts has a dynamic of its own, conditioned by factors unique to the private sector. Pat Clubb, for example, stresses that foundation behavior must be viewed in the context of reactions to the broader nonprofit community of which the arts are but one part. Her research suggests that foundations tend to make highly individualistic funding decisions and demonstrate strong concern for how the organizations they choose to fund reflect on their image.[12] This orientation to funding specific organizations does not preclude the direction of funds to promote issues or solve community problems, but in most cases, foundation trustees seem to set their own funding priorities rather than responding to the expressed needs of communities. Thus, foundations, with some notable exceptions,[13] "are unlikely to attempt to discern and address general field or discipline issues unless these are well–formulated and persuasively articulated by the arts community."[14]

As for corporate funding of the arts, research by Michael Useem makes the perhaps obvious point that the total amount of funds available for possible support of the arts is very much dependent on the general state of the economy and the income capacity of the corporate sector. The unpredictability of this factor is complicated for the arts by increased compe-tition for funds from nonprofit activities suffering from government cutbacks or increased service demand, such as health, education, and social services. Finally, in reviewing these many competitors for funds, corporations utilize specific criteria in making their decisions. Corporate patronage tends to

focus on local concerns and organizations. Thus, as Useem's research demonstrates, "geographic location" and "impact on the local community" are the grant—awarding criteria used most frequently by corporate funders, along with "management capability."[15]

These examples, while hardly a full discussion of the many dimensions of private philanthropy and the arts, do suggest that arts funding decisions in the private sector are more than a matter of mere responses to decisions of public arts agencies. That said, however, the actual relationship between public and private sector support of the arts remains an open question. Simply put, it is difficult to ascertain the extent to which private funding sources follow the lead of public arts agencies without detailed empirical studies.

The only available study of this topic, by J. Mark Davidson Schuster, explores the primary tool public arts agencies use to leverage private sector support, the matching grant. Matching grant programs stipulate that a grant made by a public arts agency must be matched by funds raised in the private sector, at a ratio of 3 to 1, with the larger amount coming from the private sector. The frequent use of this mechanism attests to its popularity among public arts agencies and their presumed belief in its effectiveness. Schuster acknowledges that matching grants are frequently effective tools for individual arts organizations to secure increased support to fund designated projects. But Schuster finds that rather than actually generating "new money," that is, an increase in the total amount of private funds donated to the arts, matching grants seem to have the effect of moving existing private funds around from one matching grant recipient to another, thereby reducing the private resources available to other arts organizations in a specific community.[16] Further, while not documented to date, it seems reasonable to assume that another consequence of the government—as—leader model is that private funding for otherwise worthy arts organizations or projects might be jeopardized if they do not receive a public arts agency matching grant.

Given the paucity of research on public—private relations in the arts, it is not surprising that research on government leverage of private funds for arts organizations rooted in ethnic cultural traditions is not extensive. The NEA cites a project of its Expansion Arts Program, the Community Foundation Initiative, as "providing a community vehicle for private support to artists and organizations that would have no other way of tapping private community resources."[17] The Community Foundation Initiative aims to assist local foundations in developing special endowments that can be directed to support minority artists and organizations. The initiative requires a 2 to 1 private to public match. As of 1990, 21 foundations throughout the country had raised $6.8 million to match $3.4 million from the Endowment.

Despite this example, the available evidence suggests that, for the most part, the success of multicultural arts organizations in securing private support has, to date, been limited. In its 1986–1990 Five–Year Plan, the NEA recognized the relative attractiveness of certain arts activities and private funders (Table 1).[18] This table suggests that the private sector tends to support major, established institutions who perpetuate traditional art forms, to the relative neglect of emerging art forms and smaller, younger institutions, including multicultural arts organizations.

A recent survey of 252 culturally diverse arts organizations in the United States, conducted for the Association of American Cultures (TAAC), the only study of its kind done to date, sheds some light on these organizations' reliance on grants funds. These organizations span all regions of the country as well as a wide spectrum of art forms and disciplines. Table 2 provides information on the relative size of these organizations' budgets.[19]

Table 1
Relative Attractiveness of Arts Activities to Private Funding

Attractive to private sector	Less attractive to private sector	Unattractive to private sector
Major museum exhibitions	Classical theater	Avant–garde and inter-disciplinary
Opera	Modern dance	Support of individuals
Ballet	Jazz	Visual artists' organizations
Orchestras	Design	Postmodern dance
Larger presenters and performing arts centers	Film presentation	Video presentation
Institutions under-taking capital construction	Folk arts	Museum maintenance
Public television	Public radio	Minority organizations
Arts presentations	New music	Archives and libraries
	Media arts centers	Service organizations
	Chamber music	Dance notation
	Arts education	
	Choral music	
	Professional training	
	Museum conservation	
	Medium and small presenters	
	Artists' colonies	

Table 2
Budget Size of Culturally Diverse Arts Organizations
in the United States (N=252)

Annual budget size	Number of organizations	% of organizations
$10,000 or less	52	20.6%
$10,000 - 25,000	29	11.5%
$25,000 - 50,000	24	9.5%
$50,000 - 100,000	43	17.1%
$100,000 - 150,000	21	8.3%
$150,000 - 200,000	21	8.3%
$200,000 - 250,000	14	5.6%
$250,000 - 300,000	7	2.8%
$300,000 or more	41	16.3%

Table 3
Reliance of Culturally Diverse Arts Organizations
on Grant Monies as a Percentage of Their Budgets (N=233)

% of grant monies in budgets	Number of organizations	% of organizations
1 - 25% of budget	75	32.2%
26 - 50% of budget	67	28.8%
51 - 75% of budget	42	18.0%
76 - 100% of budget	49	21.0%

Table 3, based on the sample of this same survey, reports the reliance of these organizations on grant monies. Unfortunately, the survey did not address other key questions the answers to which would have yielded a fuller picture of the relationship between public and private funding as applied to multicultural arts organizations. The study, for example, did not contain comparative information on the relative reliance of other arts organizations, those not rooted in a specific cultural tradition, on grant monies. Other sources have yielded breakdowns of arts organizations' reliance on earned income, private funds, and public funds. For example, in 1985, of the $109 million in income budgets of nonprofit theaters in the United States, the percentage of earned income was 65%; private, 26%; and public, 9%.[20] These figures, on the face of it, are generally comparable to average figures in the TAAC survey on culturally diverse organizations' dependence on grant monies. But herein lies a problem with the TAAC survey: For some reason, it did not ask respondents to designate the percentages of grant monies coming from private and public sources, respectively. Thus, it is impossible, on the basis of this study—unfortunately, the only one of its kind—to gauge the relative importance of private funds to public funds for multicultural arts organizations.

Still, apparently based on the answers of survey respondents to open–ended questions, the TAAC study concludes that while many culturally diverse arts organizations rely heavily on grant monies, "it appears that only a small percentage of those grants are from the private sector."[21] This conclusion is supported somewhat by TAAC survey respondents, who rated increased funding from private sources as their most pressing need. Thus, since private funding, for the most part, does not at this time seem to be a viable option for the multicultural community to foster stability, growth, and development in its organizations, the focus in this book on the importance of public policies, especially in light of the uncertain degree to which public funds leverage private support for multicultural arts organizations, certainly seems justified.

To this point, the case has been made for the focus on *public* funding as it relates to multiculturalism and the arts. But public policy for the arts is formulated and implemented at the national, state, and local levels. This book centers on the policies of state arts agencies. Thus, the final task in this section is to offer a rationale for the choice to focus on public arts agencies in the states.

A primary reason for attention to state arts agencies is rooted in the increased policy influence of these agencies within the tripartite public arts policy sector. For the past decade, the public arts policy sector has been undergoing a process of decentralization. The NEA's budget was at its zenith, in actual dollars and relative to state appropriations, in 1979. From this figure of approximately $210 million, the NEA budget has declined

nearly 40% after inflation. In 1989, Congress appropriated $169 million for the NEA, 20% of which, by law, was distributed in block grants to the states. During this same period, state legislative appropriations to the arts rose from an aggregate figure of $120 million to a high of $268 million. Thus, through budget declines at the NEA and dramatic increases in state arts funding, "the outcome was a dramatic, if unplanned, *de facto* devolution of arts funds from the federal government to the states."[22] The 1990 congressional reauthorization of the Endowment yielded legislation that will surely accelerate this process. Notably, the 80 to 20 ratio of federal to state percentages of NEA program funds, in place for two decades, was revised so that by fiscal year (FY) 1993 the ratio was to become 65 to 35.

The question, then, is to what extent will this decentralization of public arts funding affect the formulation, implementation, and impact of public arts policy? Critics of the recent congressional action fear that as a result of shifting a larger share of NEA funds to the states, state legislatures will thereby reduce their allocations to the arts, thus diminishing the total amount of public funds available to the arts.[23] Indeed, figures show that state arts agencies experienced budget declines to an aggregate figure of $213.5 million in FY 92. But the reason for these declines is far more likely the depressed condition of state economies than the redistribution of NEA funds to the states. In either case, the aggregate budget figure has increased slightly to $215.5 million in FY 93.[24] Thus, at least in the short term, it does not appear that aggregate size of public arts funds, considering both federal and state funds, will experience a dramatic decline.

Considering the relative stability of the total amount of public arts funds, other questions about the impact of decentralization emerge. Paul J. DiMaggio asks:

> Does devolution influence the fortunes of large, established organizations that produce and exhibit Euro–American art to a wide middle class public? Does it help or hurt small organizations working in non–European traditions, or organizations (in any tradition) pushing the boundaries of innovation? How does it affect the generosity, scope, and political neutrality of grants to artists? How does it influence efforts to increase the number of Americans participating in the arts, either as audiences or producers?[25]

But DiMaggio's comparative research on how the Endowment and how state arts agencies allocate their funds to the arts reveals few major differences. State arts agencies tend to fund amateur groups, humanities organizations, and local arts agencies more than the Endowment, while the NEA places greater emphasis on media arts. But in looking at different types of public arts fund applicants—artists, performing arts organizations,

and community— and service—oriented organizations within diverse discipline categories—DiMaggio found little difference in how they fared at the federal and state levels. As evidence, a regional arts service organization, the Western States Arts Foundation, found that 89% of the arts organizations it serves have received NEA funding and also obtained grants from their state arts agency.[26] These findings are somewhat surprising in that these agencies would seem to be equipped, by organizational design, with different capacities—the Endowment, with potential to take a national perspective, consult with a wide array of leading professionals in making its decisions, and act with respect to arts disciplines as a whole and national issues; and the states, with potential to serve smaller organizations within their states and to develop cooperative programs with local arts agencies. But based on the findings of DiMaggio's research, it seems reasonable to conclude that since the actions of the NEA and those of arts agencies do not diverge markedly in terms of the recipients of funds, the focus here on state arts agencies is justified, in part, because public arts agencies at the state level have, and apparently will continue to have, more funds to implement their policies.

Another reason to focus on state arts agencies is their apparent interest in policy analysis and development. It has been argued, not infrequently, that the NEA, throughout its history, has had an antianalytical predisposition, characterized by a commitment to "support all of the arts." Examining policy issues and setting those policy goals and objectives that are most worthy of a commitment of scarce public resources have not been central, over the years, to the NEA's operational style.[27] State arts agencies, through the activities of their professional service organization, the National Assembly of State Arts Agencies (NASAA), at least attempt to analyze the effects of their policies. Notably, for the past several years, NASAA has issued an annual report that analyzes state arts agencies' grant activities in terms of grants awarded, disciplines and activities supported, and individuals and organizations benefitting.[28]

A final, perhaps the most important, reason that state arts agencies merit special attention in this book is the fact that NASAA has, for many years, held that the promotion of cultural pluralism through arts policy is a key measure of state arts agency accomplishment.[29] Understanding how state arts agencies have done so forms the remainder of this chapter.

DEFINITION OF POLICY MECHANISM OPTIONS

If the goal of this chapter is to understand the actions of state arts gencies (SAAs) regarding multiculturalism, then the object of this attempt at understanding must be further specified. This involves stipulating a

definition of the term *policy mechanism* and outlining policy mechanism options adopted by public arts agencies at the state level.

A policy mechanism is defined here as the means by which grants funds are made available and allotted to potential grantees, including artists and organizations rooted in ethnic cultural traditions. In most cases, policy mechanisms were not devised solely, or even primarily, to address issues of multiculturalism; rather, policy mechanisms are the parameters under which all potential grantees must operate.

Policy mechanisms are multidimensional in nature and ultimately determine who does and does not receive funding from public arts agencies, as well as the amounts received. Yet past studies of the actions of state arts agencies have not focused on policy mechanisms, despite their significance. For example, the 1989 *Report of the NASAA Task Force on Cultural Pluralism*, lists 17 indicators that state arts agencies are encouraged to utilize as measures of their commitment to promoting cultural pluralism through arts policy. These indicators range from "staff and council technical assistance services provided," "council membership," "panel membership," and "staff membership" to "policy development resources," "publication and communication activities," and "information gathering activities," among others.[30] This report, however, does not suggest ways in which these isolated indicators can be integrated to analyze the actions of state arts agencies; in particular, it does not prescribe a method for assessing how these many factors, when taken as a whole, affect decisions and reveal patterns about funding by state arts agencies.

There is no reason to believe that state arts agencies' lack of use of "policy mechanism" as an analytical category means that they would object to its use; they simply have not utilized it to date. But some state arts agencies might resist the focus here on policy mechanisms as complex systems of funding, arguing that their agencies serve many other functions beyond that of the distribution of public funds. These include, for example, providing technical assistance to artists and arts organizations, offering information about the arts to the general public, lobbying for tax laws and postal rates favorable to the arts, and leveraging support for arts organizations and artists among other government agencies.[31] But however important these functions are in the view of public arts agencies, the fact remains that the structures of public arts agencies and the large majority of their resources are centered on the allocation of public funds.

Since state arts agencies do not refer to their funding systems as policy mechanisms as such, identifying policy mechanism options for this study has involved considerable review, analysis, and interpretation, specifically, of the publicly available texts of 48 state arts agencies gathered during the first three months of 1991. These sources of information included current guides to agency programs; goals statements; eligibility

requirements; grants categories; special programs directed to specific populations; evaluative criteria for funding decisions; terms of grants; regulatory mechanisms; application form requirements; annual reports; long–range planning documents; terminology about multiculturalism; roles and criteria for selection of agency boards and grants review panels; policy statements on multiculturalism; and special studies on agency activities.

Through analysis of these published materials, three policy mechanisms with implications for multicultural issues were identified: *open access to funding, special programs,* and *distributive pluralism*. These will be defined briefly, for now, in turn.

The open–access–to–funding policy mechanism contains the premises that a wide variety of individuals and organizations are, and should be, free to apply for public arts agency funds and to participate in a fair and open process of competition for available funds. This approach further assumes that the most worthy grant applicants, as judged by consistently applied evaluative criteria, will be awarded funds (although perhaps not the full amounts requested by potential grantees due to extensive competition and the limited availability of funds) and that through this process all individuals and groups will benefit in significant ways.

Special programs of state arts agencies, while diverse in intent and structure, each represents a policy decision that the artistic and organizational needs of ethnic cultural groups can best be met, to a significant degree, through a special funding and programming mechanism in which only representatives of such groups are eligible to participate.

Finally, the distributive pluralism policy mechanism is regulatory in nature, stipulating, in most cases, that public arts agency applicants and grantees must proportionately include representatives of Native American, African, Hispanic, and Asian descent in their programs, staffs, boards, and audiences.

These three policy mechanisms are not mutually exclusive. For example, some state arts agencies utilize both the special programs and open–access–to–funding policy mechanisms. Thus, to some degree, they have been separated here for heuristic purposes. Still, as will be seen, these policy options do embody substantively different premises in goals for arts policy and multiculturalism, ranging from equal opportunity to equal results, and in means designed to achieve those goals, comprising incentives, requirements, or mandates.

Studying these policy mechanism options, once identified and defined, remains, however, problematic. Notably, a comprehensive evaluation of these policy mechanisms would require the presence of a number of conditions. Ideally, such an evaluation would be drawn on trend data that reveal how and to whom funds have been allocated over a period of years, including number of grants and grant amounts awarded, types of

disciplines and activities, and the categories of individuals and organizations benefiting from SAA funds. Further, an evaluation would analyze the impacts of such funds on the financial health and program development of the individuals and organizations that receive grants. Finally, a comprehensive evaluation would address the effects of SAA patronage on the quality of artistic productions and presentations or its effects on the social composition and qualitative responses of arts audiences. The presence of these conditions would make possible a comparative evaluation of alternative policy mechanisms.

Unfortunately, these ideal conditions rarely exist in the arts research world. Significant strides have been made by SAAs, however, through use of the National Standard for Arts Information Exchange (NSAIE), which is administered by NASAA with support from the NEA. The NSAIE is a set of terms, definitions, and principles for organizing and reporting information used by SAAs in their information systems.[32] Its terms include both *necessary* and *optional* information. Necessary information includes items such as applicant status, applicant institution, applicant arts discipline, grant amount requested, grant award, type of activity, number of artists participating, and number of individuals benefiting. These categories are subdivided extensively. Optional categories include, among many others, the racial, age, sex, disabled, and institutionalized characteristics for applicants, artists participating, and individuals benefiting. SAAs must collect all necessary information to be in compliance with the NSAIE and must use its definitions if they choose to collect information in the optional categories. Since 1983, the NEA has required SAA use of the NSAIE as part of its Basic State Grant Funds to SAAs (for many years approximately 20% of the NEA's budget), and NASAA annually gathers supplementary information, according to the NSAIE, on grants and services funded by other state, federal, and private funds. The NSAIE is amended every four years. The most recent changes were instituted in 1983–1984 and implemented in FY 86.

State arts agencies could utilize the optional race/ethnicity code in gathering information. But the extent to which they choose to utilize this code is not apparent from a review of state arts agencies' published materials. One type of publication that might seem to be a reliable source of information on the funding activities of SAAs is annual reports. But, unfortunately, their review for this book was not very revealing, at least not by themselves, regarding the place of multiculturalism in the programs of state arts agencies. Information was presented in a fairly generic form in most cases. Items generally included were an opening narrative, often including descriptions of agency highlights and accomplishments for the fiscal year; total budget figures, including amounts budgeted by program category; and a listing of grantees by program category, including their grant award and their county or city location. Variations on this basic format

included information by one SAA on its financial allocations per citizen and by county, and several SAAs that included short project descriptions on each grantee. This relative emphasis on geographic measures of grants awards by city or county has long been a matter of concern to those who charge that nonartistic criteria, such as geographic distribution, too often govern grant decisions to the neglect of artistic quality.[33] Whether this charge is fair or whether it merely represents SAAs' pragmatic recognition that they work within sensitive political contexts is an open question. But the presentation of grants and budget data by geographic locale does suggest that while SAAs do place priority on some extraartistic considerations in presenting grants information, presentation of such information by demographic characteristics, including race/ethnicity, either has not been possible or is not a pressing priority.

SAAs require final project reports of virtually all grantees, both individuals and organizations. A review of the information required on these final report forms might have been revealing, but the forms were not made available for this study. A review of the SAA grantee application forms themselves, about 50% of which were available, was interesting. While many application forms require no information on the characteristics of the applicants or the audiences to be served, several ask for a narrative description of outreach efforts designed to benefit special populations, including ethnic cultural groups. One SAA application form asks whether and how grantee activities will be "accessible" to such populations; another requires applicants to identify the characteristics, including race/ethnicity, of populations to be served to a significant degree by the applicant's proposed project; and another asks for narrative responses on who is to be served and how these populations will be involved in program development during the grant period. Finally, one SAA requires each grant applicant to provide estimated percentages of diverse populations, by racial/ethnic characteristics, to be involved as board, staff, consultants, volunteers, and audiences and in planning activities. But a major problem with these kinds of information is the fact that they are based on the intentions of SAA applicants. The degree to which these intentions are achieved or not and the extent to which SAAs monitor, or are able to monitor, their success or lack thereof are unclear.

The future of data collection on how and to what extent ethnic cultural groups are served by SAAs is somewhat more promising. In 1991, NASAA issued a plan to provide guidance to state arts agencies in gathering race/ethnicity information. Designed to expand definitions in the NSAIE, the plan is viewed as "not simply an attempt to determine which minority organizations receive grants, but rather a comprehensive coding plan in which all grantees, and all project characteristics, will be assigned a race or ethnic classification."[34] It contains seven basic codes: American

Indian/Alaskan Native; Asian/Pacific Islander; Black, not Hispanic; Hispanic; White, not Hispanic; Multi—racial; and General (where no particular race predominates). The plan also contains principles for applying these codes to individual grantees, organizations receiving grants, and funded projects. It stipulates that coding should reflect the predominant racial characteristics of individual grantees. In the case of organizations, if at least half of an organization's staff, board, or membership belongs to one of the identified racial/ethnic groups, then the corresponding code is to be applied. Finally, for projects, the plan states that the codes should be applied when projects are derived from, or are reflective of, the traditions, values, or cultures of particular races.

Implementation of this plan, NASAA acknowledges, will be complicated for individual state arts agencies by "various state laws, perceptions that the information will be misused, and legitimate privacy concerns."[35] In response to the differing situations of individual states, NASAA therefore offers four options for states to collect such information: through application forms, grantees' final reports, grantees' grant approval letters, and race/ethnicity estimations by SAA staff, although the final option is recommended only as a last resort.

But even if these definitions of race/ethnicity and the principles of utilizing these codes were consistently applied, the utility of this kind of data collection for policy mechanism analysis and evaluation is problematic. Notably, NASAA has not addressed the need to gather information on the characteristics of individuals benefiting from actual grants, a data—gathering effort stipulated in the NSAIE and one, on the face of it, that would seem to be important to issues of multiculturalism and arts policy. Yet past efforts to gather such data by state arts agencies are not reassuring. For example, one NASAA study reports on 9,886 SAA grants in which 164 million individuals were reported as benefiting.[36] This figure seems unrealistic in a country of approximately 250 million residents. The study does acknowledge, however, that many of the figures on which these reports were based were at most "best guesses" and, further, that a more reliable means of data collection is required if the "individuals benefiting" figures are to be meaningful. Given these problems, one can imagine the many potential difficulties that SAAs might incur if they were required to provide information on the racial/ethnic characteristics of individuals who benefit from programs of SAA grantees.

A final complication is the fact that while the NEA requires use of the NSAIE by SAAs, the NEA itself utilizes it in limited ways, such as in the application forms and supplementary information sheets of a few discipline programs. Many NEA programs claim that their discipline requires a unique data collection system. The NEA, however, has discussed possible Endowment—wide adoption of the NSAIE for many years. Apparently,

there is no consensus not to utilize it, but the NEA has not yet decided how use of the NSAIE can fit within its overall mission to collect comprehensive baseline data on the arts. Until agreement between the NEA and SAAs on information systems is achieved, utilizing reliable arts data for purposes of systematic policy development on multiculturalism and the arts remains unlikely.

　　　This discussion about the lack of available data sources on the arts and multiculturalism and the problematic nature of existing sources leads to one primary conclusion: that even minimal conditions necessary for the evaluation of the effectiveness of SAA policy mechanisms related to multiculturalism are not present, at least to conduct an evaluation in terms of the tangible results of diverse policy mechanisms. This is not to say that this book will therefore forgo its declared focus on the actions, as opposed to the intentions, of state arts agencies. It does, however, mean that rather than the documented results of SAAs' policies, the focus of the following analysis will be on the actions of SAAs in organizing their funding activities as policy mechanisms—open access to funding, special programs, and distributive pluralism—and how policy agents ultimately rationalize what they do in terms of normative concepts such as art, culture, justice, and artistic value. Further, while ample justification was given above for a normative, interpretive analysis of the actions of public arts agencies, the deficient state of data collection in the arts policy world means that a normative, interpretive analysis is also a matter of necessity.

GOALS, ELIGIBILITY, CRITERIA, AND GUIDELINES
IN GRANT PROGRAMS

　　　As suggested above, the open–access–to–funding policy mechanism is a complex funding system utilized by state arts agencies. Many elements in a funding system function in conflict or in concert as logically and operationally related sets of assumptions, definitions, provisions, and criteria that mutually reinforce each other. A key assumption of this policy mechanism, for example, is that its many elements work together to ensure a fair process of open competition for funds and yield results to the significant benefit of all individuals and groups, including members of multicultural communities. This section and the next will analyze and interpret the following elements of the open–access–to–funding policy mechanism: goals; funding restrictions and eligibility requirements; evaluative criteria; qualifications and compositions of boards, review panels, and staff; nondiscrimination regulations; guidelines and requirements; and special initiatives.

Goals

As Table 4 illustrates, the stated goals of state arts agencies, even when summarized and paraphrased as they are here, are numerous and diverse. Clearly, the goals statements of most SAAs include some degree of emphasis on opportunities in and access to the arts for all citizens, including members of ethnic cultures.

Table 4
Percentages of SAAs Having Goals in Goals Statements
(N = 42 SAAs)

Goal	%
To assist organizations to produce/sponsor quality art	79
To encourage individual artists to create new works	70
To encourage community involvement/participation in the arts	64
To make high-quality arts available/accessible to the public	57
To stimulate study, awareness, and appreciation of the arts	57
To encourage freedom of artistic expression	54
To foster preservation and availability of ethnic and folk arts	45
To enhance public and private support for the arts	42
To preserve the state's cultural heritage	42
To ensure opportunities and access to the arts for special populations	42

While the goals statements of some state arts agencies only implicitly touch on issues of multiculturalism, others are quite explicit. These statements, in turn, differ considerably on several dimensions and reflect diverse value assumptions. As part of the interpretive nature of this study's approach, it is important to try to understand these goals in the terms utilized by SAAs.

The Illinois Arts Council (IAC), in its goals statements, "recognizes the importance of maintaining [the state's] rich heritage and supports the diverse art forms of all ethnic and racial groups within the state."[37] But

in stipulating its funding priorities, the IAC states "that while the social contributions that can be the result of arts experiences [are important], the Council places a greater priority on those programs that emphasize the professional presentation and production of the arts."[38] One could conclude that the IAC is equating the "diverse arts forms of ethnic and racial groups" with the "social contributions of arts experiences" and thus does not consider ethnic arts groups as sufficiently "professional" for funding. It is not clear that the IAC holds this view and acts upon it. But the lack of clarity in these goals statements suggests the possibility that value assumptions about multiculturalism and the arts, if unclarified, can lead to unintended policy actions.

A primary goal of the Georgia Council for the Arts (GCA) is "to make quality arts accessible to the citizens of Georgia, regardless of geographic isolation, race, income, age, handicap, or social barrier."[39] This goal clearly embodies the value of equal opportunity, that no citizen should be subject to overt discrimination in any attempt to gain access to or benefit from GCA's programs to support the arts. This goal does not comprise providing equal benefits for social and cultural groups from GAC programs, only that equal access be provided, a common objective among public arts agencies. But what citizens are to have access to is not clear. The term *quality art* begs a basic issues of aesthetics, namely, whether artistic standards of excellence are relative to specific cultural traditions or apply across cultures. Either of these meanings could be contained in use of the term *quality art*. Thus, the policy goal of "making quality arts accessible" can justify a wide range of incompatible, even contradictory, funding decisions.

Another example of a policy goal that stresses accessibility to the arts can be found in goals statements of the Indiana Arts Commission (IAC). This goal, "to help assure that diversified, high–quality arts are accessible to Indiana citizens, regardless of geographic area, race, religion, income, age, sex, or disability,"[40] extends the Georgia Council for the Arts' list of groups to be free from discrimination in seeking to benefit from state–supported arts programs. More significantly, at least for this discussion, the IAC expands those arts "to be made accessible" to include "diversified, high–quality arts." While not defined, this term could be taken to mean the arts of diverse cultural traditions, including the arts of ethnic cultures. Still, this usage, as with the previous example, leaves open questions about the cultural relativity of artistic standards.

Two other state arts agencies move beyond the goal of making the arts accessible to their citizens to promoting the goal of *participation* in the arts. For example, the Mississippi Arts Commission aims "to stimulate awareness of and participation in the arts by all citizens, including minorities and special constituencies."[41] Similarly, the South Dakota Arts Council states that it strives "to build active cultural participation with all ethnic and

minority groups."[42] But, as with earlier goals statements, these goals are vague about what kind of art citizens are to participate in, as well as the nature of such participation.

A goal of the Arizona Commission on the Arts, to "foster the preservation, promotion and availability of [the state's] diverse ethnic arts,"[43] on the face of it, represents a return to the access to/availability of the arts policy goal discussed earlier. Unlike those above, however, this goal specifies that the kinds of art that are to be made available, presumably to all citizens, include ethnic arts. But it is only the New York State Council on the Arts (NYSCA) that addresses aesthetic issues within the context of an "availability to the arts" policy. The NYSCA states that it is committed "to the development of a cultural environment in which the general public may participate in and appreciate a great variety of artistic events represent-ing different cultures and aesthetics"[44] and "have the opportunity to experience, first-hand, the varied and rich cultures of our people."[45] In making available the arts of diverse cultural traditions to its citizens, NYSCA also seeks to accord "equal respect to the best of all artistic forms and traditions"[46] and "to recognize the integrity of arts experiences of all cultures."[47] Admittedly, this value statement concerning the variability of artistic standards by culture does not address philosophical questions underlying such a position, but it at least recognizes that funding decisions are rooted in value assumptions.

To this point, policy goals rooted in the values of equal opportunity and access, nondiscrimination, and the cultural relativity of artistic value have been explored. But several state arts agencies have goals that constitute a significant shift in the locus of value assumptions. These goals center on the issue of justice. For example, the North Carolina Arts Council (NCAC) seeks "to uphold the principle of cultural equity by encouraging and supporting exemplary forms of artistic expression that reflect and sustain the diverse cultural identities of the people of North Carolina."[48] In setting this goal, the NCAC holds that sustaining the arts of ethnic cultural traditions, and the cultures themselves, is a matter of justice. Building on this view, the NCAC aims "to provide more representative funding for the development and support of organizations and programs which primarily involve people of color."[49] It is thereby held that funding of multicultural arts organizations in a representative manner is necessary to meet the requirements of justice. But in what way this funding is to be "representa-tive" is not specified. In a similar manner, the Michigan Council for the Arts, in setting a goal "to establish funding patterns that ensure equitable resources between diverse cultural traditions,"[50] does not clarify what constitutes "equity" in allocating resources to multicultural arts organizations.

Other state arts agencies, rather than appealing to concepts of equity or representation in setting policy goals rooted in principles of justice,

have established goals that attempt to achieve justness through the redistribution of power and control. For example, the Oregon Arts Commission, as an agency policy, seeks "to include all populations in the Commission's policy making and program development."[51] This goal, presumably, is inclusive of significant decision–making roles for representatives of ethnic cultural communities. A goal of the D.C. Commission on the Arts and Humanities spells this out more specifically—"to increase the involvement of ethnic minorities in the planning and execution of arts activities."[52] But the New Mexico Arts Division (NMAD) extends the idea of a just policy goal beyond increased decision–making power in funding allocations to empowerment. In particular, the NMAD states that it "wants to reach beyond the dissemination of grant monies, offering technical assistance and programs that empower groups to attain their own goals"[53] and to "develop methods and programs for recognition of culturally diverse arts."[54]

This brief outline of those state arts agencies addressing issues of multiculturalism and the value positions underlying those goals reveals considerable diversity. In many ways, examination of these goals presages subsequent analyses of fundamental value disputes that surround the formulation of public policies in the arts. For now, however, additional elements of the open–access–to–funding policy mechanism must be interpreted.

Funding Restrictions and Eligibility Requirements

Most SAAs, in their granting guidelines, list specific activities or projects that they, as public agencies, will not fund. Table 5 does not include all such activities and projects, but it does suggest the relative emphasis of SAAs' funding restrictions.

Table 5
Percentages of SAAs That "Won't Fund" Specific Activities
(N = 42 SAAs)

Activity	%
Capital expenditures/equipment purchases	97
Accumulated deficits	72
Activities for academic credit	61

Table 5 (continued)

Activity	%
Hospitality functions	50
Scholarships	47
Completed activities	42
Out-of-state travel	39
Activities not open to public	36
Replacement funding	28
Travel abroad	22
Tuition assistance	22
Operating expenses	22

Clearly, the activities of multicultural arts organizations are not mentioned anywhere in this list. Restrictions against activities that are not "open to the public" in some cases could apply to arts organizations rooted in ethnic cultural traditions whose programs occur in private settings. But programs targeted to multicultural communities that take place in open public settings would likely not be formally restricted from potential funding.

While the above analysis suggests that support for multicultural arts programs is at least implicit in most SAAs' goals statements and that funding is restricted in only a few cases, further analysis is required to answer the question of the degree of access that multicultural arts organizations have to SAA funds. The next step involves examining SAA funding categories and their eligibility requirements. Such an analysis will help to determine the nature of the grants for which different kinds of organizations are eligible to apply. These organizational types include arts organizations; nonprofit, non–arts organizations that have arts activities as a primary organizational purpose; nonprofit, non–arts organizations; government agencies; colleges/universities; and schools (see Tables 6 through 8).

Table 6
SAA Funding Categories and Rate of Eligibility
of Arts Organizations (N = 40 SAAs)

Funding category	% of SAAs offering eligibility
Project support	100
General operating support	78
Touring grants	53
Artists–in–residence	45
Major institution support	40
Community arts	38
Challenge grants	30
Arts presenters grants	30
Technical assistance support	28
Folk/traditional arts support	18
Salary assistance	13

There are 30 additional grants categories through which 10% or less of the SAAs make funds available to arts organizations.

Table 7
SAA Funding Categories and Rate of Eligibility of Nonprofit,
Non-Arts Organizations with Arts as a Primary Purpose
(N = 40 SAAs)

Funding category	% of SAAs offering eligibility
Project support	83
Artists–in–residence	75
Touring grants	43

Table 7 (continued)

Funding category	% of SAAs offering eligibility
General operating support	40
Community arts	28
Minigrants	25
Arts presenters grants	20
Technical assistance support	20
Folk/traditional arts support	12
Salary assistance	8

There are 24 additional grants categories through which 5% or less of the SAAs make funds available to non-profit, non-arts organizations that have the arts as a primary purpose.

Table 8
SAA Funding Categories and Rate of Eligibility of Nonprofit, Non-Arts Organizations (N = 40 SAAs)

Funding category	% of SAAs offering eligibility
Project support	68
Artists–in–residence	63
Touring grants	38
Community arts	25
General operating support	25
Minigrants	23
Arts presenters grants	20

Table 8 (continued)

Funding category	% of SAAs offering eligibility
Folk/traditional arts support	20
Challenge grants	10

There are 19 additional grants categories through which 5% or less of the SAAs make funds available to nonprofit, non-arts organizations.

A few SAAs have charts that detail their grants categories and the different types of organizations that are eligible for funds under each category, but this is rare. This lack of specificity presents difficulties in assessing the eligibility of government agencies, local arts agencies, colleges and universities, and schools to SAA funds. How, then, does one answer questions of the degree of access multicultural arts programs have to SAA funds? An answer is contingent, to a significant degree, on the answer to another question, namely, What is the organizational status of multicultural arts programs? Specifically, what percentage of these programs can be found in arts organizations; non–arts organizations that have arts activities as a primary organizational purpose; nonprofit, non–arts organizations; government agencies; colleges/universities; and schools?

A recent survey by the National Assembly of State Arts Agencies might have provided a picture of the status of organizations primarily serving African–American, Hispanic, Asian, and Native American populations.[55] To be included in this survey, 51% or more of an organization's board of directors or its audiences had to be composed of these population groups. The survey yielded responses from 103 Native American organizations, 132 Hispanic organizations, 244 African–American organizations, and 111 Asian organizations. While the survey results included information on the kinds of programs and services each organization provides, information on budgets, years of existence, and significantly, their organizational status, was not.

In lieu of such information, reliance on anecdote and observation is necessitated. Gerald Yoshitomi, for example, contends that "each of America's cultural and ethnic communities has persevered to maintain its own cultural traditions, often attempting to counteract the actions of the government or other public systems."[56] Accordingly, these communities "have established their own internal structures without public assistance to

support cultural preservation through churches, social centers, and fraternal organizations."[57] Rooted in these informal structures, Yoshitomi contends that social service, educational, religious, and fraternal groups, in the past two decades, have "developed arts projects as central elements in their cultural, community, and political mission."[58]

Of course, many organizations have evolved from ethnic communities that fit the predominant model of an arts institution as a nonprofit organization, with the requisite board of directors, paid staff, and market orientation. As such, they would seem to have the same access to funds as any other arts organization, at least in terms of formal eligibility requirements. But if the portrayal by Yoshitomi is accurate, then many ethnic arts programs are found in nonprofit, non–arts organizations. Based on Tables 6 through 8, which outlined different organizational types' access to state arts agency funding, it appears therefore that many multicultural organizations are eligible in SAAs' funding categories at considerably lower rates than nonprofit arts organizations. Of particular note, programs in non–arts organizations have far less access to general operating support and challenge grants, as well as other categories, and have virtually no access at all to major institution support, technical assistance support, or salary assistance.

Another issue is the types of SAA grants categories in which nonprofit, non–arts organizations are eligible. The two most frequently cited categories available to such organizations are project grants and artists–in–residence. Project grants tend to be short term, with relatively small dollar amounts, unlike the general operating support grants that are available primarily to arts organizations based in community or university settings. Project grants also are often the most competitive because, as this analysis shows, all types of organizations, including arts organizations, compete for funds in this category. Likewise, in most cases, nonprofit, non–arts organizations must compete with schools for artist–in–residency grants, a difficult task given the number of schools as well as SAAs' increased emphasis on K–12 arts education.[59]

In conclusion, then, it would seem that many multicultural arts programs, given the nature of the organizations in which they take place, do not have equal access to funding. This is not an evaluative conclusion; it only points out that the claim of proponents of the open–access–to–funding model that all can and will benefit from this policy mechanism must be qualified. Nor does it prejudge SAAs' apparent stress on rewarding programs under the umbrella of a nonprofit arts organization. An overall assessment of this policy mechanism must await examination of additional elements, including evaluative criteria.

Evaluative Criteria

Evaluative criteria are published normative standards by which designated decision–making panels and boards are required to make judgments about the relative merit of potential grantees for SAA funds. It seems logical that these criteria would be measures of how grantees meet the stated goals of individual agencies. Such a relationship between goals and criteria can be found in many cases, though by no means all. In either case, these criteria embody numerous value assumptions, either explicitly or implicitly.

First, evaluative criteria can be examined in light of the grants categories for which nonprofit, non–arts organizations, sponsors of many ethnic arts programs, are most frequently eligible—project grants and artist–in–residence categories. As shown in Table 9, criteria used to evaluate applicants in the project grants category such as "involvement of or outreach to special populations" appear in SAAs' lists of evaluative criteria less often than criteria such as "artistic quality" and "organizational management capacity." Additional criteria such as "community outreach" and "size and composition of audience," which appear with 25% frequency in SAA lists of evaluative criteria, could, however, be interpreted as potentially benefiting ethnic arts programs in nonprofit, non–arts organizations.

In most cases, SAAs do not seem to designate special evaluative criteria for different grant categories. In such cases, the criteria utilized in the project grants category, including planning, management, and implementation criteria, tend to apply to other categories as well. Special evaluative criteria for community arts grants and touring programs, categories that are often open to nonprofit, non–arts organizations, are found in very few cases. Those SAAs that do utilize special criteria for such programs seem to stress "involving and serving underserved population sectors" at least as often as other criteria.

Table 9
Project Grants Evaluative Criteria and Percentage of SAAs Utilizing Specific Criteria (N = 40 SAAs)

Evaluative criteria	%
Artistic quality	100
Organizational capacity/management skill	72

Table 9 (continued)

Evaluative criteria	%
Management capacity to complete project	72
Community financial support for project	62
Involvement of/outreach to special populations	58
Need, unavailability of other service providers	54
Employment of professional artists	40
Contribution to artistic development in state	32
Financial need	29
Professional strength of organization	25
Number of audiences served	25
Size and composition of audience	25

As cited above, the general operating support categories tend to be more open to arts organizations, and the major institution support categories are often open exclusively to large arts organizations. Since arts organizations could provide programs and services that benefit ethnic cultural communities, the special evaluative criteria used in these categories are of interest. Unfortunately, very few SAAs specify special evaluative criteria in these grants categories. Of the eight SAAs that do so in the general operating support category, "artistic quality" and "management capacity" appear most frequently. The "outreach to a broad population cross–section" criterion appears with some frequency, and two SAAs require grantees to provide outreach or public service activities as part of their grants in this category. In the case of major institutional support, evaluative criteria such as "broad audience demographics" and "outreach" appear approximately as frequently as criteria such as "professionalism" and "history of artistic excellence." Only four SAAs, however, seemed to utilize special evaluative criteria in this category.

In analyzing the evaluative criteria utilized by SAAs in a variety of grants categories, it would seem overall that criteria such as "outreach

to/involvement of special/underserved audiences" and "community outreach" are employed almost as frequently as "artistic quality" and "effective management" criteria. Yet while several SAAs do require their applicants to describe, in narrative form, their outreach efforts intended to benefit "special populations," few SAAs require applicants to detail the characteristics of audiences to be served by their grants. With such limited information required of applicants, it is difficult to imagine how evaluative criteria such as "outreach" and "community involvement" could be applied in an informed and specific manner. (The matter of information asked for in grant applications is discussed in greater detail below.)

In addition to examining evaluative criteria in light of eligibility requirements for grants categories, another approach to understanding the evaluative criteria SAAs utilize is to interpret the value positions those criteria embody. As in the analysis of SAAs' goals statements, this interpretation will reveal considerable diversity in the use of value–laden concepts regarding multiculturalism and the arts.

As an illustration of this diversity, the Maine Arts Commission's criteria for grant application review contain no standards that directly address multicultural concerns. They stress, instead, artistic quality, financial and organizational management, ability to raise private income, community involvement, and ability to serve areas with limited access to the arts and special constituencies (not including ethnic cultural communities).[60] The "community involvement" criterion could be construed as applying to multiculturalism, but that is not at all clear.

The Vermont Council on the Arts' specific evaluative criteria for reviewing grants applicants are only slightly more clear than those of Maine's regarding multiculturalism. One criterion pertains to accessibility and outreach, calling for the "accessibility of program materials and facilities used for presenting, and outreach to new and underserved audiences."[61] This criterion contains the concept of "underserved audiences," which can variously entail value assumptions about a "right" to participation in the arts or that for a policy to be just it must equally benefit all citizens. Apart from these thorny questions, it is not apparent that "new and underserved audiences" applies to ethnic cultural communities. A criterion of the Kansas Arts Commission, "evidence that the project/program/organization is serving the needs of traditionally under–served populations (e.g. racial minorities),"[62] is clearly more specific on who is to be considered underserved. But, as with the previous example, the concept of underserved leaves unresolved basic value questions.

The Kansas Arts Commission criterion is phrased in terms of the "needs" of underserved populations. Similarly, the Nebraska Arts Council aims to reward programs that "address the needs of ethnic minorities."[63] In neither of these cases, however, is it made clear how the needs of ethnic

minorities are identified and defined or, more basically, how needs are to be distinguished from preferences, wishes, expectations, or aspirations.

Moving beyond criteria that rely on concepts of underserved populations and needs, other state arts agencies, consistent with goals statements discussed above, stress the involvement of representatives of ethnic cultural communities in planning activities. For example, the Alabama State Council on the Arts evaluates project grant applicants on the "degree to which the project would involve/benefit minorities."[64] In a similar way, the Tennessee Arts Commission seeks evidence of "involvement by...minority groups."[65]

Some state arts agencies spell out an "involvement in planning" criterion in greater detail. Notably, the State Arts Council of Oklahoma, phrasing the criterion in question form, asks, "Does the applicant organization include representation of diverse cultural, ethnic and artistic plurality of its community in the planning, execution and evaluation of its programs and services?"[66] Also, one of the review criteria utilized by the Arkansas Arts Council is as follows: "minority involvement in the applicant's organizational structure, service areas and all aspects, levels and phases of the proposed project or program."[67] Even with this greater detail, these evaluative criteria dealing with involvement or participation in the arts, as with goals statements, are somewhat vague about the nature of participation sought, especially when participation is paired with the concept of representation.

Finally, two state arts agencies have criteria that suggest that the nature of participation by ethnic cultural communities should be a matter of civil rights or affirmative action. The Massachusetts Cultural Council uses some criteria that mirror criteria used elsewhere, such as "diverse community involvement," responsiveness to the "needs of a community," "willingness to collaborate with other cultural and community groups," and "evidence of accessibility to a broad audience." But it also seeks "evidence of affirmative action practices."[68] Further, the D.C. Commission on the Arts and Humanities requires applicants to prepare an annual Civil and Human Rights Compliance Report. Then, in evaluating applicants, the agency conducts comparative analyses to assess applicants' progress in complying with civil and human rights directives "to strengthen and expand minority participation in the arts at all levels."[69] Yet even these criteria beg questions about possible meanings of concepts of rights and affirmative action and, therefore, about the concept of justice and a just policy. In–depth analysis of these and other value–laden concepts will be saved for subsequent chapters.

For now, the evaluative criterion of "artistic quality," as used by SAAs, bears some scrutiny. Table 9 demonstrates that "artistic quality," or in some cases "artistic excellence" or "artistic merit," is used as a criterion by all state arts agencies in evaluating applicants for project grants. The same

is true for other grants categories. But, as was found in the examination of SAAs' goals statements, the term *artistic quality*," if left unclarified, could lead to an array of unintended assessments. This is so because "artistic quality," by itself, can mean either that artistic standards of excellence are relative to specific cultural traditions or apply across cultures.

Most state arts agencies leave interpretations of the term *artistic quality* quite open. Some, however, have attempted to clarify it. For example, in defining the "quality" criterion, the Georgia Council for the Arts includes both absolute and relative standards. Absolute standards refer to "quality measured by generally accepted standards of excellence"; relative standards refer to "quality measured on a relative scale, taking into account any special factors such as size and location of community, special nature of organization, etc."[70] The way in which these standards relate to the arts of ethnic cultural traditions, however, is not made clear. A similar vagueness applies to the Missouri Arts Council's policy statement that it recognizes no single standard of quality and that "artistic quality is situational."[71] Finally, the Ohio Arts Council encourages its grants panelists to consider the "artistic quality of the work or project and its aesthetic or cultural impact on its audience."[72] This could be read to mean not only that aesthetic standards are diverse but that their differences are a matter of the consequences they have for cultures. In any case, the views of artistic value that these criteria embody will be examined in far greater depth in a subsequent chapter.

This review of individual evaluative criteria geared to multicultural issues—criteria phrased in terms of accessibility, participation, needs of underserved populations, involvement in planning, representation, civil rights, affirmative action, and diverse sources of artistic quality—revealed a number of value assumptions, many of them unclarified. But clarified or not, it must be remembered that state arts agencies use multiple criteria in making decisions about grant applicants. Thus, an important issue associated with SAAs' grant evaluation criteria is the relative weight that the criteria are given during decision–making processes.

Many SAAs simply list the evaluative criteria utilized in their public documents, such as program guides. But some examples of weighted evaluative criteria can be found among those SAAs examined above who purport to address issues of multiculturalism. The Kansas Arts Commission evaluates applicants in terms of evidence that they have been serving, or will serve, the needs of traditionally underserved populations, including, but not limited to, racial minorities. But this criterion is but 1 of a list of 12 criteria. Similarly, the Alabama State Council on the Arts' criterion cited earlier, the "degree to which the project would involve/benefit minorities," is 1 out of 14 criteria utilized. Finally, the GCA rates applicants on the accessibility of their programs for special populations, that is, minorities and handicapped

individuals. The GCA seeks "documentation of their involvement in planning, developing, presenting, and attending programming."[73] But out of 150 possible rating points, the highest possible rating on this criterion is 5.

While they are relatively few in number, these examples suggest that evaluative criteria that stress potential involvement of, and service to, ethnic cultural communities can easily get lost in the evaluation of grant applications. Still, the evaluation of grant applications according to established criteria is just one part, albeit an important part, of grant decision–making processes in SAAs. While some have criticized these processes as unwieldly, providing little time for decision makers to review carefully a large number of grant applications,[74] many SAAs make provisions for extensive on–site evaluations of potential grantees. It is not clear, however, whether consideration of the provision of opportunities for ethnic cultural communities, among others, receives greater attention in the on–site evaluation process.

Terms of Grants

As another element of the open–access–to–funding policy mechanism, terms of grants constitute the requirements that SAA grantees must fulfill throughout the course of a granting period. Some SAAs require grantees in general operating support categories to provide outreach or public service activities as part of their grants. Also, as noted above, the D.C. Commission on the Arts and Humanities requires all potential grantees to submit a Civil and Human Rights Compliance Report. Further, while rarely required to prepare such reports, applicants to virtually all SAAs are required to pledge their compliance with federal and state nondiscrimination laws and regulations. The language on nondiscrimination available from 37 SAAs was examined for this study. Thirty–seven SAAs stipulated that all grantees must comply with Title VI of the Civil Rights Act of 1964, barring discrimination on the basis of race, color, or national origin; Title IX of Education Amendments of 1972, regarding discrimination on the basis of sex; and Section 504 of the Rehabilitation Act of 1973 barring discrimination against physically handicapped individuals. Finally, 14 required grantee compliance with the Age Discrimination Act of 1975, barring discrimination on the basis of age. These statutes stipulate that no member of the above groups, solely by the reason of membership in such a group, should be excluded from participation in, denied the benefits of, or subjected to discrimination in any program or activity receiving federal assistance. Clearly, racial minorities are as well protected from discrimination, at least in a legal sense, as other groups.

Such examples notwithstanding, the terms of grants of most SAAs are financial and procedural in nature. For example, in an effort to minimize grantees' dependence on public arts funds, SAAs require at least a 1 to 1 match for almost all grants, although they differ on the extent to which such a match must be made with cash or is possible through in–kind services. Also, most SAAs require all grantees to issue a final report on their grants activities. These examples, however, reinforce the point that SAAs utilize terms–of–grants requirements in relatively limited ways, in particular, as they might be used to address multicultural concerns.

DECISION MAKERS IN GRANT PROGRAMS

Evaluative criteria, whether specified or not, of necessity are interpreted and applied by individuals with diverse personal assumptions, values, and biases. Some have suggested that these individuals constitute "good–old–boy" networks that are overbalanced in terms of particular aesthetic ideologies,[75] although such charges have rarely been documented in any systematic way.

SAA funding decisions are made primarily by groups of private citizens who constitute grants panels and boards. SAA grants panels are usually many in number and are arranged by arts disciplines. They review SAA grant applications, rate them according to evaluative criteria, and often make recommendations on funding levels. SAA boards are responsible for SAA policy development and generally make all final decisions in awarding grants and the amounts of such grants.

These roles of SAA boards and panels are of interest in interpreting the open–access–to–funding model as it relates to arts programs of ethnic cultural communities. An assumption could be made that if members of ethnic groups are present on SAA boards and panels, they may increase SAAs' sensitivity to the needs of such groups in having access to the arts. This assumption can be challenged. Many ethnic group members would likely resist being thought of in this way. Specifically, those who might serve on SAA boards and panels could have greater allegiance to specific arts disciplines than to the specific cultural traditions. The possibility of increased sensitivity by ethnic group members to ethnic cultural traditions seems sufficient, however, to inquire into the roles of ethnic group members in the decision–making bodies of SAAs.

The criteria for the selection of SAAs' board members and panelists are also of interest. Of the 35 SAAs that provided information on their selection criteria for board members, 23 merely stipulate that potential members must be private citizens, 16 mention professional expertise and/or longtime interest in the arts, and 15 stipulate private citizen status or

participation in the state legislature. Of those SAAs that have multiple criteria, 17 mention geographic representation, while 11 mention cultural/ethnic representation as a criterion for the selection of board members.

Of the 38 SAAs that have guidelines for the selection of grants review panelists, 27 stress "specialized knowledge of and/or professional experience in the arts." A number of SAAs stress multiple criteria, including 20 that stress "geographic representation" and another 18 that mention "ethnic diversity."

Criteria utilized in the selection of SAAs' grants review panelists bear closer examination for two reasons—first, because, while never documented, it is widely believed that the boards of public arts agencies, or whoever has final grants decisions, follow the recommendations of grants review panels in the large majority of cases, and second, because panelist selection criteria embody diverse value assumptions. Special attention will be paid to those criteria that explicitly touch on issues of multiculturalism and the arts.

The Nevada State Council on the Arts states that its board members and panelists are "chosen for their knowledge of and experience in the arts."[76] The Florida Arts Council adds numerous other criteria to their panelist selection process, giving "consideration to professional acumen, geographical representation and minority representation [as well as] diverse aesthetic, institutional, and cultural viewpoints."[77] How "consideration" of these criteria can and does affect the makeup of panels is not clear.

Two state arts agencies, rather than publishing criteria for potential panelists, list those characteristics that their panel members exhibit. For example, the North Carolina Arts Council says that its board and panels include "citizens recognized for their accomplishments in the arts...[as well as] members from urban and rural areas...and from diverse racial, economic, and cultural backgrounds."[78] Also, the Massachusetts Cultural Council claims that its grant advisory panels "represent diverse geographic, ethnic, philosophical, and aesthetic perspectives."[79]

Rather than listing criteria or stating claims about the makeup of its panels, other SAAs pair their panel member selection criteria with principles or ideals for the composition of panels. The Virginia Commission for the Arts, for example, in addition to seeking panelists with expertise in the arts, "attempts to balance each panel with knowledge of the different arts disciplines and diverse cultural perspectives."[80] In a similar manner, the Nebraska Arts Council (NAC) states that its "panelists are selected to represent a balance of geographic, artistic and ethnic interests."[81] Interestingly, while the NAC, as with the Virginia Commission for the Arts, seeks to uphold a principle of balance in composing its panels, it is a balance not of experiences, expertise, or viewpoints but of interests. But in both cases, the principle of balance is left undefined and open to diverse interpretations.

The Michigan Council for the Arts invokes two different principles of panelist selection. One is "inclusion," namely, that "every effort is made to include African–American, Asian, Hispanic, and Native American advisors and consultants as program panel members";[82] the other is that panels are to be reflective of the cultural and ethnic diversity of the state. But whether such reflection is to be strictly proportional, reflecting the distribution of ethnic populations in the state on a percentage basis, is not clear.

Two final examples warrant scrutiny. The California Arts Council, rather than merely seeking or making a strong effort to place ethnic group members on grant review panels, has a policy on panels, one with an explicit conditional imperative. This policy "requires each panel to reflect artistic knowledge, geographic spread, and multi–cultural representation."[83] This policy notwithstanding, the concept of "reflection," as with the previous example, remains vague. Finally, the Texas Commission on the Arts (TCA) moves beyond concepts of representation of ethnic groups or reflection of cultural diversity to require of all panel members that they have personal knowledge of the arts of ethnic cultures. In its own words, the TCA's policy holds that "a panel member's knowledge must relate not only to a given discipline or field but to the diversity and cultural, ethnic, aesthetic and artistic plurality of the arts in Texas."[84]

The attention in this section on the diverse criteria used by state arts agencies to select grant review panelists, and in some cases board members, reflects the fact that SAA panels and boards have the ultimate responsibility for selecting SAA grantees and awarding funds. But two other types of participants in this process—citizens and state arts agency staff—merit attention.

As part of the guidelines for the NEA's grants to SAAs, SAAs are required to maximize the number of statewide or regional planning meetings designed to elicit needs statements and policy input from individual citizens and citizen groups. These meetings are open to the public and function as forums for exchanges of diverse points of view. While information on the characteristics of participants in these open meetings is not available, public documents of SAAs revealed that nearly half make special efforts to inform and even recruit special constituencies, including ethnic group members, for participation in their planning meetings.

It is often thought that public arts agencies' staff members can be very influential in grants decision–making processes. This influence, it is said, can be exerted at various stages of these processes—in formulating grant categories, in screening grant proposals, and by providing technical assistance to potential grantees. Also, as will be seen in the next section, some SAAs have special multicultural programs having their own staff.

To this point, the selection criteria of SAA boards and panels and the roles of panels, boards, staff, and citizens in grant–making processes have been examined. A final task in this section is to examine at least some of the characteristics of SAA panelists, board members, and staff.

Data on the ethnic characteristics of SAA panelists, board members, and staff were generated as part of a survey of SAAs' policies and operations conducted by NASAA during late 1990 and early 1991. The raw survey results were tabulated by this researcher.[85]

Tables 10 through 12 contain tabulations of data based on two questions in the NASAA survey. One asked respondents to segment their board, panel members, and staff according to race/ethnicity. The primary race/ethnicity categories included Native American/Alaskan Native, Asian/Pacific Islander, black, white, or Hispanic. The other question asked respondents for the total numbers of board members, panelists, and staff associated with their agency. It was found that the size of boards ranged from 9 to 23, with a mean and median of 15; that the number of panelists ranged from 9 to 326, with a mean of 85 and median of 74; and that staff size ranged from 6 to 94, with a mean of 21 and median of 16. But it was the responses of individual state arts agencies to these two questions that were then correlated to arrive at figures reflecting the percentage of each SAA's board members, panelists, and staff members that are Native American, Asian, African–American, Hispanic, or white. Thus, Tables 10 through 12 are tabulations of those percentages. (For example, Table 10 shows that in the case of four SAAs, 11% of their board members are African–American.)

Table 10
SAA Boards: Percentages of Ethnic Group Members
on SAA Boards (N = 48 SAAs)

%	Native American	Asian	African-American	Hispanic	White
0%	42	39	15	39	1
3%	-	1	-	1	-
5%	-	3	-	1	-
6%	-	-	1	3	-
7%	4	2	8	-	-
8%	1	-	1	-	-
9%	1	2	1	1	-
10%	-	-	1	1	-
11%	-	1	4	1	-

Table 10 (continued)

%	Native American	Asian	African-American	Hispanic	White
12%	-	-	1	-	-
13%	-	-	6	1	-
15%	-	-	1	-	-
17%	-	-	2	-	-
18%	-	-	1	-	-
19%	-	-	1	-	-
22%	-	-	1	-	-
23%	-	-	1	-	-
27%	-	-	1	-	-
28%	-	-	-	-	1
30%	-	-	1	-	-
61%	-	-	1	-	-
69%	-	-	-	-	1
70%	-	-	-	-	1
73%	-	-	-	-	2
75%	-	-	-	-	1
78%	-	-	-	-	2
81%	-	-	-	-	2
83%	-	-	-	-	2
84%	-	-	-	-	1
85%	-	-	-	-	1
86%	-	-	-	-	1
87%	-	-	-	-	5
88%	-	-	-	-	2
89%	-	-	-	-	3
91%	-	-	-	-	3
92%	-	-	-	-	2
93%	-	-	-	-	8
95%	-	-	-	-	3
100%	-	-	-	-	6

Table 11
SAA Panels: Percentages of Ethnic Group Members
on SAA Panels (N=48 SAAs)

%	Native American	Asian	African-American	Hispanic	White
0%	21	16	9	16	-
1%	9	5	2	4	-
2%	8	9	2	7	-

Table 11 (continued)

%	Native American	Asian	African-American	Hispanic	White
3%	3	6	2	3	-
4%	-	3	2	4	-
5%	1	3	2	4	-
6%	-	3	-	4	-
7%	-	-	1	-	-
8%	1	2	3	2	-
9%	-	-	1	-	-
10%	-	-	1	-	-
11%	-	-	-	-	-
12%	-	-	2	-	-
13%	1	-	2	1	-
14%	4	-	-	1	-
15%	-	-	2	-	-
17%	-	-	3	-	-
18%	-	-	1	-	-
20%	-	-	2	-	-
21%	-	-	2	1	-
22%	-	1	2	-	-
23%	-	-	2	-	-
24%	-	-	1	-	-
25%	-	-	2	-	-
27%	-	-	-	1	-
39%	-	-	1	-	-
43%	-	-	-	-	1
52%	-	-	1	-	-
56%	-	-	-	-	1
59%	-	-	-	-	1
60%	-	-	-	-	1
61%	-	-	-	-	1
65%	-	-	-	-	1
66%	-	-	-	-	1
68%	-	-	-	-	3
69%	-	-	-	-	1
70%	-	-	-	-	2
71%	-	-	-	-	2
72%	-	-	-	-	1
73%	-	-	-	-	4
74%	-	-	-	-	1
76%	-	-	-	-	2
78%	-	-	-	-	1
79%	-	-	-	-	2
80%	-	-	-	-	1
81%	-	-	-	-	1
82%	-	-	-	-	1
83%	-	-	-	-	3

Table 11 (continued)

%	Native American	Asian	African-American	Hispanic	White
85%	-	-	-	-	1
86%	-	-	-	-	2
87%	-	-	-	-	2
89%	-	-	-	-	1
90%	-	-	-	-	1
93%	-	-	-	-	1
94%	-	-	-	-	1
96%	-	-	-	-	3
97%	-	-	-	-	1
98%	-	-	-	-	1
99%	-	-	-	-	1
100%	-	-	-	-	1

Table 12
SAA Staff: Percentages of Ethnic Group Members
on SAA Staff (N=48 SAAs)

%	Native American	Asian	African-American	Hispanic	White
0%	43	37	21	35	-
2%	1	2	-	-	-
3%	-	1	-	-	-
4%	-	1	3	1	-
5%	-	3	-	-	-
6%	1	-	1	3	-
7%	1	-	-	1	-
8%	-	-	1	1	1
9%	-	-	-	1	-
10%	-	1	2	-	-
11%	-	-	2	1	-
12%	-	-	2	2	-
13%	-	1	-	-	-
14%	-	1	-	-	-
15%	-	-	1	1	-
16%	-	-	1	-	-
17%	-	-	1	-	-
18%	-	-	1	-	-
19%	1	-	-	-	-
20%	1	-	1	-	-

Table 12 (continued)

%	Native American	Asian	African-American	Hispanic	White
25%	-	-	3	1	1
27%	-	-	1	-	-
29%	-	-	1	-	-
30%	-	-	1	-	-
31%	-	-	1	-	-
33%	-	-	2	-	-
35%	-	-	-	1	-
37%	-	-	1	-	-
44%	-	-	1	-	1
47%	-	-	-	-	1
52%	-	-	-	-	1
67%	-	-	-	-	4
68%	-	-	-	-	1
69%	-	-	-	-	3
70%	-	1	-	-	1
71%	-	-	-	-	1
73%	-	-	-	-	1
75%	-	-	-	-	3
76%	-	-	-	-	1
77%	-	-	-	-	1
80%	-	-	-	-	1
82%	-	-	-	-	1
83%	-	-	-	-	2
85%	-	-	-	-	2
87%	-	-	-	-	1
89%	-	-	-	-	1
90%	-	-	-	-	2
93%	-	-	-	-	1
94%	-	-	-	-	1
95%	-	-	-	-	1
96%	-	-	-	-	2
100%	-	-	-	-	12

Table 10 reveals that the presence of Native American, Asians, and Hispanics on the boards of state arts agencies is a relative rarity. In the case of African–Americans, the picture is somewhat different, in that 22 of 48 SAAs have African–Americans on their boards at a rate equal to or higher than 10% including 1 at 61%. Still, except in very rare cases, the large majority of SAAs have boards whose membership is predominantly white.

The race/ethnicity breakdown for panelists, as Table 11 shows, is somewhat different. Notably, in far fewer instances than with boards are there SAAs with no Native American, Asians, or Hispanics serving on panels. Indeed, the level of these groups' participation on panels surpasses 12% in a number of cases. On the other hand, the participation rates hover below 10% with the large majority of SAAs. African–Americans also serve on panels at higher rates than they do on boards. In 23 SAAs, African–Americans make up more than 10% of the panelists, reaching highs, in two instances, of 39% and 52%. However, these data can also be read in a different way, namely, that in 25 out of 48 state arts agencies, African–Americans make up 10% or less of the pool of panelists. Given the somewhat higher participation of ethnic minorities on panels, the proportional dominance of whites is accordingly less on panels than it is with boards. Still, whites make up 80% or more of the panelists in 23 out of 48 SAAs.

The percentage rates of ethnic minorities serving as SAA staff members lies between the rates found in boards and panels. With a few exceptions, the majority of SAAs have no Native American, Asian, or Hispanic staff members, while 21 have no African–American staff members. Further, in 19 of 48 SAAs, 90% or more of their staff members are white.

Another measure of interest revealed by the NASAA survey is the number of staff in state arts agencies whose responsibilities include "minority–ethnic arts." Twenty–one percent of the SAAs have no staff with these responsibilities, 69% have one such staff member, and 10% of the SAAs commit two staff to minority–ethnic arts.

What, then, can be made of these data? Simply put, an answer depends on the questions one asks. There are two questions that will not be addressed at the interpretive phase of this study. First, one could ask whether the participation rates of ethnic group members on SAAs' boards, panels, and staffs are sufficient to uphold a principle of balance, adequately reflect the cultural diversity of American society, or distribute responsibility and decision–making power in a just manner. Whether it is possible to answer such a question is a matter for the subsequent chapter. Another question that, for now, will be deferred goes to a central assumption behind the above analysis of racial/ethnic characteristics of SAA board members, panelists, and staff, namely, that the presence of ethnic group members on agency decision–making bodies will increase agency sensitivity to the arts of ethnic cultural traditions. This assumption, however, is rooted in the further assumption, to be examined below, that an individual's racial/ethnic characteristics are a good predictor of the individual's knowledge of, experience in, and sensitivity to a culturally specific arts tradition. An analysis of this assumption will be key to interpreting the significance of the percentages of members of ethnic groups in SAAs' decision–making bodies.

For now, however, one question of interest is what these data say about many SAAs' stated intentions to seek increased representation of ethnic group members on boards and panels. An interesting feature of these data is that ethnic group members apparently tend to participate in SAAs' grants decision–making processes as panelists at higher rates than they do as board members. If it is true, as previously hypothesized, that the boards of SAAs follow the recommendations of panelists in the large majority of cases, then the proportionally greater presence of ethnic group members on panels might mean that African–Americans, Asians, Hispanics, and Native Americans have a considerable influence on many SAAs' grant–making decisions. But even if the hypothesis about the de facto power of panels is accurate, the fact remains that the boards of most SAAs retain the formal power to make all final grants decisions, including grant amounts, as well as the formal power to oversee policy development. Thus, what ethnic groups appear to gain in effective influence they lose in formal control.

This difference between ethnic group participation on SAA boards and on panels can be traced, in part, to different selection processes. Board members are almost invariably, by law, appointed to designated terms by a state's governor; panelists are most often chosen by boards on the recommendations of SAAs' staff and current or past panelists. While never documented, conventional wisdom is that SAA boards, as with grants decisions, tend to follow the lead of others, in this case SAA staffs, in appointing panelists. If this is so, one can conclude that SAAs' staffs have been more effective in achieving ethnic group participation in panels than governors have been in appointing ethnic group members to SAA boards. The underlying reasons for these differences are likely matters of the politics of state governorships, a topic that would require speculation at this point or another study in the future.

The attention in this section on the selection criteria for, and characteristics of, SAA board members and panelists was a necessary step toward understanding how grants decisions are made in an open–access–to–funding policy mechanism. But such an understanding, preliminary or otherwise, does not fully answer a final basic question—on what information do decision makers base their grants decisions? Some factors in grants decisions have been noted already, factors such as the experiences, biases, and perspectives panelists and board members bring to such decisions and the formal, published evaluative criteria they must apply in making decisions. But they must apply these criteria *to* something. In doing so, panelists and board members rely primarily, though not exclusively, on information contained in potential grantees' application forms. The kinds of information applicants are asked to supply by different SAAs bears examination.

Grant application forms for virtually all public arts agencies share a number of features in common. Organizational applicants, in particular, are asked to provide narrative and numerical information on their mission and goals; annual budgets; board and administrative personnel; project goals and budget; plans and time lines for implementation, documentation, and evaluation; anticipated beneficiaries; additional sources of income; and funding history. Of course the information requested can vary both by agency and by grant category and can include documentation of artists' work such as slides, audiotapes, or videotapes. But the above list does cover the most common, basic requirements.

These informational requirements for applicants seeking public arts funding are, in the view of some, biased toward established nonprofit organizations who have the professional staff time, expertise, and resources needed to complete lengthy application forms. As such, it is argued, smaller organizations, including those rooted in ethnic cultural communities, are at a considerable disadvantage.[86] In any case, of greater interest here are those specific requests for information in SAAs' application forms that might yield panelists and board members a greater understanding of organizations seeking grant funds. Some examples with particular implications for issues of multiculturalism follow.

The Illinois Arts Council, as a matter of policy, does not ask its applicants to provide information on the racial/ethnic characteristics of their boards, staffs, or audiences, in that "many groups and individuals do not feel comfortable being required to provide that information."[87] In contrast, the Nevada State Council on the Arts (NSCA) does ask organizational applicants to indicate the number and percentage of minorities (Asian, black, Hispanic, Native American) on their boards and staffs. The NSCA also states, however, that "this information is for statistical purposes only."[88] The Wyoming Arts Council does not, either as a requirement or for statistical purposes, ask applicants for race/ethnicity statistical information. But it does require applicants to address, in narrative form, this question: "What accommodations do you have to meet the needs of...special populations,"[89] including minorities?

The examples from these three states exemplify basic dimensions of approaches used by SAAs toward race/ethnicity information—not asking for it, asking for it or requiring it, and asking for it in statistical terms or in narrative form. Several other SAAs combine elements of these approaches in various ways. For example, the Georgia Council for the Arts requires applicants to provide statistical information on the race/ethnicity characteristics of applicant organizations and their staffs, board members, volunteers, and audiences; to this list, the Ohio Arts Council adds race/ethnicity information on applicant organizations' participating artists as a requirement. The North Dakota Council on the Arts (NDCA) and the Oregon Arts

Commission (OAC) have similar informational requirements; but both ask for narrative information as well. Specifically, the NDCA asks of applicants, "What efforts will you make to address the needs of the non–dominant culture of your community, including minorities [and] underserved audiences?"[90] The OAC requires applicants to describe "efforts to include and serve underrepresented communities, that is, ethnic minorities,"[91] among others.

Clearly, these two examples of application information requirements entail value assumptions as evidenced by use of terms such as *needs, nondominant culture, underserved,* and *underrepresented.* The New York State Council on the Arts (NYSCA), on the other hand, actually addresses, however implicitly, the concept of distributive justice in discussing its information requirements of grant applicants. As with other state arts agencies, the NYSCA, consistent with its goals, requires statistical information and narrative statements from applicants on efforts to increase the participation of traditionally underserved populations in their programs and services. Significantly, however, the council states that in its review of grant applications "these questions do not presuppose a certain answer. Each organization's answers will vary depending on a number of factors such as: artistic mission, geographic location, nature of community, size and resources of the organization.... The Council is looking for an applicant's good faith in its efforts to fulfill these goals."[92] Thus, the NYSCA is suggesting that while it is committed to a concept of distributive justice in its funding policy, it also seeks to apply the concept with consideration for a number of contingencies. Of course, this interpretation of the concept can be debated, a task undertaken in the next chapter. For now, this example serves to demonstrate that value assumptions are entailed in the information requirements of public arts agencies and can be clarified or not.

Even though a number of SAAs require applicants to provide race/-ethnicity information on their boards, staffs, volunteers, and/or audiences and ask for narrative accounts on efforts to involve ethnic communities in their programs, it is not always clear whether and, if so, how this information is to be used in grants decisions. The North Carolina Arts Council's information requirements are illustrative. First, as a matter of policy, the council "requires all organizations applying for funding to provide information on the inclusion of people of color in the governance, management and programming of the organization. The degree to which the organization demonstrates a commitment to involving people of color will be taken into consideration in determining funding."[93] Specifically, it requires organizational applicants to identify the racial/ethnic characteristics of their staff, volunteers, artists, and audiences and, in narrative form, to "describe how people of color are involved on the board, on the staff and in the programming of the organization."[94] Finally, a basic criterion boards and panels

use to evaluate applicants is the "involvement of people of color in governance, administration and programming."[95] In this way, the goals, information requirements, and evaluative criteria of the North Carolina Arts Council are correlated in a systematic way to assist decision makers in making grants decisions affecting, among others, organizations rooted in ethnic cultural traditions.

Finally, two SAAs, while utilizing the basic means of gathering information, have adopted additional measures to gauge applicant organizations' involvement of and response to ethnic communities. Notably, to gather information on grantees' compliance with local, state, and federal laws that prohibit discrimination on the basis of race, color, national origin, sex, handicap, or age, the Texas Arts Commission conducts preaward reviews "to determine whether the recipient is meeting compliance standards"[96] and, in some cases, "may investigate on an informal basis any complaints concerning alleged violations."[97] The Massachusetts Cultural Council, in a 1991 agreement with the Massachusetts Commission against Discrimination, states that "the Commission will audit a selection of applicants to the Council...to evaluate their civil rights performance (non–discrimination and affirmative action) in order to determine their eligibility for state financial assistance."[98] Subsequently, the council and commission will work with applicants to develop a compliance plan and schedule. An additional audit is then conducted to gauge evidence of the applicant's good faith effort in complying, evidence that is forwarded by the council's executive director to the grants review panel and eventually to the council itself, which makes final funding decisions. Yet how this information of compliance or noncompliance is to be weighted in funding decisions by the Massachusetts Cultural Council is not clear; nor is it clear in the case of the Texas Arts Commission.

This brief review of the information requirements of SAAs regarding issues of multiculturalism reveals considerable diversity in approaches and raises a number of issues. It is hard to imagine, for example, how SAAs who do not ask for or require race/ethnicity information and narrative accounts from their applicants could apply evaluative criteria such as "involvement of ethnic minorities" in an informed and specific manner. Also, it is not always clear how those SAAs who do require applicants to provide such information utilize it or make it available to grants decision makers. But, significantly, both of these conclusions beg questions of whether race/ethnicity information should be gathered by public arts agencies and, if so, whether and how it should be used as a basis for funding decisions. Addressing those questions will ultimately involve analysis of value–laden concepts such as justice, a matter for the next chapter.

SPECIAL INITIATIVES, SPECIAL PROGRAMS, AND DISTRIBUTIVE PLURALISM

The open–access–to–funding policy mechanism, it will be recalled, is a competitive funding system, one purported to be fair and open, designed to reward the most worthy applicants, and, ultimately, a system that will benefit many individuals and groups in significant ways, including members of multicultural communities. Many state arts agencies, even those whose goals, evaluative criteria, and decision–maker selection criteria reflect a commitment to multiculturalism, seem to believe that multicultural organizations are, for a number of reasons, at a competitive disadvantage in the open–access–to–funding policy mechanism. Thus, in order to enhance the competitive capacity of multicultural organizations, a number of SAAs have undertaken special initiatives that complement and supplement the open–access–to–funding policy mechanism. These special initiatives, as well as the special programs and distributive pluralism policy mechanisms, form the subject of this section.

Special Initiatives

A primary means used by SAAs to enhance the competitiveness of multicultural organizations is technical assistance workshops. Data from the National Assembly of State Arts Agencies survey cited above reveal that 29 state arts agencies provide technical assistance. Such assistance can come in various forms. A notable example is the Rural/Minority Arts Project of the Florida Arts Council (FAC). Rooted in the goal "to help marginal organizations to become mainstream,"[99] the FAC first conducted a needs assessment of 212 organizations who met rural and/or minority criteria in order to discover their administrative problems and needs. Based on these responses, the FAC scheduled nine two–day technical assistance workshops covering the topics of fundraising, grantsmanship, incorporation, tax exemption, marketing/public relations, and bookkeeping. Ultimately, the technical assistance workshops were designed to address an obstacle for rural/minority arts organizations that the FAC defined as follows: "They lack the organizational capabilities required to apply for external sources of funding, and lack of funding prevents them from getting organized."[100] Similarly, the Connecticut Arts Commission conducts training seminars for culturally diverse artists.

The Arizona Commission on the Arts (ACA) has undertaken several special initiatives. It has held workshops to assist organizations in developing culturally diverse governing boards and in preparing affirmative action plans, and plans additional workshops and conferences that address

cultural diversity issues. The ACA also plans to identify individuals from ethnic communities who can serve as board members for ACA grantee arts organizations. Further, the agency plans to facilitate the attendance of ethnic arts administrators at arts management programs nationwide.[101] Finally, the Arizona Commission on the Arts states that it actively seeks grant applications from arts and non–arts organizations rooted in ethnic cultural communities, a practice apparently replicated by numerous state arts agencies.

Many state arts agencies, 25 of the 48 surveyed in the NASAA study, indicate they have developed joint programs with other state agencies in their states to enhance the access multicultural organizations have to public funds. The Michigan Council for the Arts, for example, has identified or developed technical and financial resources from international, national, state, and local sources that, it suggests, "are diverse and are reflective of our multi–cultural global environment."[102] The identification of these resources is designed "to assist communities throughout the state provide arts activities, to increase public awareness and appreciation of the arts, to assure long–term viability of non–profit arts producing and presenting organizations, and to further promote the arts in Michigan."[103] In turn, through cooperation with other state agencies such as the Commission on Spanish Speaking Affairs, Commission on Indian Affairs, Commission on Aging, the Department of Civil Rights, and the Department of Education, "the Council has made available these resources to African–American, Asian, Hispanic, Native American and non–minority communities."[104] An additional example of a state arts agency cooperating with another state agency was cited above, namely, the cooperative agreement between the Massachusetts Commission against Discrimination and the Massachusetts Cultural Council to develop and enforce nondiscrimination and affirmative action policies.

A final, commonly utilized special initiative is that of special committees designed to assist multicultural organizations. The Nebraska Arts Council has a People of Color Arts Advisory Committee and the Georgia Council for the Arts has an ad hoc minority committee that is charged to review the council's existing programs and their responsiveness to the needs of minority constituents.

As diverse as these initiatives are in structure and intent, they share significant commonalities. First, just as with the basic elements of the open–access–to–funding policy mechanism, these initiatives are rooted, explicitly or implicitly, in value–laden concepts such as art, culture, and justice. Second, while intended to compensate for the perceived disadvantages of multicultural communities in an open–access–to–funding system, these special initiatives are consistent with the premises of the open–access––to–funding policy mechanism. The same cannot be said, however, for

SAAs' special programs. Indeed, certain features are sufficiently unique for special programs to be considered a separate policy mechanism.

Special Programs

Special programs of SAAs designed to benefit multicultural communities are diverse in intent, structure, and history. Some are exclusively for the benefit of ethnic minorities, while others serve a broad range of "special constituencies"; some are designed to stimulate arts programs at community sites, while others attempt to mainstream under-served ethnic minorities into the ongoing activities of arts organizations. Despite the differences in these programs, each represents a policy decision on the part of its SAA sponsor that the needs of multicultural communities can best be met, to a significant degree, through a special funding and programmatic mechanism. A key element of special programs is that eligibility for them, in most cases, is restricted to individuals or organizations from African–American, Asian, Hispanic, or Native American communities. Given this eligibility requirement, SAAs can and do offer special programs for multicultural communities while at the same time operating the rest of their funding systems along the open–access–to–funding model.

According to the NASAA survey, 32 out of 48 state arts agencies say that they have a program that targets minority/ethnic arts organizations. This total would seem to include both special initiatives as well as special programs. In any case, the special programs policy mechanism is frequently utilized by SAAs. The list of special programs discussed below, while not exhaustive, represents the different types of programmatic approaches adopted by SAAs.

While the reasons some SAAs do not have special programs are diverse, several SAAs have made conscious decisions not to utilize the special programs policy mechanism. The case of the Arizona Commission on the Arts is illustrative. Until 1984, the commission had an Expansion Arts Program that existed as a separate funding category. The program "was established to support, encourage and assist artists, projects and organizations of high artistic quality that relate to culturally diverse, rural or tribal communities."[105] In recent years, however, the ACA has opted to have applications from ethnic organizations reviewed by basic arts discipline panels, essentially a return to the open–access–to–funding policy mechanism. Accordingly, the ACA has sought greater ethnic representation on its grant panels and on the Arizona Arts Trust Fund, which also dispenses funds to arts organizations, including those rooted in ethnic communities. The reasons for the ACA's shift in policy mechanisms, however, are not made clear.

The special programs of some state arts agencies constitute special grants categories. These take many forms. The Delaware State Arts Council's Grants to Emerging Organizations category provides up to 50% of arts project budgets or administrative costs of organizations in the process of institutional development. Special consideration is "given to organizations that provide programming for an under–served constituency or are involved in experimental or innovative arts activities."[106] Thus, eligibility for this grants program is not restricted to multicultural arts organizations or organizations who serve ethnic communities. But the grant guidelines do state that "emphasis on multi–cultural programming is encouraged."[107] As an example of another special grants category, the State Arts Council of Oklahoma offers grants for under $5,000 "to be used primarily for technical assistance (e.g. to minority arts organizations for board development, financial record–keeping, personnel training)"[108] as part of its Minority Arts Funds program. Finally, Arts: Rural and Multicultural (ARM), a special program of the Indiana Arts Commission, aims to identify, assist, and develop a long–term commitment to "organizations and individuals in rural and multicultural communities that produce, present and promote the arts."[109] The program offers small grants, ranging from $100 to $5,000, in three areas—technical assistance, touring, and projects—as part of the IAC's goal to make the arts accessible to all citizens in the state. Applicants may request 75% of an activity's cost from the IAC, with the remaining 25% made up of any combination of cash or in–kind contributions.

The special programs of several state arts agencies are designed to offer a broad range of services to organizations in ethnic cultural communities. The Minority Arts Program of the Pennsylvania Council on the Arts, in order "to develop a strong support system for the continued growth and expansion of the multi–cultural arts community...focuses on the development of multi–cultural organizations and the training of capable administrators to ensure their continued growth and development."[110] The program offers Technical Assistance Programs and Services, including organizational development conferences, quarterly newsletters, technical assistance for organizations and individuals, and internships. In addition, the Minority Arts Program has three specific funding categories—Basic Organizational Development, Intermediate Organizational Development, and Advanced Organizational Development. While these funding categories are directed to organizations of different sizes and histories, they all offer non–matching funds to enhance the administrative skills of administrators in multicultural organizations. Of special interest, the Basic Organizational Development, in part, focuses on non–arts organizations "interested in cultivating professionally staffed arts programs."[111]

The Multicultural Arts Development Program of the South Carolina Arts Commission is also geared to the professional development of

multicultural organizations through technical assistance, conferences, and consultancies. It is unique, however, in that it also provides "consultancy grants to established organizations seeking to develop innovative dialogue with underserved ethnic populations in their community."[112]

The Ohio Arts Council's (OAC) Minority Arts Program has two primary objectives: (1) to be an information resource on minority arts in the state and (2) to provide "long– and short–term [management] assistance from arts advisors to strengthen African–American, Appalachian, Asian, Hispanic, and Native American Indian arts organizations and individual artists."[113] While this program is somewhat different from those cited above, given its use of advisers who work individually with ethnic arts organizations, it is similar in its stress on enhancing management capabilities. But the OAC also has a granting program, Traditional and Ethnic Arts, which aims to help nonprofit groups to document, preserve, present, and disseminate arts that "are created within groups that share the same ethnic heritage, language, work, religion, home area, or other cultural bonds."[114] Finally, the OAC offers a granting program for which all arts organizations are eligible. The Outreach Initiative Program makes funds available to encourage "the permanent inclusion of minorities and special constituents on boards, planning committees, and in administrative positions."[115]

The Tennessee Arts Commission has adopted a partnership strategy to achieve "access to the arts for traditionally underserved and underrepresented arts disciplines [and] increased appreciation and understanding of the arts."[116] The program, Partnerships for Access and Appreciation, funds projects spanning numerous aspects of the production, presentation, dissemination, and administration of the arts. A key requirement of the program is that each funded project must involve a partnership between two nonprofit organizations or artists and a nonprofit organization. Desired partnerships include those between large and small organizations, a "mainstream" and an "alternative" organization, or a "majority" and a "minority" organization.

To this point, special programs of state arts agencies have been identified and distinguished on various grounds. Although in most cases eligibility for special programs is limited to organizations and individuals rooted in ethnic cultural communities, eligibility for some programs cited above extends to "special constituencies" or to major arts organizations, especially those whose aim is outreach or building partnerships. These special programs also vary on the forms of assistance they adopt—technical assistance, consultancies, and grants funds for organizational development or partnership opportunities. But examination of additional examples reveals another important distinction between special programs, namely, that some encourage work by multicultural organizations to serve their

immediate communities, while others promote work by multicultural organizations to interact with audiences and institutions throughout society.

The first orientation can be illustrated by the special programs of three state arts agencies. For example, the North Carolina Arts Council's Organization of Color Development Program has three components—Organizational Support for Established Organizations of Color, Organizational Support for Emerging Organizations of Color, and Organizations of Color Management/Technical Assistance. Respectively, these components fund long–term efforts to stabilize and expand the services of established arts organizations of color; support, over three years, the growth of artistic quality and scope of emerging organizations; and provide "expert" assistance to both established and emerging organizations to enhance their artistic quality and management skills. What is significant here is not the forms of assistance provided, which are similar to those of other special programs, but the nature of those organizations eligible for the program, namely, "nonprofit, tax–exempt professional arts organizations of color...based in and focused on the African–American, Asian–American, Hispanic or Native American Communities."[117] As another example of this orientation, the Special Arts Services Program of the New York State Council on the Arts is designed to support "professional arts activities within African–American, Hispanic, Asian, and Native American communities."[118] Notably, the program's guidelines state that "organizations whose projects are directed toward general audiences or organizations whose artists do not represent those communities mentioned above are not eligible for support in the Special Arts Services Program."[119] Finally, as a condition of receiving grants for organizational development from the New Mexico Arts Division's Culturally Diverse Arts Organizations programs, "organizations must be both by and for culturally specific ethnic groups, tribal communities or multicultural neighborhoods."[120] Also, as with the previous two examples, this program's guidelines stipulate that "this category is not designed for mainstream organizations that offer outreach programs to culturally specific and multicultural communities as an aspect of their overall activities."[121]

One of the two examples of special programs that have adopted the second orientation discussed above no longer exists; but it nonetheless warrants mention. The Heritage Program of the Massachusetts Cultural Council, in place through 1990, was intended "to strengthen Third World communities' ability to expand and deepen the public's awareness and appreciation of the contemporary art, culture, and history of Afro–American, Caribbean, Asian and Pacific Islander, Cape Verdean, Hispanic and Native American people."[122] Another example of a special program designed to promote work of multicultural organizations to interact with audiences and institutions beyond their immediate communities is the California Arts Council's Multi–Cultural Entry and Advancement. The program is

multidimensional, involving technical assistance to assist with financial/administrative competence, audience development, outreach, administrative fellowship opportunities, and the development of coalitions for the production of cross–cultural work. The intent behind this program's provisions to help produce artistic work that either is rooted in two or more cultural traditions or, in some sense, cuts across cultures is of special interest. This special program, reasons the California Arts Council, is part of "laying the groundwork for a California arts environment in which cross–cultural work is the norm, the mainstream."[123]

Analysis of these different special programs can take two forms. The first form involves analysis of the value–laden assumptions underlying these programs. For example, some programs seem to assume that ethnic arts organizations should primarily or exclusively serve their immediate communities, while others seem to assume that they should reach out and interact with other populations throughout society. Also, one agency holds out the possibility that all arts organizations can be cross–cultural in nature. These diverse positions, in turn, are rooted in alternative views about actual and ideal relationships between ethnic groups in society. Exploration of these value positions is a matter for the next chapter.

The second means of analyzing these diverse special programs is to focus on their commonalities in exemplifying the special programs policy mechanism. On the one hand, it is difficult to assess the effectiveness of the special programs policy mechanism due in large part to the aforementioned lack of publicly available data on the race/ethnic characteristics of SAA grantees and individuals who benefit from such grants. Still, some degree of assessment is possible.

First, it is not difficult to imagine that some might reject in principle the notion of separate programs for specific population groups in public arts agencies, arguing that the only warranted categorical distinctions are those made on the basis of arts disciplines or organizational forms. Indeed, some SAAs, at least implicitly, seem to take this position. Others clearly take an alternative view. In addition to programs geared to ethnic organizations, many SAAs have special programs that focus on other population groups, such as physically challenged individuals or older adults.[124] But the mere existence of special programs does not constitute a justification for their use. For example, critics of special programs in other social and professional spheres argue that such programs tend to segregate and marginalize the intended beneficiaries away from mainstream institutions and practices of society.[125] This critique would not seem to apply to several of the SAA special programs discussed above, such as those that aim to increase the societywide awareness and appreciation of ethnic art traditions or the multicultural programming of all arts organizations. Critics of special programs might then argue that any form of special treatment for some

groups will likely provoke a sense of resentment among applicants from other groups, thus triggering a backlash against ethnic groups as a drain on public arts funding. But whether such a drain and backlash effect might occur is largely an empirical question, the answer to which is complicated by limited SAA data. Anecdotal evidence could be a helpful indicator of whether these effects have indeed occurred. But while some anecdotal evidence exists, as will be seen, about backlash against examples of the distributive pluralism policy mechanism, no such evidence has yet surfaced about special programs in arts policy.

A final consideration in analyzing the effectiveness of the special programs policy mechanism centers on the purposes that these programs serve. Specifically, many special programs aim to facilitate the development of multicultural arts organizations' acumen as effective, efficient nonprofit organizations. But the merit of this aim is increasingly met with skepticism, even among advocates of multiculturalism. Notably, A. B. Spellman, director of the NEA's Expansion Arts program, argues that the traditional model of the nonprofit organization is failing ethnic communities. He notes that few ethnic arts organizations are able to assemble a board of trustees that is sufficiently connected to the private philanthropic community to ensure a stability in fund–raising. Without this established traditional structure, ethnic arts organizations would seem to be at a disadvantage. As Spellman argues, "funders looking for the traditional institutional model in reviewing those organizations will focus on their weakness and not on their strength."[126] The strength of many ethnic arts organizations, contends Spellman, is in their programming; indeed, many are artist–run. Thus, in this scenario, "small staffs led by artists have to solve all of the myriad business problems of a small to mid–sized non–profit organization before they can do their creative work."[127] This state of affairs is exacerbated by another factor that Spellman cites, namely, that "minority arts organizations used to be able to solicit money from agencies that supported community projects in education, crime prevention, mental health, recreation, public housing.... But such funds are scarce today."[128] All of this is not to say that ethnic artists cannot flourish under the nonprofit umbrella. But Spellman's analysis does suggest that the stress on support for development of nonprofit management skills found in many SAAs' special programs may be a matter of overemphasis, to the neglect of development of other organizational forms.

Ultimately, however, assessment of the special programs policy mechanism rests on examination of key value questions. First, however, it remains to interpret the third and final policy mechanism that addresses issues in multiculturalism and the arts—distributive pluralism.

Distributive Pluralism

This policy mechanism is regulatory in nature. In some ways it resembles features of both the open–access–to–funding and special programs policy mechanisms. For example, as was seen earlier, SAAs utilize a number of regulations within the open–access–to–funding policy mechanism, such as required assurances of compliance with nondiscrimination laws and statutes, or reports and audits to measure grantees' progress in implementing affirmative action policies. In some cases, failure to abide by these regulations can threaten organizations' continued eligibility for grant funds. Also, the distributive pluralism policy mechanism resembles some SAAs' special programs in its stress on special provisions designed to benefit ethnic cultural communities.

Despite these similarities, distributive pluralism is identifiably unique as a policy mechanism. Through the strength and broad application of specific regulations, distributive pluralism seeks not merely to affect who is eligible for funds or the manner of access to such funds but to ensure or virtually ensure that funds will be distributed to ethnic arts organizations and their communities in a proportional manner. The three examples of the distributive pluralism policy mechanism to be discussed here, while they differ considerably in details, each shares these features.

The Colorado Council on the Arts and Humanities (CCAH) has instituted what it calls a new operational philosophy—Creative Communities. CCAH considers Creative Communities a major focus of the agency and an integral part of all its programs and grant categories. It is consistent with the agency's recognition that barriers inhibit participation in the arts for many citizens. As such, an aim of the CCAH is to make "the arts accessible to physically, emotionally, and mentally disabled, older adults, culturally and economically deprived people, as well as Afro–American, Asian–American, Latino, Native American and other ethnic populations."[129] A further aim of the agency is that "special consideration will be given to grant applications representing minorities, special constituencies and emerging organizations."[130] It is through Creative Communities that the CCAH expresses its special consideration.

Creative Communities seeks to foster and support innovative aspects of cultural activities in small, rural, suburban, urban neighborhood, and resort communities. A vital element in promoting innovation and creativity toward cultural development and collaboration among these communities is, according to the CCAH, "sensitivity to local heritage, history and diverse cultures (ethnic, challenged individuals, racial, age, occupational, socio–economic, geographic)."[131] Among the eight objectives of Creative Communities are the following three:

- To foster awareness and respect for diverse cultures;
- To increase accessibility to the arts among all segments of the population;
- To explore the power of the arts in addressing contemporary social issues.

These goals and objectives, admittedly, are no different from many found in the review of open–access–to–funding and special programs policy mechanisms. But what distinguishes Creative Communities as an instance of distributive pluralism is the CCAH's stipulation and weighting of evaluative criteria and their utilization with all individuals and organizations seeking CCAH funds. Specifically, project grant applications, for example, are reviewed according to three categories of criteria: (1) organization; (2) project; and (3) consistency with agency goals and objectives, in particular, with Creative Communities. One element of both the "organization" and "project" criteria is "recognition of the integrity of artistic expressions of all cultures."[132] The "consistency with the goals of Creative Communities" criterion means that all applicants must seek to foster awareness of and respect for diverse cultures. In assessing fulfillment of these criteria, panelists review, among other kinds of information, applicants' responses to questions regarding their alliances/partnerships with key community organizations and Community Information reports, which contain applicants' responses to numerous questions about the racial/ethnic and economic characteristics of their communities. Thus, the information requirements of applicants are closely correlated with CCAH evaluative criteria. The most important feature of CCAH's evaluation system is the weighting of the three categories of criteria outlined above—they are weighted equally.

This considerable emphasis on all applicants' serving goals of Creative Communities would seem to have significant consequences for ethnic communities. A definitive assessment of these consequences is not yet possible, since Creative Communities was instituted quite recently, in 1990. But given the weight of those evaluative criteria that reward support for the arts of diverse cultures and creative collaborations with ethnic communities, it seems reasonable to expect that a significant distribution of funds to ethnic communities will be virtually assured.

Clearly, Creative Communities, as an example of the distributive pluralism policy mechanism, can be analyzed from various points of view, including the perspective that whatever the strength and weight of certain evaluative criteria, a specific distribution of funds to representatives of ethnic communities is not mandated by law and hence not absolutely assured. But development of this point, as well as other possible critiques of Creative

Communities, awaits a review of two additional, and somewhat different, examples of distributive pluralism.

The core of the Kentucky Arts Council's (KAC) policy efforts to address multicultural issues is its civil rights policy, a regulatory policy that applies to all potential KAC grantees. The KAC's civil rights policy is rooted in its belief that as a recipient of assistance from state and federal agencies that have civil rights laws prohibiting discrimination in programs that receive such assistance, it "must certify that it does not discriminate in the delivery of programs and services and that its own grantees do not discriminate nor subgrant to organizations that discriminate."[133] The policy is designed to ensure that all citizens should be able to benefit from the arts without regard to race, color, creed, religion, national origin, age, sex, or disability.

This feature of the KAC's civil rights policy is virtually identical with the terms of grants found in examples of the open–access–to–funding mechanism. Yet the KAC's civil rights policy is much more than a regulatory nondiscrimination policy. While not defined as such by the KAC, it is also an example of distributive pluralism. Several elements of the civil rights policy confirm this interpretation, starting with the agency's goals. Of special note, the KAC seeks to "recognize and encourage the rich cultural diversity of our people by providing for the equitable distribution of the Commonwealth's cultural resources to individuals and groups representative of that diversity."[134] Further, the KAC aims "to insure that all citizens benefit fully and equally from the arts without regard to race, color, creed, religion, national origin, age, sex, or disability."[135] These goals are clearly distinguishable from a goal commonly found in other policy mechanisms, namely, to ensure access to the arts regardless of race, color, national origin, and so on. Specifically, the KAC's goals, by embodying ideas such as "equitable distribution" and "equal benefit," move beyond the provision of equal opportunity to the provision of equal results for all citizens.

The KAC utilizes two primary means of attempting to achieve these goals. First, it gives special consideration to projects that address the concerns of individuals from racial/ethnic groups, including those of Native American, African, Latin, and Asian descent, as well as the concerns of older adults, women, and persons with disabilities. Second, the KAC stipulates that all its grantees must represent the diversity of these groups, as found in their communities, programs, staffs, boards, and audiences. The KAC withholds grants funds from grantees that are not in compliance with these stipulations. The civil rights policy also applies to potential KAC grantees.

In order for both panels and the KAC's civil rights committee to gauge their civil rights compliance, each organization applying for KAC funds is required to (1) provide race/ethnicity information on its community,

governing board, advisory groups, paid staff, volunteers, artists/consultants, and audiences; and (2) provide detailed responses on their plans to address multicultural issues, in particular, how they plan to develop a culturally diverse audience, to include diverse and underserved artists in their programs, and to include representatives of diverse populations on their boards, committees, and advisory groups. The KAC's list of seven evaluative criteria for funding decisions includes "inclusion of, and outreach to, underserved populations" and "participation of a broad segment of the community being served."[136] Thus, the information KAC applicants are required to provide is correlated with both civil rights compliance and evaluative criteria.

By giving special consideration to projects that address concerns of ethnic cultural communities and by requiring all grant applicants to comply with civil rights statutes, it is virtually assured that the Kentucky Arts Council will distribute a significant portion of its funds to ethnic arts organizations or other organizations who direct programs and services to ethnic cultural communities. Still, a specific distribution of grant funds is not mandated.

The program of the Michigan Council for the Arts (MCA) shares many features with the Kentucky Arts Council's civil rights policy. For example, the MCA stipulates that all of the state's citizens "shall be provided full and equal enjoyment of the benefits provided by Council programs and services without discrimination based upon race, color, creed, national origin, age, gender, handicap, or cultural orientation."[137] Thus, as with the KAC, the MCA is committed not only to equal opportunity, but to equal results for its beneficiaries. Further, as a prerequisite for funding, MCA grant applicants are required to submit an "Affirmation of Equal Opportunity" and a "Minority–Female–Handicapper Status Report" to the council. Finally, the MCA states that it "has sought to maintain and increase the involvement of minorities in all programmatic and service areas."[138]

Despite these similarities with the other examples of distributive pluralism, the Michigan Council for the Arts has unique provisions for ensuring "equal results." Specifically, the state of Michigan includes language within the MCA's appropriations statute that requires allocation of a minimum of 16% of MCA funds to minority artists and organizations, in particular, to African–American, Asian, Hispanic, and Native American artists and organizations. Thus, the MCA's distributive pluralism policy mechanism constitutes an affirmative action policy designed to ensure a specific distribution of its funds to individuals and organizations rooted in ethnic cultural communities.

The need for this orientation is justified, in part, in terms of compensatory justice, a concept by which groups are seen as deserving of redress for past injustices inflicted. According to the MCA, ethnic

minorities "have been systemically excluded from participation in economic, educational and employment opportunities for hundreds of years, both by law and by private custom. As a result of this history of exclusion, institutions almost automatically confer advantages on whites...and impose disadvantages on racial and ethnic minorities."[139] The MCA concludes that the affirmative remedial use of race consciousness in the distribution of its funds "is a temporary means of overcoming this institutional pattern of discrimination."[140]

As might be expected, the distributive pluralism policy mechanism, in the various forms discussed here, can be analyzed and critiqued from various points of view. For example, the institution of distributive pluralism has been met, in the case of the Colorado Council on the Arts and Humanities, with a backlash of criticism. A past grant recipient of the CCAH suggests that Creative Communities, as discussed above, is not an example of a policy to support the arts but a policy to effect social engineering through the arts without regard for aesthetic quality or the personal vision of the individual. He states that "either we are funding artists and finding criteria to evaluate artistic quality, or we're funding organizations that reflect and serve the community.... Affirmative action is not art."[141] It is also predicted that applicants "will try to find projects that fit into the guidelines and goals, rather than maintaining high artistic standards.... It's very veiled, it's very insidious, but it's censorship nonetheless."[142] The extent of the backlash against Creative Communities, and other forms of distributive pluralism, is not clear. Documentation of any kind of backlash, at least by public arts agencies, is relatively rare. But even if the backlash against distributive pluralism were widespread and deep, that would be significant only in a political sense—it would hardly settle the issue. A resolution would require critical analysis of the value assumptions underlying the concept of distributive pluralism, and those of counterclaims.

This perhaps obvious point can be applied to other latent or actual value conflicts surrounding each of the different policy mechanisms discussed in this chapter. Thus, the task of reviewing and clarifying key value issues is the subject of the next section.

POLICY MECHANISMS AND VALUES ISSUES

To this point this chapter has focused on state arts agencies' choices of means by which grants funds are made available and allocated to potential grantees, with obvious emphasis on artists and organizations rooted in ethnic cultural traditions. In doing so, it has further concentrated on the actions of state arts agencies, not merely their intentions, in organizing their funding activities as policy mechanisms—open access to funding, special

programs, and distributive pluralism. Much was made in the early stages of the chapter about the problematic nature of existing sources of data on arts policy and multiculturalism, leading to the conclusion that even minimal conditions necessary for the evaluation of the effectiveness of SAA policy mechanisms related to multiculturalism were not present, at least to conduct an evaluation in terms of the tangible results of diverse policy mechanisms.

Despite such constraints, some possible assessments of these policy mechanisms emerged during this interpretive phase. Several problems with the open–access–to–funding policy mechanism were identified. All grant categories have eligibility requirements. It was found, in many cases, that multicultural programs, especially those sponsored by non–arts organizations, have limited access to certain kinds of funds, such as general operating support and challenge grants, and have no access at all to major institution support, technical assistance support, or salary assistance. This interpretive phase also revealed a difficulty with the weighting of evaluative criteria, namely, that evaluative criteria that stress potential involvement of and service to multicultural communities can easily get lost in the evaluation of grant applications. In addition, the lesser presence of members of ethnic cultural communities on SAA boards, relative to their presence on grant advisory panels, would seem to mean that while African–Americans, Asians, Hispanics, and Native Americans may be able to exert considerable influence on many SAAs' grant–making decisions, their formal power to make all final grants decisions and oversee policy development is considerably less. Finally, given the incomplete information requested of grant applicants by many SAAs and the unclear ways such information is made available to grants decision makers, it is not at all clear that evaluative criteria such as "involvement of ethnic minorities" can be applied in an informed and specific manner.

A number of problematic issues also emerged in interpreting the special programs and distributive pluralism policy mechanisms. For example, a common argument against special programs in other social spheres, an argument that could be extended to special programs in public arts agencies, is that they tend to segregate and marginalize their intended beneficiaries away from mainstream institutions and practices of society. On the other hand, it was noted that the focus of many SAAs' special programs on developing multicultural organizations' administrative acumen as effective, efficient nonprofit organizations has been critiqued. The substance of this critique is that for a number of reasons the traditional model of the nonprofit organization, with its heavy reliance on board members' leverage with the private philanthropic community, has failed small, artist–led ethnic arts organizations. Finally, critiques emerging from interpretation of the distributive pluralism policy mechanism included the perceived devaluation of aesthetic quality as a funding criterion relative to the promotion of

affirmative action and the conclusion that as a consequence of the strength of certain evaluative criteria, grant applicants are subject to a veiled yet insidious form of censorship.

As interesting as these preliminary critiques of the different policy mechanisms may be, a consistent point made during this interpretive phase, a point fundamental to the methodology of this study, is that policy mechanisms are rooted in alternative and potentially conflicting value positions, the resolution of which is only possible through analysis of the value assumptions underlying these positions. Four basic areas of value conflict, I believe, have emerged from this interpretation of the policy mechanisms of state arts agencies—perspectives on the ideal of cultural pluralism, conceptions of the relations between art and culture, arguments for the place of affirmative action and justice in arts policy, and multiple meanings of the value of the arts.

The basic policy mechanisms of state arts agencies, and specific examples of those policy mechanisms, approach a fundamental issue in several different ways: Some encourage work by multicultural arts organizations to serve, virtually exclusively, their immediate cultural communities; others promote work by multicultural organizations to interact with audiences and institutions throughout society; while still others aim to facilitate the production and dissemination of cross–cultural art work in all arts organizations. These policy positions, in turn, are rooted in different historical conceptions of "cultural pluralism." These views constitute ideals of how the political, social, and economic relations of cultural and ethnic groups ought to be in society, views that yield normative definitions of multiculturalism. Thus, a critical analysis of concepts of cultural pluralism is a necessary step toward resolving questions about the predominant approaches used by SAAs to support multicultural organizations.

A key assumption of many SAAs' goals statements is that art is rooted in or "reflects" a culture. Yet some critiques of the concept of cultural pluralism question this assumption and further question whether production and consumption of the arts of diverse ethnic groups can and do foster multiculturalism in the society at large. Therefore, assessment of these claims and counterclaims is essential to evaluating the merits of diverse policy mechanisms.

Concepts of justice suffuse numerous elements of the open–access–to–funding policy mechanism and provide the justifying rationale for the adoption of the special programs and distributive pluralism policy mechanisms. Specific concepts of equal opportunity, human rights, compensatory justice, distributive justice (which includes ideas of representation, participation, and equal results, among others), and social utility, when applied to public arts agencies, appear as various forms of affirmative action programs designed to benefit those of Native American, Asian,

African–American, and Hispanic descent. The diverse conceptual foundations of different affirmative action programs are a potent source of value conflict within arts policy, a state of affairs requiring considerable analysis.

A final conceptual issue that emerged from interpretation of the policy mechanisms of state arts agencies, especially the open–access–to–funding policy mechanism, is that of artistic value. In terms of a value conflict, claims and counterclaims were found surrounding the notion that artistic value is relative to specific cultural traditions. Resolution of this conflict through conceptual analysis is a matter of addressing a major philosophical question: Is value in art best thought of as one thing or as many? Yet once this question is raised, other questions then must be considered: Does artistic value reside in art objects or in responding individuals? What claims can be made for the aesthetic, cognitive, moral, and religious value of art? In what ways does the value of art reside in its social and cultural functions?

Analysis of the value conflicts surrounding concepts of cultural pluralism, the relations of art to culture, justice and affirmative action, and artistic value, and the implications of these concepts for choice among arts policy mechanism options, forms the subject for Chapter 4.

NOTES

1. For discussion of this argument, see Stanley N. Katz, "Influences on Public Policies in the United States," in W. McNeil Lowry, ed., *The Arts and Public Policy in the United States* (Englewood Cliffs, NJ: Prentice–Hall, 1984).

2. For a historical overview, see Livingston C. Biddle, *Our Government and the Arts: A Perspective from the Inside* (New York: American Council for the Arts, 1988).

3. Edward C. Banfield, *The Democratic Muse: Visual Arts and the Public Interest* (New York: Basic Books, 1984).

4. For detailed discussion of this argument, see Samuel Lipman, *Arguing for Music, Arguing for Culture* (Boston: David R. Godine, 1990).

5. For a discussion of this and other models of relations between private and public sectors in the arts, see Paul J. DiMaggio, "Can Culture Survive the Marketplace?" *Journal of Arts Management and Law* 13 (Spring 1983): 61–87.

6. These figures are reported in Independent Commission, *A Report to Congress on the National Endowment for the Arts* (Washington, DC: Independent Commission, 1990).

7. See, for example, Testimony of Alberta Arthurs (Rockefeller Foundation), Karen Brosius (Philip Morris Companies, Inc.), Cynthia

Mayeda (Dayton–Hudson Foundation), and Timothy McClimon (AT&T Foundation) before the Independent Commission, Washington, DC, 23 July 1990.

8. For an analysis of these factors and the "arts boom," see Margaret J. Wyszomirski, "Philanthropy, the Arts, and Public Policy," *Journal of Arts Management and Law* 16 (Winter 1987): 5–29.

9. Samuel Lipman, *Arguing for Music, Arguing for Culture*, p. 406.

10. Ibid., p. 408.

11. Ibid., p. 407.

12. Pat Clubb, "Understanding Foundation Policy Choices and Decision–Making Procedures," in Margaret Jane Wyszomirski and Pat Clubb, eds., *The Cost of Culture: Patterns and Prospects of Private Arts Patronage* (New York: American Council for the Arts, 1989).

13. The interest of the J. Paul Getty Trust in furthering the theory and practice of discipline–based art education is one example, albeit isolated, of a member of the private sector addressing broad concerns within a domain of the arts.

14. Margaret Jane Wyszomirski, "Sources of Private Support for the Arts: An Overview," in Margaret Jane Wyszomirski and Pat Clubb, eds., *The Cost of Culture*, p. 5.

15. Michael Useem, "Corporate Support for Culture and the Arts," in Margaret Jane Wyszomirski and Pat Clubb, eds., *The Cost of Culture*.

16. J. Mark Davidson Schuster, "Government Leverage of Private Support: Matching Grants and the Problem with New Money," in Margaret Jane Wyszomirski and Pat Clubb, eds., *The Cost of Culture*.

17. National Endowment for the Arts, *The Arts in America: A Report to the President and Congress* (Washington, DC: National Endowment for the Arts, Public Information Office, 1988).

18. The source of this table is: National Endowment for the Arts, *Five–Year Planning Document: 1986–1990* (Washington, DC: National Endowment for the Arts, 1984), p. 101.

19. Table 2 is based on data in: Association of American Cultures, *Culturally Diverse Organizations in the United States: An Organizational Survey* (Washington, DC: Association of American Cultures, 1988), p. 5. Table 3 is based on data in the same survey, p. 7.

20. These figures are found in: National Endowment for the Arts, *Five–Year Planning Document, 1989–1993* (Washington, DC: National Endowment for the Arts, 1987), p. 41.

21. Association of American Cultures, *Culturally Diverse Organizations in the United States*, p. 17.

22. Paul J. DiMaggio, "Decentralization of Arts Funding from the Federal Government to the States," in Stephen Benedict, ed., *Public Money*

and the Muse: Essays on Government Funding for the Arts (New York: W. W. Norton, 1991), p. 221.

23. For expressions of this point of view, stated prior to the final 1990 NEA reauthorization legislation, see Testimony of Ruth Mayleas (Independent Committee on Arts Policy) and Stephen Stamas (The American Assembly) before the Independent Commission, Washington, DC, on 30 July 1990 and 1 August 1990, respectively.

24. These figures can be found in National Assembly of State Arts Agencies, *Annual Survey Update—SAA Legislative Appropriations for Fiscal Years 1992 and 1993* (Washington, DC: National Assembly of State Arts Agencies, 1993).

25. Paul J. DiMaggio, "Decentralization of Arts Funding from the Federal Government to the States," p. 225.

26. These data are cited in National Assembly of State Arts Agencies, *The State of the State Arts Agencies 1989* (Washington, DC: National Assembly of State Arts Agencies, 1989).

27. For detailed versions of this argument, see John K. Urice, "Using Research to Determine, Challenge, or Validate Public Arts Policy," *Journal of Arts Management and Law* 13 (Spring 1983): 199–220; and Margaret Jane Wyzsomirski, Monnie Peters, and Kevin V. Mulcahy, "The Policy Utility of the NEA's Report on the State of the Arts," in David B. Pankratz and Valerie B. Morris, eds., *The Future of the Arts: Public Policy and Arts Research* (New York: Praeger, 1990).

28. See, for example, National Assembly of State Arts Agencies, *Summary of State Arts Agencies' Grantmaking Activities for Fiscal Year 1987* (Washington, DC: National Assembly of State Arts Agencies, 1989).

29. See National Assembly of State Arts Agencies, *Report of the NASAA Task Force on Cultural Pluralism* (Washington, DC: National Assembly of State Arts Agencies, 1989).

30. For a more extensive discussion of these indicators, see ibid.

31. For a discussion of the diverse functions of state arts agencies, see National Assembly of State Arts Agencies, *The State of the State Arts Agencies 1989.*

32. National Assembly of State Arts Agencies, *The National Standard for Arts Information Exchange* (Washington, DC: National Assembly of State Arts Agencies, 1985).

33. See, for example, David Cwi, "Arts Councils as Public Agencies: The Policy Impact of Mission, Role, and Operations," in William S. Hendon and James L. Shanahan, eds., *Economics of Cultural Decisions* (Cambridge, MA: ABT Books, 1983).

34. National Assembly of State Arts Agencies, *A Plan to Gather Race/Ethnicity Information: Revised Proposal* (Washington, DC: National Assembly of State Arts Agencies, 1991), p. 1.

35. Ibid., p. 4.

36. National Assembly of State Arts Agencies, *State Arts Agency Funded Activities: Analysis of Final Descriptive Reports, Fiscal Year 1985* (Washington, DC: National Assembly of State Arts Agencies, 1988).

37. Illinois Arts Council, *Program Grants Guidelines and Application, Fiscal Year 1992* (Chicago: Illinois Arts Council, 1991), p. 5.

38. Ibid, p. 6.

39. Georgia Council for the Arts, *Agency Plan for Fiscal Years 1991, 1992, 1993* (Tucker: Georgia Council for the Arts, 1990), p. 1.

40. Indiana Arts Commission, *1991–1993 Guide to Grants* (Indianapolis: Indiana Arts Commission, 1990), p. 3.

41. Mississippi Arts Commission, *Guide to Programs and Services, 1991–1992* (Jackson: Mississippi Arts Commission, 1990), p. 1.

42. South Dakota Arts Council, *Guide to Programs, FY 1991, 1992, 1993* (Sioux Falls: South Dakota Arts Council, 1990), p. 2.

43. Arizona Commission on the Arts, *Arts in Arizona: Long–Range Plan, 1991–95* (Phoenix: Arizona Commission on the Arts, 1991), p. 10.

44. New York State Council on the Arts, *Program Guidelines: 1990/91, 1991/92, 1992/93* (New York: New York State Council on the Arts, 1990), p. 3.

45. Ibid.

46. Ibid.

47. Ibid.

48. North Carolina Arts Council, *1991 Programs Guide for Organizations* (Ralcigh: North Carolina Arts Council, Department of Cultural Resources, 1990), p. 3.

49. Ibid.

50. Michigan Council for the Arts, *FY 1991 and 1992 Arts Project Guidelines* (Detroit: Michigan Council for the Arts, 1990), p. 1.

51. Oregon Arts Commission, *1990–91 Program Guide* (Salem: Oregon Arts Commission, 1990), p. 5.

52. D.C. Commission on the Arts and Humanities, *Comprehensive Arts Development, Guidelines FY '90* (Washington, DC: D.C. Commission on the Arts and Humanities, 1989), p. 1.

53. New Mexico Arts Division, *A Strategic Plan of the New Mexico Arts Division, 1989–1993: Plan Summary* (Sante Fe: New Mexico Arts Division, 1989), p. 1.

54. New Mexico Arts Division, *1991–92 Program Guidelines* (Sante Fe: New Mexico Arts Division, 1990), p. 5.

55. Johanna L. Misey, ed., *National Directory of Multi–Cultural Arts Organizations, 1990* (Washington, DC: National Assembly of State Arts Agencies, 1990).

56. Gerald D. Yoshitomi, " Cultural Democracy," in Stephen Benedict, ed., *Public Money and the Muse: Essays on Government Funding for the Arts* (New York: W. W. Norton, 1991), p. 203.

57. Ibid.

58. Ibid., p. 204.

59. For a discussion of state arts agencies' initiatives in arts education, see Jonathan Katz, ed., *Arts and Education Handbook: A Guide to Productive Collaborations* (Washington, DC: National Assembly of State Arts Agencies, 1988).

60. Maine Arts Commission, *Programs 1990–1991* (Augusta: Maine Arts Commission, 1990), p. 10.

61. Vermont Council on the Arts, *1991 Handbook: A Guide to Grants, Programs and Services* (Montpelier: Vermont Council on the Arts, 1991), p. 11.

62. Kansas Arts Commission, *Major Grant Guidelines, Fiscal Year 1992* (Topeka: Kansas Arts Commission, 1990), p. 8.

63. Nebraska Arts Council, *Guide to Programs and Services, 1991–92* (Omaha: Nebraska Arts Council, 1990), p. 40.

64. Alabama State Council on the Arts, *Guide to Programs, 91–92: Organizational Support* (Montgomery: Alabama State Council on the Arts, 1990), p. 19.

65. Tennessee Arts Commission, *Grant Guidelines, Fiscal Year 1992* (Nashville: Tennessee Arts Commission, 1991), p. 2.

66. State Arts Council of Oklahoma, *Project Assistance, 1990–91* (Oklahoma City: State Arts Council of Oklahoma, 1990), p. 11.

67. Arkansas Arts Council, *1991–92 Guide to Grants* (Little Rock: Arkansas Arts Council, 1990), p. 8.

68. Massachusetts Cultural Council, *Guide to Programs and Services 1992* (Boston: Massachusetts Cultural Council, 1991), p. 9.

69. D.C. Commission on the Arts and Humanities, *Grants–in–Aid Program, Guidelines FY 1991* (Washington, DC: D.C. Commission on the Arts and Humanities, 1990), p. 25.

70. Georgia Council for the Arts, *Guide to Programs 1992* (Tucker: Georgia Council for the Arts, 1991), p. 16.

71. Missouri Arts Council, *Long–Range Plan Working Papers* (St. Louis: Missouri Arts Council, 1989), p. 3.

72. Ohio Arts Council, *Guidelines, 1991 to 1993* (Columbus: Ohio Arts Council, 1989), p. 6.

73. Georgia Council for the Arts, *Guide to Programs 1992*, p. 15.

74. See, for example, David Cwi, "Arts Councils as Public Agencies."

75. See, for example, Margaret J. Wyszomirski, "Controversies in Arts Policymaking," in Kevin V. Mulcahy and C. Richard Swaim, eds., *Public Policy and the Arts* (Boulder, CO: Westview Press, 1982).

76. Nevada State Council on the Arts, *Grants to Organizations, 1990–1991* (Reno: Nevada State Council on the Arts, 1991), p. 1.

77. Florida Arts Council, *Grant Panelist Handbook* (Tallahassee: Florida Arts Council, 1991), p. 1.

78. North Carolina Arts Council, *1991 Programs Guide for Organizations*, p. 2.

79. Massachusetts Cultural Council, *Guide to Programs and Services 1992*, p. 8.

80. Virginia Commission for the Arts, *Guidelines for Funding, 1990–92* (Richmond: Virginia Commission for the Arts, 1990), p. 6.

81. Nebraska Arts Council, *Guide to Programs and Services, 1991–92*, p. 4.

82. Michigan Council for the Arts, *Summary Overview* (Detroit: Michigan Council for the Arts, n.d.), p. 1.

83. California Arts Council, *Report to the Joint Legislative Budget Committee on the California Arts Council's 1988–89 Multi–Cultural Programs* (Sacramento: California Arts Council, 1989), p. 12.

84. Texas Commission on the Arts, *A Plan for the Operation, Funding and Services for the Arts in Texas* (Austin: Texas Commission on the Arts, 1988), p. 21.

85. I am indebted to Dr. Jeffrey Love, Director of Research for the National Assembly of State Arts Agencies, Washington, DC, for making these data available.

86. For an example of this argument, see Gerald D. Yoshitomi, "Cultural Democracy."

87. Personal communication from Ms. Loretta Rhoads, Illinois Arts Council Director of Ethnic and Folk Arts Programs, 13 February 1991.

88. Nevada State Council on the Arts, *Direct Assistance: Guidelines and Application Forms, 1990–91* (Reno: Nevada State Council on the Arts, 1990), p. 7.

89. Wyoming Arts Council, *Grants Applications* (Cheyenne: Wyoming Arts Council, 1990), p. 17.

90. North Dakota Council on the Arts, *Institutional Support Program: Guidelines Application, FY 1992* (Fargo: North Dakota Council on the Arts, 1990), p. 16.

91. Oregon Arts Commission, *1990–91 Program Guide*, p. 50.

92. New York State Council on the Arts, *Program Guidelines: 1990/91, 1991/92, 1992/93*, p. 6.

93. North Carolina Arts Council, *1991 Program Guide for Organizations*, p. 5.

94. Ibid., p. 80.

95. Ibid., p. 16.

96. Texas Commission on the Arts, *A Plan for the Operation, Funding and Services for the Arts in Texas*, p. 9.

97. Ibid.

98. Massachusetts Cultural Council, "The Massachusetts Cultural Council and the Massachusetts Commission against Discrimination Sign Affirmative Action Memorandum of Agreement," press release, 20 February 1991, p. 3.

99. Florida Arts Council, *Final Report: Rural/Minority Arts Project* (Tallahassee: Florida Arts Council, 1990), p. 3.

100. Ibid., p. 7.

101. These plans are part of: the Arizona Commission on the Arts, *Arts in Arizona: Long–Range Plan, 1991–95*.

102. Michigan Council for the Arts, *Summary Overview*, p. 3.

103. Ibid.

104. Ibid.

105. Arizona Commission on the Arts, *Program Plans 1990–91* (Phoenix: Arizona Commission on the Arts, 1990), p. 5.

106. Delaware State Arts Council, *1991 Guide to Programs* (Wilmington: Delaware State Arts Council, 1990), p. 17.

107. Ibid.

108. State Arts Council of Oklahoma, *Project Assistance, 1990–91*, p. 8.

109. Indiana Arts Commission, *Arts: Rural and Multicultural* (Indianapolis: Indiana Arts Commission, n.d.), p. 1.

110. Pennsylvania Council on the Arts, *Guide to Programs and Services, 1991–1992* (Harrisburg: Pennsylvania Council on the Arts, 1991), p. 39.

111. Ibid., p. 40.

112. South Carolina Arts Commission, "Multicultural Arts Development Program," press release, 1 September 1990, p. 1.

113. Ohio Arts Council, *Guidelines, 1991 to 1993*, p. 78.

114. Ibid., p. 95.

115. Ibid., p. 97.

116. Tennessee Arts Commission, *Grant Guidelines, Fiscal Year 1992*, p. 33.

117. North Carolina Arts Council, *Organization of Color Development Program* (Raleigh: North Carolina Arts Council, 1990), p. 3.

118. New York State Council on the Arts, *Program Guidelines: 1990/91, 1991/92, 1992/93*, p. 105.

119. Ibid.

120. New Mexico Arts Division, *1991–92 Program Guidelines*, p. 41.

121. Ibid.

122. Massachusetts Cultural Council, *Community Arts and Education Program Guidelines, Fiscal Years 1989–90* (Boston: Massachusetts Cultural Council, 1989), p. 12.

123. California Arts Council, *Toward 2001: 1990 and Beyond—A Plan for the California Arts Council* (Sacramento: California Arts Council, 1990), p. 30.

124. For a review of SAAs' special programs for older adults, see David B. Pankratz, "Arts Policy and Older Adults," *Journal of Arts Management and Law* 18 (Winter 1989): 13–64.

125. For an example of this argument, see Arthur M. Schlesinger, Jr., *The Disuniting of America: Reflections on a Multicultural Society* (New York: W. W. Norton, 1992).

126. A. B. Spellman, "Minority Arts Organizations Thrive," *Artspace* 10 (May/June 1987): 4.

127. Ibid.

128. Ibid.

129. Colorado Council on the Arts and Humanities, *Entry Grant Program* (Denver: Colorado Council on the Arts and Humanities, 1990), p. 1.

130. Ibid.

131. Colorado Council on the Arts and Humanities, *Project Grants 1991–1992* (Denver: Colorado Council on the Arts and Humanities, 1990), p. 20.

132. Ibid.

133. Kentucky Arts Council, *Overview* (Frankfort: Kentucky Arts Council, 1990), p. 4.

134. Kentucky Arts Council, *Long–Range Action Plan for the Arts, FY 1989 to FY 1994* (Frankfort: Kentucky Arts Council, 1988), p. 11.

135. Kentucky Arts Council, *Overview*, p. 4.

136. Kentucky Arts Council, *1991 Project Grant Guidelines* (Frankfort: Kentucky Arts Council, 1990), p. 3.

137. Michigan Council for the Arts, *Michigan Council for the Arts Policy Book* (Detroit: Michigan Council for the Arts, 1988), p. 2.

138. Michigan Council for the Arts, *Summary Overview*, p. 2.

139. Michigan Council for the Arts, *Michigan Council for the Arts Policy Book*, p. 1.

140. Ibid.

141. Ed Baierlein, quoted in Hart Hill, "Creative Communities: Social Engineering or Enlightened New Philosophy?" *Muse: Colorado's Journal of the Arts* 70 (February/March 1991): 3–4.

142. Ibid., p. 4.

4

Conceptual Issues, Multiculturalism, and Arts Policy Mechanisms

In Chapter 3, a descriptive definition of *multiculturalism* was offered—the coexistence of groups of racial minorities within a common socio–political system, groups that, while continually undergoing change, are seen and see themselves as having relatively unique shared and transmitted values, dispositions, behaviors, and outlooks on the world as well as a shared economic future and that draw on the loyalty of group members to harness discontent in the face of racial discrimination and powerlessness as a basis for social and political action. At the time, I stressed that this or any other descriptive or stipulative definition of multiculturalism does not foreclose subsequent examination of value–laden, programmatic definitions of the term. Such an examination is clearly necessitated, given the value assumptions about multiculturalism that public arts agencies bring to elements of their policy mechanisms. This analysis, in turn, recognizes that normative uses of the term *multiculturalism* draw on historical conceptions of the term *cultural pluralism*, that is, views of how the coexistence of ethnic groups and their cultural, economic, political, and social relations should ideally be in American society.

With the rise of interest in multiculturalism in the arts world and other sectors of society, as outlined above, one might assume that this movement has been informed by clear concepts of cultural pluralism and the relations of ethnic groups. But, as will be seen, there are many different interpretations of the term *cultural pluralism*, a pluralism of pluralisms according to one commentator.[1] Indeed, there is even a pluralism of ways of characterizing this pluralism of pluralisms.

PERSPECTIVES ON THE IDEAL OF CULTURAL PLURALISM

The diversity of concepts of cultural pluralism can be traced, in part, to the fact that cultural pluralism is a relatively recent ideal, at least in Western intellectual history. As Stephen Thernstrom has argued, the ideal

of cultural pluralism has no great historic defenders.[2] Political philosophers who have defended the idea of democracy against concepts of authoritarian government, such as Plato's vision of the state as ruled by philosopher–kings and guardians, start with the premise that cultural unity is a necessary antidote to authoritarianism and a precondition to free, participatory democracy. Thomas F. Green notes, for example, that French thinkers have long been wary of factions that could restore feudallike privileges, while British political theory has traditionally stressed the value of individual liberty over group associations.[3] Also, the influential English cultural critic Matthew Arnold held that a broad, humanistic culture disseminated by a benevolent state and held in common across social classes was essential to curb sectarian interests and safeguard democracy.

Ideas that stand in contrast to the ideal of cultural pluralism are by no means limited in origin to eighteenth and nineteenth–century Europe. Ideologies of assimilation and amalgamation, for example, are rooted in twentieth–century American social science and political philosophy. They each combine empirical and value premises.

Assimilation, on the one hand, is an empirical, predictive theory of ethnic group conformity to the dominant majority culture. Specifically, "it holds that through time, ethnic minority groups become more and more like the dominant majority until finally all are part of one common culture patterned after the dominant group."[4] Since the dominant majority culture is viewed as derived from the Anglo–Saxon Protestant tradition, the theory of assimilation is often described as a theory of Anglo conformity. Assimilation of minority ethnic groups can occur on two different levels—cultural assimilation (acculturation) and structural assimilation.[5] Acculturation refers to the absorption of distinctive ethnic group cultural behavior into the patterns of the dominant culture; structural assimilation is a matter of the incorporation of minority group members as participants in the socioeconomic organizations, institutional activities, and civic life of the dominant culture. While these two levels are closely related in many ways, acculturation of ethnic groups may occur without structural assimilation, and vice versa. As Nicholas Appleton argues, "A minority group may adopt the values and life style of the dominant culture but may choose not to, or not be allowed to, participate in the institutions and group associations of the mainstream society."[6]

In the case of some ethnic groups, the theory of assimilation seems to accurately capture their experience in America. William Newman points out that as "ethnic groups were able to obtain a higher social class position, their members often moved out of the old ethnic neighborhoods, changed or Anglicized their names, and generally established new patterns of social relationships breaking the old European pattern of extended families."[7] But with racial minority groups, assimilationist theory is undercut by continuing

evidence of the impact of prejudice and discrimination, which effectively limits their structural assimilation into, and participation in, mainstream, socioeconomic institutions. Further, the apparent rise of many individuals' interest in reviving their ethnic group identity, as outlined in a previous chapter, obviously leaves the predictive power of the theory of assimilation in doubt.

The concept of assimilation as a societal ideal of ethnic group relations is only partially dependent on the veracity of empirical premises in the theory of assimilation. It rests, instead, on value premises. Specifically, the assimilationist position holds that all groups *should* share or conform to the values, dispositions, and outlooks of the dominant, Anglo–Saxon culture. This vision of ethnic group relations can, in turn, be based on three different sets of assumptions. First, it is sometimes held that since descendants of Anglo–Saxon culture form a majority of the American population and because many of the country's political, legal, and economic institutions are derived from Anglo–Saxon models, therefore, Anglo–Saxon values should be supported and transmitted through public institutions as the basis of a societywide common culture.

A second set of assumptions is rooted in the notion that the Anglo–Saxon cultural tradition is in some ways superior to the cultures of ethnic minorities. This notion is augmented, in a final position, by racist assumptions of racial superiority that seek to justify discriminatory practices of the dominant, Anglo–Saxon culture against ethnic minority groups, demands that ethnic minority groups conform to dominant ways, or even exclusionary policies against "undesirable," "inferior" groups.

Another alternative to cultural pluralism, the amalgamation or "melting pot" theory, also contains empirical and value premises. As a theory, it "predicts the development of a unique new cultural group resulting from the amalgam of synthesis of previously existing groups."[8] *Amalgamation* does not refer to the "melting away" of ethnic group characteristics into Anglo conformity but, rather, the formation of a hybrid, common American culture through the combination of different ethnic group features. The resulting culture, drawing on western European, eastern European, Asian, Hispanic, African, and Native American traditions, is to be different from that of any one of these traditions.

While some manifestations of amalgamation can and do occur in culturally diverse societies like the United States, these are usually limited to areas of consumption such as food, dress, or holiday celebrations and rarely entail fundamental cultural values, outlooks, and dispositions. Several factors undercut the predictive power of amalgamation theory. Most notably, a dominant group must both share its socioeconomic power with minority groups and willingly give up features of its cultural traditions if an amalgam with minority groups is to take place. Evidence of such

concessions by dominant groups is relatively rare in the American experience. Further, in societies where amalgamation has taken place, "it has usually been limited to a small number of groups and has involved long periods of time and geographical isolation, conditions not found in pluralistic societies like the United States."[9]

But, as with the assimilationist point of view, the concept of amalgamation as a societal ideal is only partially dependent on the empirical premises of melting pot theory. This ideal was formulated in the early twentieth century as a minority response to the cultural uprootedness of new immigrants in America and represented an effort to infuse this uprootedness with positive meanings. Its core value premise is that all ethnic groups should eventually merge and synthesize into a new, American culture, a culture that will provide new sources of identity and meaning for recent and later generation immigrants severed from their past. But the ideology of amalgamation envisions a special process of synthesis among ethnic groups. A key premise is the notion "that the new culture will represent only the 'best' qualities and attributes of the different cultures that contribute to it."[10] Thus, as with assimilation, the amalgamation ideology assumes that different cultures have identifiable and distinguishable qualities, some positive and others negative. But, unlike the assimilationist position, amalgamation holds that all groups can and do make their own positive, unique contributions to this new culture and, thereby, become "American" without pressure to conform to a dominant culture.

This brief review of concepts of assimilation and amalgamation was primarily intended, through use of contrast, to help to place the concept of cultural pluralism in sharper relief. But the task remains to spell out the many possible meanings of the term, the pluralism of pluralisms referred to above.

Any concept of cultural pluralism as a societal ideal entails two basic conditions: (1) the presence of a multiplicity of identifiable ethnic groups within a common political and economic system; and (2) that such diversity, and its continuation, is a desirable, valued state of affairs. These two premises, however, only go so far in clarifying the concept and its many versions. Three typologies of the pluralism of pluralisms will be examined here, typologies by Thomas F. Green, Milton Gordon, and Nicholas Appleton, in order to better understand the range of value assumptions that policymakers bring to their policy prescriptions.

Thomas F. Green offers a typology of concepts of cultural pluralism that addresses the range of possible relationships that can exist between ethnic groups within a society. This typology is rooted in a fundamental distinction between primary and secondary relationships. Primary relationships are informal and intimate in nature, occur in social and family settings, and tend to involve individuals' full personalities. Secondary relationships

are more formal; involve transactions in commercial, governance, or bureaucratic settings; are oriented to the accomplishment of tasks; and do not involve individuals' full personalities. Green then constructs three types of social organization, based on this distinction, that can occur among and between diverse ethnic groups—insular pluralism, halfway pluralism, and structural assimilation.

In insular pluralism, both the primary and secondary relationships of ethnic group members are confined to other members of the same group, with little or no interaction with individuals in other ethnic groups. As with insular pluralism, halfway pluralism entails primary relationships confined within different ethnic groups. On the other hand, in halfway pluralism, many ethnic group members regularly venture beyond their own group to pursue objectives in educational, commercial, economic, bureaucratic, and political settings. Finally, in the case of structural assimilation, members of specific ethnic groups routinely establish and maintain both primary and secondary relationships with members of other ethnic groups. Under this vision of social organization, persons interact on the basis of common interests and concerns with limited attention to the ethnicity or cultural background of individuals.

Green's typology, in effect, is a continuum of possible models of ethnic group relations within a society, models that can inform specific concepts of the ideal of cultural pluralism. But these models by no means cover the range of issues associated with the concept of cultural pluralism. For example, it can reasonably be argued that, historically, the dominant culture in America has been far from receptive in accepting cultural diversity, let alone ideal views of cultural pluralism, and that ethnic minority groups have been expected to undergo, in the face of discrimination, cultural assimilation with few rewards in terms of participation in political, social, and economic power.

This point suggests that if any form of the cultural pluralism ideal is to take hold in American society, government must play an active role. Milton Gordon offers a typology that distinguishes two positions of the state with regard to actions taken toward ethnic cultures: (1) liberal pluralism and (2) corporate pluralism. Liberal pluralism is characterized "by the absence, even prohibition, of any legal or governmental recognition of racial, religious, language, or national origin groups as corporate entities with a standing in the legal or governmental process, and a prohibition of the use of ethnic criteria of any type for discriminatory purposes, or conversely, for special or favored treatment."[11] Under liberal pluralism, members of ethnic groups benefit from government action only in relation to their eligibility as individuals, not as a function of their ethnic background. Cultural pluralism "would exist voluntarily as an unofficial societal reality,"[12] while equalitarian norms "would emphasize equality of opportunity

and the evaluation of individuals on the basis of universalistic standards of performance."[13] In contrast, corporate pluralism formally recognizes ethnic groups as legally constituted entities in society. Societal rewards, in both the public and private sectors, are allocated on the basis of some sort of formula, for example, based on relative numerical strengths in the population. "Equalitarian emphasis is on equality of condition rather than equality of opportunity, and universalistic criteria of rewards operate only in restricted spheres themselves determined in a particularistic manner."[14]

The final pluralism of pluralisms typology, that of Nicholas Appleton, combines features of the first two typologies by stressing both possible interrelationships between ethnic groups as well as government options toward ethnic groups. Appleton identifies four meanings of the concept of cultural pluralism—classical cultural pluralism, modified cultural pluralism, cultural pluralism as voluntary ethnic choice, and cultural pluralism as separation. Each is examined in turn.

The classical cultural pluralism position can be traced to the writings of Horace Kallen who, in the early to midtwentieth century, rejected the primacy of assimilation and melting pot ideologies among government officials and intellectuals.[15] In Kallen's view, cultural pluralism means that diverse ethnic groups should live in peaceful coexistence under the banner of American democracy while, at the same time, maintaining their unique ethnic identities. He envisioned America as a stable democracy of groups based on the preservation of ethnic inheritance—a "federation" of nations. This vision of a stable future rooted in the past assumes that ethnicity is not voluntary but inherited, that ethnic identities will naturally endure over time, and because all cultural traditions are of equal value, that each ethnic group can make positive contributions to society. Finally, while the classical cultural pluralism position entails the view that maintenance and continuance of ethnic group identity is a "natural" process, it also entails the point that state action is necessary to cultural pluralism. In particular, as with the notion of corporate pluralism cited above, ethnic groups are to be seen as legally constituted entities entitled to economic and political rewards resting on their relative numerical strength within political processes.

Modified cultural pluralism, in contrast to classical cultural pluralism, envisions a substantial common culture shared by all of a society's members as well as considerable interaction between diverse ethnic groups. This interaction can occur in both informal, primary relationships and in formal secondary relationships. Thus, with modified cultural pluralism, it is expected that ethnic groups, through such interaction and adaptation to the experience of American society, will undergo change. But, in many contexts, ethnic groups will still function as distinct groups. As Appleton states, embedded in the concept of modified cultural pluralism "is the belief that ethnicity, albeit in changed form, will continue to be important for

individuals, and that attempts to eliminate it will prove ineffective."[16] Finally, in modified cultural pluralism, the state's role toward ethnic groups lies between liberal pluralism and corporate pluralism, as cited above. On the one hand, citizen participation in politics is encouraged for individuals, while the "public interest" and the general welfare of society are generally seen as superseding the political claims of groups, including ethnic groups. Government, on the other hand, while not viewing ethnic groups as corporate, legal entities deserving of specified political and economic rewards, is at least obliged to recognize and be responsive to the claims and demands of ethnic groups and other societal groups.

Cultural pluralism as voluntary ethnic choice does not emphasize the preservation and maintenance of ethnic groups. Instead, it stresses "the opportunity for individuals to determine to what extent they wish to remain members of a group and partake of its cultural offerings or, alternatively, to venture out and participate in or adopt other cultural ways."[17] Several assumptions underlie this concept of cultural pluralism. First, ethnicity is not viewed as inherited in a biological sense or as a stable set of values, outlooks, and dispositions that will necessarily endure over time. Rather, ethnicity is viewed as freely chosen based on broad familiarity with the beliefs, values, and outlooks characteristic of many cultural traditions. Accordingly, it is also held that social boundaries among diverse ethnic groups should be relaxed and fluid in nature, and that no individual should be assigned an ethnic identity that he or she has not chosen. Clearly, the primary values held by advocates of the cultural pluralism as voluntary ethnic choice position are those of liberty and freedom. Ethnic cultural traditions are seen primarily as resources available to enhance the development and self–fulfillment of individuals. Indeed, the virtual dissolution of some ethnic groups as corporate, legal entities is not unwelcome under this view, so long as such change is not the result of one culture's domination over another or inhibiting of individuals' freedoms and range of cultural choices. Not surprisingly, then, this position does not envision an active role for the state in supporting ethnic groups as political or economic entities.[18]

The final version of cultural pluralism in Appleton's typology, cultural pluralism as separation, is rooted in observations of imbalances in economic and political power between ethnic groups, especially minority groups, and the dominant culture. These inequalities, it is argued, are the result of years of ethnic groups' subjugation as colonized peoples and the contemporary salience of dominant culture racism that reinforces and legitimizes these inequalities. In response, proponents of this position contend that "minority groups must separate themselves from the dominant majority—if not physically, at least socially and culturally—to develop a strong sense of unity and autonomy and then return when they are able to negotiate from a position of strength."[19] Without processes of developing

a sense of peoplehood and group history, an economic base and mutual support systems, political mobilization, and political coalition–building, specific ethnic minority groups, advocates conclude, will not be able to neutralize the majority culture's domination and exploitation. With these processes, individual ethnic minority groups, it is predicted, will be far more likely to exert control over their destiny. Finally, given this position's stress on the economic and political self–determination of ethnic groups, the role of government is envisioned as limited. Recourse to dependence on a benevolent state to mete out political opportunities and rewards is rejected as impossible in a racist society and ultimately self–defeating to the potential empowerment needed for effective competition in a democratic, capitalistic society.

Cultural pluralism as a societal ideal has spurred criticisms from a variety of perspectives. This is hardly surprising because this ideal, even in the many different forms cited above, is perceived as challenging to key interest groups in American society, especially among those who support the assimilation of ethnic groups. However, a different alternative to the ideal of cultural pluralism, the vision of an open society, is the source of many critiques of the concept of cultural pluralism.

The ideology of the open society envisions a social order where the individual person, regardless of his or her group association, is the center of the social order. "There is the belief that all individuals are capable of making a positive contribution to the well–being of society and that each person and the ideas of each person should be evaluated on the basis of individual merit and relevance to a particular situation."[20] This stress on individual merit and individual rewards for accomplishments, it is argued, is an essential condition for professional development and achievement of excellence in many sectors as well as economic competitiveness. A further claim is that this position, by seeking to reward individual achievement, also upholds the principle of justice that individuals should not be subjected to discrimination based on their ascribed, rather than earned, status. In an open society, ethnicity can still be an important factor in an individual's sense of ideality. But in political settings, membership in ethnic groups holds no weight. Instead, membership in groups is to be voluntary and based on the congealing of like interests and concerns. "When group goals are met or when individuals determine that the group no longer serves their best interests, they are free to dissociate themselves."[21] In the political environment of an open society, ethnic group affiliations are seen as unsophisticated, reactionary, and inhibitory to the fair, effective functioning of a modern state.[22]

Criticisms of the ideal of cultural pluralism, whether from the perspective of advocates of the "open society" or other perspectives, tend to focus on two broad issues—(1) concepts of individual development and

opportunity and (2) concepts of the relationships between groups and the state and society's social structure. As will be seen, these criticisms almost exclusively focus on three versions of the concept of cultural pluralism—–insular pluralism, classical cultural pluralism, and cultural pluralism as separatism. The other versions of the cultural pluralism ideal cited above are rarely considered in these critiques.

Many critiques of cultural pluralism are based on the premise that the preservation and maintenance of ethnic groups can be and is restrictive to individuals' sense of identity and their opportunities for self–determination. For example, Francis Hsu, a psychological anthropologist, contends that in order to maintain a strong sense of group cohesion, many ethnic groups demand conformity to values and outlooks from their own members and discriminate against and ostracize those who do not conform to these viewpoints.[23] Philosopher Thomas F. Green argues that restrictions on individual self–determination are a result of the processes that ethnic groups utilize to transit values, outlooks, and dispositions across generations. He contends that such cultural transmission is most thorough and effective when groups are most insulated from intergroup associations. Green thus argues that maintenance of individual ethnic groups is assured only at the expense of individuals' opportunities for interactions with individuals in different ethnic groups. He concludes that restrictions on individuals' freedoms are an inevitable consequence of processes to solidify ethnic groups' identities and social standing.[24] Orlando Patterson, taking an historical point of view, contends that in modern societies that have a high degree of cultural diversity, ethnic groups tend toward becoming interest groups in order to enhance their competitiveness in seeking societal rewards and power. He argues, in turn, that ethnic groups' effectiveness as interest groups is dependent on the level of group cohesiveness they are able to maintain. Patterson therefore concludes that a primary effect of the retention of ethnic group cohesiveness is constriction of individuals' autonomy and freedom.[25]

Other critics focus not only on the possible effects of cultural pluralism on individuals as political or economic actors but on the psychosocial effects of group cohesion. Philosopher John Wilson, taking a humanistic perspective, is skeptical of claims that individuals' identities tend to reside in cultural traditions. He calls for empirical inquiry to investigate the question. In lieu of such inquiry, however, Wilson poses the question of whether a person's identity must or ought to reside in her or his culture. His response is that features in a culture "may not be, in themselves, good enough to rely on. They may not be worthy."[26] By this he means that some cultural practices may be unarguably wrong or unjust, may be trivial in comparison to the accomplishments of other cultures, or may be antirational and antidemocratic, in that some cultures prevent rational discussion of significant issues and problems. Nor is Wilson persuaded by

a person who claims that a specific culture is "mine" and therefore above criticism, arguing that such a claim in no way shows that certain cultural practices are true, worthwhile, or valuable. In conclusion, Wilson envisions individuals seeking their personal identities not within a transmitted, stable culture but in a culture–free, personal search for truth and beauty.

Wilson's point about the pursuit of truth dovetails with a critique of cultural pluralism by educational historian Diane Ravitch. Ravitch, arguing from the open society perspective, contends that the insular pluralism she says is embedded in many contemporary versions of multiculturalism aims to raise the pride and self–esteem of ethnic group members at the expense of the truth. Specifically, she argues that advocates of cultural pluralism too often call for the transmission of an ethnic group's history that is only a record of heroes and accomplishments, without due regard to influences exerted by other cultures on the group or consideration of debatable actions and practices in the group's history. Ravitch concludes that an individual's ethnic identity rooted in historical falsehoods or exaggerations is more a matter of self–deception than individual growth and development.[27]

A final issue regarding the potential psychosocial effects of cultural pluralism and ethnic group cohesion on individuals is raised by educational theorist Charles Tesconi. Tesconi contends that cultural pluralism rests on numerous untested assumptions. Among these is the assumption that attachment to a group, including an ethnic group, promotes an individual's sense of self and well–being. This assumption, Tesconi argues, is at best untested. But he concludes that even if it could be demonstrated that attachment to an ethnic group is conducive to an individual's development, it does not follow that such an individual would be able to feel respect and consideration for individual members of different ethnic groups. In other words, Tesconi contends that ethnic group cohesion does not necessarily lead to intergroup understanding and may therefore lead to conflict among individuals of diverse ethnic groups.[28]

This review of criticisms of the ideal of cultural pluralism now shifts to those that focus on relationships between ethnic groups, the state, and society's social structure. Some of these criticisms were foreshadowed in the discussion of the open society alternative to cultural pluralism. Nathan Glazer and Daniel P. Moynihan, for example, focus on the possible effects of state action on behalf of ethnic groups, that is, corporate pluralism. They argue that such action, which they label "affirmative discrimination," would lead to reverse discrimination toward qualified individuals in both public and private sectors, leading, in turn, to lowered performance standards in society as a whole and a backlash effect from those who perceive that corporate pluralism discriminates against them. A final consequence of corporate pluralism envisioned by Glazer and Moynihan is the "Balkanization" of ethnic groups, that is, a strengthening of group boundaries and the

intensification of feelings of group loyalties, inevitably leading to intergroup conflicts over resources and rewards.[29]

R. Freeman Butts, an educational philosopher, contends that cultural pluralism reinforces the tendency in the modern state toward single–issue, interest group politics. He argues that no single interest group or coalition of interest groups is, or can be, strong enough to set policy priorities to serve the overall public interest. Further, Butts claims that a contradiction is embedded in the ideal of cultural pluralism, namely, that the societal conditions necessary to the development of cultural pluralism—-freedom, equality, and justice—are not necessarily shared by those who promote the ideal of cultural pluralism. As an alternative to cultural pluralism, Butts recommends the promotion, through public institutions, of the knowledge and skills of participation needed for strengthening the values of freedom, equality, and justice characteristic of an open society.[30] Tesconi further contends that increased ethnic group cohesion, found in the ideal of cultural pluralism, and the associated feelings of group loyalties, can threaten ethnic groups members' loyalties to the nation in which they are citizens.[31]

Finally, two theorists contend that cultural pluralism, whatever its psychosocial consequences for individual members of ethnic groups, restricts the social mobility of ethnic minority groups and reinforces an inequitable status quo in society. Patterson, for example, argues that the continued existence and maintenance of ethnic groups is dependent upon often paternalistic gestures from the state that treats ethnic groups as corporate entities. This treatment, he contends, can limit, intentionally or not, opportunities for the social mobility of individual ethnic group members by reinforcing stereotypes, for example, the idea that all members of an ethnic group think and act alike and share the same aspirations.[32]

Stephen Steinberg argues that any assessment of cultural pluralism as a societal ideal must be tempered with consideration of historical experience and the American social structure. Taking a neo–Marxist perspective, Steinberg stresses that ethnic pluralism has its origins in conquest, slavery, and the exploitation of foreign labor and that it was the extreme segregation of racial minorities that allowed for the evolution of distinctive ethnic cultures built upon vestiges of traditional cultures. Given these historical roots, he contends that ethnic pluralism in America has a weak structural basis, that is, that continuation of distinct ethnic cultures is achieved only at the cost of maintaining inequitable power relations in society. Steinberg does not argue, as some have, that the values of some ethnic groups are socially dysfunctional and that therefore retention of these values limits ethnic group members' social and economic mobility. Instead, he concludes that the effort required by minority ethnic groups to retain and transmit their cultural values leaves them at the margins of social and

economic power and diverts attention away from the necessity of political mobilization to effect societal change toward redress of fundamental inequities.[33]

The many criticisms of cultural pluralism cited above tend to be *predictive* in nature, a necessary feature of such criticisms in that the cultural pluralism ideal is just that, an ideal. As was seen, these criticisms focused on anticipated consequences of the realization of the cultural pluralism ideal on both individuals and society at large. Cultural pluralism, it was argued, can, for a number of reasons, restrict individuals' opportunities for autonomous self–determination and limit possibilities for intergroup understanding; the anticipated societal effects of cultural pluralism included increased intergroup conflict, undermining of basic democratic values, cultivation of competing loyalties for a nation's citizens, reinforcement of status quo inequitable relations, and diversion from the mobilization needed for ethnic minority groups to effect change in society's economic and power relations. But because these critiques are primarily predictions of possible consequences of the cultural pluralism ideal and because, after all, cultural pluralism is a yet–to–be–realized ideal, these critiques do not, by themselves, negate cultural pluralism as a guide to public policy prescriptions.

Deciding on the merit of cultural pluralism as a guide to public policy prescriptions is not merely a matter of calculating potential consequences on individuals and society at large. As stressed in earlier chapters, policy analysis, specifically, normative policy analysis, is a matter of clarifying the concepts in policy arguments and the value positions that underlie them. Here is where the critiques of the cultural pluralism ideal cited here are most vulnerable, in that they seem to assume particular meanings of the term *cultural pluralism*, specifically, the meanings comprised by "insular pluralism" and "classical cultural pluralism," as discussed above.

That these critiques do not consider proposed meanings of cultural pluralism such as "modified cultural pluralism" or "cultural pluralism as voluntary ethnic choice" is a more significant point to make than any counterarguments that could be marshaled against specific criticisms of concepts of cultural pluralism dependent on the premise that ethnicity or group cohesion is necessarily restrictive to individuals or destructive to the broader public interest. As will be remembered, neither modified cultural pluralism nor cultural pluralism as voluntary ethnic choice holds that individual ethnic group members should be restricted, by design or in effect, in their exposure to and involvement with members of other ethnic groups. For its part, modified cultural pluralism envisions transmission of a substantial common culture rooted in commitment to basic democratic values of freedom, equality, and justice and, as well, considerable interaction between diverse ethnic group members in their primary and secondary relationships. Cultural pluralism as voluntary ethnic choice, far from

advocating a restrictive sense of group cohesion, advocates a view of ethnic group traditions as broadly shared resources available for the development and self–fulfillment of all individuals in a society.

While exposing common misconceptions about the concept of cultural pluralism, this response to various critiques does not, by itself, constitute a full–fledged defense of, or rationale for, cultural pluralism as a societal ideal. Many open questions remain. Notably, a logical dilemma seems to be embedded in the concept of modified cultural pluralism. This position calls for considerable interaction between members of diverse ethnic groups in their primary and secondary relationships as well as the continued significance of ethnic group identification. But it is not clear that these premises can be reconciled—interaction between ethnic groups may, in some cases, lead to virtual dissolution of the ethnic group identification necessary for the continued salience and even existence of specific ethnic groups. This dilemma is not an issue for supporters of cultural pluralism as voluntary ethnic choice, who view ethnic group maintenance as secondary to individual development and self–fulfillment. With modified cultural pluralism, however, this dilemma remains unresolved.

But most of the key open questions surrounding the cultural pluralism ideal as a guide to public policy are not logical dilemmas, but fundamental value questions. Paramount among these is the potential role of the state in facilitating the continuation and growth of ethnic groups as corporate entities and the consequences of state action or inaction, a question on which supporters of various forms of cultural pluralism differ considerably. An associated question centers on the standards of merit that should apply to ethnic group members when the state, or those acting on behalf of the state, makes decisions about the distribution of societal rewards and benefits. These questions, as they apply to the formulation of goals for public arts policy, are addressed in subsequent sections on affirmative action and artistic value.

First, however, a final criticism of the cultural pluralism ideal merits attention, a critique that places cultural pluralism in some historical perspective and questions the viability of the cultural pluralism ideal within the American social structure. Notably, Stephen Thernstrom contends that the rise of interest in multiculturalism and the associated concept of cultural pluralism is a class–based phenomenon led primarily by ethnic group members of high social status who, in an effort to retain their groups' status as corporate entities meriting state support, deny the effects of past assimilationist policies and intergroup contact on ethnic group distinctiveness. Thernstrom argues that in the face of reduced ethnic group cohesion and distinctiveness, advocates of cultural pluralism do not base their claims for continued corporate entity status of ethnic groups on the retention and maintenance of cultural traditions that make behavioral demands on ethnic

group members but on the "symbolic" or "expressive" activities of ethnic group members.[34] Similarly, Orlando Patterson interprets the rise of interest in multiculturalism and cultural pluralism as merely a function of the pursuit of economic claims against the state. He contends that without these economic interests ethnicity would consist only of symbolic cultural activities based on idealized views of ethnic traditions or on the expression of group grievances.[35]

Whatever the merit of these arguments as commentaries on the current state of ethnicity in America, they do embody an assumption that bears significantly on multiculturalism and arts policy. This assumption is that symbolic cultural activities, not limited to but including artistic activities, are virtually autonomous in origin from those aspects of ethnic cultural traditions that make behavioral demands on ethnic group members. In other words, according to this view, artists can and do produce art works that draw on symbolic aspects of ethnic group traditions while not committing themselves to the retention of an ethnic group culture's behaviors, outlooks, and dispositions.

This assertion, in turn, raises a perennial question: What are the relationships between art and culture? The possible answers to this question have important implications for arts policy. One aspect of this question centers on the cultural origins of artistic production; another aspect of the question, one not addressed by critics of the cultural pluralism ideal, centers on the actual and potential impact of the development and transmission of artistic forms rooted in ethnic cultural traditions on the continuation and maintenance of ethnic group identities. These two aspects of the relationship between art and culture, the effects of culture on art and the effect of art on culture, form the substance of the next section.

RELATIONS BETWEEN ART AND CULTURE

Seeking an understanding of the multidimensional relationship between art and culture is complicated by the apparent fact that this question either has not been of paramount interest to social scientists or has been construed in limited or problematic ways. Sociologist Vera Zolberg, while not impugning anthropological inquiry or the work of individual anthropologists, makes the point that the traditional orientations of anthropology have limited applicability to modern, complex, culturally diverse societies such as American society. First, anthropologists, as discussed in an earlier chapter, tend to view culture as the whole way of life of a society, consisting of structures of thought that, in turn, structure ways of thinking and behavior, including symbol systems such as the arts. Zolberg contends that this holistic approach to understanding art as a part of culture

is best and most often applied to smaller, relatively homogeneous societies. Seeking such a holistic understanding of the art–culture relationship in a large, complex, heterogeneous society with its many cultural traditions and institutional arenas, she concludes, is a virtually impossible task.[36]

Assessment of the limits of anthropological inquiry into relations between art and culture in a complex, culturally diverse society is not only the province of members of other social science disciplines like sociology. Anthropologist Alan P. Merriman contends that, historically, anthropologists have, for the most part, produced isolated, descriptive, microstudies confined within the contexts of specific cultures. This orientation, Merriman argues, not only is problematic as applied to complex societies but also limits the possibility for studies on the similarities and differences in art–culture relations across cultures. Merriman concludes that without cross–cultural, comparative studies, studies that focus on artists' own concepts and evaluations of what they do and the contexts in which their work is produced and received, attempts to construct theoretical accounts of the relations between art and culture are premature.[37]

For their part, sociologists with interests in the arts have tended to utilize data on the production, critical evaluation, distribution, and consumption of the arts as evidence in the construction of more general theories about social processes, institutions, and social structures. This "art as institution" orientation, as sociologist Milton Albrecht argues, has been premised on a strict separation of social factors from the cultural matrix of the arts, including the cultural meanings embedded in objects of art and the meanings and functions such objects have for individuals and groups.[38] Given this orientation, the sociology of art has not been fertile ground for explanatory theories on relations between art and culture in culturally diverse societies.

Despite these assessments and self–assessments of social scientists' progress in understanding art–culture relations, the impression should not be left that the question has been of no interest to anthropologists, sociologists, or others. Indeed, various aspects of this question have received attention, as will be seen. But first, and perhaps more significantly, it is clear that assumptions about relations between art and culture are and can be operative in practical contexts including, as noted in the previous chapter, arts policy contexts. A common such assumption, one expressed as a metaphor, is that art in some way "reflects" a culture. This assumption is prominent in language justifying public arts agencies' policies toward ethnic group cultures. While social scientists may not have progressed far on constructing theories of art–culture relations, many have critiqued the "art–reflects–culture" metaphor.

This metaphor has been critiqued from diverse perspectives. Culture theorist Raymond Williams and sociologist Vera Zolberg critique

the art–reflects–culture metaphor as inadequate on theoretical and empirical grounds. Williams suggests that the art–reflects–culture metaphor can be found in both traditional Marxist and liberal models of explanation. In its simplest position, Marxism asserts that art reflects the socio–economic structure of the society in which it is produced, while traditional liberalism holds that artistic production reflects the conditions for individual expression in a society. These theories of art–culture relations, Williams concludes, reverse the process of constructing a theoretical framework rooted in necessary empirical work by starting with the interpretive framework, then searching for illustrations to support the framework, all without due consideration for the unique qualities of different societies, historical periods, or local conditions.[39] Zolberg, in a similar manner, contends that the assumption that art reflects culture is a virtual **cliche** providing little illumination of the complex relations between art and culture in diverse societies. She argues that coming to an understanding of art–culture relations "entails paying attention to micro and macro–levels of society; considering structure and agency; encompassing cultural values as well as material interests. Only then can production, dissemination, and reception of the arts be fruitfully observed over time and across societal boundaries."[40]

Richard Wollheim's position on the art–reflects–culture metaphor in some ways mirrors those of Williams and Zolberg. He argues, for example, that no historian or social scientist has yet "produced any correlation between social conditions and art forms except on the most general, and therefore most trivial, level."[41] This critique is directed to one kind of concept of the art–reflects–culture metaphor, one that makes claims that the relationship of culture and art is a matter of causation. But Wollheim notes that other theorists seem not to rely on a causation theory of art–culture relations but on a noncausal type of explanation, one holding that art is "expressive" of societal conditions. Wollheim acknowledges that in contradistinction to the causal explanations of art–culture relations, the noncausal conception "does not presuppose any general correlation between kinds of art and kinds of society."[42] However, he does not absolve this position of the charge of bringing general presuppositions to the study of art, culture, and society. Wollheim notes that the noncausal conception of the idea that art reflects culture presupposes "a general and consistent method of reading of social conditions from works of art so that every particular work tells us uniquely of one set of social conditions. Such a method most naturally takes the form of a general theory about the function of art in society, for example, that art depicts society, or that it idealizes society, or that it is a compensation for society."[43] Yet Wollheim's critique of causal and noncausal conceptions of the art–reflects–culture metaphor is not limited to points about deficiencies in their explanatory value. Even if it

could be shown that art in some sense is caused by or is expressive of a culture, this conclusion, in Wollheim's view, would be less than satisfactory. This is so because any explanation of characteristics of art that relates them directly to social and cultural conditions necessarily leaves out other factors of potential explanatory value, including psychological factors.

Despite these critiques of the art–reflects–culture metaphor and critiques of social scientists' orientations to understanding art–culture relations, there has been no shortage of theoretical explanations of various aspects of relations between art and culture. One subject of theoretical activity is of special significance to multiculturalism and the arts, namely, the degree to which the production of art by artists rooted in ethnic cultural traditions is conditioned by socioeconomic relations in society. Theoretical accounts diverge significantly. For example, some neo–Marxists focus on the power of the modern state, which, as they see it, serves to protect inequitable power relations and the status quo. As part of its program of ideological control and hegemony, the state–supported dominant culture defines "good art" in terms of its own preferences and by positing ahistorical categories of artistic merit, while at the same time denying opportunities for dominated groups, especially ethnic minorities, to create and disseminate their own cultural products.[44] Henry Giroux, while also a neo–Marxist, offers a divergent account of the socioeconomic context of ethnic arts. He contends that the dominant culture's systems of ideological control are far from cohesive in contemporary society. This relative lack of control opens up tensions within the dominant culture and generates, in Giroux's terms, the possibilities for counter–hegemonic struggles. Among the possibilities he envisions are the production and dissemination of art rooted in ethnic cultures, ethnic cultures not defined in terms of traditional cultural values but redefined in relation to and in opposition to the dominant culture and power relations in society.[45]

The first two neo–Marxist accounts of contemporary socioeconomic conditions portray them either as oppressive to ethnic arts or as fractured enough to permit artistic production that uses ethnic identification to challenge the dominant culture. Raymond Williams, also a neo–Marxist who construes socioeconomic conditions as dominated by one culture over others, sees a range of possible responses by ethnic artists. On the one hand, Williams contends that ethnic arts may be sufficiently distanced from general socioeconomic conditions and the concerns of the dominant culture that they can be produced and disseminated in virtual autonomy from dominant socioeconomic interests. Williams, however, sees two additional responses in which ethnic groups engage the dominant culture, either implicitly or directly. *Alternative* cultural activity involves "the provision of alternative facilities for the production and exhibition...of certain kinds of work, where it is believed that existing institutions exclude or tend to exclude

these."[46] *Oppositional* cultural activities "characteristically begin with attacks on prevailing art forms and cultural institutions, and often with further attacks on the general conditions which are believed to be sustaining them."[47]

Other theoretical activity surrounding art–culture questions extends beyond the socioeconomic contexts of ethnic arts to the basic question of the relationship of art to culture. On this question, as well, there is no dearth of theoretical diversity. Arnold Hauser, a social historian of art, argues that ethnic culture is a virtually irrelevant factor in the development of elements of art. For ethnicity to exert an influence on the production of art, he argues, it would have to be a relatively static factor among other possible influences on artistic production. But Hauser contends that despite past evidence of ethnic group cohesion, contemporary ethnic groups, because of numerous socioeconomic factors, are undergoing constant change and are thus rendered irrelevant as a factor in the production of art.[48] Anthony Saville also holds that the influence of cultural factors on artistic production is negligible, arguing that there is no lawlike connection between forms of cultural life and the content of art, that is, the values espoused in art works. Saville makes this point because, in his view, any theory that views culture as determinative of the content of art necessarily assumes that individual artists have little or no freedom to create art that diverges from or challenges cultural influences, an assumption belied by the history of art.[49]

These views of the relative lack of salience of ethnicity in shaping artistic production can be contrasted with views that arrive at opposite conclusions. For example, Edmund Barry Gaither contends that all art is, in fundamental ways, culture specific. "Cultures generate aesthetic ideals according to their own history and beliefs. Cultures are validated by the authentic experience of a people as they understand it."[50] But Gaither, unlike critics of theories that posit culture as a strong influence on artistic production, does not assume a lawlike correspondence between art and culture. On the one hand, Gaither notes that "the creation of a particular work takes place within the context of technical and aesthetic traditions, whose canons govern the modes of presentation."[51] But Gaither qualifies this point by stating that "this does not limit how an artist may change or expand the scope of these prior traditions; rather, prior traditions are a backdrop against which one can easily recognize new growth."[52]

David J. Elliott, while recognizing a strong relationship between art and culture, construes the relationship somewhat differently than other theorists. He begins with the premise that culture is more than something a group of people has; it is something they do, comprising shared beliefs, concepts, and intentional actions. The expressive dimension of a culture, including the arts, comprises the systems deployed to communicate concepts and beliefs. Since the arts are rooted in these beliefs and concepts, Elliott

argues that "to develop insight into the meaning and use of culture it is not sufficient to pick the fruits of a culture, one must also look to its roots and shoots."[53] In other words, the arts are tangible results of action systems grounded in a culture's concepts and beliefs. "The roots of a culture lie in the belief system that informs how...tangible aspects of culture [like the arts] are generated, understood, evaluated, and categorized."[54]

The previous paragraphs summarized a range of views on aspects of relationships between art and culture. These views, for the most part, focused on the influence of culture and socioeconomic conditions on the production of art. Clearly, though, theories that focus on the production of art only go so far in addressing the original question of this chapter, namely, What role can art play in the maintenance of group cohesion in a multicultural society? But before examining this question, a few points on the production of art need to be made.

Whatever one's theoretical perspective, it must be conceded that many artists in contemporary American society create work that is rooted in subject matter inspired by the beliefs and concepts of ethnic cultural traditions. Such work is created both by artists immersed in a specific cultural tradition and by artists who self–consciously draw on the subject matter of ethnic cultural traditions in creating contemporary work. Documentation of this activity is the province of historians in various arts disciplines. But many of these historians make a significant point about the production of ethnic arts in contemporary society. The visual art historian Eugene Grigsby, for example, admits that in American society, because of the effects of various forms of ethnic group interaction and subsequent borrowing of cultural symbols, styles, and images, as well as the effects of past assimilationist policies, there are no "pure" traditions of ethnic art. As such, work that is created represents in most cases an amalgam of cultural influences and styles.[55] Ethnomusicologist Bruno Nettl makes a similar point, arguing that no contemporary culture in America can fairly claim an artistic style completely as its own without acknowledging considerable influence from other cultural traditions.[56] Finally, anthropologist Jacques Macquet argues that art works, whatever their cultural origins, embody dimensions that cut across cultures and dimensions that are culture specific. Art works have aesthetic and symbolic dimensions that Macquet contends can be perceived directly by viewers regardless of their cultural background or identity. This universal quality to art works from diverse cultures, according to Macquet, is rooted in the fact that many symbols in art works spring from experiences common to all human beings and because many visual symbols in art works based in a particular culture have potential meaning and significance for persons outside the culture. Macquet concludes that even those aspects of art works that are specific to a culture,

those referential features of art that shape its use and meanings within a culture, can be apprehended cognitively by outsiders.[57]

The time has come to move beyond questions of the production of art in cultural contexts to other aspects of the relationship between art and culture. This is so because whatever the content, style, and origins of ethnic art in its production, to address the basic question of the actual and potential effects of art on ethnic group cohesion, it is necessary to seek an understanding of how ethnic art is utilized in a multicultural society. Seeking such an understanding is particularly important because, in complex, modern societies, relationships between artists and individuals and groups who may in some way utilize their art are not simple or direct. Indeed, an important line of inquiry among sociologists of art is "artists' inability to control reception behavior of publics, either immediately at their creation, or later."[58]

An initial aspect of the relationship between art, including ethnic art, and its publics is the matter of perception, that is, how objects of art and their qualities and characteristics are perceived by individuals and groups. Of particular interest is the specific question of whether perception of art varies cross–culturally and, if so, how. This question has received some attention as it relates to the visual arts. For example, several empirical, cross–cultural studies conducted in past decades suggested that individuals from diverse cultural settings, when confronted with the same artistic phenomena, perceived artistic qualities in a similar fashion and even judged these qualities according to the same types of criteria.[59] But these sorts of empirical studies of perception have been critiqued on the grounds that what is measured is not some universal, cross–cultural mode of artistic perception but the lingering effects of the broad dissemination and influence of Western art objects on the perceptions and preferences of persons in non–Western cultures.[60]

More recent empirical studies also arrive at seemingly contradictory conclusions. A study by Adrienne Hoard yielded results that seem to support the hypothesis that the perceptual responses of African–Americans demonstrate sensitivities to the visual attributes of images created by African artists that embody cultural or ethnic stylistic cues.[61] A different study, one conducted by Ronald Neperud, Ronald Serlin, and Harvey Jenkins, examined the hypothesis that blacks differ significantly from non–blacks on the value and meaning perceived in the art of blacks. The study, however, revealed no significant differences between blacks and non–blacks in their perceptions of nonrepresentational art works by blacks. The authors conclude that ethnic identity alone is not a reliable predictor of perceptions and evaluations of ethnic art and that if certain perceptual and evaluative responses to ethnic art are to be attained and perpetuated, specific education and training are required.[62]

It would seem, after this brief review, that the results of empirical studies of cultural differences in the perception of art works are, at best, equivocal. But empirical studies such as those cited here utilize experimental or quasi–experimental methodologies. In other words, such studies are conducted in controlled situations. It seems reasonable to assume, however, that to understand the effects of art on ethnic groups in a multicultural society it is necessary to examine the nature of responses to art in noncontrolled situations, that is, in everyday life. Such an examination entails questions about the behavior of ethnic groups toward art, that is, in the language of economics, the consumption of art. How best to measure consumption of the arts has been the subject of considerable debate among arts researchers. Some define consumption of the arts as time spent on attending arts events and institutions and participating in artistic activities, while others focus on money spent on such activities. A final option, one to be utilized here, centers on determining the rates of yearly participation in artistic activities by individuals and groups.[63]

While research into arts consumption patterns is usually a matter of empirical inquiry, some researchers have offered theoretical accounts of patterns of participation in the arts. The most notable of these is the theory of taste cultures by Herbert Gans. Gans defines taste cultures not as organized societal or cultural groups but as "aggregates of people with usually but not always similar values making similar choices from the available offerings of culture."[64] He identifies five primary taste publics and their cultures in contemporary American society—high culture, upper–middle culture, lower–middle culture, low culture, and quasi–folk low culture. A review of these categories will not be attempted here. The point made by Gans that is most important for this discussion are his claims about factors shaping persons' choices among taste cultures. The determining factors he identifies include "class, age, religion, ethnic and racial background, regional origin, and place of residence, as well as personality factors which translate themselves into wants for specific types of cultural content."[65] But Gans qualifies this view by stating that "because ethnic, religious, regional, and place differences are disappearing rapidly in American society,...the major source of differentiation between taste cultures and publics is socioeconomic level or class."[66]

Gans's apparent deemphasis on race and ethnicity as a predictor of taste and consumption of the arts is also reflected in his view of the growth of black culture in American society. He describes the content of contemporary black culture and the arts as "directly or indirectly political, expressing, demanding, and justifying the legitimacy of a Black identity and a Black tradition in order to establish a cultural basis for racial equality."[67] Yet despite the growing salience of black culture, Gans refers to it as a partial culture in that for many aspects of everyday life "blacks share the

taste cultures created by whites, and their aesthetic standards, leisure, and consumption habits are little different from whites of similar socioeconomic level and age."[68]

The account of participation in the arts provided by Gans, in that it is a theoretical construct, requires at least supplementation by more empirical types of research. A prominent example of such inquiry is a recent study by Paul DiMaggio and Francie Ostrower on participation in the arts by whites and African–Americans. This study draws on data from a major National Endowment for the Arts study entitled *Survey of Public Participation in the Arts (SPPA)*, conducted in 1982 and replicated in 1985.[69] The surveys, with 13,675 responses, yielded the most comprehensive and, arguably, most reliable national data base on arts participation in America to date.

Based on the *SPPA* data, DiMaggio and Ostrower document relatively small but persistent differences in the nature of arts participation by blacks and whites. For example, it was found that black attendance at live, traditional Euro–American performing–arts events in music, theater, and dance as well as visual art exhibitions is lower than that of whites. It was also found, however, that the effects of race on these activities are far less than those of educational attainment and less than factors such as income, gender, or place of residence. In other words, blacks and whites of comparable educational attainment and income appear to attend Euro–American arts events at similar rates. In contrast, even when variables such as education, income, gender, or location are controlled, "blacks are substantially more likely than whites to attend jazz concerts, watch them on television, report enjoying jazz music, and report enjoying soul, blues, or rhythm and blues."[70] Thus, as DiMaggio and Ostrower point out, it appears that "race plays a far more decisive predictive role with respect to historically black forms than with respect to participation in Euro–American high culture."[71] But what, then, is one to make of data showing that many African–Americans participate at high levels in both Euro–American art forms and historically black forms? DiMaggio and Ostrower conclude that these data "suggest a pattern for blacks, especially middle–class blacks, of *dual engagement*, based on occupancy of multiple roles that provide incentives for involvement with both elite Euro–American and historically Afro–American artistic forms."[72]

As revealing as the DiMaggio–Ostrower study is on the arts consumption patterns of African–Americans and their apparent need for competencies in more than one cultural tradition, the authors caution against generalizing very far beyond these data. The reason for caution is based on the nature of *Survey of Public Participation in the Arts*, which yielded the data for the DiMaggio–Ostrower study. They argue that a national survey such as the *SPPA*, of necessity, focused on categories of arts participation

that pretests indicated would be understood by all potential survey respondents. As a consequence, the survey did not ask about artistic styles and forms that might be of significance to many Americans, including some ethnic art forms. DiMaggio and Ostrower conclude that if ethnic arts groups are oversampled in future replications of national surveys such as the *SPPA*, a better reading might be possible on questions of whether ethnic groups participate in the same art forms in similar or different ways and the degree of diversity both between and within ethnic groups.

The collection of data on the rates and nature of arts participation, even the comprehensive, fine–grained type of study proposed by DiMaggio and Ostrower, while a valuable line of inquiry, has its limitations. Examination of the types of arts events individuals choose to attend and how their participation is correlated with socio–economic and cultural variables leaves unresolved a number of questions about the origins and consequences of their choices. Arnold Hauser identifies several such questions. He notes that data collection on arts participation does not get at the role of the marketplace in shaping production of the arts and their dissemination, a factor that obviously conditions the nature of choices available. Hauser also argues that arts participation studies leave unexamined the quality, significance, and meaning of experiences in the arts for individuals and groups.[73] These two issues, the role of the marketplace and the meaning of arts experience, will be addressed in turn.

A common conclusion among sociologists who study the contemporary marketplace of the arts, a point cited above, is that artists are relatively unable to control the reception or consumption of their art among diverse publics. A key reason for this state of affairs is the heterogeneity of the contemporary art world consisting, as Vera Zolberg puts it, of "a plethora of art forms and styles, representing societies, states, and peoples of the world with few or no barriers of space and time."[74] As a consequence, then, many kinds of art work, including ethnic arts, find their own market of consumers whatever their origins or intended purposes.

These premises about relationships between the heterogeneity of art styles in contemporary society, their simultaneous availability through the marketplace, and how art is utilized by consumers are explored in recent analyses of the baby–boom generation's involvement with the arts. A National Endowment for the Arts Research Division analysis of its *Survey of Public Participation in the Arts* reveals two possible scenarios about baby–boomers and the arts: "If one assumes that baby boomers will adjust their attendance desires as they grow older and adopt attendance patterns similar to those reported by the older age groups, that implies a general expansion of audiences for the arts.... Alternatively, if one assumes that the baby–boomers are inherently different and will maintain their current participation preferences as they age, this will have a very different effect on

the art future."[75] A number of contemporary sociologists concur with the second scenario, arguing that baby boomers are indeed inherently different in artistic terms.

Judith H. Balfe, for example, in drawing on data from the *Survey of Public Participation in the Arts*, notes that despite their higher levels of education, more extensive socialization in the arts than their elders, and the fact that they were reared during the "arts boom" fueled by their elders, baby–boomers' "actual participation rates are lower than the national average for many arts forms."[76] Balfe cites many reasons for this phenomenon, ranging from tax laws to decreased leisure time. But she also stresses that these findings only apply to participation in Euro–American art forms. Elsewhere, speaking in theoretical terms, Balfe argues that "the internationalized market, the expansion of higher education, the democratization of the arts, and the availability of formerly elite culture through the mass media...[have fostered] cultural crossovers in all directions."[77] Such cultural crossovers, not limited to but including the simultaneous consumption of multiple, eclectic styles in the arts, are key characteristics of the ideology of postmodernism, itself embodying the goal of liberation from traditional hierarchies and imposed "high culture" standards in the arts.

Sociologist Richard Peterson examines the effects of postmodernism, with its simultaneous availability of an eclectic mix of artistic styles through the marketplace, on the reception and consumption of the arts by baby–boomers. Peterson describes a new aesthetic for the arts among baby–boomers, one that challenges foundations of the aesthetics of Western art. Two features of this new aesthetic Peterson terms "transvaluation" and "collaging."

Transvaluation is a process by which certain art forms undergo changes in how they are evaluated, a kind of aesthetic mobility. Historically, argues Peterson, many art works in the Western tradition initially "were created to meet the demands of a commercial market and have only since been transvalued as fine art."[78] Peterson cites the traditionally African–American musical form of jazz as a more recent example of transvaluation, an art form that was originally consumed as entertainment and later reinterpreted and patronized as fine art music. The transvaluation process in contemporary society extends to popular culture and ethnic arts with the consequence, as Peterson argues, that the Western fine art tradition, while sometimes part of the mix, "is not granted a privileged place in the emerging aesthetic."[79]

Another feature of postmodernism examined by Peterson, collaging, refers to a kind of demand–side aesthetic in which all art, "irrespective of its aesthetic origins, can be scanned, combined, and evaluated on the basis of its uses and effects."[80] In the case of visual arts, collaging has its roots in the wide–scale reproduction of visual arts of all ages, cultures, and

nations and their presentation at one place, such as exhibitions or publications, and on the same scale; as another example, recorded music "makes it possible for people to juxtapose pieces of music created in vastly different traditions that nonetheless sound good together."[81] Collaging has implications for possibl~ responses to ethnic art works. On the one hand, collaging means that ethnic arts can be coequal parts of the range of aesthetic choices made by consumers; on the other hand, however, response without regard to origins or intended effects would seem to render ethnic arts ineffective as a means to maintaining ethnic group cohesion in a multicultural society.

Characteristics of the contemporary marketplace for the arts having implications for ethnic arts are not limited to the simultaneous availability of an eclectic mix of artistic styles from diverse traditions. Specifically, it must be noted that in many instances the relationship between the production of art and its consumption is not merely consumer driven, or characterized by a demand–side aesthetic. The arts production–consumption relationship can be, and often is, interactive in nature, in which art is created and disseminated by artists with the intention of meeting the demands of specific market segments. This state of affairs, however, does not usually enhance the salience of ethnic arts in ethnic communities themselves.

Nelson Graburn, an anthropologist, has developed a typology of the production–consumption of ethnic arts that have resulted from the conquered or dominated status of ethnic groups in international contexts or multicultural societies. Graburn's typology is based on a basic distinction between two major types of ethnic arts: (1) those arts that are directed inwardly toward a culture, arts "that are made for, appreciated, and used by peoples within their own society";[82] and (2) "those arts for an external, dominant world."[83] As an example of the latter type of ethnic arts, an example consistent with an interactive production–consumption marketplace for ethnic arts, Graburn cites *souvenir art*. Graburn contends that in souvenir art, often termed "tourist art" or "airport art," "the symbolic content is so reduced, and conforms so entirely to the consumers' popular notions of the salient characteristics of the minority group, that we may call these items ethno–kitsch."[84] As a consequence, souvenir art tends to bear only a superficial resemblance to the traditional art of the culture of its creators. Souvenir art works are created, according to Graburn, "when the profit motive or the economic competition of poverty override aesthetic standards [and when] satisfying the consumer becomes more important than pleasing the artist."[85]

The types of ethnic arts identified in Graburn's typology are not limited to ethnic art created merely for consumption by the dominant culture in a multicultural society. For example, Graburn talks of *commercial fine arts*, or pseudotraditional arts. Such art works, "although they are made

with eventual sale in mind, adhere to culturally embedded aesthetic and formal standards."[86] The production of two other types of ethnic art is contingent not so much on the marketplace but in response to the effects of cultural domination and assimilation. *Assimilated fine arts* are created by ethnic artists who have adopted the established art forms of a dominant culture. *Reintegrated arts* are new art forms or syntheses created by integrating the themes, materials, and techniques of the arts of the dominant culture with those of ethnic cultural traditions. Finally, Graburn identifies a type of ethnic art relatively autonomous from the effects of the market-place and the dominant culture—*traditional or functional fine arts*. This is not to say that such art may not reflect changes in technique and form from traditional styles or even incorporate stylistic elements from the dominant culture. But traditional or functional fine arts do, according to Graburn, facilitate the transmission of culturally specific symbolic meanings.

The identification of traditional or functional fine arts, ethnic art that, as Graburn claims, retains a power to transmit culturally specific symbolic meanings, raises a final question surrounding relations between art and culture or, more specifically, the effects of art on culture—What meanings do ethnic arts have within ethnic groups? Unfortunately, inquiry into this significant question by social scientists, even among those with interests in the arts, has not been a priority. Anthropological inquiry, argues Edmund Feldman, would focus on the cultural and social functions and meanings of art and how "1) it influences the collective behavior of people; 2) it is created to be seen or used primarily in public situations; and 3) it expresses or describes collective aspects of life as opposed to personal kinds of experience."[87] For their part, sociologists are only beginning to study the social processes that shape how art works are interpreted and reinter-preted over time and the negotiations among and between cultural groups to establish the meaning of art works.

Despite the relative lack of research into the functions and meanings of art within ethnic group cultures, there has been no shortage of claims about what those functions and meanings might be. June King McFee, for example, summarizes historically identified functions that can operate individually or in combination and in varying degrees. Specifically, McFee claims that: (1) art can be used to objectify subjective values, emotions, ideas, and beliefs by making them sensuously tangible; (2) art can enhance and thereby enrich ritual and celebration in the life of a culture; (3) art can serve the purpose of communication by recording and transmit-ting a culture's meanings, qualities, and ideas; and (4) art can stabilize and contribute to a culture's stability by perpetuating its concepts of reality, identities, and accomplishments.[88] But this typology of the functions of art can be critiqued on the same grounds identified above in discussing anthropological inquiry into art—that it applies better to smaller, relatively

homogenous societies than to large, complex, heterogeneous societies with their diverse traditions and institutional arenas.

Some theorists, however, do consider the meaning and functions of art for ethnic groups in a multicultural society. Bruno Nettl, for example, contends that an important function of art is to symbolize the experiences and heritage of contemporary ethnic groups facing extinction, dissolution, or the effects of assimilationist policies.[89] Further, Samella Lewis argues that the meaning of art within an ethnic group is tied directly to the status and conditions of the group in a pluralistic society. In particular, she contends that the creation of ethnic art can lead to a cultural revival in the face of cultural oppression, celebrate the historical and contemporary experience of a people, and foster communication about political issues important to the survival and flourishing of ethnic groups.[90] However, as persuasive and plausible as these accounts of the functions and meanings of art for ethnic group cultures may be, documentation of these phenomena is notably scant in the social scientific literature, leaving assessment of the effects of art on cultural maintenance and cohesion problematic.

At this point, then, it is time to review the primary points in this section on relations between art and culture. A basic conclusion is that while the art–culture question has not been of paramount interest to social scientists, the research that does exist reveals considerable theoretical diversity. One relatively rare point of agreement centers on the common claim that art in some sense reflects a culture. The claim, while critiqued from various perspectives, does not and cannot specifically illuminate the complex relationships between art and culture in diverse societies. Among the many aspects of relationships between art and culture, one question that has received attention is the cultural context of production of the arts. Several neo–Marxist theories differ on the nature and extent of the effects of socioeconomic conditions on the production of ethnic art, while theorists from diverse perspectives differ sharply on the salience of ethnicity in shaping artistic production. Despite this diversity, it seems apparent that many artists in contemporary American society create work that can be reasonably said to be rooted in subject matter inspired by the beliefs and concepts of ethnic cultural traditions. At the same time, however, it also seems apparent that there are no "pure" traditions of ethnic art in American society and that no ethnic culture can claim an artistic style completely as its own without acknowledging considerable influence from other cultural traditions.

Yet, with those points made, it was further suggested that to address the question of the actual and potential effects of art on ethnic group cohesion it is necessary to examine how ethnic art is utilized in a contemporary, multicultural society. This question is addressed through review of available research on the perception, consumption, and meanings of art. It

was found that the results of empirical studies of cultural differences in the perception of art works are, at best, equivocal. Further, the significance of race and ethnicity as a predictor of taste and consumption varied among researchers. Even those studies that show that race/ethnicity plays a decisive role in the consumption of traditionally ethnic art forms, race/ethnicity has little significant, independent effect on consumption patterns for Euro–American art forms. Another dimension to the consumption question is the role of the marketplace. A primary conclusion based on a review of recent research is that the heterogeneity of artistic styles available through the marketplace means that art, including ethnic art, can be utilized in ways that are autonomous from art's cultural origins or intended effects. But it was also found that the marketplace for ethnic art can be not merely consumer driven but interactive between producers and consumers. This feature of the marketplace often means, however, that ethnic art is created not out of a fidelity to a cultural tradition but to meet the expectations and purchasing power of the dominant culture. Yet it was also found that some ethnic art is created predominantly to facilitate the transmission of culturally specific symbolic meanings. A final question examined in this section centered on the meanings ethnic arts have within ethnic groups. Despite a plethora of claims about the functions and meanings of art for ethnic group cultures, documentation of these phenomena was notably thin.

These conclusions suggest that the effects of ethnic art on the maintenance and cohesion of ethnic groups are far from clear. On the one hand, it appears that such effects are not as negligible as critics of the ideal of cultural pluralism suggest, that is, that ethnic art is virtually autonomous in origin from its cultural traditions and is tantamount, in its effects, to a middle–class diversion. Yet research also seems to indicate that the functions and meanings of ethnic art for ethnic groups in a multicultural society are complicated and potentially diminished by a wide range of factors. Therefore, it does seem clear that the creation and dissemination of ethnic art that has important meanings for ethnic groups in complex, heterogeneous societies do not occur naturally and that if such phenomena are to occur, they require some kind of support from the state as a matter of public policy.

This point leads to the topic of the next section—affirmative action and arts policy. Consideration of this topic is important for several reasons. First, as was seen in the previous chapter, affirmative action is a prominent feature of the policy mechanisms of many public arts agencies. Further, the value–laden concept of affirmative action must be addressed in considering what role the state should have in promoting the art of ethnic cultures. Finally, it was concluded above that the ideal of cultural pluralism, while often critiqued based on narrow conceptions of the term, was in some ways

a problematic basis for justifying the formulation of public policy goals in the arts. Examination of the concept of affirmative action, then, can also serve the purpose of clarifying whether a justification other than cultural pluralism can be found for policies to support the production and dissemination of ethnic arts, namely, a justification rooted in the concept of justice.

ARGUMENTS FOR AFFIRMATIVE ACTION IN ARTS POLICY

The introduction of the concept of justice into discussions about public policy and the arts can be related to the premises of some culture theorists who view the promotion of justice in a society and the achievement of a "high culture" as incompatible. T. S. Eliot, for one, sees culture as an organic structure, whereby the tools of culture are fostered through hereditary transmission, a process essentially contingent upon the persistence of defined social classes. In Eliot's view, the ideals of culture and social equality fundamentally conflict. He argues that if one cannot accept this state of affairs, then one should not use the term *culture*; conversely, if one wishes justice to prevail in a society, then one must also accept the deterioration of culture.[91] Culture theorist George Steiner similarly contends that the achievement of high culture is inevitably enmeshed with social injustice.[92] To take this viewpoint to its logical conclusion would entail state action to maintain and solidify class privilege for the sake of the growth and development of culture and its products, the arts. But apart from the question of the veracity of empirical premises embedded in this viewpoint, that is, that social inequality is necessary to the flourishing of culture and the arts, it is difficult to imagine a persuasive defense of social policy with the aim of perpetuating inequitable social relations. Few would be willing to sacrifice a society's fundamental sense of justice and equality to enhance the standing and significance of culture and the arts.

The question to be explored here is not an either/or, societal-wide choice between justice and the arts but the place of concepts of justice within a particular policy sphere—the arts. Discussion of justice and related concepts by arts policy analysts has been rare except for the frequent invocation of the importance of "access to the arts." Yet even in these instances the concept of justice underlying this slogan is most often left unclarified. A notable exception of this apparent rule is the concept of aesthetic justice, as developed by Monroe Beardsley. Discussed in Chapter 3, aesthetic justice refers to the equitable distribution of aesthetic wealth, the total set of objects of aesthetic value in a society, to members of that society.[93]

Affirmative action is the specific application of concepts of justice in a policy sphere such as arts policy. In general terms, affirmative action

programs stipulate the conditions under which the state and its agencies make societal opportunities and rewards available to groups, groups usually identified by race, ethnicity, sex, handicap, or age. Beyond this basic feature, however, public programs instituted in the name of affirmative action vary dramatically in terms of purpose, rationale, design, and intended consequences.

A brief review of the affirmative action programs found in state arts agencies illustrates this point. Many state arts agencies make equal opportunity an organizing principle of their policy mechanisms, seeking to ensure that no applicant, whatever his or her race, ethnicity, age, sex, handicap, or sexual preference, is subject to discrimination or other unfair practices in the competition for grant funds. Another feature common to state arts agencies' policy mechanisms are special initiatives designed primarily, though not exclusively, to enhance the competitiveness of ethnic group members of African–American, Asian, Hispanic, and Native American heritage in seeking grants. Special initiatives, which are usually integrated with the open–access–to–funding policy mechanism, take many forms that can be utilized singularly or in combination—technical assistance workshops, leadership training, active recruitment of grant applicants from minority ethnic groups, special advisory committees on multicultural issues, and the identification of ethnic group members for potential service on state arts agency boards and grant advisory panels. Still other state agencies utilize a special programs policy mechanism. Special programs, in most cases, are in–depth efforts to enhance the competitiveness of minority ethnic group artists and arts organizations in seeking arts funds. What distinguishes special programs from special initiatives is their comprehensive nature and the fact that only ethnic group members of African–American, Asian, Hispanic, and Native American heritage are eligible to participate. Finally, the distributive pluralism policy mechanism is more regulative in nature, requiring either that state arts funds be distributed on a formula basis to representatives of minority ethnic groups or that all potential organizational grantees must reflect in their programming and governing bodies the racial/ethnic makeup in the communities of which they are a part.

These diverse approaches to affirmative action utilized by public arts agencies at the state level embody most of the strategies and, significantly, the value assumptions about concepts of justice that are found in other policy spheres that adopt affirmative action programs. As such, affirmative action programs in public arts agencies are subject to and inherit many of the same problems and controversies found frequently in other areas of public policy. Among these challenges are the common responses to the idea of affirmative action in public discussions and the political forums of legislative bodies. Robert Fullinwider describes well the nature of appeals made for and against affirmative action in these contexts.

Although appealing to widely accepted moral intuitions, the arguments constructed on these appeals are usually imprecise, indecisive, and incomplete even when they are moderate and careful. Opponents talk past one another, never coming to grips. Catch–phrases and slogans substitute for analysis and criticism. The issues remain unfocused, unrefined, and no progress is made toward bringing a full understanding of the moral and legal questions in dispute.[94]

This conceptual morass is simultaneously the result of and exacerbated by two additional inherent problems in debates about affirmative action in public contexts. First, policy choices about affirmative action are inherently made under conditions of "partial ignorance," given "the incompleteness of our knowledge about the future effects of alternative social policies and, beyond that, the absence of a common and uniform way of weighing those effects."[95] This complication clearly applies to the arts policy arena in which, as discussed in detail in previous chapters, data on the distribution and effects of arts funding on artists and arts organizations rooted in ethnic cultural traditions are not uniformly defined, collected, or disseminated.

A further complication, one made more potent by the lack of information on the actual and potential effects of alternative affirmative action programs, "lies in the vagueness and indeterminacy inherent in the broad principles of justice to which we must appeal."[96] Any argument used to marshal support for or against specific affirmative action programs of necessity draws on concepts and principles of justice in that, as stated above, affirmative action entails the application of concepts of justice to a particular policy problem, that is, the condition of minority ethnic groups within a society. In the arts policy sphere, the use of concepts of justice in policy arguments is more often implicit than explicit, a phenomenon common to most other policy arenas. But because of the lack of other modes of analysis that could calculate the effects of affirmative action programs on the arts, analysis of the implicit use of concepts of justice is an essential means of evaluating the options available to and utilized by public arts agencies in formulating and implementing diverse affirmative action programs. Such an analysis will not likely settle the issue, but without clarification of the principles that can and do inform public policies, the possibility of resolving the seemingly intractable controversies surrounding affirmative action will be foreclosed.

In order to facilitate the analysis of implicit concepts of justice, it is possible to develop a typology of arguments that have been used historically to justify affirmative action programs in public policy settings.[97] These arguments include the following: (1) *compensatory justice*–that those who have benefited from injustices in a society acquire an obligation to

compensate victims for their losses; (2) *rights*—that individuals or groups have an unabridgeable entitlement to equal treatment or, in some cases, preferential treatment; (3) *utilitarian justice*—that positive actions toward minority ethnic groups will lead to social consequences that contribute to the overall well–being of society; (4) *distributive justice*—that governments have a positive duty to redistribute society's opportunities and resources and to improve the condition of those underserved by societal benefits; and (5) *equal opportunity*—that the opportunities of persons should be equal with respect to societal rewards and benefits and not subject to inappropriate forms of discrimination. These arguments will be analyzed in turn.

1. The idea of compensatory justice has a simple form about which few would argue in that it appeals to the widely felt intuition about making a victim of an injustice whole. In such instances, an individual is wronged by another in a specific situation; for example, one individual appropriates the property, causes physical harm to, or abrogates the rights of another individual. According to the principle of compensatory justice, then, the injured party acquires a right to be compensated in some way for the injury incurred. The nature of compensation, though, is of special importance to the simple form of compensatory justice. The wronged individual does not have the right to seek or receive compensation in an arbitrary way. Rather, "that right lies against a specific party and encompasses what that party rightfully has as a means of payment."[98]

Arguments for affirmative action that invoke the concept of compensatory justice, however, do not rely upon a simple form of the concept. The difference lies in the fact that affirmative action arguments hold that the obligation for compensation is incurred by a whole community, that it is a corporate responsibility. It is argued that the wrongs that have been visited upon minority ethnic groups historically, for example, slavery, segregation, and discrimination," are not simply the sum of individual wrongs done by whites. They are corporate wrongs flowing from the legal practices and legislative policies of the state itself."[99] Because so many of these wrongs were committed by groups of persons acting in official capacities and not merely by informal aggregates of individuals acting in private settings, the actions of these public officials, it is concluded, constitute the basis of a national debt inherited and incurred by living Americans.

This complex form of the concept of compensatory justice is rooted in the notion of vicarious liability. Vicarious liability entails the idea that an individual person "need not commit a particular act in order to be liable for obligations that arise from it."[100] It follows, then, that an individual white person in contemporary society is liable to limitations on his or her rights to equal consideration and treatment, even if he or she never personally caused injury to an individual member of a minority ethnic group, because he or she must contribute to reduction of the inherited debt of white

Americans. But the notion of vicarious liability extends further. This extension is based on a different interpretation of the debt inherited by white Americans. It is argued that the debt is incurred not only because the ancestors of contemporary white Americans acted in official capacities to enslave, segregate, or discriminate against minority ethnic groups but because white Americans have benefited from and still enjoy benefits derived from these wrongs. As such, even white Americans who claim they have not personally injured an individual ethnic group member cannot persuasively make a case for their innocence. The argument for affirmative action based on this interpretation of vicarious liability due to wrongful benefits is as follows: "Since these benefits derived from great wrongs, possession of them constitutes an unjust enrichment and the possessor is under an obligation to restore the benefits to their rightful recipients. Possession of illicit benefits undermines one's claim to 'innocence.' Such possession makes one an accessory after the fact, so to speak. The wrongful possession serves the same function as personal fault; it makes one liable to pay appropriate compensation."[101]

Use of the concept of compensatory justice in arguments justifying affirmative action has certain advantages. Notably, by focusing on making victims of past injustices whole, it does not depend on complicated means to calculate the future effects of affirmative action programs on minority ethnic groups. But the concept of compensatory justice, and its associated concept of vicarious liability, is problematic on several grounds. One critique challenges an empirical claim embedded in the notion of compensatory justice by arguing that the concept is rooted in a false premise. William Bradford Reynolds, for one, disputes the claim that inequitable racial and ethnic imbalances in contemporary public situations, such as workplaces, are explainable only as lingering effects of past discrimination or segregation. Instead, Reynolds asserts that the selection of occupations and securing of workplace positions are often determined by individual interest, industry, and ability.[102] The persuasiveness of these different explanations of the persistence of inequities in American society can, of course, be debated. But resolution of this debate is ultimately a matter for empirical inquiry. The most telling critiques of the concept of compensatory justice, on the other hand, can be made on logical grounds.

Marshall Cohen and Thomas Nagel, for example, question whether it is possible for affirmative action programs to meet the central goal of compensating victims of past injustices by requiring concessions from the beneficiaries of these injustices. They argue that even if affirmative action programs are defensible in terms of compensatory justice, inevitably, in practical terms, such programs can compensate only some of the victims of injustice and do not and cannot elicit concessions from all beneficiaries of injustice. According to Cohen and Nagel, then, affirmative action programs,

because they cannot cover all aspects of society where accrued benefits of injustice can be found, do not meet the requirement that justice must be truly compensatory on a societywide basis.[103]

This argument, that affirmative action programs are not fully just because they do not go far enough, is a relative rarity. A more common form of argument is one that contends that compensatory justice is an inadequate basis for public policy on the grounds that, in its pursuit of justice, other injustices are permitted. In its simplest form, the argument goes like this: Under compensatory justice, nonvictims benefit and the nonguilty are made to pay. The first part of this argument rests on an empirical claim that many of the minority group beneficiaries of affirmative action programs in educational and workplace settings have middle— or upper—middle—class status and are hence, according to those who make this argument, nonvictims.[104] But this claim requires empirical verification. The "nonguilty are made to pay" part of the above argument, however, entails basic questions about rights and responsibilities.

One premise in the notion of vicarious liability, where it is held that because of the past conduct of public officials all living white Americans incur a debt they must repay, can be reasonably argued to be based on an unwarranted inference. The premise involves a leap from the obligations of public officials to the obligations of individual citizens. By this logic, whites living in contemporary society must make restitution for the legal and legislative actions of past government officials in support of slavery, even though these individuals' ancestors may have been abolitionists or emigrated to America in the twentieth century. To hold that every individual acquires debts and liabilities merely because he or she is a member of a community defined by race seems unreasonable and threatening to important rights. The point can be made that any individual citizen has obligations to shoulder his or her fair share to the society of which she or he is a part. What constitutes a fair share? However one might define this term, it would be difficult to show that an individual's fair share "consists in his being deprived of his right to equal consideration."[105]

The argument that a government policy such as affirmative action, no matter how worthy its aims may be, cannot abrogate fundamental rights such as equal consideration and equal treatment can be extended to the idea of vicarious liability due to wrongful benefits. Any perpetrator who can be proven to have wrongfully injured another can be fairly expected to make that victim whole through some form of restitution. But can another individual, who may not have received any unjust deserts as a result of past injustices, or who had no means of avoiding inherited benefits, be obligated to make restitution solely on the basis of his or her race? Before answering this question, it should be pointed out that this same individual may well incur a personal loss in making restitution as a result of an affirmative action

program; that is, he or she may not have an equal opportunity to secure, for example, placement in a university program, a job, or grants funds. Thus, in this scenario, an individual who may not have benefited from past injustices or has done so unknowingly or even unwillingly both has his or her rights to equal opportunity abrogated and may indeed suffer a tangible loss of equal treatment in the pursuit of a position, job, or funds. Such a scenario, it seems to me, is not defensible.

It does not follow from this critique of the concept of compensatory justice that no one is personally responsible for discriminative practices against minority ethnic groups. It is the principle of vicarious liability, which makes persons liable for what they could not avoid or help, that cannot be defended. On the other hand, this critique in no way forecloses the possibility that a different justification of affirmative action programs within public policies can be found. Other possibilities will be examined.

2. A major impediment to the justification of affirmative action programs on the basis of compensatory justice was the idea that such programs violate the fundamental rights of individuals, most notably, the right to equal treatment. But depending on how one conceives of rights, the right to equal treatment may not be an insuperable barrier to building a case for affirmative action programs. Indeed, the concept of rights can be at the core of such a justification.

One possible approach to citing rights in a justification of affirmative action programs is to contend that individuals have rights against the state that are prior to the rights created by explicit legislation. In this sense, rights are an inherent part of human nature and thus cannot be superseded by public policies or legislation in a defensible way. This conception of rights has a long tradition and has regained currency among contemporary theorists.[106] Based on this conception, then, it could be argued that some individuals have a fundamental right to special treatment due to the past deprivation of the group of which they are a member. But such an argument would hardly resolve the issue. Specifically, it can be asserted that the right to equal treatment is a fundamental right that is inviolate and cannot be dismissed with justification by a policy or legislation. Thus, these two rights are defined and asserted as fundamental and inviolate, leading to a scenario of contending fundamental rights and arguments for and against affirmative action programs.

A primary means of resolving such a dilemma, whether the rights are viewed as fundamental or not, is to show that one right in some way supersedes another in specific contexts. Judith Thomson contends that some rights can override others if one right is more stringent than the other.[107] Can it be said, then, that the right to special treatment for minority ethnic group members supersedes others' right to equal treatment? It is hard to conclude that this conflict of rights meets the criterion set by Thompson.

This is so because merely stipulating that affirmative action (and special treatment) is a fundamental right does not solve problems associated with the idea of vicarious liability, that is, that individuals who may not have benefited from past injustices or have done so unknowingly or even unwillingly suffer a tangible loss in the pursuit of a position, job, or funds. Under these conditions, it is not clear that the right to equal treatment should be superseded.

Another means of justifying affirmative action programs is to construe conflicts of rights not as an issue of individual rights versus individual compensation but, rather, as a matter of group rights and group compensation. Such a reconception could seemingly render moot difficulties that arose in discussions of compensatory justice associated with the establishment of individual liability and compensation. What, then, is meant by group rights? If one were to define group rights only as an aggregate of the rights of all individuals in a group, then the concept of group rights would be saddled with many of the same problems cited above.

The question becomes, then, whether it is possible "to attribute to the group a right which is distinct from and independent of the rights of its members."[108] Or, as the question applies to minority ethnic groups, is it possible to talk about a group interest that is harmed when individual members of the group are victims of discrimination? To talk in this way, however, seems to involve an equivocation. It is plausible, for example, that a group, such as a minority ethnic group, can be the object of an individual's interest. An individual ethnic group member can clearly desire the right of equal treatment for her entire group as well as for herself. More specifically, she could desire a significant increase in the average annual income of the members of her group. But this example, and others like it, seems to represent a group–oriented interest on the part of an individual ethnic group member. The sum of these group–oriented interests, however, does not appear to satisfy a criterion of the concept of group rights, namely, that group rights are distinct from and independent of the rights of its members.

Using the concept of rights as the center of a defense of affirmative action programs is, to say the least, problematic. On the one hand, conceiving of affirmative action and special treatment as rights leads to the various problems with compensatory justice and vicarious liability cited above; and the concept of group rights seems to entail an equivocation. Clearly, other bases for justifying affirmative action must be explored, including utilitarian justice.

3. The concept of utilitarian justice does not depend on notions of compensation, vicarious liability, or group rights in justification arguments for affirmative action programs. Instead, utilitarian justice is a conception of how the consequences of a public policy can serve the public interest or the common good. The public policy of affirmative action, it is argued, can

result in social, racial, and ethnic interaction contributing to the overall well–being of society.

A number of utilities or positive consequences are anticipated by proponents of the utilitarian justice justification of affirmative action. For example, it is argued that affirmative action programs in workplace settings can increase the representation of minority ethnic group members in more lucrative jobs, thereby increasing the average income of these persons and their families. This upward economic mobility can, in turn, help to break down ethnic stereotypes born of the perceived association of ethnic minority status and poverty. This view is premised on the prediction that as more ethnic minority group members become owners, managers, executives, and supervisors in workplaces, psychological supports for ethnic stereotyping and even racism will be weakened. In turn, as more minority ethnic group members occupy decision–making roles, "the decisions made in these roles are less likely to reflect prejudice."[109] Further, persons in these positions can serve as role models for young minority group members to aspire to. Finally, the anticipated positive consequences of utilitarian justice can be phrased in terms of arts policy as well. An argument of this sort could cite anticipated benefits such as increases in the production of art work rooted in ethnic cultural traditions, art of potential meaning to ethnic groups themselves and a source of valuable experience to the entire citizenry.

Two primary criticisms of the utilitarian justice justification of affirmative action programs are often cited: (1) that it permits the rewarding of unqualified or underqualified workers, applicants, or grant seekers, and (2) that the hiring of unqualified workers will lead to reduced efficiency in the workplace. Meeting each of these criticisms turns on the concept of qualifications. Qualifications refer to the full range of capacities and talents that will help a person do what an employer seeks or a funder requires. Affirmative action programs can surely be designed where differences in qualifications between the best qualified and the minimally qualified are not very great and where any special treatment is extended only to those that are at least minimally qualified.

Further, it could be argued that the ethnicity of an applicant is a legitimate qualification for a job, position, or grant. Such an argument could assert that persons of a particular ethnic background will bring such valuable perspectives and life experiences to a workplace or program that such background can be considered a qualification, or it could assert that ethnic background is so important to the performance of a specific kind of work that it is a necessary qualification sought in any applicant. But this second type of argument with its ethnicity–as–a–qualification premise, taken to its logical conclusion, can be turned against proponents of affirmative action. If one is to count a particular ethnic background as a necessary qualification that must be met because applicants meeting it will satisfy a need that an

employer or institution defines for itself, then it must be allowed that the same employer or institution can count ethnic background as a disqualification in meeting its goals. To not allow for this implication is to engage in equivocation. Fullinwider articulates the point about equivocation well, arguing that "persons receiving benefits justified solely by the social utility of their receiving them cannot complain when these benefits are taken away because new utility maximizing policies are adopted. Nor can they complain when they are called upon to make sacrifices for the public interest if their previous immunity from sacrifice derived only from the public interest. The public interest can change."[110]

This point illustrates a basic problem with invoking utilitarian justice in justifying affirmative action programs. A central premise of utilitarian justice is that social policy is a matter of weighing the costs and benefits of proposed actions as they relate to the public interest or common good. As such, any policy, of necessity, imposes sacrifices on some persons, in some cases, unevenly so. But such sacrifices are seen, according to utilitarian justice, as regrettable, but justified, in calculations for the collective good.

The idea of calculating costs and benefits of social policy is a key to critiquing the idea of utilitarian justice. To determine the collective good or collective welfare, one must be able to measure the welfare of an individual. But, as Ronald Dworkin asks, "how can the welfare of an individual be measured, even in principle, and how can gains in the welfare of different individuals be added and then compared with losses, so as to justify the claim that gains outweigh losses overall?"[111] Theorists have tried to answer this question in two ways. One way argued for historically is to first calculate the pain or pleasure that a specific policy brings to an individual, add all affected individuals' pleasures together, and then subtract all of the pain the policy brings to the same individuals. The difference constitutes the collective welfare. This solution to the "calculation" problem, however, is hardly satisfactory. In Dworkin's words, "It is doubtful whether there exists a simple psychological state of pleasure common to all those who benefit from a policy or of pain common to all those who lose by it; in any case it would be impossible to identify, measure, and add the different pleasures and pains felt by vast numbers of people."[112]

Another approach to solving the calculation problem is preference utilitarianism. Rather than calculating individuals' pains and pleasures, preference utilitarianism attempts to arrive at the collective welfare by calculating the preferences individuals have for the consequences of one policy decision over another. It would seem that measuring preferences, for example, through survey research, is at least feasible, unlike the measurement of pleasures and pains. But other problems remain with preference utilitarianism, most notably, that it can be contradictory to the utilitarian tenet of promoting the collective welfare. This is so because, first,

preference utilitarianism is designed to give equal weight to all individuals' preferences, and policymakers are expected to satisfy people's preferences as much as possible. This expectation extends to individuals' preferences for consequences of a policy that are both *personal* and *external*. A personal preference refers to a person's own actual or anticipated enjoyment of opportunities, resources, and rewards; an external preference relates to the assignment of opportunities, resources, and rewards to others. External preferences, by this definition, can include preferences for the opportunities and rewards of minority ethnic groups that reflect racist ideologies. Therefore, because such preferences are to be given equal weight in preference utilitarianism, it is hard to imagine how the resulting calculation of preferences for policies' consequences can contribute to achievement of the ultimate goal of utilitarian justice, that is, promotion of collective welfare.

In conclusion, this scenario concerning the accommodation of racism highlights an issue that was raised above in the ethnicity–as–a–qualification discussion. As will be recalled, utilitarian justice permits uneven sacrifices by some individuals for the sake of the collective good. It has been since shown that utilitarian justice permits calculations that clearly cannot contribute to the collective good. But this scenario suggests that utilitarian justice allows not only for unequal sacrifice but for unequal treatment as well. This premise would clearly be anathema to those who consider the right to equal treatment as inviolable in public policy formulation and implementation. But whatever value one places on the right to equal treatment, it seems clear that few persons would willingly phrase a justification of affirmative action programs in terms of utilitarian justice, considering that, if taken to its logical conclusion, utilitarian justice permits accommodation of racist ideologies.

4. The concept of distributive justice offers another possible basis for justifying affirmative action programs. It differs in substantive ways from the concepts of compensatory justice and utilitarian justice. Arguments rooted in distributive justice contend that affirmative action programs are justified regardless of whether individual minority ethnic group members merit or need compensation for past injustices and regardless of whether affirmative action maximizes social utilities. Distributive justice entails the distribution of resources and rewards to members of a society. Beyond this, however, there seems to be little agreement about the requirements of distributive justice. As Fullinwider asks, "Does a just society assure that the rewards people receive are commensurate to their need? Or their contribution? Or their moral desert? All of these? None of these? Or, does a just society distribute and redistribute resources so as to make each person's income, wealth, or social position approximately equal to everyone else's?"[113]

This final version of the concept of distributive justice will be the focus of analysis here, largely because this concept appears to underlie the distributive pluralism policy mechanism adopted by several state arts agencies. As will be recalled, the Kentucky Arts Council seeks to distribute its funds so that all of the state's citizens will benefit fully and equally from the arts. The Michigan Council for the Arts, a somewhat different example of the distributive pluralism policy mechanism, requires a specific percentage distribution of its funds to African–American, Asian, Hispanic, and Native American artists and arts organizations. Even though these examples of the distributive pluralism policy mechanism differ in details, they both embody the assumption that a justifiable goal for public agencies is to distribute their resources in order to secure equal results and benefits among the citizenry.

The concept of distributive justice can be critiqued from a variety of perspectives. Thomas Nagel, for one, contends that the redistribution of a particular policy sphere's resources and benefits to the citizenry does not go far enough. Nagel arrives at this conclusion based on the belief that economic inequality in contemporary society is not a matter of how rewards are distributed but a result of a reward system that justifies reward schedules that are vastly different even though, in his view, persons do not differ sufficiently in their efforts to warrant such different rewards. Thus, he reasons, affirmative action programs that aim to redistribute rewards and benefits on the basis of race and ethnicity do little to address the fundamental inequalities of a market economy that permits unwarranted economic rewards in the first place.[114]

Other critiques that can be and have been marshaled against the concept of distributive pluralism for equal results are, in many ways, reminiscent of the critiques of compensatory justice, group rights, and utilitarian justice. Nathan Glazer, for example, questions an underlying empirical premise of the distributive pluralism concept, that differential representation of minority ethnic groups in a variety of public settings is only the result of past discrimination or continuing institutional racism. Glazer contends that such an explanation neglects individual interest, industry, and ability as significant variables in explaining racial ethnic imbalances in contemporary society.[115] It is also argued that under distributive justice nonvictims benefit and the nonguilty are made to pay. The first claim rests on the conclusion that the minority group beneficiaries of a specific, prearranged distribution of resources are often of middle– or upper–class status and, hence, in no special need of receiving redistributed resources. The second claim recalls the above critique of vicarious liability, that persons who may not have benefited from past injustices or have done so unknowingly or unwillingly should not have their resources redistributed through affirmative action.

An alternative critique of distributive justice is unique to arts policy. In particular, this critique centers on the regulation found in some versions of the distributive pluralism policy mechanism that all arts agency applicants and grantees must proportionately represent the ethnic diversity of their communities in their organizations' audiences. This application of the idea of distributive justice is difficult to defend. The DiMaggio–Ostrower study cited above demonstrated that while education and income are the most potent predictors of participation in the arts, race/ethnicity does exert an independent influence on consumption patterns for certain art forms, most notably, jazz, blues, and rhythm and blues. It was also found that rates of participation by blacks in forms such as classical music and opera are significantly lower than those of whites.[116] Finally, it will be remembered that DiMaggio and Ostrower pointed out that the *Survey of Public Participation in the Arts*, on which they based their study, did not collect data on participation rates for a wide variety of ethnic art forms; but it seems reasonable to assume that race/ethnicity is a significant factor in determining participation in ethnic arts.

This brief review of findings on arts participation illustrates a basic and perhaps obvious point, that many of the art forms and artistic styles that arts organizations seeking public arts agency funds present are not equally attractive to Euro–Americans, African–Americans, Asians, Hispanics, and Native Americans. As such, then, requiring that all arts organizations proportionately represent these communities among their audiences seems, at best, impractical and, at worst, unreasonable. On the other hand, another regulation used by public arts agencies who adopt the distributive pluralism policy mechanism, the requirement that grant funds be distributed proportionately to artists and arts organizations in ethnic communities, is not impractical. A policy with this regulation could be implemented. However, it can certainly be objected to on other than practical grounds. Some might say that such a regulation could potentially reward unqualified grant seekers. But substantiating a prediction like this is an empirical matter, and as the discussion of qualifications indicated above, such a prediction may beg the question of what can count as qualifications. A more substantive critique of this type of regulation rests on the principles of equal opportunity and equal treatment. Such an argument would go something like this: By directing prearranged percentages of an agency's available funds on the basis of race/ethnicity, those not included in these categories will be denied equality of opportunity and, hence, equal treatment.

To this point, the principles of equal opportunity and equal treatment have been cited in critiques of compensatory justice, utilitarian justice, and now, distributive justice. The time has come to examine these principles more closely. A primary question to be explored is whether the principles of equal opportunity and equal treatment stand unalterably

opposed to any justification of affirmative action programs and, if so, whether such opposition is decisive. But the discussion will also attempt to distinguish possible meanings of *equal opportunity* and *equal treatment*. Indeed, depending on how one conceives of these terms, they might even constitute the basis for a defense of affirmative action programs.

5. The concepts of equal opportunity and equal treatment have a complex relationship. At times they are thought to be synonymous. But equal treatment is usually thought of as a more specific concept that can be subsumed under the general concept of equal opportunity. Yet, as will be seen, it is possible to draw very different conclusions about affirmative action based on these two concepts.

The concept of equal treatment refers to the right of all individuals who seek employment, a position, or funding to receive equal consideration. This right does not entail the notion that everyone is equally entitled to every job, position, or grant. This is so because the concept of equal treatment includes two qualifying premises: (1) that persons to which this right applies must be qualified for the job, position, or grant in question, and (2) that the candidate chosen be chosen solely on the basis of his or her best fulfilling the qualifications of the job, position, or grant. The right of equal opportunity is consistent with these two premises. But it goes further by requiring that individuals not be subjected to inappropriate forms of discrimination in competing for a job, position, or grant. Additionally, according to different interpretations, equal opportunity either entails equalizing qualified persons' obstacles in their pursuit of a job, position, or grant or entails taking positive steps to enhance the competitiveness of individuals and groups in this pursuit.

These different versions of the concept of equal opportunity will be explored below. First, however, it is important to see how implications for affirmative action are derived from the concept of equal treatment. Some interpret equal treatment as an inviolable, individual human right rooted in the principle "that it is wrong to treat two persons differently if there is no morally relevant difference between them. It does not proscribe treating people differently, only treating people differently who are not differ-ent."[117] When applied to employment or grant—seeking situations, this principle holds that instances in which an otherwise qualified person's race or ethnicity counts against him or her are morally wrong; it also holds that instances in which a person's race or ethnicity counts in favor of him or her, especially where there is some question about the applicant's qualifications, are morally wrong. Affirmative action programs that take positive account of applicants' race and ethnicity are therefore unjustified because they permit the rights to equal treatment of persons not in these categories to be abrogated. As such, such persons are the victims of reverse discrimination

and are at an unfair disadvantage in the competition for jobs, positions, or grants.

Proponents of the principle of equal opportunity, and anyone else not committed to a racist ideology, clearly contend that qualified persons should not suffer a competitive disadvantage in the pursuit of their personal employment or funding goals solely on the basis of race or ethnicity. But the question then becomes whether it is sufficient only to ensure that persons not be subject to unwarranted forms of discrimination, as "equal treatment" theorists contend, or whether it is necessary to actively make up competitive disadvantages so that all qualified persons or those who seek to be qualified can compete for jobs, positions, or grants on an equal basis. Policies that propose actions to equalize competitive opportunities, such as various versions of affirmative action, must address two fundamental questions: (1) What is the nature of obstacles to fair competition? and (2) What sorts of remedies are permissible and consistent with principles of justice?

It is certainly possible to define obstacles to equal opportunity as the effects of past injustices visited upon ethnic groups. But this conception entails support for problematic notions of vicarious liability and group rights discussed above. It is also possible to define obstacles to equal opportunity extremely broadly to include everything from "natural" intelligence to family background to individual motivation and effort. But such definitions raise the spectre of eugenics and broad social engineering, both of which could virtually extinguish basic individual rights such as freedom and liberty, not to mention the right to equal treatment.[118]

A more limited concept of obstacles, then, is required to use equal opportunity as a justification for affirmative action programs. Such a definition, it seems to me, must be related closely to the situation in which the idea of equal opportunity applies, namely, the situation in which individuals are competing in the pursuit of jobs or positions and where individuals or organizations are competing for grants funds. Implicit in any definition of this sort is the idea that effective competition for, for example, grants funds requires knowledge, accomplishment, talent, and skills on the part of the applicant. In other words, the individual or organization must exhibit to a substantive degree the required knowledge, accomplishment, talent, and skills stipulated by public agencies to merit a grant award. Deficits in these areas are a necessary condition of a definition of obstacles within the concept of equal opportunity; but, by themselves, they are hardly sufficient. Otherwise, anyone or any organization, no matter how great the deficits in their qualifications, could claim to be subjected to obstacles in seeking a grant. Thus, it seems reasonable to suggest that applicants be at least minimally qualified, that they exhibit some of the knowledge,

accomplishments, talent, and skills, before they can be said to face obstacles in pursuit of a grant.

That said, it could still be argued that any obstacles certain applicants face are the result of their own lack of interest, industry, or talent. Thus, a further necessary condition of the definition of obstacles is that they are impediments that individuals or organizations, through no lack of effort on their own, could not have avoided. Admittedly, this conception of the term *obstacles* casts a rather wide net. It could be further argued that if public agencies base their affirmative action programs on this concept of obstacles, then they commit themselves to an extensive effort to determine whether individuals' relative deficiencies in terms of qualifications could have been avoided or not, a virtually impossible task. But this conclusion about implications of the conception of obstacles is not a necessary one; it depends on how one answers the second question referred to above, that is, how one conceives of remedies to address obstacles to equal opportunity.

To be consistent with the definition of obstacles outlined here, any remedies for individuals' lack of opportunity must be directed to the qualifications necessary to compete effectively for jobs, positions, or grants while not compromising others' rights to equal treatment. It also seems to me, as a matter of common sense, that any remedies should be directed to those factors within a policy sphere that can actually be affected by an agency's actions or requirements. Taking the arts policy sphere as an example, it seems clear that arts policymakers, whatever their good intentions, cannot be effective if they devise remedies designed to address those basic socioeconomic structures in society that condition opportunities for ethnic artists and arts organizations to produce and disseminate their work. Such policy activities are beyond the scope of what small public agencies, such as public arts agencies, directly can affect. There are other factors beyond the scope of public arts agencies to affect that bear more directly on the qualifications of grant seekers. It was noted earlier that individuals or organizations, in order to both effectively compete for and merit a grant, must exhibit the required knowledge, accomplishments, talent, and skills stipulated by public agencies. The talents and accomplishments of applicants, clearly, are not factors that a public agency can directly control or affect. The development of knowledge and skills in potential and actual applicants, however, is within the scope of a public agency's activities. If agency–sponsored activities take the form of training opportunities such as workshops or technical assistance designed to enhance the knowledge and skills, it seems reasonable to conclude that these sorts of opportunities may help otherwise qualified applicants to compete effectively for grants. As such, these sorts of remedies would be consistent with the equal opportunity concept of justice by helping individuals and organizations to overcome obstacles they may face in situations where the principle of equal treatment

pertains. These remedies also reward efforts to seek out and take advantage of opportunities available.[119]

This description of justifiable remedies, however, begs a basic question—To whom should these remedies be available? The problems with identifying individuals to whom compensatory justice applies and those problems associated with groups rights and vicarious liability have been discussed at length to this point. Bearing these problems in mind, it does not seem warranted, on practical grounds, to restrict remedies designed to equalize opportunity for grant seekers to members of ethnic groups. Further, and more substantively, such restrictions would be inconsistent with the definition of obstacles as defined above, that some applicants, whatever their racial or ethnic background, face impediments to effective competition that they could not have avoided. But can these remedies then be called examples of affirmative action? They can be, I believe, if making training opportunities available is supplemented by special initiatives to build awareness of these opportunities among artists and organizations rooted in ethnic cultural communities and actively recruiting applicants as well. There is nothing in the concepts of equal treatment and equal opportunity that could prohibit these special initiatives.[120]

This concept of equal opportunity, and its associated concepts of obstacles to equal opportunity and remedies to promote fair competition, can serve as a justification for many types of affirmative action programs utilized currently by state arts agencies. These include technical assistance workshops, leadership training, and active recruitment of grant applicants from minority ethnic groups. But special programs in which eligibility is restricted to members of ethnic groups and the distributive pluralism policy mechanism requiring either formulaic distribution of arts funds or the "reflection" of the racial/ethnic makeup found in artists' and arts organizations' communities, in that they draw on concepts of compensatory justice and distributive justice, cannot be justified by the equal opportunity argument. It must be stressed, however, that because some types of affirmative action programs can be justified by clarifying underlying value assumptions that inform them, does not mean that any specific program is effective in neutralizing obstacles to equal opportunity among ethnic groups. Documentation of effectiveness is ultimately a matter of empirical inquiry.

But the equal opportunity argument outlined to this point leaves open one additional theoretical question that warrants close examination. It will be remembered that the remedies described and justified here are designed to facilitate fair competition for grants, competition to be decided by reference to qualifications and criteria designated by public agencies. The many criteria utilized by state arts agencies were outlined in the previous chapter. It is not difficult to imagine affirmative action programs that can enhance the capacity of funding applicants from ethnic groups to

better meet criteria such as skills in management, marketing, and fund–raising. But such programs would not directly address the decision–making criteria cited most often and given the greatest weight by state arts agencies, namely, artistic excellence or artistic value. As was also seen in the previous chapter, views of what constitutes artistic value and whether it is a concept that varies by culture or can be applied cross–culturally either vary or are left unclarified by state arts agencies. But if an argument justifying affirmative action programs based on an equal opportunity concept of justice is to be sustained, then the concept that is the most prominent of all criteria in arts funding decisions, artistic value, must be clarified. If decision–making policies are established and implemented that are founded on a concept of artistic value that is inapplicable to artists and arts organizations based in ethnic cultural traditions, then no matter what remedies are in place to equalize opportunities in the pursuit of arts agency funding, such policies cannot be said to be justified. An examination of the key concept of artistic value is the subject of the next section.

MULTIPLE MEANINGS OF THE VALUE OF THE ARTS

A rationale for exploring the nature and possible meanings of the concept of artistic value was offered in the previous section: If equal opportunity is to be realized in the decision–making practices of public arts agencies, then the most important criterion used to evaluate grant applicants, artistic value, must be clarified as to its status, that is, a criterion that can be applied cross–culturally or one that can reasonably be said to vary by cultural tradition. In the literature of public policy, this sort of question about the appropriateness of decision–making criteria is not unique. Much has been written about examinations and tests used in hiring decisions that are culturally biased, reducing the opportunities of minority ethnic group members for employment.[121] Conversely, many argue that universal criteria can and should be applied to hiring decisions as a necessary means of safeguarding equal treatment and ensuring that the most qualified candidates are hired, thus leading to considerable gains in workplace productivity and efficiency.[122] Given this diversity of viewpoints, it seems clear that making public policy decisions merely on the basis of procedural fairness is not a replacement for clarifying the substance of evaluative criteria that are and must be utilized in making decisions of such import to those potentially affected.

As prominent as the criterion of artistic value is in the formal decision–making policies of public arts agencies, the meaning of this concept is usually unclarified and left undefined. There are several reasons for this apparent anomaly. For example, the arts organizations that seek funding

from public arts agencies are extremely diverse along numerous lines, and their "institutional aesthetic philosophies often are complex and collective and seldom explicitly articulated."[123] Thus, arts policymakers could argue that stipulating specific definitions of artistic value that could apply to these many and diverse organizations is a practical impossibility. Another, more common reason cited by public arts agencies for not defining artistic value is that the concept is inherently subjective, so that judgments made that make reference to artistic value are mere statements of opinion. Finally, public arts agencies avoid stipulating definitions of artistic value by appealing to democratic values. The argument goes something like this: If a public arts agency were to stipulate a definition of artistic value and made decisions on the basis of it, the consequence would be the creation, dissemination, and legitimation of an official state culture such as those found in countries ruled by totalitarian governments. As a further consequence, freedom of artistic expression and the range of artistic forms and styles available to the citizenry would be unacceptably constrained.[124] Public arts agencies are also sensitive to charges that they support "official culture" because of critiques of their funding practices that some would argue exhibit a Eurocentric bias. In other words, or so the argument goes, public arts agencies have a de facto policy of supporting a Eurocentric concept of artistic value that is unfairly imposed on all applicants to the detriment of artists and arts organizations of different cultural traditions.[125] Thus, as a result of this thicket of issues surrounding the possible stipulation of an explicit definition of artistic value as a basis of their funding decisions, public arts agencies usually purport to have no aesthetic philosophy[126] and, in some cases, seek to balance decision–making bodies such as boards and grant review panels with persons of diverse aesthetic viewpoints.

These explanations for arts agencies' reticence about defining a concept of artistic value may or may not be persuasive, but they are largely beside the point of the issue at hand. The point here is not to arrive at a stipulative definition in which conventions will be laid down for correct usage of *artistic value* by public arts agencies in funding contexts. Rather, in clarifying the possible meanings of the term, the aim is to determine whether, to what extent, and in what ways assumptions about artistic value are variable from theoretical points of view, so that the funding policies of public arts agencies can be grounded in a clear sense of the assumptions behind their evaluative criteria. Ultimately, though, as the argument above makes clear, such evaluative criteria should be consistent with the premise of the equal opportunity argument that applicants be judged on appropriate standards of merit.

The issue at hand in this section, putting it in the most basic of terms, is this: Are the artistic criteria used to evaluate the quality and merit of art works variable by culture and, if so, on what basis do they vary?

Arriving at a definitive answer to this question is complicated by a number of factors. First, many cultures do not have a word for the concept of art, in that what can be called artistic activities are indistinguishably integrated with other aspects of life such as work, religion, and ritual.[127] As such, formal theories of artistic value are not to be found in some cultures. This is not to say, however, that there is an absence of aesthetic concerns or implicit standards for what is valued or not. Coming to an understanding of the aesthetic dimension of cultures, whether those in small, homogeneous societies or those in complex, heterogeneous societies, is a matter of delicate, empirical inquiry. But such inquiry among social scientists is relatively rare, despite frequent calls for it. Anthropologist Alan P. Merriman, for example, argues that without empirical inquiry into artists' own concepts and evaluations of what they do, and how these activities are valued within and beyond the cultural context of the art's origin, then any theory of how aesthetic standards apply cross–culturally is premature.[128]

Sociologists with interests in the study of the arts would seem to be a valuable resource in at least coming to an understanding of how social processes condition the evaluation of art works. But in their quest to draw boundaries between themselves and more humanistic study of art and society, sociologists tend to consider question of artistic value as not within the province of a value–free, scientific discipline. On the other hand, sociologist Vera Zolberg contends that philosophers of art, who often treat art as a specialized activity divorced from social and cultural conditions, do not sufficiently consider how the concept of artistic value is formulated and conditioned by social processes.[129]

Sociologists, however, have given considerable attention to undercutting claims that "great" art, art that has stood the test of time, speaks for all time and to all of humanity. Janet Wolff, among others, argues that any attempt to posit an independent, ahistorical meaning of aesthetic value obscures the contingent, historical, and ideological nature of such judgments.[130] Pierre Bourdieu, a French sociologist, based on numerous empirical studies, posits a theory of the social foundations of aesthetic judgments. The theory is based on a distinction between pure taste and the popular aesthetic. Pure taste, as defined by Bourdieu, is rooted in the clear–cut separation between ordinary dispositions from specifically aesthetic dispositions and in the subordination of the functions of art to its formal aspects. Pure taste, according to Bourdieu, is the province of dominant classes in society who, as a result of their dominance, are able to posit a conception of artistic value that views art as a timeless, autonomous, symbolic realm. To perpetuate this conception, dominant classes portray the popular aesthetic, which is based on the affirmation of continuity of art and life and the idea that art works are to be evaluated in terms of their content and capacity to serve functions, as barbarous. Bourdieu contends that in this

way dominant classes are able to make arbitrary value distinctions seem natural and timeless. He terms this phenomenon "symbolic violence." As a consequence of symbolic violence, dominant classes are able to solidify inequitable social relations in their favor. Bourdieu further concludes that by limiting access to pure taste and the capacity to develop it, dominant classes are able to reproduce inequitable relations over time.[131]

Bourdieu's theory of how judgments of artistic value are arbitrary, used by dominant classes to negate the aesthetic values of dominated classes, and utilized as means to solidify and perpetuate their class standing, has had considerable influence with American social science. For example, DiMaggio and Ostrower suggest that Bourdieu's theory, while conducted in relatively unicultural France, has applicability to the multicultural United States. Based on their research on the arts consumption patterns of black and white Americans, they arrive at the following conclusion: "The extent to which Black Americans share artistic–consumption patterns of white Americans, the absence of taste segmentation, and the fact that Black participation in Euro–American high culture is predicted by the same status measures that influence white participation indicate that the Euro–American high–culture arts operate as a cultural standard for the United States as a whole."[132] In other words, according to this view, dominant classes in America have effectively made Euro–American concepts of artistic value as the benchmark of value of art produced and disseminated in America. But even DiMaggio and Ostrower acknowledge that traditionally African Ameri can art forms are at least a supplementary source of consumption and, hence, artistic value for African–Americans.

Further, as will be recalled from the discussion of relations between art and culture, many neo–Marxist theorists who on the one hand accept Bourdieu's general account of dominant–dominated social and cultural relations in complex societies also conclude that ethnic groups can and do create artistic forms whose artistic value represents an alternative to the dominant culture or stands in opposition to it. The existence of these sources of artistic value is explained in two different ways: (1) The lack of cohesive ideological control by the dominant culture opens up the possibili-ties for the creation and dissemination of oppositional cultural forms;[133] and (2) ethnic groups experience sufficient distance from general socioeco-nomic conditions and the concerns of the dominant culture so that ethnic arts can be produced and disseminated in virtual autonomy from dominant socioeconomic interests.[134]

Apart from the considerable diversity in its theoretical explanations of the effects of dominant–dominated social relations on the possible creation of alternative sources of artistic value, the neo–Marxist position has further problems. Most notably, in directing their attention to socioeco-nomic structures and their effects on artistic production and dissemination,

proponents of the neo–Marxist position do not address the question of what is and can be meant by the term *artistic value* except, perhaps, to dismiss stipulated definitions of *artistic value* as arbitrary conventions laid down by philosophers unable or unwilling to appreciate how social processes determine the use of concepts. This reductionist view can be critiqued on various grounds. But, for now, in more practical terms, such a view cannot be considered helpful in considering a policy context where some measure of clarity is needed for a concept that underlies the most prominent criterion utilized in funding decisions.

That said, however, the neo–Marxist position on artistic value does raise two important questions: (1) Do the social origins of art works, for example, art works created and disseminated through the influence and ideological power of a dominant culture in a society, thereby negate their value? and (2) Do the uses to which art works are put, for example, as means to solidify the social status of members of the dominant culture, also negate their value? These questions will be dealt with below. But, first, there are a number of other questions surrounding the concept of artistic value that warrant examination. These will emerge through exploring a summary of diverse viewpoints, from philosophical and social scientific perspectives, on the origins, meaning, and implications of the concept of artistic value.

Arnold Hauser, as a social historian of art, rejects the view that art is an autonomous realm of value with its own distinct properties. In particular, he contends that the stature and value of works of art depend on the moral and social power of their subject matter. But he makes a further important point, namely, that values in moral or social realms do not transfer to the artistic realm of necessity. Specifically, if art works are to serve any function within or beyond a culture, then they must exhibit a high level of artistic value defined in terms of formal properties.[135] Philosophers of art Matthew Lipman and Anthony Saville similarly argue, respectively, that artistic value is no way dependent on the values of the nonaesthetic and that the aims and benefits of art have nothing to do with aesthetic excellence.[136] For his part, anthropologist Jacques Macquet contends that criteria of artistic excellence are formal in nature and universally so, in that they are found in all cultures. Distinctions of artistic value, he argues, are based largely on preferences, most often the result of a correspondence between cultural values expressed in the art work and those values held by the individual viewer.[137]

These points of view, which hold that artistic value is rooted in the formal properties of art works, can be contrasted with conceptions of artistic value that locate the value of art in its functions or consequences. June McFee, for example, argues that the value of art resides in its capacity to fulfill social functions such as (1) objectification of subjective values and

beliefs, (2) enrichment and celebration of ritual in human events, (3) comm-
unication of meanings and qualities, and (4) stabilization and perpetuation
of cultures' identities and conceptions of reality.[138] Nelson Graburn, an
anthropologist, holds that judgments about the artistic value of art works are
as much determined by the context of their production and use for social
and cultural purposes as by features of the art works themselves.[139]
Finally, Robert Plant Armstrong rejects the applicability of Western concepts
of artistic value that hold that the value of art is located in formal properties
and argues that there are substantively different standards for evaluating the
arts from culture to culture. As an example, Armstrong contends that art
works from many African cultures are to be construed not as symbols of
something else but as works of what he calls "affecting presence." Works of
art with affecting presence are treated in their culture of origin virtually as
persons, and their value resides in their power, the power to command
attention, rather than in beauty.[140]

 These viewpoints clearly were reviewed here in brief, and many
points in arguments used to support these views were not included. But, at
this point, this summary was intended primarily to identify basic questions
that must be addressed in clarifying the concept of artistic value. After
reviewing neo–Marxist views and views on the locus of artistic value, several
questions have emerged: Do the social origins of art works negate their
value? Do the uses to which art can be put negate their value? Does the
value of art works reside in formal characteristics of art objects themselves;
in the ideas and values expressed in art works; or in the consequences of
interaction with art objects and, if so, what sorts of consequences? These
will be addressed in turn.

 The first two questions emerged from the review of neo–Marxist
views of how art works are produced, disseminated, and utilized in societies
characterized by inequitable socioeconomic structures and dominant–domin-
ated cultural relations. It is not difficult to imagine an argument being made
relating neo–Marxist theory to the arts of ethnic cultures. It could go
something like this: The production, preservation, and dissemination of art
rooted in Euro–American cultural traditions are facilitated by the
socioeconomic power of individuals and groups who, as a result of such
power, can ensure that their tastes and preferences are met. It is on these
inequitable foundations that the dominant culture is able to define concepts
of artistic value, concepts that are posited as universal criteria for evaluating
art but in reality merely reflect the preferences of privileged classes in
society. As a result, then, opportunities for ethnic groups to produce and
disseminate cultural products, such as the arts, as well as concepts of the
value of ethnic arts are, at best, constrained. Therefore, or so it could be
argued, the value of art works created in Euro–American traditions, because
of their origins in equitable socioeconomic relations, is negated, especially

for persons most negatively affected by these relations, that is, minority ethnic groups.

Such an argument, however, would be flawed on various grounds. As a previous discussion pointed out, it is not at all clear that the opportunities for the creation and dissemination of ethnic arts are as constrained as this argument assumes, even if one were to agree with neo–Marxists' portrayal of inequitable, dominant–dominated socio–economic relations in contemporary society. But the more significant flaw in such an argument is not empirical but logical. The argument contains a false deduction, namely, that if the creation of certain kinds of art is founded on inequitable socioeconomic relations, its value as art is therefore negated. Such a deduction does not necessarily follow in that it involves a leap from a premise about one realm of human value to a conclusion about a different realm of value. Simply put, the argument confuses realms of human values—justice and artistic value.

This is not to say that aesthetic considerations are totally removed from other realms of human value—it can be, and has been, argued that art, while in many ways a unique human activity, embodies values from the full range of human experience.[141] Further, it can be reasonably conceded that when areas of human value conflict in specific contexts, certain areas of value do supersede others. For example, in considering whether to hold stock in companies that do business with South Africa, many universities have concluded that, in this instance, moral values should supersede economic values. Also, history is replete with examples of persons acting on a moral imperative, persons who have gone to jail rather than obey what they viewed as an unjust law of the state. But these two points—first, that art embodies human values and, second, that certain areas of value do supersede other areas of value, including artistic value, in specific contexts—do not undercut the above conclusion that the argument that the socioeconomic foundations of Euro–American art negate its artistic value involves a confusion about realms of value. It is the generality of the argument that results in the confusion. If the argument were based on specific instances where certain art works were created and disseminated at the direct expense of the rights and opportunities of individual ethnic group members, then it could be said, with reason, that the value of justice should supersede whatever artistic value the art works may have. But, even in such an instance, it does not follow that the value of these art works is negated, only superseded. And when the argument is extended to a general level, then the conclusion that the value of justice of necessity supersedes artistic value, let alone the conclusion that matters of justice of necessity negate the potential and actual value of art works, is not supported.

This discussion of justice and artistic value is in some ways reminiscent of the previous discussion of compensatory justice. It is as

though proponents of the argument concerning the socioeconomic foundations of Euro–American art conceive of the negation of the value of such art as a sort of compensation to minority ethnic groups for past injustices visited upon them as corporate entities. But the argument, as just shown, inherits the many problems associated with the concept of compensatory justice cited above.

The other question: Do the uses to which art can be put negate their value?—poses its own, different problems. It runs up against the social phenomenon discussed earlier, namely, that artists have little control over how their work is received at the time of its creation and, especially, over time. Clearly, then, whether one accepts the neo–Marxist portrayal of the dominant culture's power to use art that meets its preferences to legitimate and reproduce its social standing, it is plausible. But this acknowledgment hardly demonstrates that the way in which art works are used of necessity negates or even compromises their artistic value. The logic of the argument that if something is misused or utilized for indefensible purposes, if applied to other areas of human experience, would entail a commitment to absurdities. We do not say that if a child is abused, her value as a person is therefore negated; we do not say that if a policy is implemented poorly, its value as a policy is negated; and we do not say that good intentions, if taken advantage of or even misdirected, are therefore rendered without value. Why we would then say that the value of Euro–American art is negated because some may use it to reinforce their social status is not clear. To conclude so would be to fall prey to the is–ought conflation, whereby one makes value conclusions directly from observations or interpretations of how and why phenomena occur. Further, to arrive at such a conclusion borders on violation of a principle of justice, that an individual cannot be held responsible for consequences that he or she could not avoid. Of course, this point depends on an analogy between art and human individuals, but, I believe, the point still holds.

Two final points about the two questions concerning the origins and consequences of art works and artistic value need to be made. Even though the viewpoint that the value of art if conditioned by its socioeconomic origins and consequences has its roots in neo–Marxist theory, it should be stressed that this view is not shared by all neo–Marxists. Most notably, sociologist Janet Wolff makes two points: (1) that to comment on the origins of an assessment of artistic value is not necessarily a comment on the validity or defensibility of such an assessment; and (2) a sociological, historical analysis of the origins and consequences of judgments of artistic value need not lead inevitably to relativism or reductionism regarding criteria for aesthetic judgment.[142] Finally, and this is a significant point, to put to rest the notion that art's origins or consequences negate its artistic value only takes us so far, especially regarding interaction between Euro–American art works

and minority ethnic groups. It does not follow from the above conclusion that Euro–American art works can be and are perceived as objects of value and meaning by minority ethnic group members, and it certainly does not resolve the basic question of whether artistic value can be said to vary from culture to culture.

In addition, and perhaps obviously, the above discussion, even though to an extent it saves the concept of artistic value from reduction to socioeconomic conditions, does not even address another basic question—In what does the value of art reside? There are numerous ways to approach this issue. One way that may prove fruitful, I believe, is to seek an answer to another question—Is the value of art one thing or many? Three answers have been offered historically, that the value of art resides in the art object itself, in the response to objects, or in the effects of responses to art objects. These views will be reviewed in turn.

The view that the value of art resides in the art object itself is commonly termed by aestheticians the *objective intrinsic theory of artistic value*.[143] This theory is based on the idea of intrinsic good, that something is wanted for its own sake with no reference to functions or means to further experiences. Works of art are considered valuable if they possess objective intrinsic value properties to a high degree. These intrinsic value properties have been defined in various ways historically. But such definitions will not be reviewed here because the objective intrinsic theory of artistic value is flawed from the outset. To evaluate a work of art by reference to intrinsic properties, one would have to be able to ascertain, recognize, or know such properties. But how this is possible without some reference to the effects of such properties on the viewer either involves a curious theory of knowledge or is impossible. Further, the idea of valuing something, such as a work of art, for its intrinsic properties seems odd. This would mean that what is valued is a physical object or thing. It seems more plausible to say that it is the experience of an object, such as an art work, that can be valued for its own sake. As Ralph A. Smith and C. M. Smith point out, "What is desired is not the object as such but the pleasure or satisfaction of possessing, using, or experiencing it."[144]

These sorts of objections can also be applied to the idea that the value of art resides in the responses to art objects, often termed the *subjective intrinsic theory of artistic value*. Specifically, this theory holds that "works are valuable because they are intrinsically valued by some person or persons."[145] Addition of the phrase "by some person or persons," however, does nothing to mitigate problems associated with the objective intrinsic theory of artistic value. It does not resolve or even address the issue of how it is possible to know objective intrinsic properties of art works or how one can value something without reference to the experience of it. Also, the phrase "by some person or persons" raises further problems. In particular,

the phrase means that the locus of artistic value is in an individual person or persons. But this sort of valuing, without clarification, can easily be construed as referring to preferences for certain kinds of art work over others. Such a conception would mean that judgments of artistic value could be made with virtually no reference to properties or qualities of art works and be based on phenomena like wish fulfillment, psychological projection, prejudice, and association with favored ideas and sentimentalities. If one were to trace the subjective intrinsic theory of artistic value to its logical conclusion, public arts agencies' practice of stipulating criteria of artistic merit for decision making and giving these criteria such weight in making decisions would be pointless. A further implication would be to render moot the question of whether artistic value is relative to a culture or universal in nature. Without some reference to artistic criteria rooted in properties of art works, aesthetic judgment would be relative only to the preferences of individuals and thereby could not be relative to a culture.[146]

The final category of theories of artistic value, *instrumental theories*, avoids many of the problems identified with the objective intrinsic and subjective intrinsic theories. Instrumental theories reject the notion that something can have value without reference to the experience of it. Indeed, such theories locate the experience of art, and the consequences of these experiences, as the locus of artistic value. Further, as George Dickie contends, "even the most rudimentary reflection on the kinds of things that works of art are indicates that they are the kind of thing that are the source of and are used as a source of valuable experience and that they are created to serve this purpose."[147] But these general features of instrumental theories do not, in themselves, address the issue of whether artistic value is one thing or many. To say that artistic value is located in the experience of art does not prejudge the issue. As will be seen, instrumental theories of artistic value vary considerably on this point. Three instrumental theories of artistic value will be explored here, those of Monroe Beardsley, Nelson Goodman, and Nicholas Wolterstorff.

Monroe Beardsley proposes that art works are to be evaluated in terms of how well they produce aesthetic experience, that is, experience of art that is intrinsically satisfying. Art that is good is instrumental to aesthetic experience. Since it is so central to Beardsley's theory of artistic value, the concept aesthetic experience bears close scrutiny. As his starting point, Beardsley states "that it can be not only enjoyable, but also desirable, for experience to have a high aesthetic level."[148] He does not include in his definition of the aesthetic dimension of experience sheer sensuous agreeableness or pleasure. Aesthetic quality refers to "the kind of pleasure or sense of satisfaction and fulfillment that comes from the awareness of the

way elements of experience interrelate in order to bring about the formation of complex unities that are marked by emergent regional qualities."[149]

Beardsley holds that experience of this nature, aesthetic experience, has five characteristics: (1) It involves attention to a portion of a phenomenally objective field, either sensuous (such as the colors in a painting) or intentional (such as events in a novel), and to its elements and internal relationships. (2) It involves an awareness of form, that is, relationships among the elements of the phenomenal field, especially (but not exclusively) relationships of similarity/contrast and serial order. (3) It involves an awareness of regional quality, that is, simple qualities of complexes, and especially (but not exclusively) those qualities that are described by words taken over metaphorically from human contexts. The class of regional qualities corresponds roughly to aesthetic concepts such as beauty, elegance, grace, dignity, and irony. (4) It is characterized by a fairly high degree of unity, in comparison with ordinary everyday experiences. Unity has two distinguishable parts: coherence and completeness. An aesthetic experience is unusually coherent in that the various perceptions, feelings, inferences, recognitions, memories, desires, and so on, that occur in the course of its development have a character of belonging or fitting together or succeeding one another with continuity. An aesthetic experience is unusually complete, in that the experience marks itself off fairly definitely from other experiences. (5) It is intrinsically gratifying or, in other words, brings with it both a continuing enjoyment that is felt as part of the development of the experience and a final satisfaction or fulfillment that may linger after the experience has ended.[150]

Beardsley argues that it makes sense to say that objects themselves have the capacity to raise the level of aesthetic experience. Certain objects, in virtue of their aesthetic qualities, are peculiarly well suited to reward repeated attention. Again, this capacity Beardsley terms the aesthetic value of the object.

Beardsley's apparent claim that the proper experience of art is the aesthetic experience of art, with its insulated character, seems unnecessarily limited in character. Beardsley, according to Dickie, "mistakes the absorption one experiences in attending to art for detachment from moral and cognitive concerns."[151] It is one thing to say that the experience of some or even many works of art is detached in character, but the conclusion that connections to moral and cognitive concerns is irrelevant to the evaluation of art works does not follow. Numerous examples can be cited of art works the experience of which involves recognitions and realizations in dealing with moral and cognitive content. This is not to say that a more defensible moral idea in an art work therefore makes that art work better, only that richness of the experience of art can be and is enhanced by interaction with moral and cognitive content beyond the distinctively

aesthetic properties. It would seem, then, that since his account of the experience of art is limited, Beardsley's theory of art evaluation, which makes art's capacity to produce aesthetic experience the sole basis for the evaluation of art, is inadequate.

Another sort of instrumental theory of artistic value is proposed by Nelson Goodman. But apart from its similar formal features, that art is to be evaluated in terms of its capacity to achieve consequences, Goodman's theory could not be more different from the theory of Beardsley.

At the core of these differences are conceptions of the proper experience of art works. As will be recalled, Beardsley began with a theory of aesthetic experience that then served as a basis for his account of the evaluation of art. Because he maintained that aesthetic experience has a detached character, Beardsley claimed that works of art are most properly experienced as the focus of an experience insulated from any references outside the art work itself, including moral and cognitive issues. Thus, since such references have no place in the experience of art, works of art, according to Beardsley, must be evaluated on the basis of their nonreferential features and properties.

Goodman, on the other hand, begins with a theory of the nature of art that, in turn, is utilized to construct a theory of the evaluation of art. He He maintains that works of art are symbols, that is, that art works are essentially cognitive in nature. They are to be experienced, then, in terms of their cognitive relation to things outside of themselves. In distinguishing between aesthetic experiences and nonaesthetic experiences, Goodman holds that aesthetic experiences are those in which some attention is centered on the symbols themselves as well as on their references.[152]

Goodman's evaluation theory can be summarized into the four following claims:[153] (1) Every work of art is a symbol that refers to something outside of itself either through description, representation, or exemplification or in combination; (2) symbols are a matter of cognition; (3) the primary purpose of art is cognition—the utility of art for functions like pleasure and communication are dependent on the cognitive nature of art; and (4) art is ultimately to be evaluated not merely in terms of its capacity to foster pleasure or communication but by how well it serves its cognitive purpose.

Since Goodman's definition of artistic value is ultimately dependent on the concept of "cognitive efficacy," one might expect an explicit definition of this term. But what he offers is a general statement about cognitive efficacy:

Symbolization, then, is to be judged fundamentally by how well it serves the cognitive purpose: by the delicacy of its discriminations and the aptness of its allusions; by the way it works in grasping,

exploring, and informing the world; by how it analyzes, sorts, orders, and organizes; by how it participates in the making, manipulation, retention, and transformation of knowledge. Considerations of simplicity and subtlety, power and precision, scope and selectivity, familiarity and freshness, are all relevant and often contend with one another; their weighting is relative to our interests, our information, and our inquiry.[154]

It is difficult, and perhaps impossible, to evaluate Goodman's theory of artistic value on the basis of this general, rather obtuse, statement. But Goodman's concept of art provides the grounds for some degree of assessment of his artistic value theory. As Dickie says of Goodman, "Underlying his claim about cognitive efficacy is the more basic claim that all art is referential: unless a work of art is referential in some way, the question of cognitive efficacy cannot arise for it. Thus, if there are nonreferential artworks, they cannot be evaluated according to Goodman's scheme. Goodman must show that there are no nonreferential works of art."[155]

Goodman attempts to make this case by arguing that, for example, a color in a nonobjective painting is referential because it exemplifies itself. Further, an art work with such a color has artistic value only because the color refers by means of exemplification. But what it is that color in a painting refers to or how it exemplifies itself is not at all clear. The following explanation by Goodman does little to clarify this point:

The properties that count in a purist [nonobjective] painting are those that the picture makes manifest, selects, focuses upon, exhibits, heightens in our consciousness—those that it shows forth—in short, those properties that it does not merely possess but *exemplifies*, stands as a sample of.[156]

Goodman's theory does take an important step beyond Beardsley's - insulated theory of aesthetic experience and corollary theory of artistic value by arguing that value can accrue to the experience of art in virtue of its reference to cognitive issues. But, just as Beardsley's theory was found inadequate by virtue of its limited notion of the experience of art, Goodman's theory is inadequate by making cognitive efficacy the sole criterion of artistic value, even though many works of art could not be reasonably said to be symbolic or referential. As Dickie contends, "Both Beardsley and Goodman suffer from the philosopher's passion for theoretical neatness and simplicity. Each wants a theoretical explanation for the value of art that involves only one kind of feature."[157]

The two major theories of artistic value reviewed to this point have addressed a major question of this section—Is the value of art one thing or many? While very different, the response by each was "one thing." Though not merely because these theories identified artistic value as one thing, each was found inadequate. The philosopher Nicholas Wolterstorff offers a different view. He holds that art works can have artistic value by virtue of their capacity to induce a detached kind of aesthetic experience focused solely on the aesthetic properties of art works; Wolterstorff also contends that cognitive characteristics of art works are important to their evaluation. But, unlike Beardsley and Goodman, Wolterstorff does not conclude that the value of art is one thing, either exclusively aesthetic or cognitive in character. Instead, Wolterstorff offers an instrumental theory of artistic value whereby the value of art is many things and can be aesthetic, cognitive, moral, and religious in character.

In developing his theory of artistic value, Wolterstorff agrees that some works of art are instruments with a single purpose, while others are instruments with several purposes. By these purposes he means the purposes for which a work of art is made or distributed. Among the possible purposes of art works is the "purpose of contemplation for aesthetic delight."[158] Wolterstorff makes the idea of the purposes of art central to his concept of artistic value. For example, in the case of some art works, "an aesthetically excellent object is one that effectively serves the purpose of contemplation for aesthetic delight."[159] But, as noted above, Wolterstorff contends that art can serve many purposes besides aesthetic purposes, in particular, cognitive, moral, and religious purposes. Thus, his view of the nature of artistic value is phrased in more general terms to apply to many kinds of art: "A work of art has *artistic excellence* if it serves well the purposes for which it was made or distributed."[160]

On the face of it, phrasing a conception of artistic value in terms of the purposes it serves seems problematic. In many cases, one does not know, and in other cases it is virtually impossible to know, the purpose or purposes for which an art work was made. Moreover, it must be granted that a specific work of art may have an unintended feature or features that can be said to undercut its artistic value. Finally, speaking about the purposes behind an art work's creation raises the perennial question of the relevance of an artist's intention to the evaluation of an art work. These problems can be avoided, however, if Wolterstorff's principle of artistic value is phrased not in terms of the purposes for which art works are created or distributed but in terms of the variety of aspects of art works, aspects that can be aesthetic, cognitive, moral, or religious in nature.

With this slight amendment in mind, what, then, does Wolterstorff mean by, for example, the cognitive features of art works? He cites two meanings: "the fact that a proposition asserted by means of some work is

true [or] the fact that the world of a work is *true to* actuality in some respect."[161] Such cognitive features of art works, then, are considered grounds for positive judgments of artistic merit because, phrased in instrumental terms, persons can derive satisfaction from perceiving that elements of an art work are true or illuminate aspects of the world in a vividly accurate way.

If this view, however, committed Wolterstorff to the belief that an art work *must* be true in a propositional sense, uphold a defensible moral principle or display, by some definition, only moral acts, or support a religious belief system, then this form of the instrumental theory of artistic evaluation would be difficult to defend. Such a view could surely be invoked to justify restrictions on artistic expression and even censorship if adopted by public arts agencies or those with oversight power over public arts agencies. Unfortunately, Wolterstorff does not address these possible implications or even clarify, in his view, whether the content of an art work must be true or morally acceptable to have artistic value. This question, therefore, must be resolved if this instrumental theory, with its concept of many sources of artistic value, is to be defended. Three theories, those developed by Beardsley, Dickie, and Melvin Rader and Bertrum Jessup, can be brought to bear on this question.

The concept of inherent value, as developed by Beardsley, could be helpful here. Beardsley holds that art can indeed have value beyond that found in immediate, qualitative experience by eliciting desirable effects. These effects can include resolution of conflicts within the self; refinement of perception and discrimination; development of the imagination and the ability to put oneself in the place of others; and the fostering of mutual sympathy and understanding. Beardsley admits that while many of these claims have been persuasive to many at various times, "it will take much thorough and delicate psychological inquiry before they can be made good."[162] Art works that have the capacity to produce these effects, in Beardsley's terms, can be said to have inherent value. What is of greater interest here, however, are the conditions that must be present for art works to have inherent value. Of inherent value, Beardsley says:

> First, it is produced by means of, or *via*, aesthetic enjoyment, and
> therefore it is produced to some degree (however small) by all works
> of art; second, the degree to which it is produced is correlated (at
> least roughly) with the aesthetic value of the work, so that, on the
> whole and generally speaking, the better the work of art the greater
> the effect is capable of producing.[163]

It is clear, then, that the capacity of art works to produce desirable effects is wholly dependent on their aesthetic value, which, in turn, is dependent on

their capacity to induce the detached kind of aesthetic experience described by Beardsley. But since this conception of aesthetic experience previously was found inadequate, the notion of inherent value therefore is of little help here. If one does not accept that cognitive, moral, or religious features of art works bear on artistic evaluation, then the issue of whether these features must be true or right or believable is bypassed.

Dickie, as seen above, does not accept Beardsley's account of aesthetic experience and hence his view of aesthetic value. He holds that the experience of cognitive, moral, and religious features of art works is relevant to their evaluation. But he also argues that most art works contain various combinations of these and aesthetic features. Based on this view, then, Dickie contends that the experience of art works is not a matter of focusing on one type of feature but an integrated experience where the experience of aesthetic features is intertwined with the experience of cognitive, moral, or religious features.[164] If this account is granted, implications for the question of whether an art work must be true or right or believable can be drawn. While not stated by Dickie in these terms, it seems reasonable to conclude that if art works' features are experienced in an integrated way, then the nature of one type of feature in an art work cannot be said to determine that work's artistic value. Thus, even if an art work's truth value or defensibility according to moral principles can be challenged, the artistic value of the work would not necessarily be negated or even compromised.

This point, however, only establishes that questionable veracity or moral value in art works need not detract from their overall artistic value. But such a weak conclusion hardly provides a persuasive reply to someone who might say that an art work must be true or morally acceptable to have artistic value. Such a person could still say that an art work would have greater artistic value if its truth value or moral acceptability were not in dispute, a position consistent with constrictions on freedom of artistic expression and even censorship. A stronger position on the contributions of cognitive and moral characteristics of art works to artistic value is needed. A point by Melvin Rader and Bertrum Jessup suggests such a position.[165]

This position can be applied to the moral content of art works, even art works whose subject matter many might find foreign, shocking, disgusting, or morally repugnant. It seems clear that art, and the experience of art, has the capacity to convey the vivid qualities of the full range of human experience. Morality, for its part, requires a capacity to put ourselves in the place of others, to see the world and its predicaments from the point of view of the other. Without this capacity, persons are viewed as categories and morality becomes a matter of the application of rules in an impersonal way. Imagination affords persons the opportunity of going beyond the boundaries of their individual selves. But while imagination may

be a capacity in all human beings, it can remain undeveloped or underdeveloped without experience. The concepts and abstractions of science and philosophy are not good guides for developing human imagination. These premises about art, morality, and imagination can be combined to address the moral content of art works in this way: Art, by its capacity to present the vivid qualities of the full range of human experience, including human experience many may find morally repugnant, has the unique capacity to develop persons' imaginative ability to put themselves in the place of others, an ability without which morality is narrow, rule based, and devoid of passion. It seems to me that this argument, at least in the case of the moral content of art works, provides a sufficient and positive response to those who would hold that for art works to have moral efficacy they must present moral acts that all would find defensible according to a moral principle.

To this point, two premises in this argument in support of the instrumental theory of artistic value have been established: (1) The value of art is many things rather than one and can be rooted in the integrated experience of aesthetic, cognitive, moral, and religious features of art works; and (2) the efficacy of cognitive, moral, and moral features of art works for artistic value is not a matter of their adherence to principles of propositional truth, morality, or religious orthodoxy but in their capacity to make vivid the qualities of the range of human experience.

To say that artistic value is multidimensional and variable and inheres in art works' capacities to elicit different kinds of valuable experience, however, only takes us so far. Most instrumental theories contain the premise that art is valuable because it is a means to valuable experiences not just in isolated individuals but in many individuals. To contend otherwise would leave the instrumental theory with the same problems associated with the subjective intrinsic theory of artistic evaluation and would foreclose the possibility of utilizing artistic criteria in decision making about the merit of those seeking grants from public arts agencies. The question then becomes not only whether it is possible to say that the art is instrumental to valuable experiences in many individuals but whether it is also permissible to conclude that the value of art works varies by culture, that is, that the features of some art works are better able to elicit valuable experiences from members of one ethnic group culture than another.

Attempting to answer this question affirmatively involves a number of complications that must be first addressed. As will be recalled from a previous section of this chapter, research on the creation, perception, consumption, and meanings of art in complex, contemporary society painted an equivocal picture. On the one hand, it was granted that many artists in contemporary American society create work rooted in subject matter inspired by the beliefs and concepts of ethnic cultural traditions; on the other hand, it was found that no ethnic culture in complex societies can

claim an artistic style as its own without acknowledging at least some influence from other cultural traditions. It was also found that results of research on cultural differences in perception of art works were, at best, equivocal, while the weight given race and ethnicity as a predictor of arts consumption patterns varied among researchers. Further, contradictory effects of the contemporary marketplace on ethnic art were also found: the simultaneous availability of a heterogeneous range of artistic styles, the utilization of ethnic art in ways autonomous from their cultural origins or intended effects, and the creation and dissemination of ethno–kitsch but, also, ethnic art created predominantly to facilitate the transmission of culturally specific symbolic meanings. Finally, despite a plethora of claims about the functions and meanings of art for ethnic group cultures, documentation of these claims was found notably thin.

If one were to glean selectively from these diverse findings on the creation, perception, consumption, and meanings of ethnic art, a case could probably be made that, at least in complex, multicultural societies, the value of art does not vary by culture. Such an argument could go something like this: Most ethnic art either draws on more than one cultural tradition in its creation or is made to satisfy the expectations of consumers from other traditions. Research reveals that race and ethnicity have minimal effects on perception and consumption of the arts. The meanings such art can and does have for ethnic groups is not clear. In any case, ethnic art, whatever its origins or intended effects, can be utilized to serve the many diverse purposes of consumers. Therefore, or so the argument could go, there seems little basis to conclude that art's capacity to produce valuable experiences rooted in art works' aesthetic, cognitive, moral, and religious features varies by culture.

But such an argument is surely flawed. Apart from the fact that it ignores evidence about the creation, consumption, and meaning of ethnic art that could challenge its premises, this argument contains flawed premises exposed earlier. In particular, this argument contains the premise that the origins of art and uses to which it is put can undercut or even negate its value. This premise was initially reviewed in considering neo–Marxist claims that the value of Euro–American art is negated because of its origins in inequitable social relations and its use to reinforce class power and privilege. The arguments used to demonstrate the weaknesses of these claims will not be reviewed here. Suffice it to say here that if the value of Euro–American art is not negated by its origins and uses to which it can be put, then the same applies to the value of ethnic art, whatever its origins or uses.

Another question must be addressed, however, before a persuasive case can be made that the value of art varies by culture: If such a case can be made, does this consign us to relativism in setting evaluative criteria for

the arts? Relativism is "the view that there is no way to adjudicate between differing evaluations of a work of art."[166] One way to avoid the problem of relativism is to argue, as does Beardsley, that since there is only one instrumental value for art, its capacity to induce aesthetic experience, if there are differing evaluations of an art work, one evaluator must be either wrong or incapable of having an aesthetic experience. But this sort of argument, based on a singular notion of the value of art, cannot be used if one holds that the value of art is multifaceted and rests in aesthetic, cognitive, moral, or religious features of art works that have the capacity to induce a range of valuable experiences. It can be argued that this considerable range of possible responses to art works makes the matter of the comparison of these responses and the consequent judgments about art works highly problematic.

This complication can be met, I believe, in two ways. First, even if it is granted that art works variously include aesthetic, cognitive, moral, or religious features, it does not follow that the experience of an art work, and hence its evaluation, is a matter of focusing on one type of feature. As noted above, the experience of art works with multiple features is more accurately described as integrated in nature, where the experience of aesthetic features is intertwined with the experience of cognitive, moral, or religious features. As such, the artistic value of an art work can be said to reside in the integrated experience of its diverse features. Under this conception, it follows that if persons disagree in their evaluations of an art work, one evaluator must either be wrong or be incapable of having an integrated experience of multidimensional works of art.

This latter point highlights the other issue that must be addressed in order to show that this version of the instrumental theory of artistic evaluation need not lead to relativism. Implicit in the idea expressed above that some persons are incapable of having an integrated experience of multidimensional works of art is the idea that some persons are in some sense qualified to do so. This question is particularly important to making a case that artistic value varies by culture. Admittedly, there are numerous practical problems associated with identifying individuals qualified to evaluate works of art. For example, how is it possible to distinguish pretenders from qualified individuals? A common response to such a question is to point to the model of the critic. Definitions of the characteristics and qualifications are quite diverse, too diverse to be debated here. Suffice it to say that minimal qualifications of arts critics are the capacity to think reflectively about the features, qualities, and meanings of art works and to effectively verbalize their insights and judgments. But Dickie points out another significant feature of individuals qualified to evaluate art: "When someone can point out to me some feature of a work of art of which I was unaware but which I can then come to see, hear, understand, and so on, then I have the best evidence I could possibly have that person is, if not

a fully qualified judge, then at least more qualified than I am and someone to whom I ought to pay attention."[167]

A final point needs to be made about the qualifications of individuals to have integrated experiences of multidimensional works of art and to therefore make defensible judgments about their artistic value. Throughout this section it has been stressed that the moral, religious, and cognitive (including symbolic) features of art works are important to their evaluation. As such, then, it seems reasonable to conclude that familiarity with the cognitive, moral, and religious beliefs and practices of a culture, while by no means a sufficient qualification for defensible artistic evaluation, is a necessary qualification. History is replete with examples of critical evaluation of art works from ethnic cultures based solely on aesthetic features and qualities. Indeed, the way ethnic arts are exhibited and displayed in museum settings often reflects this limited focus of evaluation.

The implications of this point can be summarized as follows: If defensible judgments are to be made about multidimensional works of art based on these works' capacity to induce valuable, integrated experiences, then familiarity with a culture's cognitive, moral, and religious beliefs and practices is a necessary qualification of those making such judgments. This conclusion is important in two regards. First, it suggests that the value of art can vary by culture, because the cognitive, moral, and religious beliefs and practices embodied as features in art works, features of special relevance to the evaluation of art, can and do vary by culture. Second, this conception guards against the prospect of relativism, whereby there is no means of resolving differences in the evaluation of art works. It does not follow, as some might suspect, that contending that the value of art varies by culture consigns one to relativism as defined here. This is so because this conception makes clear that some evaluations of art works are more reliable and defensible than others. More defensible evaluations are made by those persons who are capable of having integrated experiences of multidimensional art works whose features embody a culture's cognitive, moral, and religious beliefs and practices, persons having, at minimum, a familiarity with those beliefs and practices. Such persons also evidence their qualifications to make defensible judgments by being able to point out and clarify features of art works with which other persons were at first unaware but could then come to see, hear, and understand.

It is now time to bring these various strands together in a summary of this instrumental conception of artistic value. It was granted that much ethnic art is multicultural in origin, is variously valued by ethnic group members, and can be utilized for purposes with little relation to its origins or intended effects. Still, it was found that these phenomena, in themselves, do not negate the potential value of such art. Further, it was also established that much art work has been, and continues to be, created that draws

on the cultural traditions, beliefs, and practices of ethnic groups. This art is best and most fairly evaluated by persons capable of having integrated experiences based on their familiarity with the cognitive, moral, and religious beliefs and practices embodied in the features of such art works.

This conception of the variability of artistic value by culture has obvious implications for the practices of public arts agencies. As was stipulated earlier, if the equal opportunity concept of justice is to prevail in arts policy, then all grant applicants must be evaluated according to appropriate criteria. Since artistic value is the most prominent of all evaluative criteria utilized by public arts agencies, its clear definition and fair application are of utmost importance in maintaining the equal opportunities of those seeking funds. Then, when these conceptions of justice and artistic value are combined, it seems obvious that public arts agencies must rest considerable decision–making responsibility in persons qualified to make defensible judgments about the artistic value of art rooted in ethnic cultural traditions. Such an assertion does, admittedly, present practical problems. For example, identifying and recruiting such qualified individuals for service can take considerable effort on the part of public arts agencies. However, mere inclusion of a certain percentage of ethnic group members on arts agencies' grants decision–making panels and boards, some of whom may not by virtue of knowledge and experience be qualified to evaluate the merits of works of ethnic art, does not suffice. For equal opportunity to be upheld, public arts agencies must not only make the effort but in fact secure the service of individuals qualified to make defensible judgments about the artistic value of ethnic art.

ANALYSIS AND EVALUATION OF ARTS POLICY MECHANISMS

This chapter began with the identification of four conceptual issues that emerged during the interpretation of the policy mechanisms utilized by state arts agencies. These issues included the following: conceptions of cultural pluralism, that is, normative definitions of how the political, social, and economic relations of cultural and ethnic groups ought to be in society; relations of art and culture in society and the effects of these relations; the place of concepts of justice and their applications to arts policy contexts; and questions surrounding the concept of artistic value, including, In what does artistic value reside? Is value in art best thought of as one thing or as many? and Does value in art vary by culture? Analysis of these questions reflected the belief that policy mechanisms are rooted in alternative and potentially conflicting value positions, the resolution of which is only possible through analysis of the value assumptions underlying these positions.

Through conceptual analysis of the concepts in forming these positions a number of conclusions emerged, conclusions that, I believe, can serve as the basis for the evaluation of public policy goals in the arts. The concept of "cultural pluralism," a pluralism of pluralisms as articulated and advocated for, was found to be a problematic basis for the formulation of arts policy goals. Certain definitions of cultural pluralism, it was found, could resist criticisms that the ideal of cultural pluralism inevitably leads to the constriction of individual development or threatens basic democratic values. Yet many open questions remained about the concept of cultural pluralism, in particular, What is the proper role of the state in fostering cultural pluralism? It was also concluded that, by itself, the concept did not address the criticism that ethnic artistic activities involve little commitment to the retention of ethnic group cultures' behaviors, outlooks, and dispositions, a necessary condition of most ideals of cultural pluralism.

This open question led to consideration of two aspects of the relationship between art and culture, the effects of culture on art and the effects of art on culture. The review of research on the creation, perception, consumption, and meanings of ethnic art was equivocal, although it was acknowledged that many artists create art works rooted in beliefs and practices of ethnic groups and that these art works potentially serve functions and have meanings for such groups. Still, it was concluded that support for the creation and dissemination of ethnic art that has important meanings for ethnic groups in complex, heterogeneous societies was limited at best and, therefore, that ethnic art activities, to serve important purposes, require some kind of support from the government as a matter of public policy.

This conclusion led to the exploration of concepts of justice, and its associated concept of affirmative action, in order to see if a justification of policies to support the production and dissemination of ethnic arts could be rooted in a concept of justice. Concepts of compensatory justice, rights, utilitarian justice, and distributive justice were found wanting on a variety of grounds. But the concept of justice as equal opportunity was found a sufficient justification for at least some forms of affirmative action programs within the arts policy sphere. This concept contained two basic principles: (1) that persons receive equal treatment and not be subjected to inappropriate forms of discrimination on the basis of factors such as race and ethnicity in the competition for, for example, grant funds; and (2) that for equal opportunity to be upheld, the state has an obligation to reduce the competitive obstacles individuals and organizations face, through no lack of effort on their own, in seeking grant funds by offering remedies directed to enhance applicants' knowledge and skill, and hence their qualifications, so that they can more effectively meet the standards of merit stipulated for receipt of grant funds. This point led to a final conclusion, that if a standard

of merit rooted in an inapplicable concept of artistic value is utilized in the evaluation of work produced and disseminated by artists and arts organizations based in ethnic cultural traditions, then the principle of equal opportunity is not upheld.

This point then led to exploration of a final conceptual issue—whether artistic value can be said to vary by culture. After review of a wide range of theories of artistic value, including neo–Marxist views as well as the objective intrinsic, subjective intrinsic, and various versions of the instrumental theory of artistic evaluation, a definition of artistic value was stipulated. This definition holds that artistic value resides in the capacity of art works to induce, in qualified individuals, valuable, integrated experiences of the aesthetic, cognitive, moral, and religious features of art works. It was also concluded that a definition of qualified individuals must, of necessity, include familiarity with those cognitive, moral, and religious beliefs and practices that are embodied as features in art works rooted in ethnic cultural traditions. Finally, it was concluded that this conception of artistic value, on the one hand, supports the view that defensible judgments of artistic value can and do vary by culture and, on the other hand, guards against the prospect of relativism, by positing conditions for the possibility of resolving disputes over different evaluations of art works.

Out of all of this analysis, then, two basic criteria have emerged that can be utilized in the evaluation of the policy mechanisms of public arts agencies: (1) that the principles of equal opportunity, barring inappropriate discrimination and requiring positive remedies to equalize opportunities, must be upheld; and (2) that applicants must be evaluated using culturally appropriate standards of merit applied by individuals qualified to do so. These criteria clearly can justify many of the policies and practices of public arts agencies toward issues of multiculturalism and the arts. These include technical assistance workshops and leadership training opportunities, and active publicizing of these opportunities in ethnic cultural communities, as well as the active recruitment of grant applicants from minority ethnic groups and the retention of individuals qualified to make appropriate judgments about ethnic art on art agencies' grants decision–making bodies. Just as clearly, these two criteria can be invoked in critiquing other public arts agency policies and practices. These include the selection of individuals to serve on grants decision–making bodies solely on the basis of their race and ethnicity without due consideration to their qualifications to make evaluative judgments according to culturally appropriate criteria; special programs restricted only to members of ethnic groups; and distributive pluralism policy mechanisms requiring either formulaic distribution of arts funds or "reflection" of the racial ethnic makeup of artists' and arts organizations' communities in their audiences. It is not difficult to imagine other policies and practices that can be justified or judged unjustified

according to these two criteria. It must be stressed, however, that justifying the policy goals of public arts agencies does not mean that any specific program that is adopted consistent with these criteria is therefore effective in meeting its goals or does so with a minimum of unanticipated, negative consequences. Documentation of the effectiveness and efficiency of specific programs is a matter for policy research of a more empirical nature.

It must also be acknowledged that the establishment of these criteria for the evaluation of policy mechanisms does not cover other possible policy options available to public arts agencies. For example, it can be argued that public arts agencies should broaden their eligibility requirements for applicants to open up the competitive process to smaller organizations, non–arts organizations such as social service agencies and religious organizations, and even amateur groups. These organizational types, it is said, are frequently the institutional home for the creation and dissemination of ethnic art. The merits of this policy option will not be debated here. Suffice it to say that, on the face of it, nothing in the two evaluative criteria identified above would prohibit the adoption of this policy option. As another example of a policy option public arts agencies could perhaps adopt, it has been argued that the most potentially effective means of supporting ethnic artists and arts organizations is not merely to revise or supplement arts policy mechanisms but to devise and implement cultural policies, policies designed to support the maintenance and development of the foundations of ethnic arts, namely, ethnic cultures themselves.[168] How cultural policies should be formulated and how they can be implemented fairly and effectively could surely be a topic for extensive debate. But whether they could be justified or not, issues implicit in the adoption of cultural policies, while not irrelevant or unimportant here, are beyond the scope of the public policy sphere under consideration here, the arts.

NOTES

1. See Nicholas Appleton, *Cultural Pluralism in Education: Theoretical Foundations* (New York: Longman, 1983).

2. Stephen Thernstrom, ed., *Harvard Encyclopedia of American Ethnic Groups* (Cambridge, MA: Belknap Press of Harvard University Press, 1980).

3. For a full discussion of this point, see Thomas F. Green, *Education and Pluralism: Idea and Reality* (Syracuse, NY: School of Education, Syracuse University, 1966).

4. Nicholas Appleton, *Cultural Pluralism in Education*, p. 29.

5. For a comprehensive discussion of the theory of assimilation as well as acculturation and structural assimilation, see Milton Gordon,

Assimilation in American Life: The Role of Race, Religion, and National Origins (New York: Oxford University Press, 1964).

6. Nicholas Appleton, *Cultural Pluralism in Education*, p. 30.

7. William A. Newman, *American Pluralism: A Study of Minority Groups and Social Theory* (New York: Harper & Row, 1973), p. 75.

8. Nicholas Appleton, *Cultural Pluralism in Education*, p. 31.

9. Ibid., p. 32.

10. Ibid., p. 69.

11. Milton Gordon, "Toward a General Theory of Racial and Ethnic Group Relations," in Nathan Glazer and Daniel P. Moynihan, eds., *Ethnicity: Theory and Experience* (Cambridge, MA: Harvard University Press, 1975), p. 105.

12. Ibid., p. 106.

13. Ibid.

14. Ibid.

15. See, for example, Horace M. Kallen, *Culture and Democracy in the United States* (New York: Boni and Liveright, 1924).

16. Nicholas Appleton, *Cultural Pluralism in Education*, p. 75.

17. Ibid., p. 78.

18. For further discussion of cultural pluralism as voluntary ethnic choice, see William A. Newman, *American Pluralism*.

19. Nicholas Appleton, *Cultural Pluralism in Education*, p. 84.

20. Ibid., p. 70.

21. Ibid.

22. For further discussion of the "open society" alternative to cultural pluralism, see Nathan Glazer and Daniel P. Moynihan, eds., *Affirmative Discrimination: Ethnic Inequality and Public Policy* (New York: Basic Books, 1975).

23. Francis L. K. Hsu, "American Core Values and National Character," in Francis L. K. Hsu, ed., *Psychological Anthropology* (Cambridge, MA: Schenkman, 1972).

24. Thomas F. Green, *Education and Pluralism*.

25. Orlando Patterson, *Ethnic Chauvinism: The Reactionary Impulse* (New York: Stein and Day, 1977).

26. John Wilson, "Art, Culture, and Identity," *Journal of Aesthetic Education* 18 (Summer 1984): 93.

27. See Diane Ravitch, "Multiculturalism: E Pluribus Plures," *American Scholar* (Summer 1990): 337–354.

28. See Charles A. Tesconi, "Multicultural Education: A Valued But Problematic Ideal," *Theory into Practice* 23 (Spring 1984): 87–92.

29. Nathan Glazer and Daniel P. Moynihan, eds., *Affirmative Discrimination*.

30. R. Freeman Butts, *The American Tradition in Religion and Education* (Boston, MA: Beacon Press, 1950).

31. Charles Tesconi, "Multicultural Education."

32. See Orlando Patterson, *Ethnic Chauvinism*.

33. Stephen Steinberg, *The Ethnic Myth: Race, Ethnicity, and Class in America* (New York: Atheneum, 1981).

34. See Stephen Thernstrom, ed., *Ethnic Relations in America* (Englewood Cliffs, NJ: Prentice–Hall, 1982).

35. Orlando Patterson, *Ethnic Chauvinism*.

36. For further discussion of this argument, see Vera L. Zolberg, *Constructing a Sociology of the Arts* (New York: Cambridge University Press, 1990).

37. For further discussion, see Alan P. Merriman, *The Anthropology of Music* (Evanston, IL: Northwestern University, 1964).

38. For additional discussion of these points, see Milton C. Albrecht, "Art as an Institution," in Milton C. Albrecht, James H. Barnett, and Mason Griff, eds., *The Sociology of Art and Literature: A Reader* (New York: Praeger, 1970).

39. This argument is made in greater detail in Raymond Williams, *The Sociology of Culture* (New York: Schocken Books, 1981).

40. Vera L. Zolberg, *Constructing a Sociology of the Arts*, p. 214.

41. Richard Wollheim, "Sociological Explanations of the Arts: Some Distinctions," in Milton C. Albrecht, James H. Barnett, and Mason Griff, eds., *The Sociology of Art and Literature: A Reader*, p. 575.

42. Ibid., p. 576.

43. Ibid.

44. For an example of this argument, see Another Standard, *Culture and Democracy: The Manifesto* (London: Comedia Publishing Group, 1986).

45. This argument is made in Henry A. Giroux, *Ideology, Culture, and the Process of Schooling* (Philadelphia, PA: Temple University Press, 1981).

46. Raymond Williams, *The Sociology of Culture*, p. 70.

47. Ibid., p. 71.

48. See Arnold Hauser, *The Sociology of Art*, translated by Kenneth J. Northcott (Chicago: The University of Chicago Press, 1982).

49. This argument is made in Anthony Saville, *The Test of Time* (New York: Oxford University Press, 1982).

50. Edmund Barry Gaither, "Brunswick Stew," in Getty Center for Education in the Arts, *Inheriting the Theory: New Voices and Multiple Perspectives on DBAE* (Los Angeles, CA: J. Paul Getty Trust, 1990), p. 28.

51. Ibid.

52. Ibid.

 53. David J. Elliott, "Music as Culture: Toward a Multicultural Concept of Arts Education," *Journal of Aesthetic Education* 24 (Spring 1990): 151.
 54. Ibid., pp. 149–150.
 55. For a more complete articulation of this argument, see Eugene Grigsby, *Art and Ethnics* (Dubuque, IA: William C. Brown, 1977).
 56. This argument is contained in Bruno Nettl, *The Western Impact on World Music: Change, Adaptation and Survival* (New York: Schirmer Books, 1985).
 57. For further discussion of these views, see Jacques Macquet, *The Aesthetic Experience: An Anthropologist Looks at the Visual Arts* (New Haven: Yale University Press, 1986).
 58. Vera L. Zolberg, *Constructing a Sociology of the Arts*, p. 196.
 59. See, for example, Irwin L. Child and Leo Siroto, "Bakwele and American Aesthetic Evaluations," *Ethnology* 4 (1965): 349–360; C. S. Ford, Terry E. Prothro, and Irwin L. Child, "Some Transcultural Comparisons of Aesthetic Judgment," *Journal of Social Psychology* 68 (1966): 19–26; Sumiko Iwao and Irwin L. Child, "Comparison of Aesthetic Judgments by American Experts and by Japanese Potters," *Journal of Social Psychology* 68 (1966): 27–33; and Alvin W. Wolfe, "Social Structural Bases of Art," *Current Anthropology* 10 (1969): 3–29.
 60. This critique is articulated in F. Graeme Chalmers, "Artistic Perception: The Cultural Context," *Journal of Art and Design Education* 3 (1984): 279–289.
 61. Adrienne Walker Hoard, "The Black Aesthetic: An Empirical Feeling," in Bernard Young, ed., *Art, Culture, and Ethnicity* (Reston, VA: National Art Education Association, 1990).
 62. Ronald W. Neperud, Ronald Serlin, and Harvey Jenkins, "Ethnic Aesthetics: The Meaning of Ethnic Art for Blacks and Non–Blacks," *Studies in Art Education* 28 (Fall 1986): 16–29.
 63. For a discussion of options in measuring participation in the arts, see Harold Horowitz, "Measuring Arts Participation," in Virginia L. Owen and William S. Hendon, eds., *Managerial Economics for the Arts* (Akron, OH: Association for Cultural Economics, 1985).
 64. Herbert J. Gans, *Popular Culture and High Culture: An Analysis and Evaluation of Taste* (New York: Basic Books, 1974), p. 70.
 65. Ibid.
 66. Ibid.
 67. Ibid., p. 101.
 68. Ibid.
 69. John P. Robinson, Carol A. Keegan, Marcia Karth, and Timothy A. Triplett, *Survey of Public Participation in the Arts: 1985, Volume 1,*

Project Report (Washington, DC: University of Maryland Survey Research Center and the National Endowment for the Arts, 1987).

70. Paul J. DiMaggio and Francie Ostrower, "Participation in the Arts by Black and White Americans," in David B. Pankratz and Valerie B. Morris, eds., *The Future of the Arts: Public Policy and Arts Research* (New York: Praeger, 1990), p. 130.

71. Ibid.

72. Ibid., p. 131.

73. This argument is made in Arnold Hauser, *The Sociology of Art*.

74. Vera L. Zolberg, *Constructing a Sociology of the Arts*, p. ix.

75. NEA Research Division Note 14, "Age, Desire and Barriers to Increased Attendance at Performing Arts Events and Museums," 4 February 1986, p. 2.

76. Judith Huggins Balfe, "The Baby–boom Generation: Lost Patrons, Lost Audience?" in Margaret J. Wyszomirski and Pat Clubb, eds., *The Cost of Culture: Patterns and Prospects of Private Arts Patronage* (New York: American Council for the Arts, 1989), p. 10.

77. Judith Huggins Balfe, "Modernism and Postmodernism: Implications for Arts Policy," in David B. Pankratz and Valerie B. Morris, eds., *The Future of the Arts*, p. 190.

78. Richard A. Peterson, "Audience and Industry Origins of the Crisis in Classical Music Programming: Toward World Music," in David B. Pankratz and Valerie B. Morris, eds., *The Future of the Arts*, p. 211.

79. Ibid.

80. Ibid., p. 212.

81. Ibid., p. 211.

82. Nelson H. Graburn, ed., *Ethnic and Tourist Arts: Cultural Expressions from the Fourth World* (Berkeley: University of California Press, 1976), pp. 4–5.

83. Ibid., p. 5.

84. Ibid., p. 6.

85. Ibid.

86. Ibid.

87. Edmund Burke Feldman, *Varieties of Visual Experience* (Englewood Cliffs, NJ: Prentice–Hall, 1981), p. 42.

88. This typology of the functions of art within a culture is found in June King McFee, "Cross–cultural Inquiry into the Social Meanings of Art: Implications for Art Education," *Journal of Multi–Cultural and Cross–Cultural Research in Art Education* 4 (Fall 1986): 6–16.

89. See Bruno Nettl, *The Western Impact on World Music*.

90. Samella S. Lewis, "Introduction," in Samella S. Lewis and Ruth G. Waddy, eds., *Black Artists on Art, Volume 1* (Los Angeles: Contemporary Crafts, Inc., 1969).

91. See T. S. Eliot, *Notes towards the Definition of Culture* (New York: Harcourt, Brace, 1949).

92. This argument is contained in George Steiner, *In Bluebeard's Castle: Some Notes towards the Redefinition of Culture* (New Haven, CT: Yale University Press, 1971).

93. See Monroe C. Beardsley, "Aesthetic Welfare, Aesthetic Justice, and Educational Policy," *Journal of Aesthetic Education* 7 (Winter 1973): 49–61.

94. Robert K. Fullinwider, *The Reverse Discrimination Controversy: A Moral and Legal Analysis* (Totowa, NJ: Rowan and Littlefield, 1980), pp. 5–6.

95. Ibid., p. 8.

96. Ibid.

97. This typology is based on one found in Robert K. Fullinwider, *The Reverse Discrimination Controversy*.

98. Ibid., p. 33.

99. Ibid., p. 30.

100. Ibid., p. 33.

101. Ibid., p. 37.

102. This argument is contained in William Bradford Reynolds, *Equal Opportunity, Not Equal Results* (College Park: Center for Philosophy and Public Policy, University of Maryland, 1985).

103. Marshall Cohen and Thomas Nagel, "Introduction," in Marshall Cohen, Thomas Nagel, and Thomas Scanlon, eds., *Equality and Preferential Treatment* (Princeton, NJ: Princeton University Press, 1977).

104. This argument can be found in William Bradford Reynolds, *Equal Opportunity, Not Equal Results*.

105. Robert K. Fullinwider, *The Reverse Discrimination Controversy*, p. 36.

106. For a discussion of this conception of rights, see Ronald Dworkin, *Taking Rights Seriously* (Cambridge, MA: Harvard University Press, 1977).

107. See Judith Jarvis Thomson, "Preferential Hiring," *Philosophy and Public Affairs* 2 (Summer 1973): 364–384.

108. Robert K. Fullinwider, *The Reverse Discrimination Controversy*, p. 58.

109. Ibid., p. 70.

110. Ibid., p. 91.

111. Ronald Dworkin, *Taking Rights Seriously*, p. 232.

112. Ibid., p. 233.

113. Robert K. Fullinwider, *The Reverse Discrimination Controversy*, p. 94.

114. This argument is made in Thomas Nagel, "Equal Treatment and Compensatory Discrimination," in Marshall Cohen, Thomas Nagel, and Thomas Scanlon, eds., *Equality and Preferential Treatment*.

115. These points are made in Nathan Glazer and Daniel P. Moynihan, eds., *Affirmative Discrimination*.

116. Paul J. DiMaggio and Francie Ostrower, "Participation in the Arts by Black and White Americans."

117. Robert K. Fullinwider, *The Reverse Discrimination Controversy*, p. 13.

118. Discussions of broad definitions of obstacles to equal opportunity and the problems associated with such definitions can be found in Alvin H. Goldman, *Justice and Reverse Discrimination* (Princeton, NJ: Princeton University Press, 1979).

119. A version of this argument can be found in George Sher, "Justifying Reverse Discrimination in Employment," in Marshall Cohen, Thomas Nagel, and Thomas Scanlon, eds., *Equality and Preferential Treatment*.

120. This argument is made in Alvin H. Goldman, *Justice and Reverse Discrimination*.

121. A review of such arguments can be found in Robert K. Fullinwider, *The Reverse Discrimination Controversy*.

122. For arguments of this sort, see Nathan Glazer and Daniel P. Moynihan, eds., *Affirmative Discrimination*; and Sidney Hook, "Discrimination, Color Blindness, and the Quota System," in Barry Gross, ed., *Reverse Discrimination* (Buffalo, NY: Prometheus Books, 1977).

123. Margaret J. Wyszomirski, "Philanthropy, the Arts, and Public Policy," *Journal of Arts Management and Law* 16 (Winter 1987): 11.

124. For a discussion of "official culture," public policy, and the arts, see Kevin V. Mulcahy, "Official Culture and Cultural Repression," *Journal of Aesthetic Education* 18 (Summer 1984): 69–83.

125. This argument is made in Cultural Arts Task Force, *Toward Cultural Democracy: The Development and Implementation of a Policy for Cultural Diversity in New York State* (Albany: New York State Black and Puerto Rican Legislative Caucus, 1988).

126. This point is made in Margaret J. Wyszomirski, "Philanthropy, the Arts, and Public Policy."

127. This point is made in Melvin Rader and Bertram Jessup, *Art and Human Values* (Englewood Cliffs, NJ: Prentice–Hall, 1976).

128. See Alan P. Merriman, *The Anthropology of Music*.

129. Vera L. Zolberg, *Constructing a Sociology of the Arts*.

130. Janet Wolff, *The Social Production of Art* (New York: New York University Press, 1984).

131. See Pierre Bourdieu, *Distinction*, translated by Richard Nice (Cambridge, MA: Harvard University Press, 1984).

132. Paul J. DiMaggio and Francie Ostrower, "Participation in the Arts by Black and White Americans," pp. 131–132.

133. This argument is made in Henry Giroux, *Ideology, Culture, and the Process of Schooling*.

134. This argument can be found in Raymond Williams, *The Sociology of Culture*.

135. Arnold Hauser, *The Sociology of Art*.

136. For a full discussion of these arguments, see Matthew Lipmann, "Can Non–Aesthetic Consequences Justify Aesthetic Values?" *Journal of Aesthetics and Art Criticism* 34 (Winter 1975): 117–123; and Anthony Saville, *The Test of Time*.

137. Jacques Macquet, *The Aesthetic Experience*.

138. June King McFee, "Cross–cultural Inquiry into the Social Meanings of Art: Implications for Art Education."

139. Nelson H. H. Graburn, *Ethnic and Tourist Arts*.

140. Robert Plant Armstrong, *The Powers of Presence: Consciousness, Myth, and Affecting Presence* (Philadelphia: University of Pennsylvania Press, 1981).

141. This view is fully developed in Melvin Rader and Bertram Jessup, *Art and Human Values*.

142. See Janet Wolff, *Aesthetics and the Sociology of Art* (London: G. Allen and Unwin, 1983).

143. For example, see George Dickie, *Evaluating Art* (Philadelphia: Temple University Press, 1988).

144. Ralph A. Smith and C. M. Smith, "Justifying Aesthetic Education," in Ralph A. Smith, ed., *Aesthetics and Problems of Education* (Urbana: University of Illinois Press, 1971), p. 127.

145. George Dickie, *Evaluating Art*, p. 5.

146. This argument can be found in David Best, "Concepts and Cultures," *Journal of Multi–Cultural and Cross–Cultural Research in Art Education* 3 (Fall 1985): 7–18.

147. George Dickie, *Evaluating Art*, p. 8.

148. Monroe C. Beardsley, "Aesthetic Welfare, Aesthetic Justice, and Educational Policy," p. 50.

149. Ibid., p. 49.

150. This description of aesthetic experience is contained in Monroe C. Beardsley, "Aesthetic Theory and Educational Theory," in Ralph A. Smith, ed., *Aesthetic Concepts and Education* (Urbana: University of Illinois Press, 1970).

151. George Dickie, *Evaluating Art*, pp. 78–79.

152. This is a summary of the views expressed in Nelson Goodman, *Languages of Art: An Approach to a Theory of Symbols* (Indianapolis: Bobbs–Merrill, 1968); and idem, *Ways of Worldmaking* (Indianapolis: Hackett, Publishing Company, 1978).

153. This summary is based on one found in George Dickie, *Evaluating Art*.

154. Nelson Goodman, *Languages of Art*, p. 258.

155. George Dickie, *Evaluating Art*, p. 106.

156. Nelson Goodman, *Ways of Worldmaking*, p. 65.

157. George Dickie, *Evaluating Art*, p. 112.

158. Nicholas Wolterstorff, *Art in Action* (Grand Rapids, MI: William B. Eerdsmann, 1980), p. 158.

159. Ibid.

160. Ibid., p. 157.

161. Ibid., p. 159.

162. Monroe C. Beardsley, *Aesthetics: Problems in the Philosophy of Criticism* (New York: Harcourt, Brace and World, 1981), p. 573.

163. Monroe C. Beardsley, "The Aesthetic Problem of Justification," *Journal of Aesthetic Education* 1 (Spring 1966): 34.

164. See George Dickie, *Evaluating Art*.

165. See Melvin Rader and Bertram Jessup, *Art and Human Values*.

166. George Dickie, *Evaluating Art*, p. 130.

167. Ibid., p. 143.

168. For an argument in support of the need for cultural policies, see Gerald D. Yoshitomi, "Cultural Democracy," in Stephen Benedict, ed., *Public Money and the Muse: Essays on Government Funding for the Arts* (New York: W. W. Norton, 1991).

5

Epilogue:
Prospects for Policy
Research in the Arts

This study of policy issues regarding multiculturalism and the arts has been rooted in one basic premise: that an integrated methodology of interpretive policy analysis and conceptual analysis, in recognition of the value–laden nature of policy formulation, can clarify the conceptual grounds for the adoption of policy goals and means. Through an interpretive analysis of documents that revealed the policy goals and means currently in place in state arts agencies, and a subsequent analysis of the value–laden concepts that underlie these goals and means, one primary conclusion emerged: Public arts policy should be rooted in the equal opportunity concept of justice and implemented through policies to ensure that the proposals of artists and arts organizations rooted in ethnic cultural traditions are reviewed by individuals qualified to make defensible judgments of the artistic value of these artists' work.

This conclusion is not rooted in the belief that research should always have direct effects on policy or that the aim of policy research is to reach some "scientifically best" solution to all policy problems. Instead, this conclusion is offered in the spirit of interpretive policy analysis. The aim here is not to contribute directly to any particular reform agenda but, instead, to generate thoughtful attention to the value assumptions that underlie debate about policy options in the arts and arts education, that is, to contribute to the quality of such debate. But what is offered here are not fixed conclusions, in that this study also reflects another value assumption of interpretive policy analysis, that the merits of policy prescriptions ultimately are to be debated through democratic processes involving those with interests in implementing a policy and those potentially affected by its adoption.

It was stressed at various points that an integrated interpretive policy analysis/conceptual analysis methodology to study policy issues has many potential benefits, most notably, that it can help to clarify the conceptual grounds for choices about policy goals and means. But another point was also emphasized, namely, that the relative dearth of available data on numerous aspects of arts and arts education virtually necessitated use of

this integrated methodology. As will be recalled, a key feature of the theory of interpretive policy analysis is the importance of data. It is argued that any policy analysis "must contain an empirically accurate description of the factual circumstances surrounding [an] action, and an understanding of the norms and values operating in the cultural context."[1] Thus, it can be argued that without the ongoing generation of reliable data in the arts, the possibility of conducting many kinds of policy research is, at best, inhibited. That said, a brief review of the possible range of subject matter and aims of policy research is in order here.

The subject matter of policy research is quite broad and can examine several kinds of policies in the arts. *Direct policies* are those that regulate and formalize explicit government support (channeled through public agency grants, fellowships, and contracts) to individual artists, nonprofit arts and arts education organizations, and public schools; another example of direct policies are those in which government agencies act as producers and presenters of the arts. *Indirect policies* include a broad range of government regulations, laws, and measures that indirectly affect production and distribution of education in the arts in significant ways. For example, tax laws accord the tax–exempt status of nonprofit arts and arts education organizations; affect corporate, foundation, and individual giving to the arts, as well as donations of visual arts objects; exempt related business income of arts organizations from taxation; and accord individual artists business deductions. Other laws and regulations extend copyright protection, levy special consumer taxes that are allocated to the arts, extend discount postal privileges, mandate curricular and graduation requirements in public schools, provide unemployment compensation for artists, and affect zoning regulations.[2] Both direct and indirect policies can either be *explicit*, that is, formal and institutionalized, or *implicit*, where the absence of a specific policy, in effect, constitutes a policy, or where the behavior of decision makers or administrators alters the state goals and implementation strategies of policies, resulting in de facto policies.

Policy research can focus on several elements of policies—goals, means, enforcement, and impacts—either separately, as they work in conjunction, or at cross–purposes. *Policy goals* can be viewed in terms of their clarity, comprehensiveness, and worthwhileness, while the processes utilized to formulate goals can be interpreted in terms of concepts of justice and political participation. The *means* to achieve policy goals can be analyzed in terms of *effectiveness* (their adequacy to meet policy goals) and *justness* (their fairness with respect to groups and individuals affected by a particular policy). The *enforcement* of policies can be *imposed* (stringent enforcement backed by sanctions or penalties), *endorsed* (compliance motivated by anticipated benefits), or *implied* (completely voluntary compliance).[3] The *impacts* of policies can be direct or indirect, immediate

or long term, anticipated or unanticipated, primary or secondary (usually termed *externalities*), or measurable or nonmeasurable. With specific regard to arts and arts education policies, impacts can be economic, social, political, administrative, educational, and aesthetic in nature, and those affected can range from artists, arts organizations, schools, and professional service organizations to government agencies, legislatures, a public audience, teachers and students, or the general citizenry.

Finally, policy research in the arts can examine decision–making policies and administrative processes involved in the formulation and implementation of policies. Policy–making decisions themselves can be directed to rationales for government support for the arts; legislative initiatives; authorization and reauthorization of public arts agencies; budget appropriations and allocations; policy priorities; and decisions among those competing for grants, contracts, or fellowships. Any level or branch of government can make policy decisions in the arts, including executive and legislative branches, legislative committees, and the courts, as well as public departments and agencies, and appointed panels of artists, arts educators, scholars, and arts organization representatives who provide policy oversight or make direct grants decisions. The responsibility for implementing policies lies largely with the staff of public education and arts agencies at the local, state, and federal levels. The administration of policy implementation can also be an important subject for policy research in the arts and arts education.

Policy formulation and implementation do not occur in a vacuum but in a variety of contexts. Advocacy groups, in the tradition of interest group politics, work to exert pressure and influence on policymakers.[4] In the arts, advocacy groups address issues such as budget levels for public arts agencies, the implications of tax policies for arts organizations and artists, and measures that affect the right and freedom of expression of artists and arts institutions. Arts critics, artists, and editorialists write about these issues and others, while individual citizens and elected representatives have increasingly spoken out on issues of community standards of artistic merit and acceptability, in particular, in cases where the religious, sexual, ethnic, and political content of government–subsidized art is at issue.[5] Finally, influences from other policy spheres such as communications policy, educational policy, and policies on nonprofit organizations make up the context of arts policy as well. All of these contextual influences, in turn, are included in the broad subject matter of policy research in the arts.

Finally, policy research can serve several aims: analysis, comparison, evaluation, and forecasting. *Analysis* involves systematic study of the content of the goals, means, and intended impacts of arts policies; the processes of policy formulation; and factors such as leadership, contextual influences, terms of policy debates, points of contention, and resolutions of

conflicts; and the implementation of policies. *Comparative analysis* explores different policies—at the federal, state, and local levels, during different historical periods[6] or among nations[7]—as well as relationships between different policy spheres. Comparative analysis also seeks to highlight and explain commonalities and differences in the content, formulation, and implementation of such policies. *Evaluation* focuses on the worthiness of policy goals, the potential effectiveness and justness of the means as formulated, and the effectiveness and cost–efficiency of means in achieving desired impacts or producing secondary consequences. Evaluative criteria utilized can be economic, social, political, educational, aesthetic, and administrative in nature and can be those of policymakers, the researchers, or those affected by the policy. Finally, *forecasting* entails inquiry into broad trends, including demographic, political, social, economic, educational, and aesthetic trends, whose future impacts may necessitate the revision of existing policies, the formulation of new policies, or changes in decision–making processes.[8]

The questions explored in this study can be related to this policy research typology. The interpretive study of state agencies' arts policies centered on an analysis and evaluation of the clarity of goals and justness of means of explicit and implicit direct policies in a comparative fashion. But also in reference to the policy research typology cited above, this book does not address a number of questions of potential interest. For example, the study of arts policies did not address how state arts agencies make and implement their policy decisions (apart from noting the racial/ethnic makeup of decision–making bodies); or their current, past, and future budgets to implement policies; or most important, the impacts of policies, that is, who is affected and in what ways by the implementation of policies.

The reasons for these omissions, apart from the obvious one that not all questions of interest can be addressed in a single book, can be related to the relative lack of development of policy research as an accepted methodology to study issues of the arts. For this study, it was possible, in analyzing the value–laden concepts underlying policy positions, to draw on an extensive extant literature from culture theory, sociology, educational philosophy, philosophical aesthetics, anthropology, and political science. The same cannot be said of policy studies of the arts. As such, then, without a background of research with which to work, the pursuit of many kinds of policy questions would have been problematic at best.

Clearly, the promise of arts policy research has yet to be realized in the United States. But the complex environment of the arts is undergoing great change. The change portended by dramatic shifts in the demographic, aesthetic, technological, and educational contexts of the production and distribution of the arts has spawned uncertainty among policymakers.

Furthermore, these challenges could well stimulate renewed calls for policy formulation based on a comprehensive base of research.[9]

That said, however, a concluding, cautionary note is needed. It might seem from this discussion of policy research for the arts that research *should* always have direct effects on policy. But such a view, a sort of technocratic view of policy research, would undermine the imperatives of democratic decision making in which diverse interests are represented and have a voice. Thus, a normative criterion for the effectiveness of policy research is success in contributing to participatory decision making.

However, this democratic ideal is just that, an ideal. It is always subject to subversion by forces far more potent than research—power. The distribution of power within societies and institutions shapes, to a significant degree, *whose* research, including policy research, gets a hearing. But a more serious consequence of inequitable power relations, at least for policy research, is the misuse of research to bolster ideological positions. This phenomenon raises questions about the ethical meaning of policy research. Policy researchers must ask of their work, Useful for whom and for what purpose?

The actual and potential misuse of research has spurred two responses from policy researchers. Some take the values underlying policy goals as the subject of research and analyze these values through survey research to see the extent of their support among policy actors.[10] The other response to the misuse of research is based on an acknowledgment on the part of policy researchers, namely, that all elements of research processes—posing questions, gathering data, making inferences, and drawing conclusions—are suffused with values, and that policy researchers cannot pretend to conduct value–free scientific inquiry. This point of view has led some to recommend that researchers have an obligation to make their philosophical value positions clear in presenting research results. Such an acknowledgment, it can be argued, reduces the possibility of (although by no means eliminates) misapplication of research findings to bolster a favored ideology. But Charles W. Anderson reminds us that policy researchers, however skilled they may be, do not have a unique wisdom in applying value criteria in public policy contexts. Despite this, academic policy researchers can play a distinctive role vis–à–vis value issues, namely, by interpreting policy decisions in light of value perspectives neglected in public policy debates because of inequitable power relations, undue influence, established practice, or the mere striving for novelty.[11] This conclusion points to a key but often neglected criterion in evaluating effectiveness of policy research—the degree to which it explores and introduces neglected value perspectives into debates about the goals and means of public policies. "Utilization" is not the sole criterion.

NOTES

1. Bruce Jennings, "Policy Analysis: Science, Advocacy, or Counsel?" in Stuart S. Nagel, ed., *Research in Public Policy Analysis and Management* Volume 4 (Greenwich, CT: JAI Press, 1987), p. 130.

2. See, for example, Milton C. Cummings, Jr., "Government and the Arts: Policy Problems in the Fields of Art, Literature and Music," *Policy Studies Journal* 5 (Fall 1976): 114–124.

3. See, for example, Anthony L. Barresi and Gerald B. Olson, "Policy Initiatives and American Music Education," in Charles Colwell, ed., *Handbook for Research in Music Education* (New York: Macmillan, 1992).

4. See, for example, Margaret J. Wyszomirski, "Arts Policymaking and Interest Group Politics," *Journal of Aesthetic Education* 14 (October 1980): 28–34.

5. See, for example, Hilton Kramer, "Is Art Above the Laws of Decency?" *New York Times*, 2 July 1989.

6. See, for example, Gary O. Larson, *The Reluctant Patron: The United States Government and the Arts, 1943–1965* (Philadelphia: University of Pennsylvania Press, 1983).

7. See, for example, Milton C. Cummings, Jr., and Richard S. Katz, eds., *The Patron State: Government and the Arts in Europe, North America, and Japan* (New York: Oxford University Press, 1987); and Milton C. Cummings, Jr., and J. Mark Davidson Schuster, eds., *Who's to Pay for the Arts? The International Search for Models of Support* (New York: American Council for the Arts, 1989).

8. See, for example, John K. Urice, "Government Support for the Arts in the United States, 1990–2015: A Forecast," in David B. Pankratz and Valerie B. Morris, eds., *The Future of the Arts: Public Policy and Arts Research* (New York: Praeger, 1990).

9. For discussions both of the shifting policy contexts of the arts and the need for arts policy research, see David B. Pankratz and Valerie B. Morris, eds., *The Future of the Arts*.

10. This sort of activity is discussed in Stuart S. Nagel, "Political Science and Public Policy," in George J. McCall and George H. Weber, eds., *Social Science and Public Policy: The Roles of Academic Disciplines in Policy Analysis* (Port Washington, NY: Associated Faculty Press, 1984).

11. This idea is expressed in Charles W. Anderson, "Political Philosophy, Practical Reason, and Policy Analysis," in Frank Fischer and John Forester, eds., *Confronting Values in Policy Analysis: The Politics of Criteria* (Newbury Park, CA: Sage Publications, 1987).

Bibliography

Adams, Don, and Arlene Goldbard, *Crossroads: Reflections on the Politics of Culture* (Talmage, CA: DNA Press, 1990).

Albrecht, Milton C., "Art as an Institution," in Milton C. Albrecht, James H. Barnett, and Mason Griff, eds., *The Sociology of Art and Literature: A Reader* (New York: Praeger, 1970).

Albrecht, Milton C., James H. Barnett, and Mason Griff, eds., *The Sociology of Art and Literature: A Reader* (New York: Praeger, 1970).

American Arts Alliance, *Artistic Freedom: Our American Heritage* (Washington, DC: American Arts Alliance, 1990).

Anderson, Charles W., "Political Philosophy, Practical Reason, and Policy Analysis," in Frank Fischer and John Forester, eds., *Confronting Values in Policy Analysis: The Politics of Criteria* (Newbury Park, CA: Sage Publications, 1987).

Another Standard, *Culture and Democracy: The Manifesto* (London: Comedia Publishing Group, 1986).

Apfel, Jeffrey, and John Worthley, "Academic Technical Assistance: The University and State Government," *Public Administrative Review* 39 (September/October 1979): 408–413.

Appleton, Nicholas, *Cultural Pluralism in Education: Theoretical Foundations* (New York: Longman, 1983).

Arian, Edward, *The Unfulfilled Promise: Public Subsidy of the Arts in the United States* (Philadelphia, PA: Temple University Press, 1989).

Arizona Commission on the Arts, *Program Plans 1990–91* (Phoenix: Arizona Commission on the Arts, 1990).

Arizona Commission on the Arts, *Arts in Arizona: Long–Range Plan, 1991–95* (Phoenix: Arizona Commission on the Arts, 1991).

Arkansas Arts Council, *1991–92 Guide to Grants* (Little Rock: Arkansas Arts Council, 1990).

Armstrong, Robert Plant, *The Powers of Presence: Consciousness, Myth, and Affecting Presence* (Philadelphia: University of Pennsylvania Press, 1981).

Arnold, Matthew, 1869, J. Dover Wilson, ed., *Culture and Anarchy* (Cambridge: Cambridge University Press, 1971).

Association of American Cultures, *Culturally Diverse Organizations in the United States: An Organizational Survey* (Washington, DC: Association of American Cultures, 1988).

Association of American Cultures (TAAC), *Open Dialogue III* (Washington, DC: TAAC, 1988).

Austin–Broos, Diane J., *Creating Culture: Profiles in the Study of Culture* (Boston, MA: Allen and Unwin, 1987).

Balfe, Judith Huggins, "The Baby–boom Generation: Lost Patrons, Lost Audience? in Margaret J. Wyszomirski and Pat Clubb, eds., *The Cost of Culture: Patterns and Prospects of Private Arts Patronage* (New York: American Council for the Arts, 1989).

Balfe, Judith Huggins, "Modernism and Postmodernism: Implications for Arts Policy," in David B. Pankratz and Valerie B. Morris, eds., *The Future of the Arts: Public Policy and Arts Research* (New York: Praeger, 1990).

Banfield, Edward C., *The Democratic Muse: Visual Arts and the Public Interest* (New York: Basic Books, 1984).

Banks, James A., and James Lynch, eds., *Multicultural Education in Western Societies* (New York: Praeger, 1986).

Beardsley, Monroe C., "The Aesthetic Problem of Justification," *Journal of Aesthetic Education* 1 (Spring 1966): 29–39.

Beardsley, Monroe C., "Aesthetic Theory and Educational Theory," in Ralph A. Smith, ed., *Aesthetic Concepts and Education* (Urbana: University of Illinois Press, 1970).

Beardsley, Monroe C., "Aesthetic Welfare, Aesthetic Justice, and Educational Policy," *Journal of Aesthetic Education* 7 (Winter 1973): 49–61.

Beardsley, Monroe C., *Thinking Straight: Principles of Reasoning for Readers and Writers*, fourth edition (Englewood Cliffs, NJ: Prentice–Hall, 1975).

Beardsley, Monroe C., *Aesthetics: Problems in the Philosophy of Criticism* (New York: Harcourt, Brace and World, 1981).

Beardsley, Monroe C., "Art and Its Cultural Context," in Monroe C. Beardsley, ed., *The Aesthetic Point of View* (Ithaca, NY: Cornell University Press, 1982).

Bell, Daniel, "Ethnicity and Social Change," in Nathan Glazer and Daniel P. Moynihan, eds., *Ethnicity: Theory and Experience* (Cambridge: Harvard University Press, 1975).

Bellah, Robert N., "Social Science as Practical Reason," in Daniel Callahan and Bruce Jennings, eds., *Ethics, the Social Sciences, and Policy Analysis* (New York: Plenum Press, 1983).

Biddle, Livingston C., *Our Government and the Arts: A Perspective from the Inside* (New York: American Council for the Arts, 1988).

Bibliography											205

Birch, Thomas L., "Michigan Arts Council Is Reborn," *Art View* 11 (Summer 1991): 4.

Bourdieu, Pierre, *Distinction*, translated by Richard Nice (Cambridge, MA: Harvard University Press, 1984).

Butts, R. Freeman, *The American Tradition in Religion and Education* (Boston, MA: Beacon Press, 1950).

California Arts Council, *Report to the Joint Legislative Budget Committee on the California Arts Council's 1988–89 Multi–Cultural Programs* (Sacramento: California Arts Council, 1989).

California Arts Council, *Toward 2001: 1990 and Beyond—A Plan for the California Arts Council* (Sacramento: California Arts Council, 1990).

Callahan, Daniel, and Bruce Jennings, eds., *Ethics, the Social Sciences, and Policy Analysis* (New York: Plenum Press, 1983).

Child, Irwin L., and Leo Siroto, "Bakwele and American Aesthetic Evaluations," *Ethnology* 4 (1965): 349–360.

Clifford, James, *The Predicament of Culture: Twentieth–Century Ethnography, Literature, and Art* (Cambridge, MA: Harvard University Press, 1988).

Clubb, Pat, "Understanding Foundation Policy Choices and Decision–Making Procedures," in Margaret Jane Wyszomirski and Pat Clubb, eds., *The Cost of Culture: Patterns and Prospects of Private Arts Patronage* (New York: American Council for the Arts, 1989).

Cohen, Marshall, and Thomas Nagel, "Introduction," in Marshall Cohen, Thomas Nagel, and Thomas Scanlon, eds., *Equality and Preferential Treatment* (Princeton, NJ: Princeton University Press, 1977).

Colorado Council on the Arts and Humanities, *Entry Grant Program* (Denver: Colorado Council on the Arts and Humanities, 1990).

Colorado Council on the Arts and Humanities, *Project Grants 1991–1992* (Denver: Colorado Council on the Arts and Humanities, 1990).

Cultural Arts Task Force, *Toward Cultural Democracy: The Development and Implementation of a Policy for Cultural Diversity in New York State* (Albany: New York State Black and Puerto Rican Legislative Caucus, 1988).

Cummings, Milton C., Jr., "Government and the Arts: Policy Problems in the Fields of Art, Literature and Music," *Policy Studies Journal* 5 (Fall 1976): 114–124.

Cummings, Milton C., Jr., "To Change a Nation's Cultural Policy: The Kennedy Administration and the Arts in the United States, 1961–1963," in Kevin V. Mulcahy and C. R. Swaim, eds., *Public Policy and the Arts* (Boulder, CO: Westview Press, 1982).

Cummings, Milton C., Jr., and Richard S. Katz, eds., *The Patron State: Government and the Arts in Europe, North America, and Japan* (New York: Oxford University Press, 1987).

Cummings, Milton C., Jr., and J. Mark Davidson Schuster, eds., *Who's to Pay for the Arts? The International Search for Models of Support* (New York: American Council for the Arts, 1989).

Cwi, David, "Arts Councils as Public Agencies: The Policy Impact of Mission, Role, and Operations," in William S. Hendon and James L. Shanahan, eds., *Economics of Cultural Decisions* (Cambridge, MA: ABT Books, 1983).

D.C. Commission on the Arts and Humanities, *Comprehensive Arts Development, Guidelines FY '90* (Washington, DC: D.C. Commission on the Arts and Humanities, 1989).

D.C. Commission on the Arts and Humanities, *Grants–in–Aid Program, Guidelines FY 1991* (Washington, DC: D.C. Commission on the Arts and Humanities, 1990).

Delaware State Arts Council, *1991 Guide to Programs* (Wilmington: Delaware State Arts Council, 1990).

Dickie, George, *Evaluating Art* (Philadelphia: Temple University Press, 1988).

DiMaggio, Paul J., "Can Culture Survive the Marketplace?" *Journal of Arts Management and Law* 13 (Spring 1983): 61–87.

DiMaggio, Paul J., "Cultural Policy Studies: What They Are and Why We Need Them," *Journal of Arts Management and Law* 13 (Spring 1983): 241–248.

DiMaggio, Paul J., "The Nonprofit Instrument and the Influence of the Marketplace on Policies in the Arts," in W. McNeil Lowry, ed., *The Arts and Public Policy in the United States* (Englewood Cliffs, NJ: Prentice–Hall, 1984).

DiMaggio, Paul J., "Decentralization of Arts Funding from the Federal Government to the States," in Stephen Benedict, ed., *Public Money and the Muse: Essays on Government Funding for the Arts* (New York: W. W. Norton, 1991).

DiMaggio, Paul J., "Nonprofit Organizations in the Production and Distribution of Culture," in Walter W. Powell, ed., *The Nonprofit Sector: A Research Handbook* (New Haven, CT: Yale University Press, 1987).

DiMaggio, Paul J., and Francie Ostrower, "Participation in the Arts by Black and White Americans," in David B. Pankratz and Valerie B. Morris, eds., *The Future of the Arts: Public Policy and Arts Research* (New York: Praeger, 1990).

DiMaggio, Paul J., and Michael Useem, "Cultural Property and Public Policy: Emerging Tensions in Government Support for the Arts," *Social Research* 45 (1978): 356–389.

Dworkin, Ronald, *Taking Rights Seriously* (Cambridge, MA: Harvard University Press, 1977).

Eliot, T. S., *Notes towards the Definition of Culture* (New York: Harcourt, Brace, 1949).

Elliott, David J., "Music as Culture: Toward a Multicultural Concept of Arts Education," *Journal of Aesthetic Education* 24 (Spring 1990): 147–166.

Feldman, Edmund Burke, *Art as Image and Idea* (Englewood Cliffs, NJ: Prentice–Hall, 1967).

Feldman, Edmund Burke, *Varieties of Visual Experience* (Englewood Cliffs, NJ: Prentice–Hall, 1981).

Feller, Irwin, *Universities and State Governments: A Study in Policy Analysis* (New York: Praeger, 1986).

Fischer, Frank, *Politics, Values, and Public Policy: The Problem of Methodology* (Boulder, CO: Westview Press, 1980).

Fischer, Frank, and John Forester, eds., *Confronting Values in Policy Analysis: The Politics of Criteria* (Newbury Park, CA: Sage Publications, 1987).

Florida Arts Council, *Final Report: Rural/Minority Arts Project* (Tallahassee: Florida Arts Council, 1990).

Florida Arts Council, *Grant Panelist Handbook* (Tallahassee: Florida Arts Council, 1991).

Ford, C. S., Terry E. Prothro, and Irwin L. Child, "Some Transcultural Comparisons of Aesthetic Judgment," *Journal of Social Psychology* 68 (1966): 19–26.

Foster, John L., "An Advocate Role Model for Policy Analysis," *Policy Studies Journal* 8 (Summer 1980): 958–964.

Frohnmayer, John, "Talking Points" (Briefing paper prepared for Newsmakers Breakfast, National Press Club, Washington, DC, 17 September 1990).

Fullinwider, Robert K., *The Reverse Discrimination Controversy: A Moral and Legal Analysis* (Totowa, NJ: Rowan and Littlefield, 1980).

Gaither, Edmund Barry, "Brunswick Stew," in Getty Center for Education in the Arts, *Inheriting the Theory: New Voices and Multiple Perspectives on DBAE* (Los Angeles, CA: J. Paul Getty Trust, 1990).

Gans, Herbert J., *Popular Culture and High Culture: An Analysis and Evaluation of Taste* (New York: Basic Books, 1974).

Gardner, Howard, *The Arts and Human Development: A Psychological Study of the Artistic Process* (New York: John Wiley and Sons, 1973).

Garfias, Robert, "Cultural Diversity and the Arts in America," in Stephen Benedict, ed., *Public Money and the Muse: Essays on Government Funding for the Arts* (New York: W. W. Norton, 1991).

Geertz, Clifford, *The Interpretation of Cultures* (New York: Basic Books, 1973).

Geertz, Clifford, "Blurred Genres: The Refiguration of Social Thought," *American Scholar* 49 (Spring 1980): 165–179.

Georgia Council for the Arts, *Agency Plan for Fiscal Years 1991, 1992, 1993* (Tucker: Georgia Council for the Arts).

Georgia Council for the Arts, *Guide to Programs 1992* (Tucker: Georgia Council for the Arts, 1991).

Giroux, Henry A., *Ideology, Culture, and the Process of Schooling* (Philadelphia, PA: Temple University Press, 1981).

Glazer, Nathan, and Daniel P. Moynihan, *Beyond the Melting Pot* (Cambridge: Harvard University Press and MIT Press, 1963).

Glazer, Nathan, and Daniel P. Moynihan, eds., *Affirmative Discrimination: Ethnic Inequality and Public Policy* (New York: Basic Books, 1975).

Glazer, Nathan, and Daniel P. Moynihan, eds., *Ethnicity: Theory and Experience* (Cambridge: Harvard University Press, 1975).

Goldman, Alvin H., *Justice and Reverse Discrimination* (Princeton, NJ: Princeton University Press, 1979).

Goodman, Nelson, *Languages of Art: An Approach to a Theory of Symbols* (Indianapolis: Hackett, 1976).

Goodman, Nelson, *Ways of Worldmaking* (Indianapolis: Hackett, 1978).

Gordon, Milton, *Assimilation in American Life: The Role of Race, Religion, and National Origins* (New York: Oxford University Press, 1964).

Gordon, Milton, "Toward a General Theory of Racial and Ethnic Group Relations," in Nathan Glazer and Daniel P. Moynihan, eds., *Ethnicity: Theory and Experience* (Cambridge, MA: Harvard University Press, 1975).

Graburn, Nelson H. H., ed., *Ethnic and Tourist Arts: Cultural Expressions from the Fourth World* (Berkeley: University of California Press, 1976).

Gray, Donovan, ed., *Open Dialogue II: Summary Report* (Washington, DC: Association of American Cultures and National Assembly of Local Arts Agencies, 1987).

Greeley, Andrew, *Ethnicity in the United States* (New York: John Wiley and Sons, 1974).

Green, Thomas F., *Education and Pluralism: Idea and Reality* (Syracuse, NY: School of Education, Syracuse University, 1966).

Green, Thomas F., "What Is Educational Policy?" in J. Weaver, ed., *Educational Policy* (Danville, IL: Interstate, 1975).

Grigsby, Eugene, *Art and Ethnics* (Dubuque, IA: William C. Brown, 1977).

Habermas, Jurgen, *Knowledge and Human Interests* (Boston: Beacon Press, 1971); Habermas, Jurgen, *Legitimation Crisis* (Boston: Beacon Press, 1973); Habermas, Jurgen, *Theory and Practice* (Boston: Beacon Press, 1973); Habermas, Jurgen, *Communication and the Evolution of Society* (Boston: Beacon Press, 1979).

Harris, Louis, and Associates, Inc., *Americans and the Arts V: A Nationwide Survey of Public Opinion* (New York: American Council for the Arts, 1988).

Hauser, Arnold, *The Sociology of Art*, translated by Kenneth J. Northcott (Chicago: University of Chicago Press, 1982).

Hawkesworth, M. E., *Theoretical Issues in Policy Analysis* (Albany: State University of New York Press, 1988).

Hill, Hart, "Creative Communities: Social Engineering or Enlightened New Philosophy?" *Muse: Colorado's Journal of the Arts* 70 (February/March 1991): 3–4.

Hoard, Adrienne Walker, "The Black Aesthetic: An Empirical Feeling," in Bernard Young, ed., *Art, Culture, and Ethnicity* (Reston, VA: National Art Education Association, 1990).

Hook, Sidney, "Discrimination, Color Blindness, and the Quota System," in Barry Gross, ed., *Reverse Discrimination* (Buffalo, NY: Prometheus Books, 1977).

Horowitz, Harold, "Measuring Arts Participation," in Virginia L. Owen and William S. Hendon, eds., *Managerial Economics for the Arts* (Akron, OH: Association for Cultural Economics, 1985).

Horowitz, Harold, "Fact and Fantasy in Arts and Cultural Information," in David B. Pankratz and Valerie B. Morris, eds., *The Future of the Arts: Public Policy and Arts Research* (New York: Praeger, 1990).

Hsu, Francis L. K., "American Core Values and National Character," in Francis L. K. Hsu, ed., *Psychological Anthropology* (Cambridge, MA: Schenkman, 1972).

Hutchins, E., *Culture and Inference* (Cambridge, MA: Harvard University Press, 1980).

Illinois Arts Council, *Program Grants Guidelines and Application, Fiscal Year 1992* (Chicago: Illinois Arts Council, 1991).

Independent Commission, *A Report to Congress on the National Endowment for the Arts* (Washington, DC: Independent Commission, 1990).

Indiana Arts Commission, *1991–1993 Guide to Grants* (Indianapolis: Indiana Arts Commission, 1990).

Indiana Arts Commission, *Arts: Rural and Multicultural* (Indianapolis: Indiana Arts Commission, n.d.).

Iwao, Sumiko, and Irwin L. Child, "Comparison of Aesthetic Judgments by American Experts and by Japanese Potters," *Journal of Social Psychology* 68 (1966): 27–33.

Jennings, Bruce, "Interpretation and the Practice of Policy Analysis," in Frank Fischer and John Forester, eds., *Confronting Values in Policy Analysis: The Politics of Criteria* (Newbury Park, CA: Sage Publications, 1987).

Jennings, Bruce, "Policy Analysis: Science, Advocacy, or Counsel?" in Stuart S. Nagel, ed., *Research in Public Policy Analysis and Management* 4 (Greenwich, CT: JAI Press, 1987).

Johnson, Lesley, *The Cultural Critics: From Matthew Arnold to Raymond Williams* (Boston: Routledge and Kegan Paul, 1979).

Kallen, Horace M., *Culture and Democracy in the United States* (New York: Boni and Liveright, 1924).

Kallen, Horace M., *Cultural Pluralism and the American Idea: An Essay in Social Philosophy* (Philadelphia: University of Pennsylvania Press, 1956).

Kansas Arts Commission, *Major Grant Guidelines, Fiscal Year 1992* (Topeka: Kansas Arts Commission, 1990).

Kansas State Board of Education, *Guidelines for Program Development—Art*, second edition (Topeka: Kansas State Board of Education, 1990).

Katz, Jonathan, "Decentralization and the Arts: Principles, Practice, and Policy," *Journal of Arts Management and Law* 13 (Spring 1983): 109–120.

Katz, Jonathan, ed., *Arts and Education Handbook: A Guide to Productive Collaborations* (Washington, DC: National Assembly of State Arts Agencies, 1988).

Katz, Stanley N., "Influences on Public Policies in the United States," in W. McNeil Lowry, ed., *The Arts and Public Policy in the United States* (Englewood Cliffs, NJ: Prentice–Hall, 1984).

Keens, William, ed., *The Road Ahead: Arts Issues in the 1990s* (New York: American Council for the Arts, 1989).

Keens, William, and Naomi Rhodes, eds., *An American Dialogue* (Washington, DC: Association of Performing Arts Presenters, 1989).

Kentucky Arts Council, *Long–Range Action Plan for the Arts, FY 1989 to FY 1994* (Frankfort: Kentucky Arts Council, 1988).

Kentucky Arts Council, *1991 Project Grant Guidelines* (Frankfort: Kentucky Arts Council, 1990).

Kentucky Arts Council, *Overview* (Frankfort: Kentucky Arts Council, 1990).

Kerr, Donna, *Educational Policy: Analysis, Structure, and Justification* (New York: David McKay, 1976).

Knight, Robert H., *The National Endowment for the Arts: Misusing Taxpayers' Money* (Washington, DC: Heritage Foundation, 1991).

Kohlberg, Lawrence, *The Philosophy of Moral Development* (New York: Harper & Row, 1981).

Kramer, Hilton, "Is Art Above the Laws of Decency?" *New York Times*, 2 July 1989.

Larson, Gary O., *The Reluctant Patron: The United States Government and the Arts, 1943–1965* (Philadelphia: University of Pennsylvania Press, 1983).

Leavis, F. R., *Education and the University* (London: Chatto and Windus, 1961).

Leavis, F. R., and Denys Thompson, *Culture and the Environment* (London: Chatto and Windus, 1960).

Lindblom, Charles, and David Cohen, *Usable Knowledge: Social Science and Social Problem Solving* (New Haven, CT: Yale University Press, 1979).

Linn, Chris, *Culturally Diverse Organizations in the United States: An Organizational Survey* (Washington, DC: Association of American Cultures, 1988).

Lipman, Matthew, "Can Non–Aesthetic Consequences Justify Aesthetic Values?" *Journal of Aesthetics and Art Criticism* 34 (Winter 1975): 117–123.

Lipman, Samuel, *Arguing for Music, Arguing for Culture* (Boston: David R. Godine, 1990).

Macquet, Jacques, *The Aesthetic Experience: An Anthropologist Looks at the Visual Arts* (New Haven: Yale University Press, 1986).

Maine Arts Commission, *Programs 1990–1991* (Augusta: Maine Arts Commission, 1990).

Massachusetts Cultural Council, *Community Arts and Education Program Guidelines, Fiscal Years 1989–90* (Boston: Massachusetts Cultural Council, 1989).

Massachusetts Cultural Council, *Guide to Programs and Services 1992* (Boston: Massachusetts Cultural Council, 1991).

Massachusetts Cultural Council, "The Massachusetts Cultural Council and the Massachusetts Commission against Discrimination Sign Affirmative Action Memorandum of Agreement," press release, 20 February 1991.

McCall, George J., "Social Science and Social Problem Solving: An Analytic Introduction," in George J. McCall and George H. Weber, eds., *Social Science and Public Policy: The Role of Academic Disciplines in Policy Analysis* (Port Washington, NY: Associated Faculty Press, 1984).

McFee, June King, "Cross–cultural Inquiry into the Social Meanings of Art: Implications for Art Education," *Journal of Multi–Cultural and Cross–Cultural Research in Art Education* 4 (Fall 1986): 6–16.

McFee, June King, and Rogena M. Degge, *Art, Culture, and Environment: A Catalyst* (Belmont, CA: Wadsworth, 1977).

Merriman, Alan P., *The Anthropology of Music* (Evanston, IL: Northwestern University, 1964).

Michigan Council for the Arts, *Michigan Council for the Arts Policy Book* (Detroit: Michigan Council for the Arts, 1988).

Michigan Council for the Arts, *FY 1991 and 1992 Arts Project Guidelines* (Detroit: Michigan Council for the Arts, 1990).

Michigan Council for the Arts, *Summary Overview* (Detroit: Michigan Council for the Arts, n.d.).

Misey, Johanna L., ed., *National Directory of Multi–Cultural Arts Organizations*, 1990 (Washington, DC: National Assembly of State Arts Agencies, 1990).

Mississippi Arts Commission, *Guide to Programs and Services, 1991–1992* (Jackson: Mississippi Arts Commission, 1990).

Missouri Arts Council, *Long–Range Plan Working Papers* (St. Louis: Missouri Arts Council, 1989).

Mulcahy, Kevin V., "The Rationale for Public Culture," in Kevin V. Mulcahy and C. Richard Swaim, eds., *Public Policy and the Arts* (Boulder, CO; Westview Press, 1982).

Mulcahy, Kevin V., "Official Culture and Cultural Repression," *Journal of Aesthetic Education* 18 (Summer 1984): 69–83.

Mulcahy, Kevin V., "The Arts and Their Economic Impact: The Values of Utility," *Journal of Arts Management and Law* 16 (Autumn 1986): 33–48.

Nagel, Stuart S., "Political Science and Public Policy," in George J. McCall and George H. Weber, eds., *Social Science and Public Policy: The Role of Academic Disciplines in Policy Analysis* (Port Washington, NY: Associated Faculty Press, 1984).

National Assembly of Local Arts Agencies, *Minority Art Issues Focus Group* (Washington, DC: National Assembly of Local Arts Agencies, 1986).

National Assembly of Local Arts Agencies, *Policy on Cultural Diversity and Cultural Equity* (Washington, DC: National Assembly of Local Arts Agencies, 1991).

National Assembly of State Arts Agencies, *The National Standard for Arts Information Exchange* (Washington, DC: National Assembly of State Arts Agencies, 1985).

National Assembly of State Arts Agencies, *State Arts Agency Funded Activities: Analysis of Final Descriptive Reports, Fiscal Year 1985* (Washington, DC: National Assembly of State Arts Agencies, 1988).

National Assembly of State Arts Agencies, *Report of the NASAA Task Force on Cultural Pluralism* (Washington, DC: National Assembly of State Arts Agencies, 1989).

National Assembly of State Arts Agencies, *The State of the State Arts Agencies 1989* (Washington, DC: National Assembly of State Arts Agencies, 1989).

National Assembly of State Arts Agencies, *Summary of State Arts Agencies' Grantmaking Activities for Fiscal Year 1987* (Washington, DC: National Assembly of State Arts Agencies, 1989).

National Assembly of State Arts Agencies, *A Plan to Gather Race/Ethnicity Information: Revised Proposal* (Washington, DC: National Assembly of State Arts Agencies, 1991).

National Endowment for the Arts, *Five–Year Planning Document: 1986–1990* (Washington, DC: National Endowment for the Arts, 1984).

National Endowment for the Arts, *Expansion Arts: Application Guidelines Fiscal Year 1988* (Washington, DC: National Endowment for the Arts, 1987).

National Endowment for the Arts, *Five–Year Planning Document, 1989–1993* (Washington, DC: National Endowment for the Arts, 1987).

National Endowment for the Arts, *The Arts in America: A Report to the President and Congress* (Washington, DC: National Endowment for the Arts, Public Information Office, 1988).

National Endowment for the Arts, *Arts in America 1990: The Bridge between Creativity and Community* (Washington, DC: National Endowment for the Arts, 1990).

NEA Research Division Note 14, "Age, Desire and Barriers to Increased Attendance at Performing Arts Events and Museums," 4 February 1986.

Nebraska Arts Council, *Guide to Programs and Services, 1991–92* (Omaha: Nebraska Arts Council, 1990).

Neperud, Ronald W., Ronald Serlin, and Harvey Jenkins, "Ethnic Aesthetics: The Meaning of Ethnic Art for Blacks and Non–Blacks," *Studies in Art Education* 28 (Fall 1986): 16–29.

Nettl, Bruno, *The Western Impact on World Music: Change, Adaptation and Survival* (New York: Schirmer Books, 1985).

Netzer, Dick, *The Subsidized Muse: Public Support for the Arts in the United States* (New York: Cambridge University Press, 1978).

Nevada State Council on the Arts, *Direct Assistance: Guidelines and Application Forms, 1990–91* (Reno: Nevada State Council on the Arts, 1990).

Nevada State Council on the Arts, *Grants to Organizations, 1990–1991* (Reno: Nevada State Council on the Arts, 1991).

New Mexico Arts Division, *A Strategic Plan of the New Mexico Arts Division, 1989–1993: Plan Summary* (Sante Fe: New Mexico Arts Division, 1989).

New Mexico Arts Division, *1991–92 Program Guidelines* (Sante Fe: New Mexico Arts Division, 1990).

New York State Council on the Arts, *Program Guidelines: 1990/91, 1991/92, 1992/93* (New York: New York State Council on the Arts, 1990).

Newman, William A., *American Pluralism: A Study of Minority Groups and Social Theory* (New York: Harper & Row, 1973).

North Carolina Arts Council, *1991 Programs Guide for Organizations* (Raleigh: North Carolina Arts Council, Department of Cultural Resources, 1990).

North Carolina Arts Council, *Organization of Color Development Program* (Raleigh: North Carolina Arts Council, 1990).

North Dakota Council on the Arts, *Institutional Support Program: Guidelines Application, FY 1992* (Fargo: North Dakota Council on the Arts, 1990).

Ohio Arts Council, *Guidelines, 1991 to 1993* (Columbus: Ohio Arts Council, 1989).

Oregon Arts Commission, *1990–91 Program Guide* (Salem: Oregon Arts Commission, 1990).

Orend, Richard J., *Socialization in the Arts* (Washington, DC: National Endowment for the Arts, 1987).

Pankratz, David B., "Toward an Integrated Study of Cultural and Educational Policy," *Design for Arts in Education* 87 (November/December 1987): 12–21.

Pankratz, David B., "Arts Policy and Older Adults," *Journal of Arts Management and Law* 18 (Winter 1989): 13–64.

Pankratz, David B., and Valerie B. Morris, eds., *The Future of the Arts: Public Policy and Arts Research* (New York: Praeger, 1990).

Paris, David C., and James F. Reynolds, *The Logic of Policy Inquiry* (New York: Longman, 1983).

Parsons, Talcott, "Some Theoretical Considerations on the Nature and Trends of Change of Ethnicity," in Nathan Glazer and Daniel P. Moynihan, eds., *Ethnicity: Theory and Experience* (Cambridge: Harvard University Press, 1975).

Patterson, Orlando, *Ethnic Chauvinism: The Reactionary Impulse* (New York: Stein and Day, 1977).

Pennsylvania Council on the Arts, *Guide to Programs and Services, 1991–1992* (Harrisburg: Pennsylvania Council on the Arts, 1991).

Peterson, Richard A., "From Impresario to Arts Administrator: Formal Accountability in Cultural Organizations," in Paul J. DiMaggio, ed., *Nonprofit Enterprise in the Arts: Studies in Mission and Constraint* (New York: Oxford University Press, 1986).

Peterson, Richard A., "Audience and Industry Origins of the Crisis in Classical Music Programming: Toward World Music," in David B. Pankratz and Valerie B. Morris, eds., *The Future of the Arts: Public Policy and Arts Research* (New York: Praeger, 1990).

Piaget, Jean, *The Construction of Reality in the Child* (New York: Basic Books, 1954).

Pratte, Richard, *Pluralism in Education: Conflict, Clarity, and Commitment* (Springfield, IL: Charles C. Thomas, 1979).

Rader, Melvin, and Bertram Jessup, *Art and Human Values* (Englewood Cliffs, NJ: Prentice–Hall, 1976).

Ravitch, Diane, "Multiculturalism: E Pluribus Plures," *American Scholar* (Summer 1990): 337–354.

Rawls, John, *A Theory of Justice* (Cambridge, MA: Belknap Press, 1971).

Reynolds, William Bradford, *Equal Opportunity, Not Equal Results* (College Park: Center for Philosophy and Public Policy, University of Maryland, 1985).

Robinson, John P., Carol A. Keegan, Marcia Karth, and Timothy A. Triplett, *Survey of Public Participation in the Arts: 1985, Volume 1, Project Report* (Washington, DC: University of Maryland Survey Research Center and the National Endowment for the Arts, 1987).

Sahlins, M., *Culture and Practical Reason* (Chicago: University of Chicago Press, 1976).

Saville, Anthony, *The Test of Time* (New York: Oxford University Press, 1982).

Scheffler, Israel, *The Language of Education* (Springfield, IL: Charles C. Thomas, 1960).

Schlesinger, Arthur M., Jr., *The Disuniting of America: Reflections on a Multicultural Society* (New York: W. W. Norton, 1992).

Schuster, J. Mark Davidson, "The Interrelationships between Public and Private Funding of the Arts in the United States," *Journal of Arts Management and Law* 14 (Winter 1985): 77–105.

Schuster, J. Mark Davidson, "The Search for International Models: Results from Recent Comparative Research in Arts Policy," in Milton C. Cummings, Jr., and J. Mark Davidson Schuster, eds., *Who's to Pay for the Arts? The International Search for Models of Support* (New York: American Council for the Arts, 1989).

Seaman, Bruce A., "Arts Impact Studies: A Fashionable Excess," in Anthony J. Radich, ed., *Economic Impact of the Arts: A Source-*

book (Denver, CO: National Conference of State Legislatures, 1987).

Sher, George, "Justifying Reverse Discrimination in Employment," in Marshall Cohen, Thomas Nagel, and Thomas Scanlon, eds., *Equality and Preferential Treatment* (Princeton, NJ: Princeton University Press, 1977).

Shweder, Richard A., "Preview: A Colloquy of Culture Theorists," in Richard A. Shweder and Robert A. Levine, eds., *Culture Theory: Essays on Mind, Self, and Emotion* (Cambridge, MA: Cambridge University Press, 1984).

Smith, Ralph A., ed., *Aesthetics and Criticism in Art Education* (Chicago: Rand McNally, 1966).

Smith, Ralph A., and C. M. Smith, "Justifying Aesthetic Education," in Ralph A. Smith, ed., *Aesthetics and Problems of Education* (Urbana: University of Illinois Press, 1971).

Smith, Ralph A., and C. M. Smith, "The Artworld and Aesthetic Skills: A Context for Research and Development," *Journal of Aesthetic Education* 11 (April 1977): 117–132.

Smith, Ralph A., and C. M. Smith, "The Government and Aesthetic Education: Opportunity in Adversity?" *Journal of Aesthetic Education* 14 (October 1980): 5–20.

South Carolina Arts Commission, "Multicultural Arts Development Program," press release, 1 September 1990.

South Dakota Arts Council, *Guide to Programs, FY 1991, 1992, 1993* (Sioux Falls: South Dakota Arts Council, 1990).

Spellman, A. B., "Minority Arts Organizations Thrive," *Artspace* 10 (May/June 1987): 4.

State Arts Council of Oklahoma, *Project Assistance, 1990–91* (Oklahoma City: State Arts Council of Oklahoma, 1990).

Steinberg, Stephen, *The Ethnic Myth: Race, Ethnicity, and Class in America* (New York: Atheneum, 1981).

Steiner, George, *In Bluebeard's Castle: Some Notes towards the Redefinition of Culture* (New Haven, CT: Yale University Press, 1971).

Sullivan, Kathleen M., "Artistic Freedom, Public Funding and the Constitution," in Stephen Benedict, ed., *Public Money and the Muse: Essays on Government Funding for the Arts* (New York: W. W. Norton, 1991).

Swaim, C. Richard, "The National Endowment for the Arts, 1965–1980," in Kevin V. Mulcahy and C. Richard Swaim, eds., *Public Policy and the Arts* (Boulder, CO: Westview Press, 1982).

Tennessee Arts Commission, *Grant Guidelines, Fiscal Year 1992* (Nashville: Tennessee Arts Commission, 1991).

Testimony of Alberta Arthurs (Rockefeller Foundation), Karen Brosius (Philip Morris Companies, Inc.), Cynthia Mayeda (Dayton–Hudson Foundation), and Timothy McClimon (AT&T Foundation) before the Independent Commission, Washington, DC, 23 July 1990.

Testimony of Ruth Mayleas (Independent Committee on Arts Policy) and Stephen Stamas (American Assembly) before the Independent Commission, Washington, DC, on 30 July 1990 and 1 August 1990, respectively.

Texas Commission on the Arts, *A Plan for the Operation, Funding and Services for the Arts in Texas* (Austin: Texas Commission on the Arts, 1988).

Thernstrom, Stephen, ed., *Harvard Encyclopedia of American Ethnic Groups* (Cambridge, MA: Belknap Press of Harvard University Press, 1980).

Thernstrom, Stephen, ed., *Ethnic Relations in America* (Englewood Cliffs, NJ: Prentice–Hall, 1982).

Thomson, Judith Jarvis, "Preferential Hiring," *Philosophy and Public Affairs* 2 (Summer 1973): 364–384.

Tyler, S. A., *Cognitive Anthropology* (New York: Holt, Rinehart and Winston, 1969).

Tylor, E. B., *Primitive Culture*, Volume 7 (London: Murray, 1871).

Urice, John K., "Using Research to Determine, Challenge, or Validate Public Arts Policy," *Journal of Arts Management and Law* 13 (Spring 1983): 199–220.

Urice, John K., "Planning at the National Endowment for the Arts: A Review of the Plans and Planning Documents, 1978–1984," *Journal of Arts Management and Law* 15 (Summer 1985): 79–91.

Urice, John K., "Government Support for the Arts in the United States, 1990–2015: A Forecast," in David B. Pankratz and Valerie B. Morris, eds., *The Future of the Arts: Public Policy and Arts Research* (New York: Praeger, 1990).

U.S., Congress, *Reauthorizaton of Foundation on the Arts and the Humanities Act of 1990*, 101st Cong. (Washington, DC: Government Printing Office, 1990).

Vermont Council on the Arts, *1991 Handbook: A Guide to Grants, Programs and Services* (Montpelier: Vermont Council on the Arts, 1991).

Virginia Commission for the Arts, *Guidelines for Funding, 1990–92* (Richmond: Virginia Commission for the Arts, 1990).

Vobejda, Barbara, "Asian, Hispanic Numbers in U.S. Soared in 1980s, Census Reveals," *Washington Post*, 11 March 1991, pp. A1, A5.

Weiss, Carol H., "Improving the Linkage between Social Research and Public Policy," in Laurence E. Lynn, Jr., ed., *Knowledge and Policy:*

The Uncertain Connection (Washington, DC: National Academy of Sciences, 1978).

Weiss, Carol H., "Ideology, Interests, and Information: The Basis of Policy Positions," in Daniel Callahan and Bruce Jennings, eds., *Ethics, the Social Sciences, and Policy Analysis* (New York: Plenum Press, 1983).

Weitz, Morris, *The Opening Mind* (Chicago: University of Chicago Press, 1977).

Wildavsky, Aaron, *Speaking Truth to Power: The Art and Craft of Policy Analysis* (Boston: Little, Brown, 1979).

Williams, Raymond, *The Long Revolution*, revised edition (New York: Harper & Row, 1966).

Williams, Raymond, "Culture and Civilization," in *The Encyclopedia of Philosophy* (New York: Macmillan and Free Press, 1967).

Williams, Raymond, *Keywords: A Vocabulary of Culture and Society* (New York: Oxford University Press, 1976).

Williams, Raymond, *The Sociology of Culture* (New York: Schocken Books, 1981).

Williams, Raymond, *Culture and Society, 1780–1950*, second edition (New York: Columbia University Press, 1983).

Wilson, John, "Art, Culture, and Identity," *Journal of Aesthetic Education* 18 (Summer 1984): 89–97.

Wisconsin Alliance for Arts Education, *Facing the Challenge: A Comprehensive Arts Education Planning Guide for Wisconsin* (Madison: Wisconsin Alliance for Arts Education, 1990).

Wolfe, Alvin W., "Social Structural Bases of Art," *Current Anthropology* 10 (1969): 3–29.

Wolff, Janet, *Aesthetics and the Sociology of Art* (London: G. Allen and Unwin, 1983).

Wolff, Janet, *The Social Production of Art* (New York: New York University Press, 1984).

Wolff, Janet, "Questioning the Curriculum: Arts, Education and Ideology," *Studies in Art Education* 31 (Summer 1990): 198–206.

Wollheim, Richard, "Sociological Explanations of the Arts: Some Distinctions," in Milton C. Albrecht, James H. Barnett, and Mason Griff, eds., *The Sociology of Art and Literature: A Reader* (New York: Praeger, 1970).

Wolterstorff, Nicholas, *Art in Action* (Grand Rapids, MI: William B. Eerdsmann, 1980).

Wyoming Arts Council, *Grants Applications* (Cheyenne: Wyoming Arts Council, 1990).

Wyszomirski, Margaret J., "Arts Policymaking and Interest Group Politics," *Journal of Aesthetic Education* 14 (October 1980): 28–34.

Wyszomirski, Margaret J., "Controversies in Arts Policymaking," in Kevin V. Mulcahy and C. Richard Swaim, eds., *Public Policy and the Arts* (Boulder, CO: Westview Press, 1982).

Wyszomirski, Margaret J., "Philanthropy, the Arts, and Public Policy," *Journal of Arts Management and Law* 16 (Winter 1987): 5–29.

Wyszomirski, Margaret J., and Pat Clubb, eds., *The Cost of Culture: Patterns and Prospects of Private Arts Patronage* (New York: American Council for the Arts, 1989).

Wyszomirski, Margaret J., and Monnie Peters, *The Arts Research System: Its Structure and Current State* (New York: American Council for the Arts, 1988).

Wyzsomirski, Margaret Jane, Monnie Peters, and Kevin V. Mulcahy, "The Policy Utility of the NEA's Report on the State of the Arts," in David B. Pankratz and Valerie B. Morris, eds., *The Future of the Arts: Public Policy and Arts Research* (New York: Praeger, 1990).

Yoshitomi, Gerald D., "Cultural Democracy," in Stephen Benedict, ed., *Public Money and the Muse: Essays on Government Funding for the Arts* (New York: W. W. Norton, 1991).

Zolberg, Vera L., *Constructing a Sociology of the Arts* (New York: Cambridge University Press, 1990).

Index

Acculturation: defined, 120

Aesthetic experience: and artistic value, 174, 178–179; Beardsley's concept of, 173–174; Goodman's concept of, 175

Aesthetic value: concept of undermined, 21

Affirmative action: and principles of justice, 149; conceptual morass of, 149; dcfincd, 147–148; diversity of programs of, 148; in state arts agencies, 148; policy choices regarding, 149

Affirmative discrimination: defined, 128

Alabama State Council on the Arts: weighted evaluative criteria of, 80

Amalgamation: as predictive theory, 121; as societal ideal, 122; explanatory value of, 121–122; premises underlying, 122

Appleton, Nicholas: on classical cultural pluralism, 124; on cultural pluralism as voluntary ethnic choice, 125; on cultural separation, 125–126; on modified cultural pluralism, 124–125

Arizona Commission on the Arts: goal statements of, 69; shift in policy mechanisms, 97; special initiatives of, 95–96

Arkansas Arts Council: evaluative criteria of, 79

Art: and imagination, 180; as culture specific, 136; as undefined by many cultures, 166; conditions for definitions of, 14; Eurocentric concept of, 21; evaluated by its uses, 23

Art/culture relations: and causal relationships, 134, 136; and "reflection" metaphor, 133–135; anthropological inquiry into, 132–133; as complex, 134; as multidimensional, 132; sociological inquiry into, 133

Artistic value: and anthropology of art, 166; and artistic subject matter, 168; and equality of opportunity, 164; and formal artistic properties, 168; and human values, 170; and moral content of art, 179–180; and public arts agencies, 164–165, 184; and purposes

About the Author

DAVID B. PANKRATZ is a research consultant in arts policy, management and education in the Washington, D.C. area. The author of numerous articles on public policy, the arts, and arts education, Dr. Pankratz co-edited *The Future of the Arts: Public Policy and Arts Research* (Praeger, 1990.)

4.6.94 COURTS 49.95 58718